DELIUS KLASING

GREEN PEACE VIEWS

GREENPEACE

DELIUS KLASING VERLAG

»How can we sleep while our beds are burning«
50 years of Greenpeace - 50 years of »Hope in Action« for a green, peaceful and just world

by Jennifer Morgan and Thomas Henningsen

50 years of Greenpeace

A more spectacular beginning could not have been imagined for Greenpeace. In September 1971, a crew of just twelve set out to peacefully confront the U.S.A., the world's most powerful military force, over the detonation of an underground nuclear bomb on the island of Amchitka. Although the test went ahead, the mission was a success, as it would be the last nuclear test on the island due to the vociferous protests that were held during Greenpeace's voyage.

The waves caused by the courage and compassion of that small crew have been resonating ever since, and the work being done by Greenpeace has only intensified as the climate and biodiversity crisis tragically continues to worsen. Injustice in all its forms, from climate to race to gender to economic disparity, continues to reign supreme due to corrupt politicians and greedy elites, and yet the hope and power of people both young and old, from all walks of life, holds firm. A safer, healthier, greener tomorrow can still happen, as we already have the solutions to the climate and biodiversity crises, but we are still on our journey to implementing them and turning them into reality.

Greenpeace has always based its campaigns and missions on its vision of a green and peaceful world. Then as now, the environmental network's activities are based on five pillars:

MISSION
Greenpeace is an international environmental campaigning network that aims to protect the diversity of life and the planet.

ACTIONS
Bearing witness and non-violent direct actions are central to Greenpeace's campaigns and aim to hold polluters to account. Documenting environmental crimes to show the world what it does not know or has forgotten helps us to make it a witness to our actions when intervening and calling out those in power who are causing the planet harm. The development of scientific principles and solutions to influence political processes have become an important activity over the network's lifetime. Climate litigation is becoming an increasingly potent campaigning tool for bringing about positive change.

GLOBALNESS
Peace and the environment know no borders, which is why Greenpeace has had an international focus right from the start, and now has a more diverse and global outlook than ever before. We have grown into a global movement with an international network alongside allies. This means we no longer stand alone in tackling what are often challenges facing specific nations – quite the contrary, in fact, because the international implications and global threat they present make these challenges opportunities as well – ones that can often be overcome more effectively with global support. Greenpeace is active on all seven continents, and maintains a permanent presence in 55 countries, bringing together millions of supporters across the planet, from all ethnicities, creeds, sexes, gender identities and economic backgrounds.

POLITICAL AND FINANCIAL INDEPENDENCE
From the very outset, a focus was directed at maintaining financial and political independence. This was prioritised because only this gives Greenpeace the freedom to act and criticise openly. It is private donations that make our work possible – we do not accept money from companies, state or government agencies.

PEOPLE POWER
A mind bomb 50 years ago has led to a movement that has an impact on the entire world, thanks to millions of courageous volunteers. More than 3,000 people currently work for Greenpeace. Worldwide, many thousands more provide their support on a voluntary basis and many millions support Greenpeace.

WHAT HAS GREENPEACE ACHIEVED?
Greenpeace has achieved important successes from the Arctic to the Amazon, as well as in Africa, Asia and beyond; from the halls of power to mining towns to school rooms, from the

end of commercial whaling to the ban on dumping radioactive and toxic waste in the world's oceans. Its successes also include the World Park Antarctica, and the development and the roll-out of CFC-free refrigerators, as well as its key role in achieving a phase-out of nuclear power and preventing genetic engineering in agriculture – not to mention stopping deforestation and promoting the fossil-fuel phaseout.

Greenpeace has had an impact on countless lives – improving the conditions in which people, animals and plants live, at times saving them – with every hectare of forest spared, with every square kilometre of marine reserve declared, and with every improvement made to nature conservation and environmental protection laws.

Ecological thinking and sustainable action have become an essential part of political discussions across the world – in stark contrast to the situation at the beginning of the 1970s. Of course, this was no easy feat – a strong will, courage, creativity, perseverance and, above all, the tireless commitment of so many people were, and will remain, necessary. And Greenpeace cannot take credit for all this positive change alone.

The environmental movement, which Greenpeace is proud to be a part of, has had to reassert and reinvent itself time and again, changing with the constantly shifting backdrop of corrupt lobbying, insipid greenwashing, anachronistic thinking, and polluters putting profit before people and the planet. It has also had to change and grow, welcoming unexpected allies, sharing precious resources, and broadening the vision we share of a healthier tomorrow for everyone. This has involved self-reflection on the need to empower the most marginalized and vulnerable groups among us, while we are constantly challenging ourselves to be more inclusive and egalitarian.

We have arrived in a decisive decade for the climate, and we have had to place a keener focus than ever before on the intersectionality of the crises the world is facing today, highlighting the interdependency of the solutions, and exhibiting the boldness necessary to embrace radical systemic change. We need to remain courageous enough to hope.

Even our mission is evolving, because it is no longer just about protecting the foundations on which life rests but is now also about preserving them and ensuring their survival on earth.

Today we are facing the greatest environmental crisis of all time – the biodiversity and climate crisis. The climate change caused by humans and, in particular, the inaction of many politicians is expediting the loss of biodiversity. This scenario is racing towards us at a speed that could soon see a future arrive that it is imperative to prevent.

The sixth status report of the Intergovernmental Panel on Climate Change (IPCC), which was just published in August 2021, vividly shows how dramatic the situation is and what unspeakable suffering we are in for if we do not manage to use the remaining period of a few years to change course and avert the worst climate scenarios.

The polar caps are melting at an unprecedented rate – the amount of meltwater from Greenland in the last 20 years totalled around 4,000 gigatonnes, or around 400,000 tonnes per minute every day for the last 20 years. The Ohio State University warned that the »point of no return« could be reached for Greenland's ice cap in August 2020, this would mean that no matter what we do, Greenland's ice will melt and raise the global sea level by around seven metres. The only question that would remain is how fast this will happen. In the same year, the highest temperature ever recorded in Antarctica, almost 21 degrees Celsius, was measured. And the world is literally on fire, with the earth's forests burning more than ever, deadly and destructive fires in the tropical forests of Amazonia, Africa and Asia, but also in North America, southern Europe, Australia and even in the far north of Russia.

We are experiencing more and more violent storms, floods, fires and other extreme catastrophic weather events – combined with water scarcity, droughts, failed harvests and the famines that result from them. According to the latest study by the Institute for Economics and Peace, there will be 1.2 billion people seeking a new home over the coming 30 years as climate refugees.

The climate crisis is nothing new, and by now, we should be more than aware that we are heading towards a hitherto unseen period of upheaval – if we fail to take fast and consistent measures to counteract climate change.

It is precisely because of these impending dangers that the climate movement is so vital, and makes it all the more necessary to form alliances now. Forging powerful networks is a global priority for Greenpeace. Because governments are still not implementing the urgently needed climate goals, alliances with industry – the ones prepared to take responsibility – or with local politicians are necessary. This

**QR code for the original songs by Midnight Oil.
Beds Are Burning (1987) and Beds are Burning – TckTckTck (2009) – Time for Climate Justice**

also extends to groups you might not initially associate with us, such as the Black Lives Matter movement in the U.S.A. or First Nations on all continents, People of Colour, and LGBTQI+. Greenpeace supports them because it is the system that we have to change. The same economic and , in part , the same social system that oppresses marginalised communities, People of Colour and Indigenous peoples is also a system that allows the exploitation and destruction of nature. In addition, support, cooperation, and alliances with the youth of the world – the next generations – has a key importance.

Some things have still not changed since the 1970s: the environmental ignorance of most politicians, and the lack of conscience exhibited by many corporations. Investors, banks and financiers are simply carrying on with activities that are injurious to the climate and environment instead of taking responsibility and promoting change. We have to get people around the world to vote for politicians who will support the energy, mobility and agricultural transition. We need leaders in power who are prepared to implement solutions, take immediate measures, and promote technologies that are already available, and also ensure all industry investments are made with environmental requirements in mind, moving the world towards an ecologically compatible economic system.

»HOW DO WE SLEEP WHILE OUR BEDS ARE BURNING?«
The song by the Australian band Midnight Oil describes the forced displacement of the Australian Pintupi Aborigines and the subsequent contamination of their traditional grounds by nuclear weapons testing. This text not only resonates with Greenpeace due to its anti-nuclear origins, but also because of the current situation around the world. This song was rewritten for the global climate summit in Copenhagen in 2009 in order to warn the participating politicians about the impending climate crisis.

The world failed to seize the opportunity in Copenhagen, resulting in the loss of valuable time. We are determined to keep going and keep contributing to real change on the basis of strong alliances. We maintain hope, and that gives us the will to keep growing, to get the international youth climate movement involved, and to inspire the same hope among the new generation of activists.

The current climate and biodiversity emergency shows the urgency of a radical and fundamental systemic change for a green and just future for everyone – the youth of today and tomorrow, Indigenous peoples and marginalised communities on the climate frontlines, and other living beings that share our beautiful lands, waters and sky with us. Greenpeace continues to confront, to learn, to be creative, and to be compassionate and courageous.

This book should not only be a book that shares insights into the exciting, moving and richly illustrated history of our organisation, thereby also sharing insights into the people who have contributed so much to it, but also be a book that shows this to everyone who has yet to become involved, and that encourages and motivates them to join the fight for a diverse, peaceful, clean and just world.

This is why the credo that motivates and drives us at Greenpeace, and those who support Greenpeace, is:

IT IS NOT THE TIME TO REST, EVEN MORE SO NOW, BECAUSE OUR EARTH IS STARTING TO BURN.

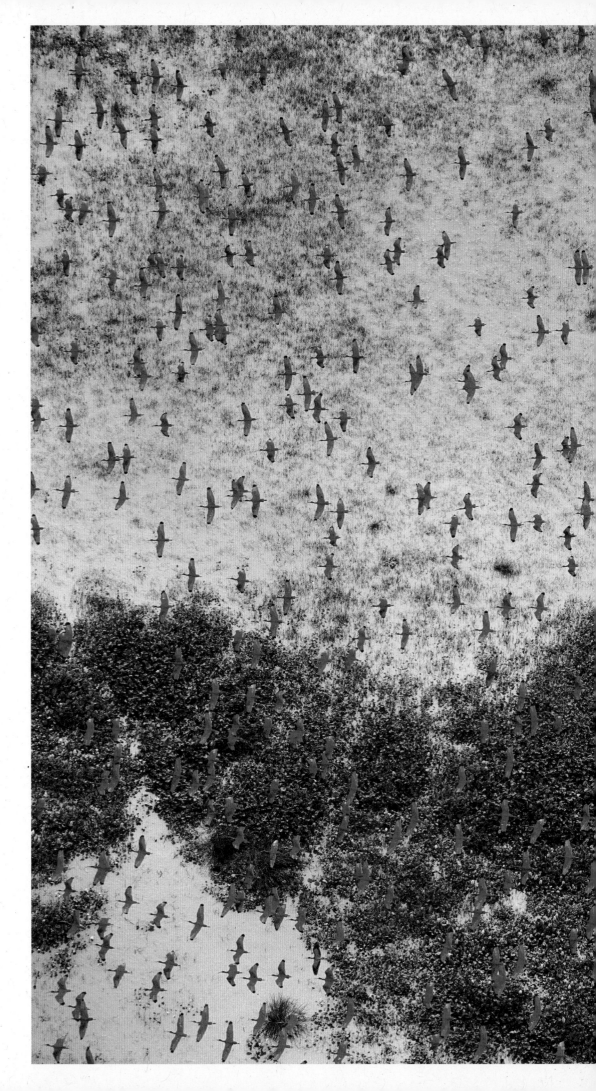

Fascinating wonders of nature
Our earth is actually a planet full
of fascinating wonders of nature,
as evidenced by flocks of bright red
scarlet ibis flying over a wetland on
the coast of Brazil
5 February 2017

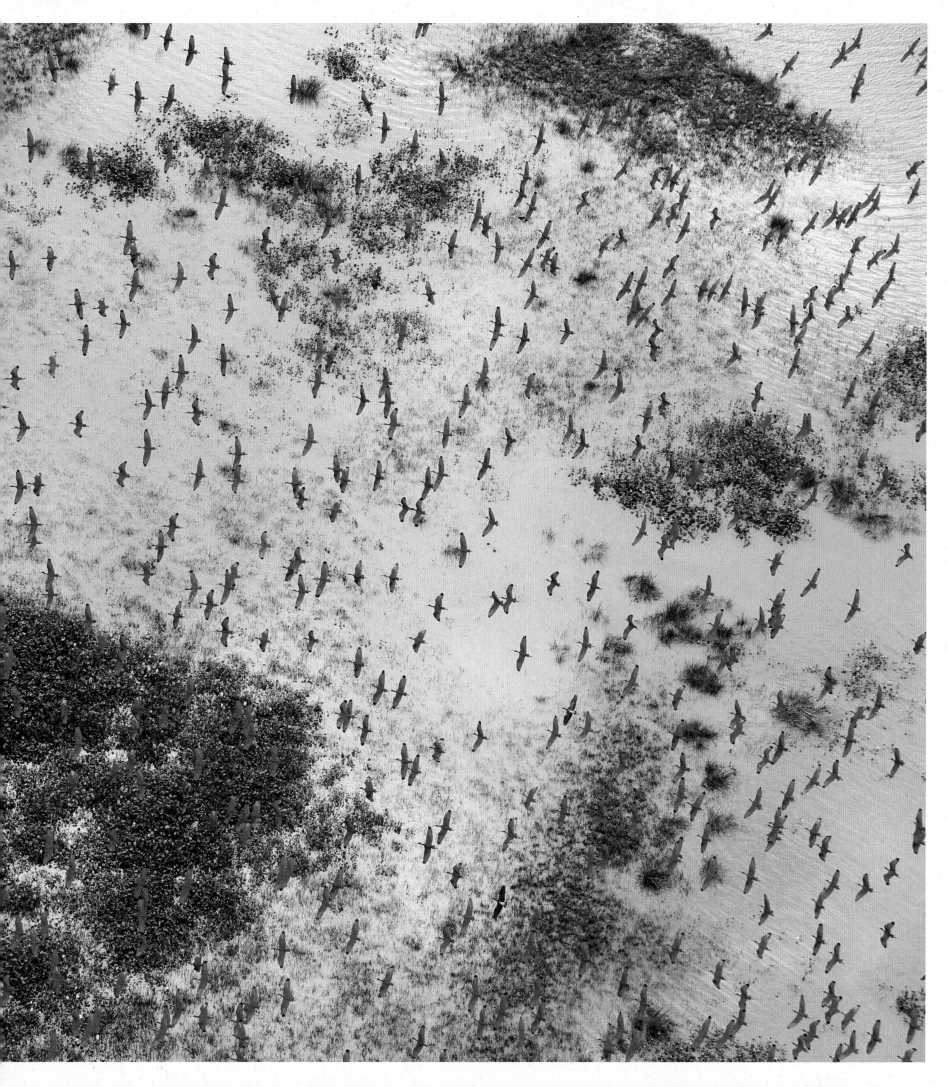

Unforgivable environmental destruction
Complete destruction of a primaeval forest area in Papua/Indonesia for the irresponsible expansion of oil palm mono-cultures. Palm oil is used in many foods, cosmetics and often even so-called biodiesel in Europe and North America, and is a major cause of rainforest destruction
1 April 2018

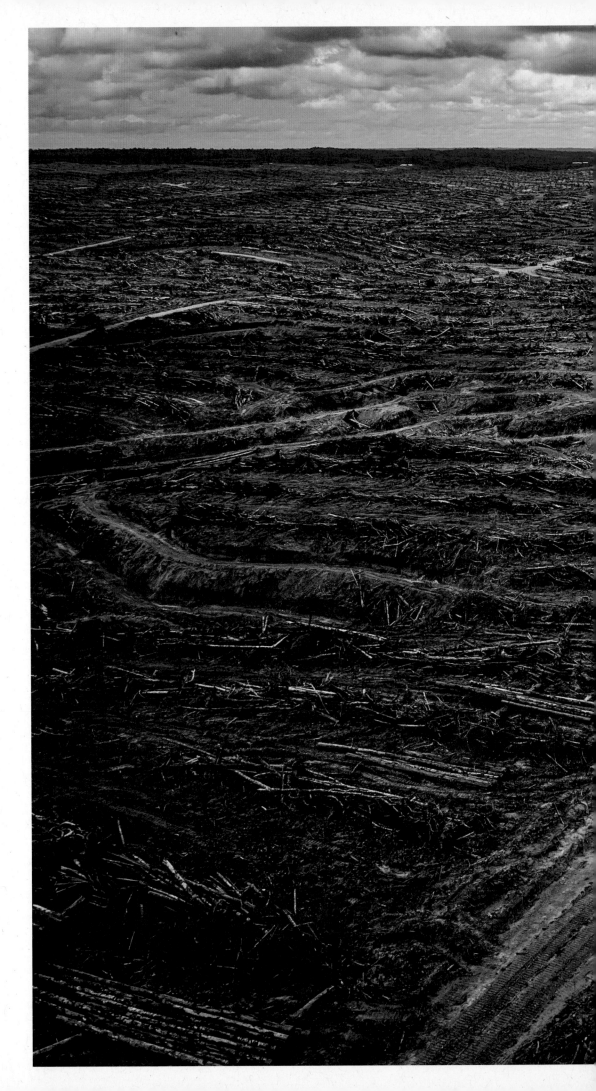

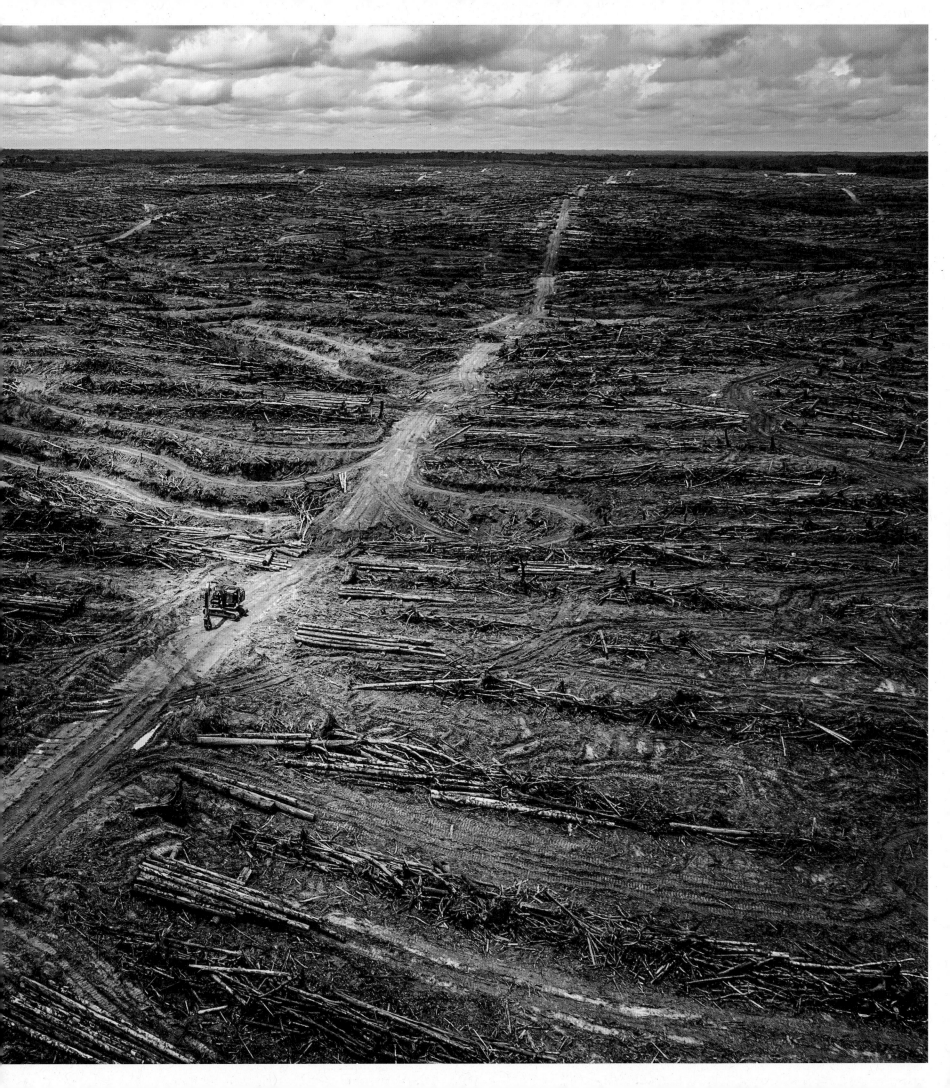

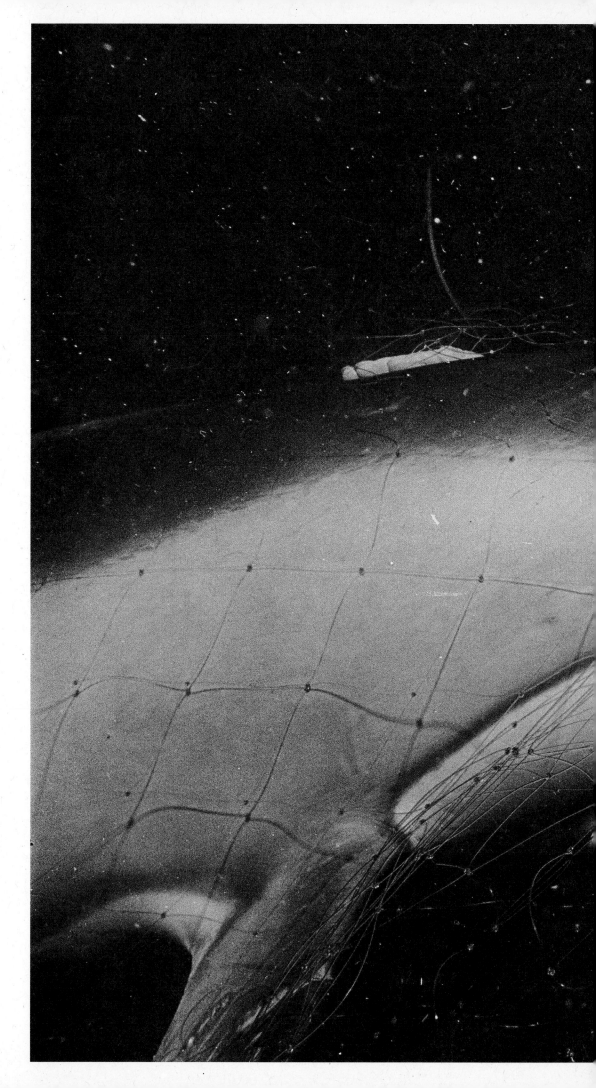

Death in the net
Gruesome image of a Pacific
white-sided dolphin drowning in a
Japanese fishing company's drift
net. Around 300,000 small and large
cetaceans and millions of other marine
creatures are still dying as so-called
bycatch in the drift, trawl, set and ghost
nets of the world's oceans
18 August 1990

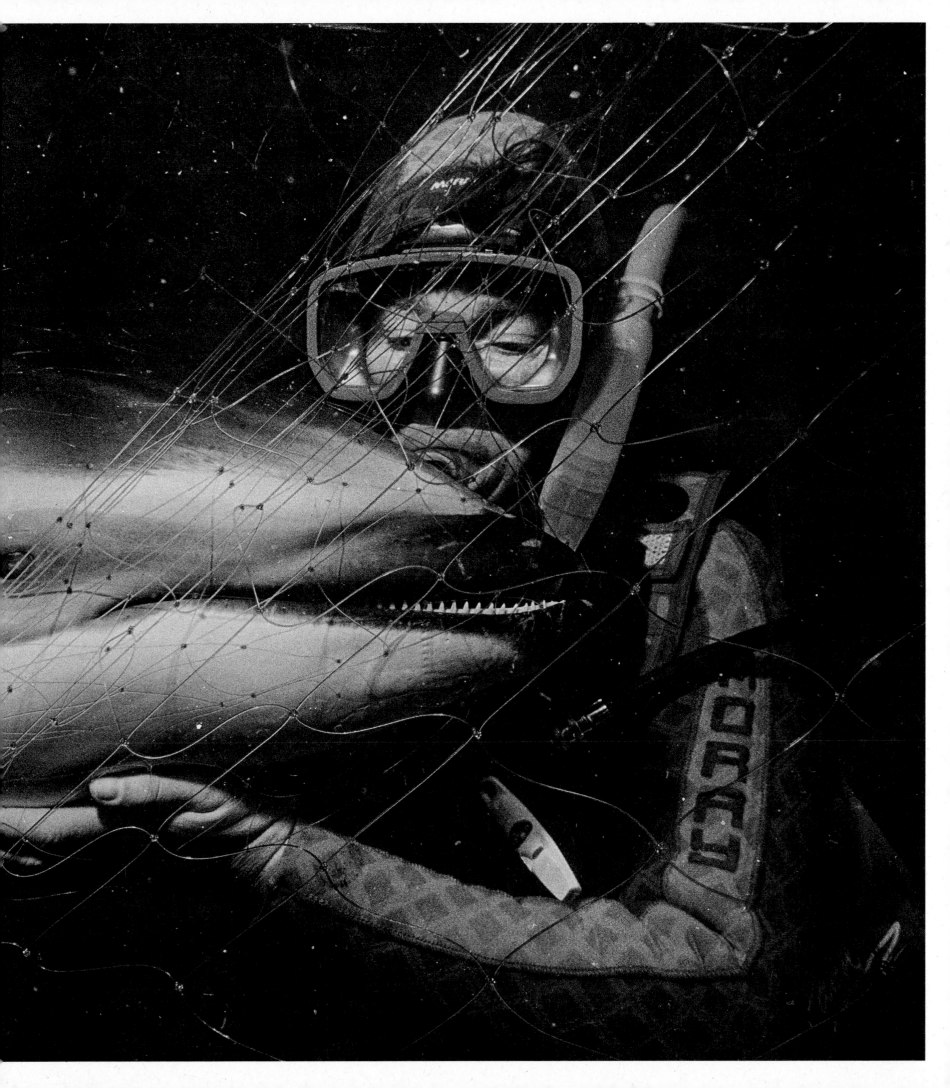

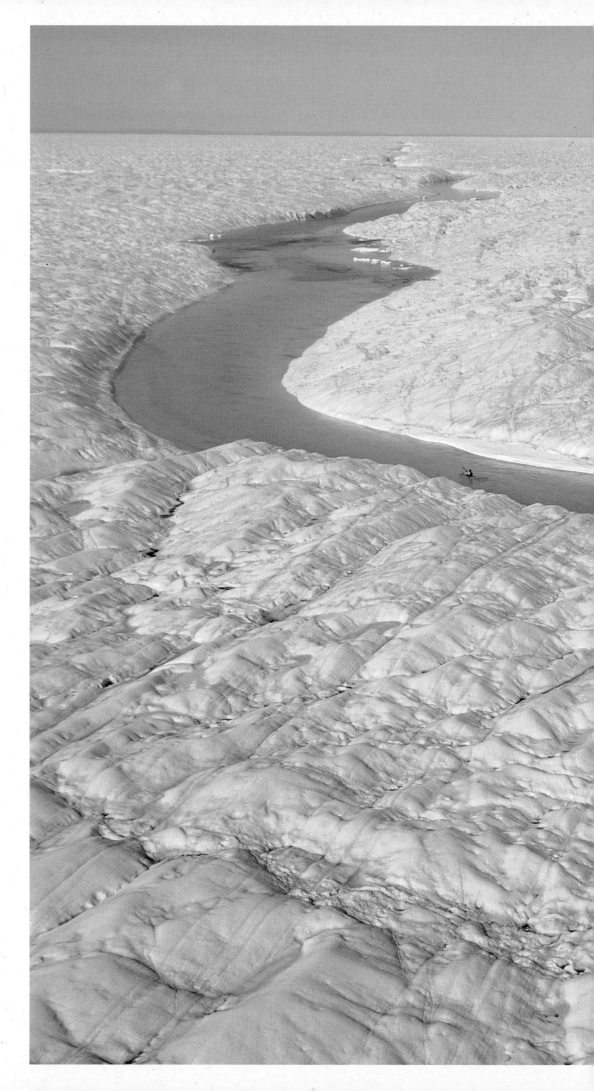

»Point of no return«
The polar regions are melting
at a dramatic rate, affecting the
climate and life all over the world.
In August 2020, after years of study,
Ohio State University warned of a
»point of no return« for Greenland's
gigantic ice sheet, which is up to
three kilometres thick. A dangerous
global tipping point because the
melting, which will result in a sea
level rise of around seven metres
17 March 2017

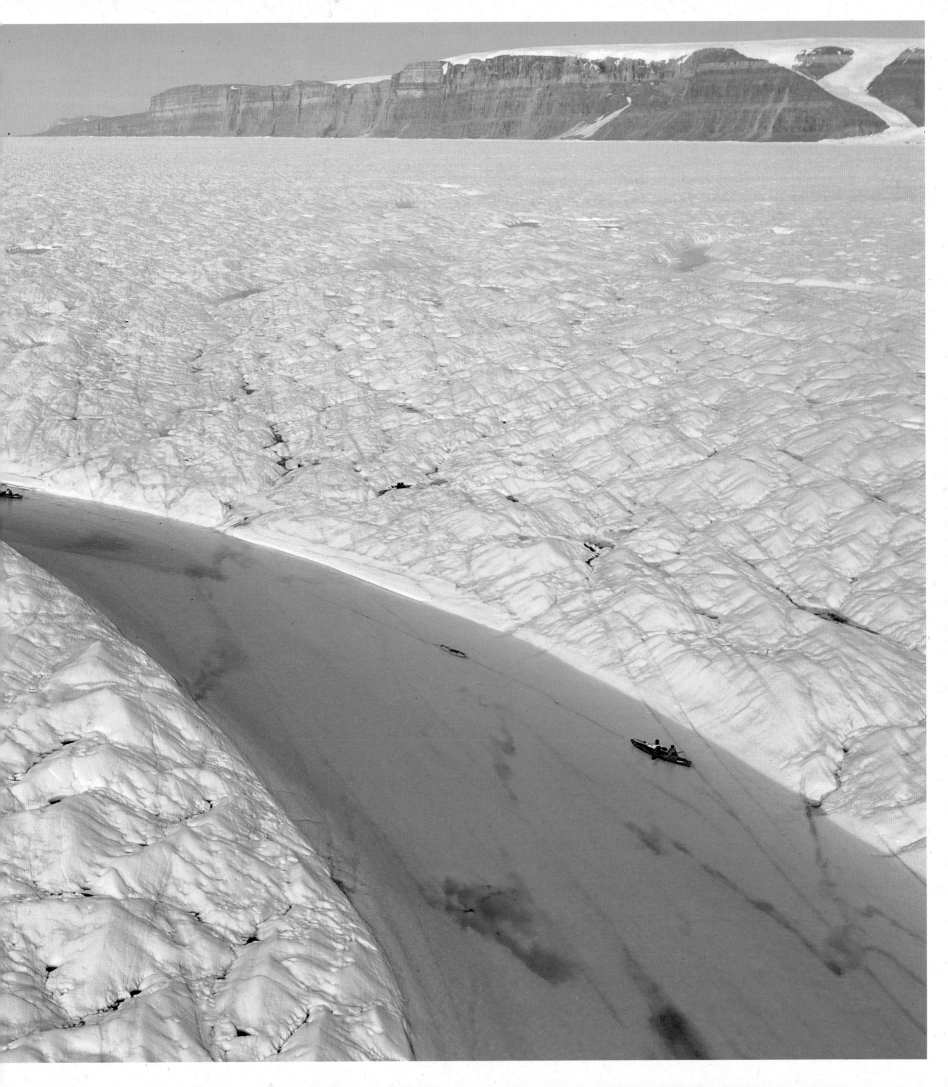

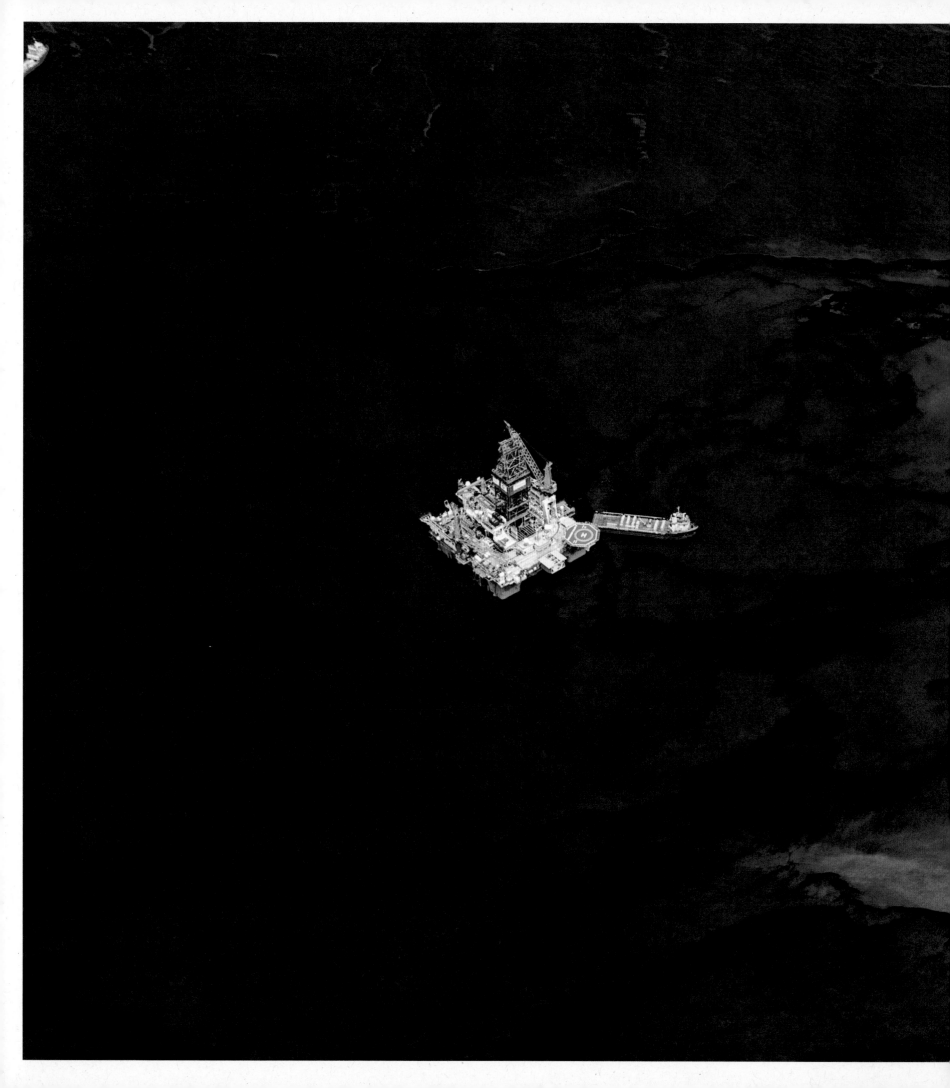

Ocean contamination
The Deep Water Horizon disaster in
the Gulf of Mexico, for which British oil
company BP was responsible, was one of
the biggest environmental disasters in
history. The oil industry is still respon-
sible for massive poisoning of our oceans,
with accidents and daily oil spills a part
of regular operations
24 June 2010

**A truckload of plastic
every minute**
Piles of plastic on the beaches of
the Philippines: every year, some
400 million tonnes of plastic are
produced. At least 60 million
tonnes, or one truckload every
minute, finish up in the oceans and
remain there for centuries. Plastic
not only poisons the environment,
as on the Philippine beaches shown
here, but also animals and humans,
who ingest it as microplastic with
their food. Our throwaway society
is therefore costing the lives of over
130,000 marine mammals – whales,
dolphins and seals – and over a
million sea birds – every year
3 May 2017

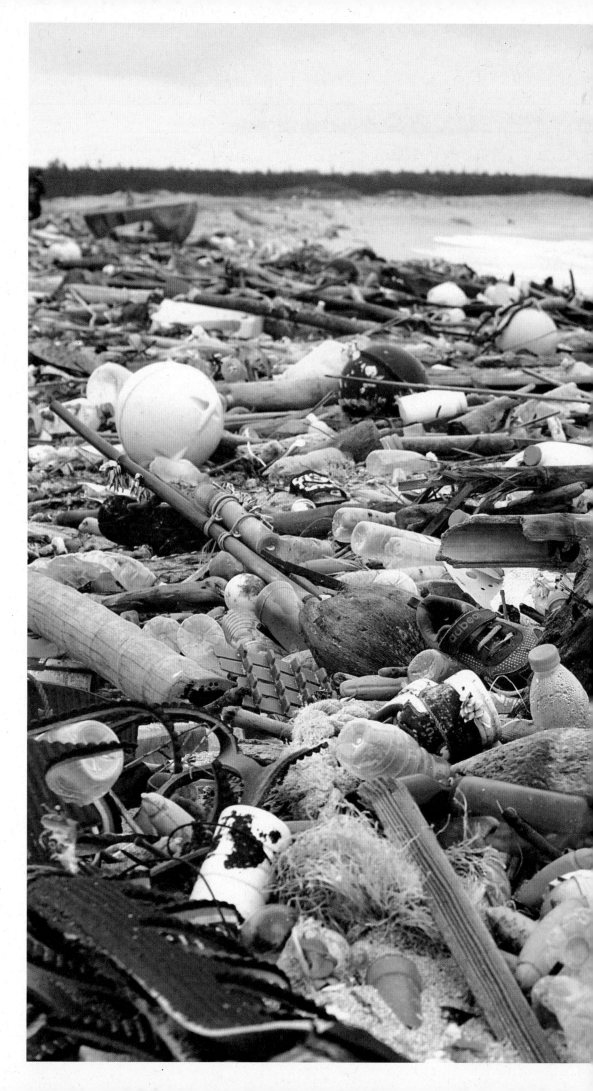

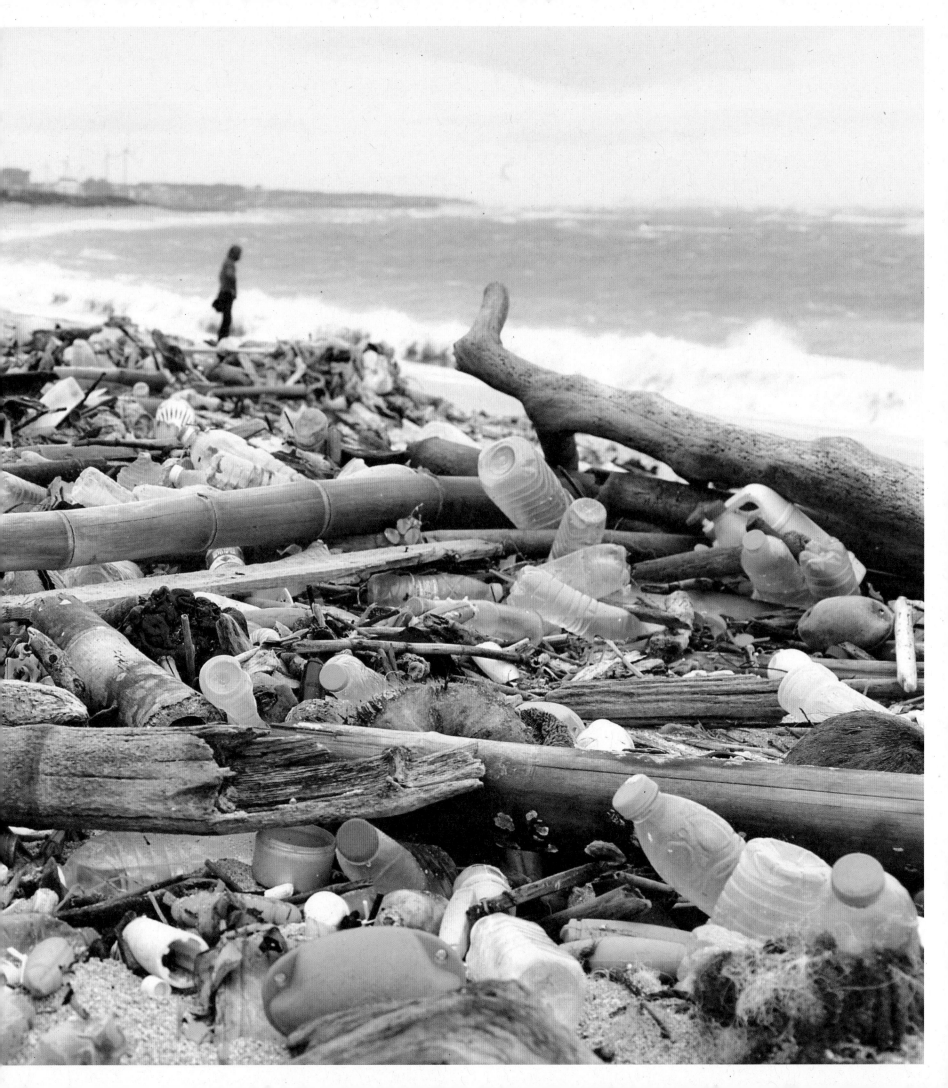

Worldwide droughts
Droughts are becoming more
frequent and more severe, and they
are now happening worldwide. Even
the Amazon, which has the largest
volume of water by far of any river
on earth, is increasingly affected –
as are its unique creatures
27 October 2005

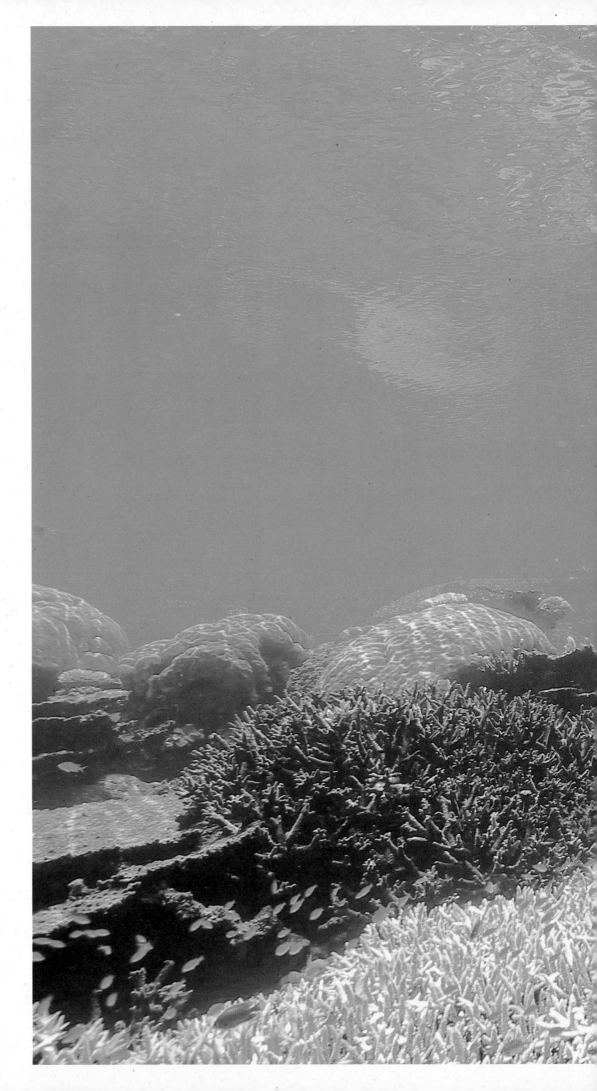

Global coral die-off

Corals, which are a species of cnidaria, live in close symbiosis with the smallest single-cell algae (zooxanthellae), which lend the corals their colourful appearance. This symbiosis usually has a very sensitive reaction to environmental changes. Even small temperature changes can cause the coral-algae relationship to break down. The stone corals lose their wonderful colours, are bleached, and die if the conditions do not change again. The current climate change may already result in a mass extinction of the corals, and according to the World Biodiversity Forum, a temperature increase of 1.5 degrees Celsius could kill off 70 to 90 percent of the stone corals, with 2 degrees causing 99 percent to die. This would mean that the most biodiverse biocoenosis found in the oceans, which has been developing for around 225 million years, could be wiped out in just a few decades – with incalculable consequences for all life on earth. This is one more dramatic result of the climate change caused by humans, and another reason to finally take consistent action against it

1 March 2017

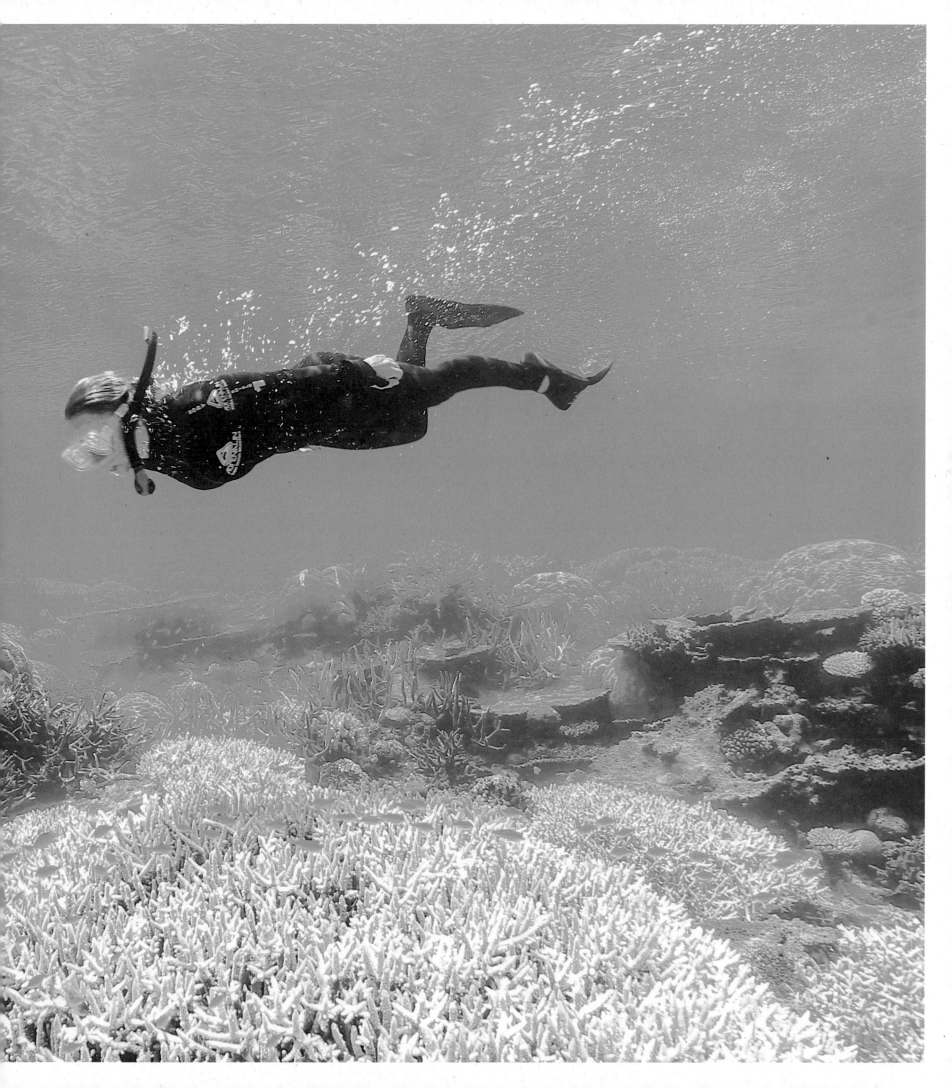

Contaminated food
A villager in Shuanggio, China,
holds contaminated oranges in
his hands. The fruits, vegetables,
grains and even the water were
contaminated by nearby chemical
factories – with cadmium in
particular
25 May 2005

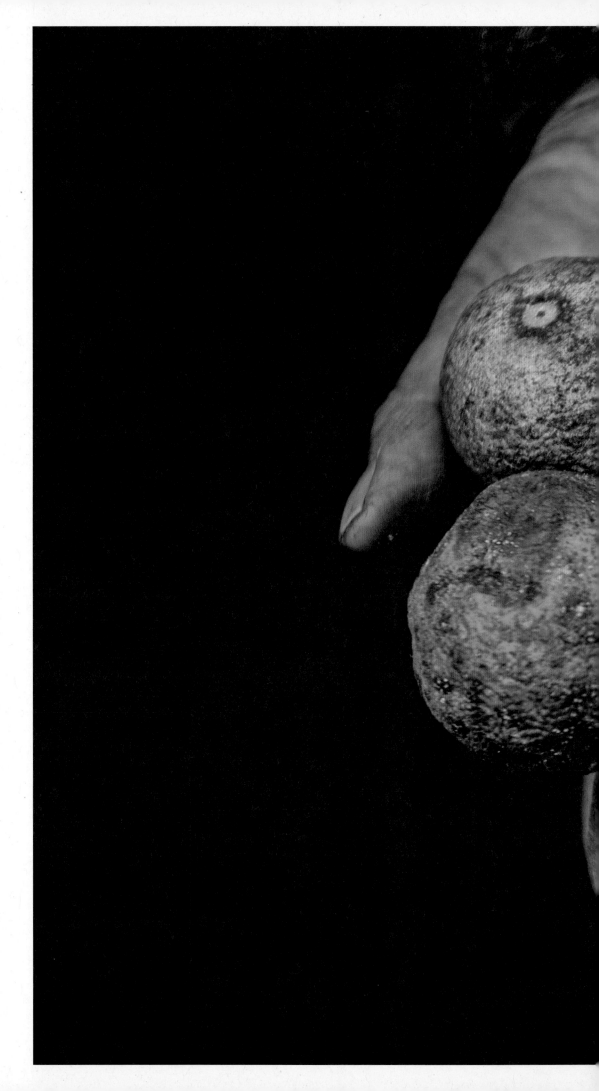

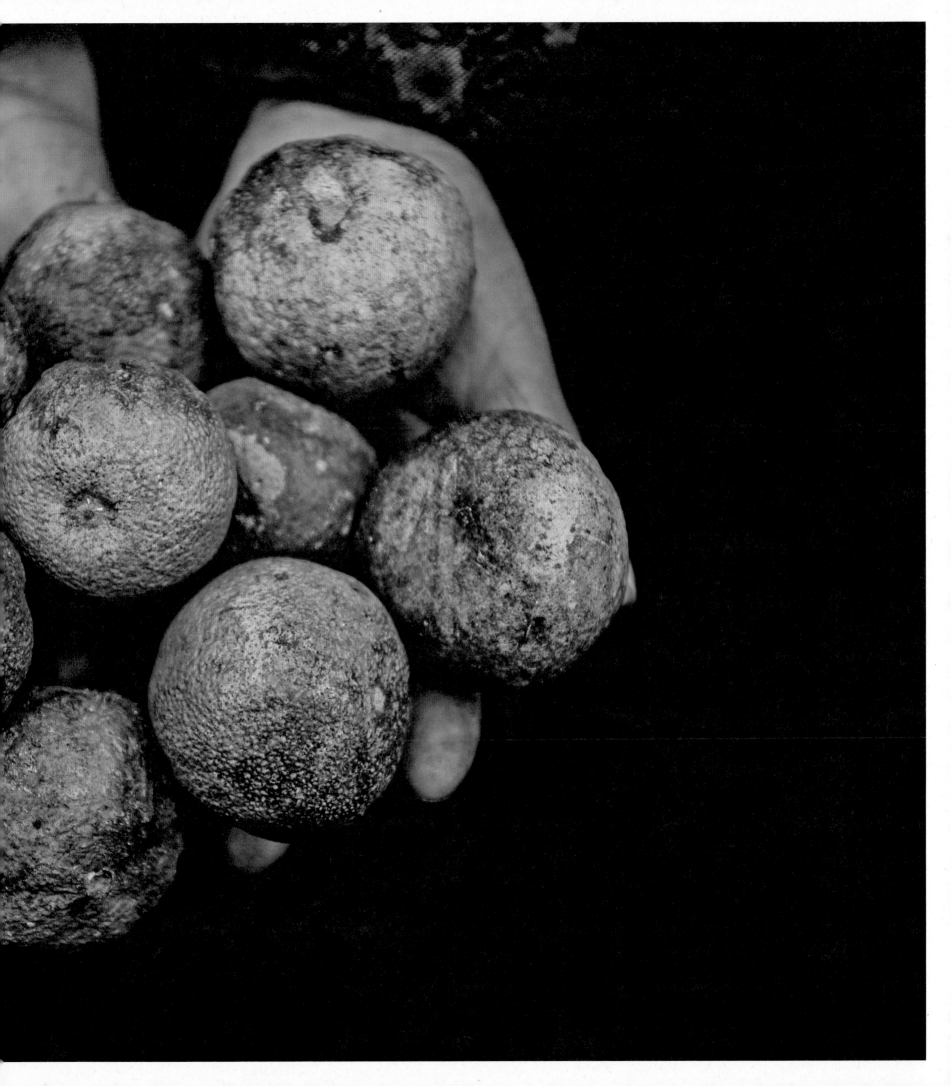

Endless cattle farms
In places where species-rich
rainforest previously grew,
more and more gigantic cattle
farms are being established,
primarily to satisfy wealthy
nations' hunger for meat
8 August 2008

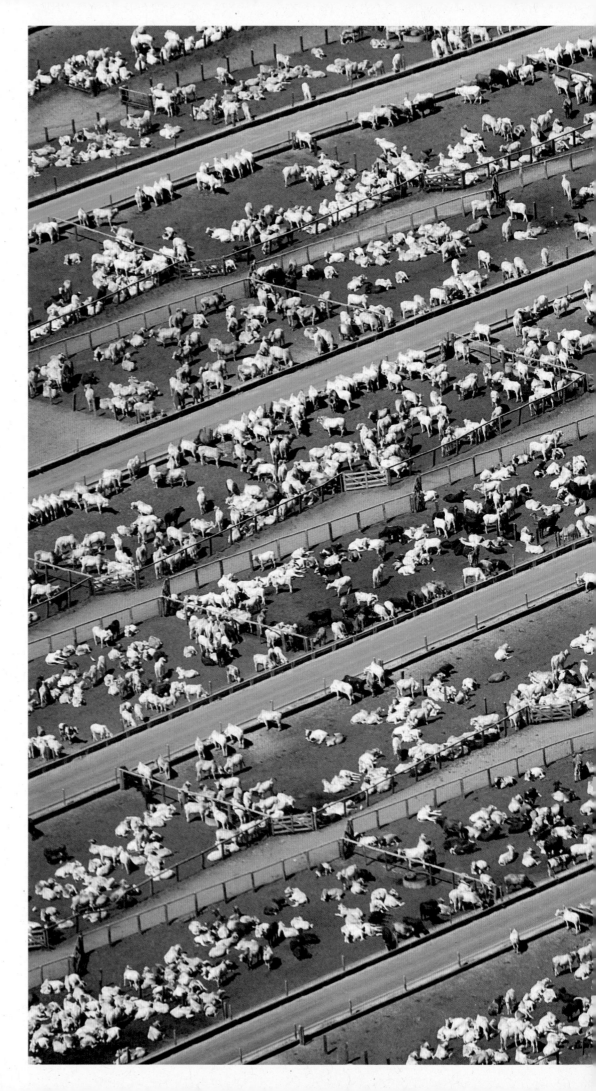

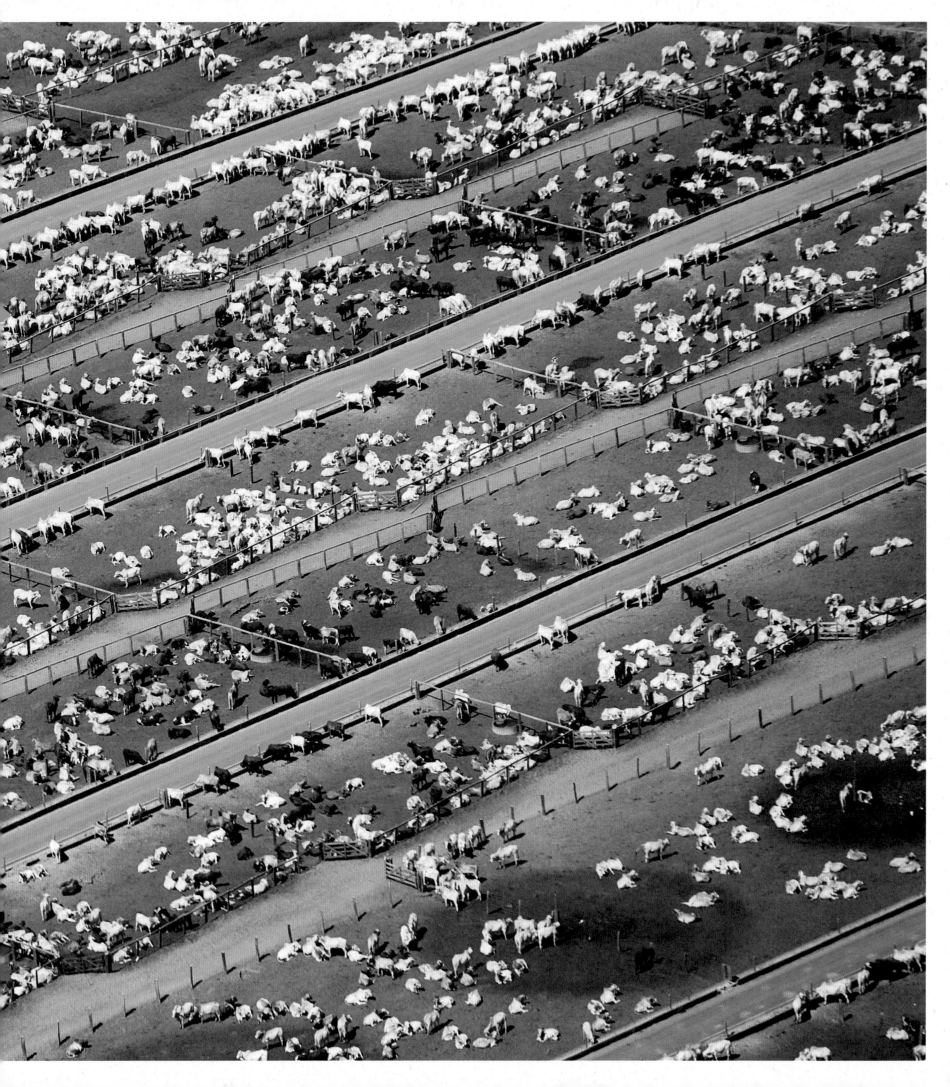

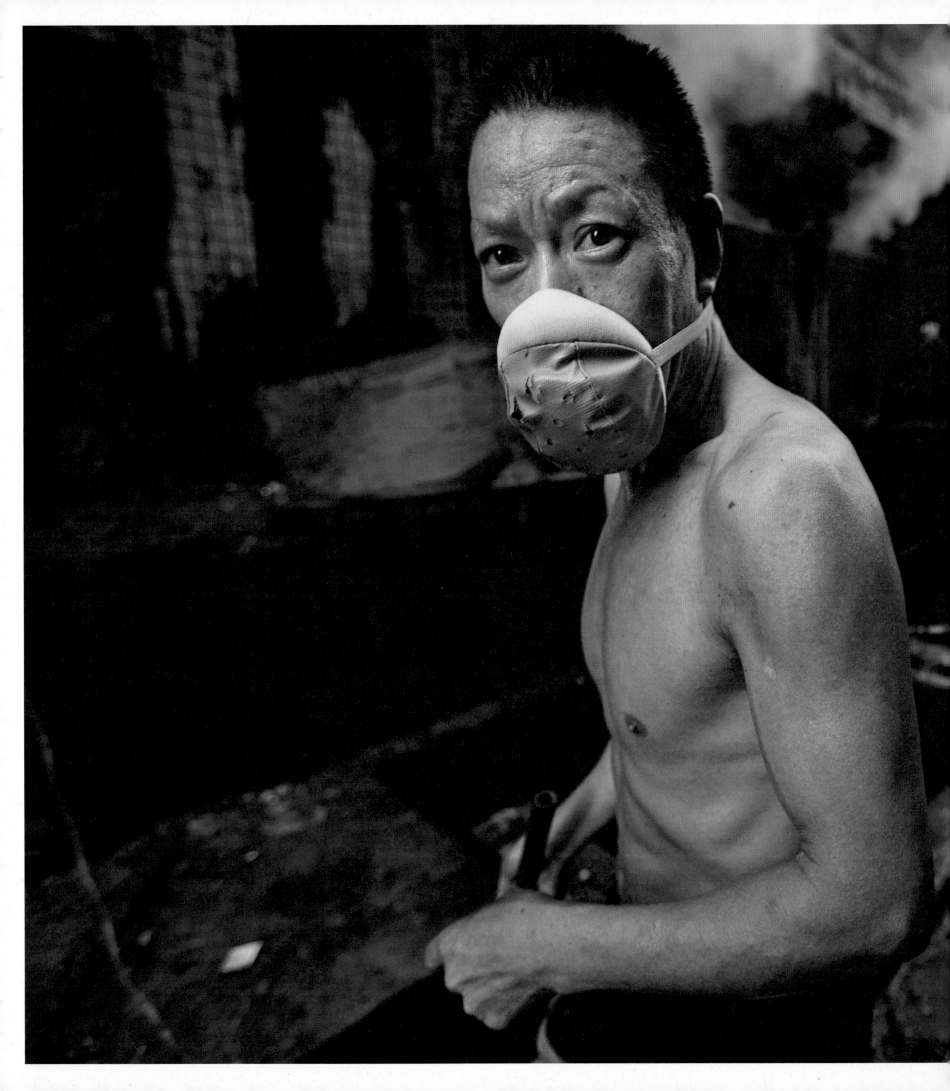

Poisoned workplaces
With its large-scale air and water pollution, a jeans-washing factory in the Chinese city of Xintang is poisoning workplaces and residential areas
14 August 2010

Enormous overfishing
More and more ships are hunting fewer and fewer fish. Industrial fishing fleets worldwide are using ever larger ships and nets for their operations, thereby also robbing subsistence fishermen of food and their livelihoods. Meanwhile, 80 percent of all fish stocks worldwide are already considered overfished or on the brink of overfishing
12 November 2012

Entire rainforests are disappearing and being boiled down to pulp for paper
In Indonesia, mind-boggling amounts of wood are processed into pulp to make paper. Valuable, biodiverse rainforests are disappearing in the huge factories – such as this one belonging to the Asia Pulp and Paper Company in southern Sumatra. Factories like this can also simultaneously poison the environment, water, soil and air
16 October 2010

More and more forest fires

Australia, California, Greece, Italy, Spain, the Amazon and, again and again, Russia, where thousands of square kilometres of fascinating taiga forests burn every year: all over the world, wildfires are becoming more frequent, more intense, and more deadly. In Australia alone, between 500 million and one billion vertebrates – including what might have been more than half of the entire koala population – died a horrible death in the flames during the disastrous fire season of 2019/2020. More and more wildfires around the world also mean faster and faster global warming – a self-perpetuating effect that leads to even more devastating fires. We have set a vicious cycle in motion. And the conflagrations are leading to another feedback effect, namely that Russian forest fires in particular are dumping large quantities of soot into the Arctic, which is deposited as what is known as black carbon on the white ice flats, thereby preventing the sun's rays from being reflected. As a result, the ice melts even faster, further accelerating global warming and, in turn, making the forests increasingly susceptible to catching fire

17 June 2020

GREENPEACE EXISTS BECAUSE THIS FRAGILE EARTH DESERVES A VOICE. IT NEEDS SOLUTIONS. IT NEEDS CHANGE. IT NEEDS ACTION.

OUR VISION

OUR MISSION

WE BELIEVE OPTIMISM IS A FORM OF COURAGE. WE BELIEVE THAT A BILLION ACTS OF COURAGE CAN SPARK A BRIGHTER TOMORROW. TO THAT END WE MODEL COURAGE, WE CHAMPION COURAGE, WE SHARE STORIES OF COURAGEOUS ACTS BY OUR SUPPORTERS AND ALLIES, WE INVITE PEOPLE OUT OF THEIR COMFORT ZONES TO TAKE COURAGEOUS ACTION WITH US, INDIVIDUALLY IN THEIR DAILY LIVES, AND IN COMMUNITY WITH OTHERS WHO SHARE OUR COMMITMENT TO A BETTER WORLD. A GREEN AND PEACEFUL FUTURE IS OUR QUEST. THE HEROES OF OUR STORY ARE ALL OF US WHO BELIEVE THAT A BETTER WORLD IS NOT ONLY WITHIN REACH, BUT BEING BUILT TODAY.

GREENPEACE IS AN INDEPENDENT CAMPAIGNING NETWORK THAT USES NON-VIOLENT AND CREATIVE FORMS OF CONFRONTATION TO EXPOSE GLOBAL ENVIRONMENTAL PROBLEMS AND TO ADVANCE THE SOLUTIONS THAT ARE ESSENTIAL FOR A GREEN AND PEACEFUL FUTURE. GREENPEACE'S GOAL IS TO ENSURE THE ABILITY OF THE EARTH TO NURTURE LIFE IN ALL ITS DIVERSITY. THIS IS WHY GREENPEACE SEEKS TO PROTECT BIODIVERSITY IN ALL ITS FORMS, PREVENT POLLUTION AND THE ABUSE OF THE EARTH'S OCEANS, LAND, AIR AND FRESH WATER, AND TO END ALL NUCLEAR THREATS, PROMOTE PEACE, GLOBAL DISARMAMENT AND NON-VIOLENCE.

OUR CORE VALUES

PERSONAL RESPONSIBILITY AND NON-VIOLENCE

WE TAKE ACTION BASED ON CONSCIENCE. THIS MEANS WE ARE ACCOUNTABLE FOR OUR ACTIONS AND TAKE PERSONAL RESPONSIBILITY. WE ARE COMMITTED TO PEACEFULNESS; EVERYONE ON A GREENPEACE ACTION IS TRAINED IN NONVIOLENCE.

INDEPENDENCE

WE DO NOT ACCEPT MONEY FROM GOVERNMENTS, CORPORATIONS OR POLITICAL PARTIES. INDIVIDUAL CONTRIBUTIONS, TOGETHER WITH GRANTS FROM FOUNDATIONS, ARE THE ONLY SOURCE OF OUR FUNDING.

GREENPEACE HAS NO PERMANENT FRIENDS OR FOES

IF YOUR GOVERNMENT OR COMPANY IS WILLING TO CHANGE, WE WILL WORK WITH YOU TO ACHIEVE YOUR AIMS. REVERSE COURSE, AND WE WILL BE BACK. WHAT MATTERS ISN'T WORDS, BUT ACTIONS.

PROMOTING SOLUTIONS

IT'S NOT ENOUGH FOR US TO POINT THE FINGER; WE DEVELOP, RESEARCH AND PROMOTE CONCRETE STEPS TOWARDS A GREEN AND PEACEFUL FUTURE FOR ALL OF US.

DISCLAIMER

»HOPE IN ACTION« BE AN EYEWITNESS – SO THAT THE WORLD ITSELF BECOMES AN EYEWITNESS

WE HUMANS CAN SMELL, HEAR, TASTE, FEEL, AND YET WE PERCEIVE ALMOST 80 PERCENT OF OUR SURROUNDINGS USING OUR EYES ALONE.

A QUARTER OF OUR BRAIN IS CONSTANTLY BUSY ANALYSING THE VISIBLE WORLD. WE THINK, WORK, DREAM AND EVEN SPEAK IN IMAGES, THEREFORE MANY OF OUR EMOTIONS ARE ALSO LINKED TO IMAGES.

GREENPEACE WAS STARTED 50 YEARS AGO, IN SEPTEMBER 1971. RIGHT FROM THE VERY BEGINNING, OUR CENTRAL CONCERN WAS TO BE EYEWITNESSES, AND TO LET IMAGES SPEAK AS WITNESSES AND TESTIMONIES AS WELL. TO BE AN EYEWITNESS TO THE INTOXICATING BEAUTY AND FASCINATING DIVERSITY OF NATURE, AND THEREBY SHOW OTHERS JUST HOW SPECIAL FORESTS AND OCEANS, MOUNTAINS, DESERTS AND POLAR REGIONS, LAKES AND RIVERS, AND ALL THEIR INHABITANTS ARE – BUT ALSO, AS AN EYEWITNESS, TO HIGHLIGHT THE DESTRUCTION, POLLUTION AND POISONING, AND TO CLEARLY NAME THOSE WHO ARE RESPONSIBLE FOR THIS.

FROM THE BEGINNING, IMAGES HAVE BEEN STRONG ALLIES WITH WHOSE HELP AND TESTIMONY IT HAS BEEN – AND WILL CONTINUE TO BE – NECESSARY TO MOVE AND AWAKEN PEOPLE TO STOP ACCEPTING THE ONGOING CRIMES AGAINST THE ENVIRONMENT. TO SHOW THE WORLD WHAT IT DOES NOT KNOW OR HAS FORGOTTEN, AND THEREFORE LET THE WORLD ITSELF BECOME AN EYEWITNESS WITH THESE IMAGES.

THIS IS EXACTLY WHAT THE 130 PHOTOS THAT FOLLOW IMPRESSIVELY SHOW US. IMAGES FROM 50 COUNTRIES, FROM ALL SEVEN CONTINENTS, AND OF COUNTLESS ACTION-PACKED CAMPAIGNS THAT WERE OFTEN ALSO DAMN SUCCESSFUL. PHOTOS OF OUR IMPORTANT, DIVERSE, EXHAUSTING, AND CREATIVE, AS WELL AS CONSISTENTLY COURAGEOUS ACTIONS, WHICH DRAW ATTENTION TO THE INJURIES AND SCARS THAT NATURE HAS SUFFERED, AND THEREBY ALSO HELP TO PREVENT FURTHER ONES.

THEY ARE DOCUMENTS THAT SHOW THE COMMITMENT AND THE ACTIVE STRUGGLE TO GIVE NATURE A VOICE AND A FACE – DOCUMENTS THAT ALSO SHOW THE LOVE FOR OUR PLANET.

»Give Me Liberty From Nuclear Weapons – Stop Testing«
Warning about nuclear weapons at the Statue of Liberty in New York
8 June 1984

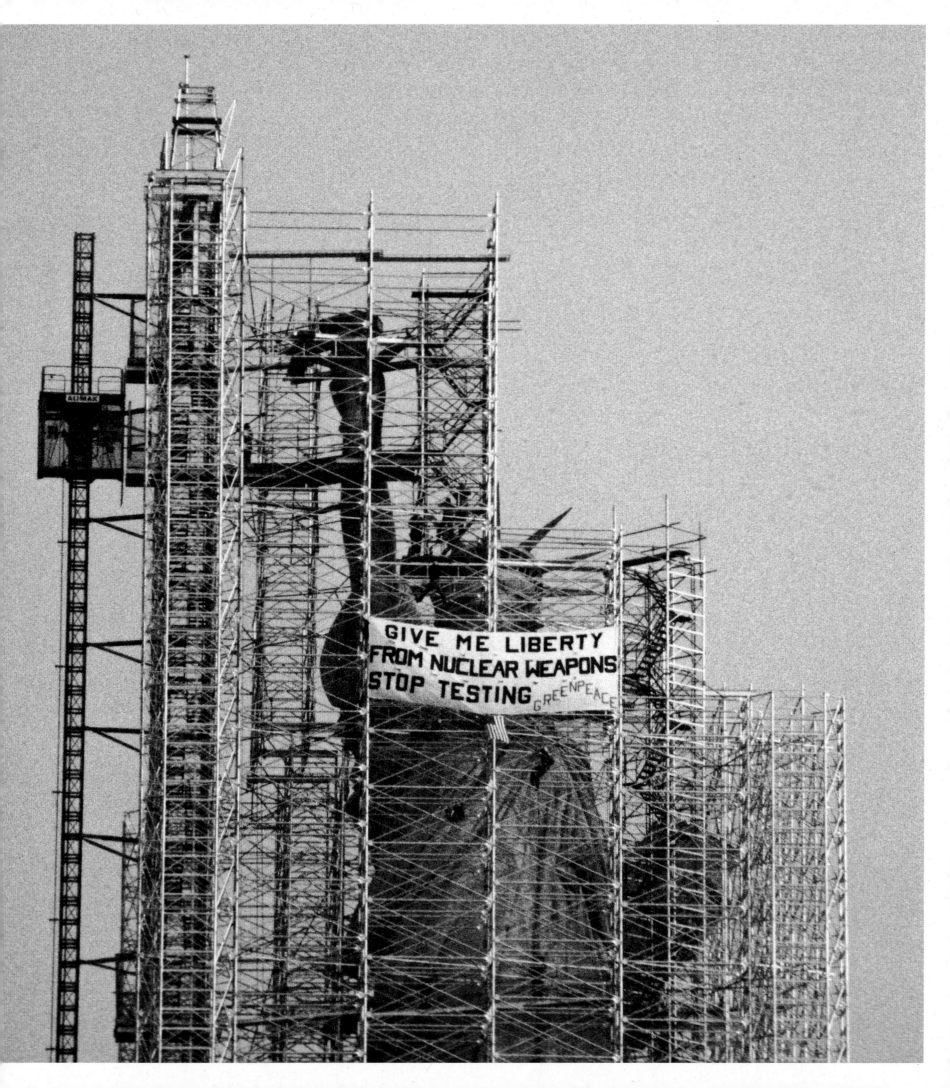

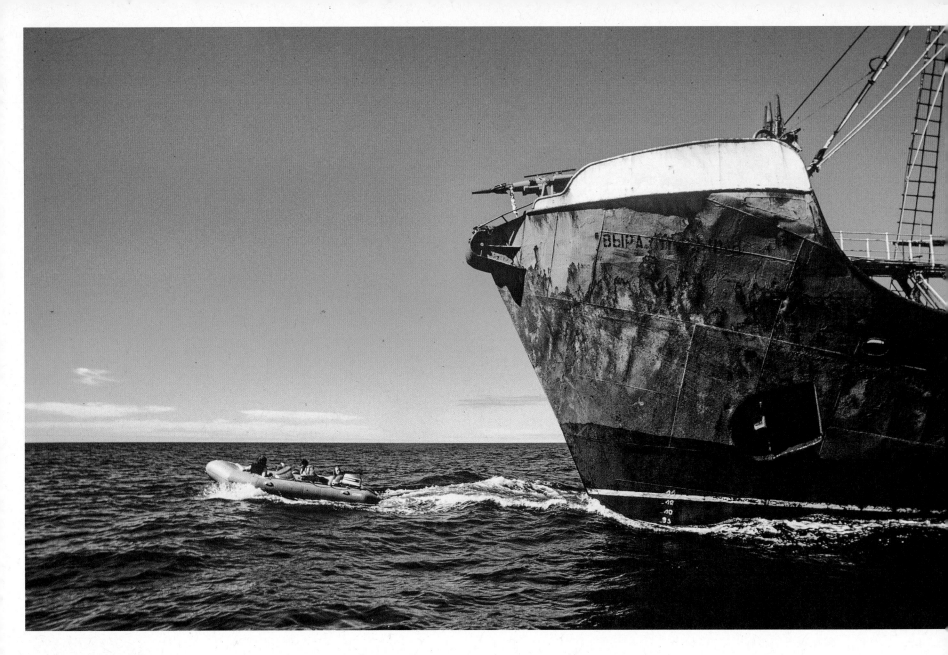

Protecting the whales
Courageous inflatable pilots
position themselves directly in front
of the harpoons of Soviet whalers
in the North Pacific
1 June 1976

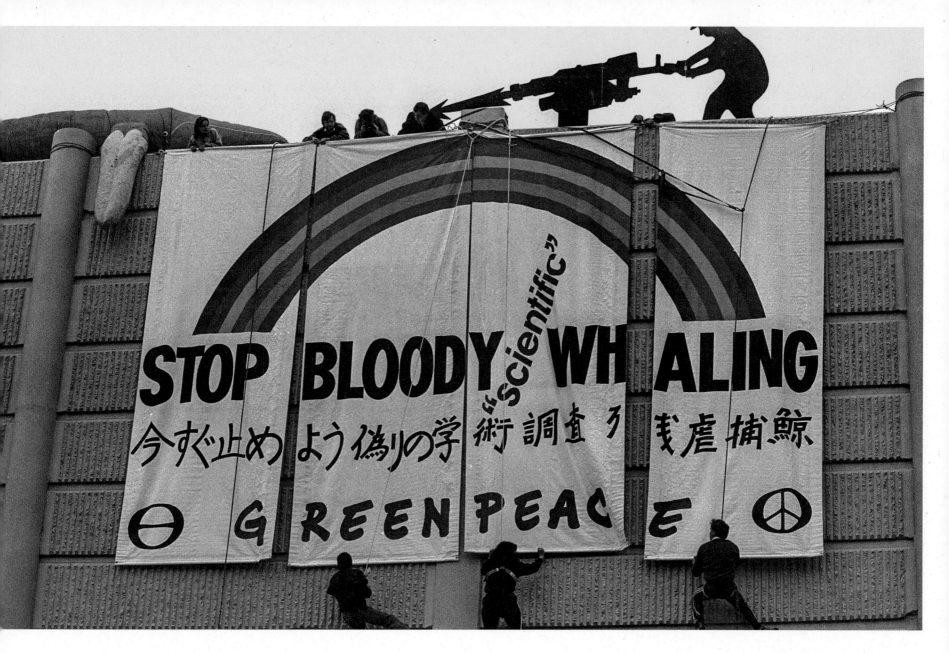

Stop the whaling
… is what's being called for on the
political stage as well – for instance,
at the meeting of the International
Whaling Commission in Auckland,
New Zealand
30 May 1984

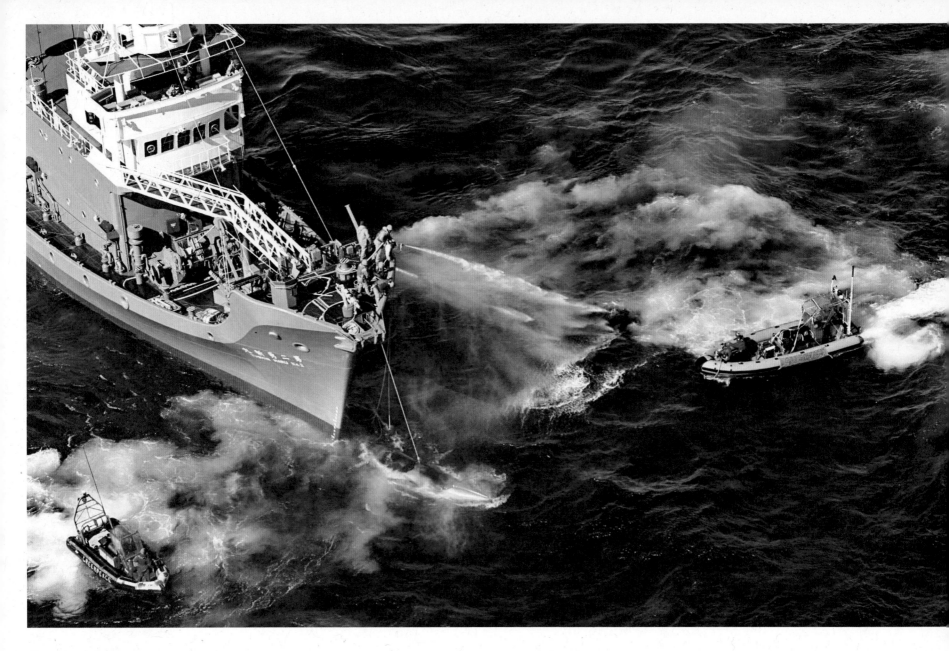

Greenpeace intervenes
Despite an international ban on whaling
in Antarctic waters, Japan intends to
continue killing hundreds of whales
every year – labelling it »scientific
whaling«. Ships ESPERANZA and
ARCTIC SUNRISE campaign by putting
themselves between the whales and wha-
lers to prevent their slaughter in
the Southern Ocean for several years.
In 2014, the International Court of
Justice in The Hague also condemns
the Japanese whale hunt in the
Antarctic as illegal
18 February 1999

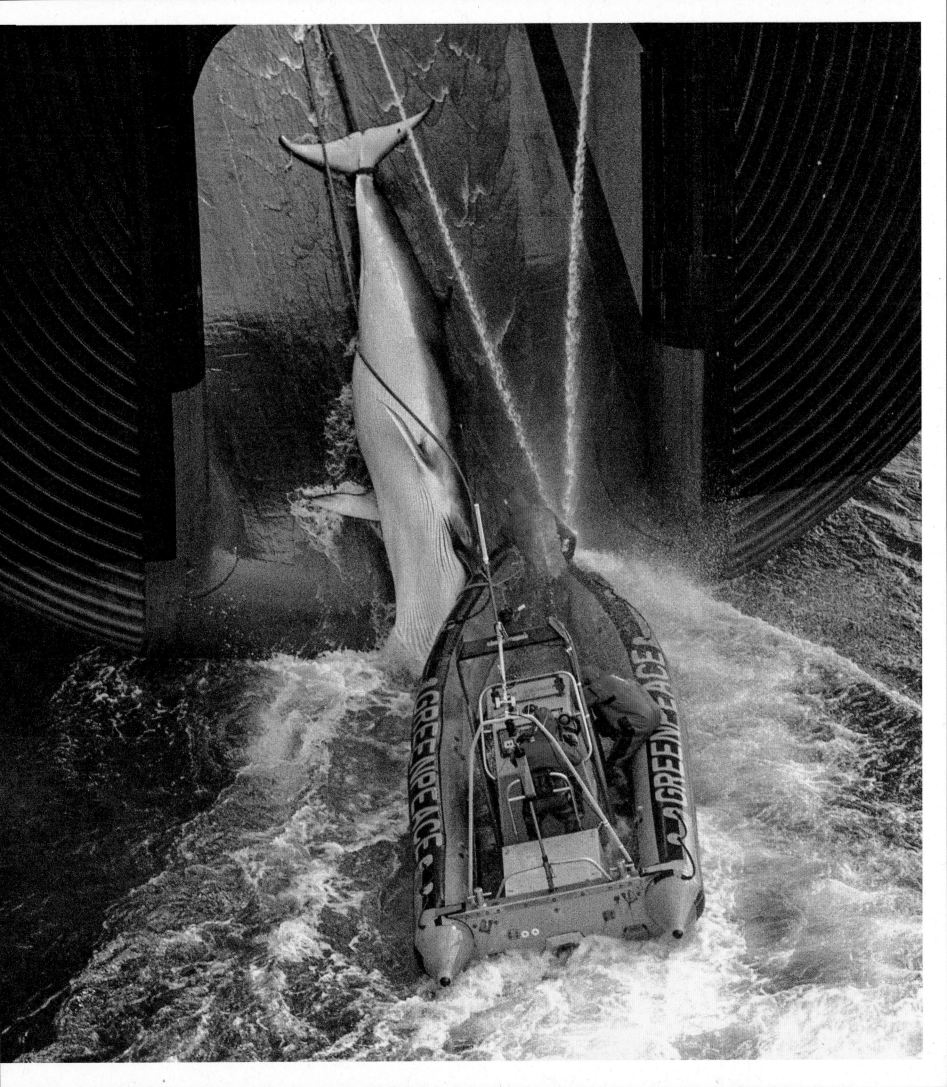

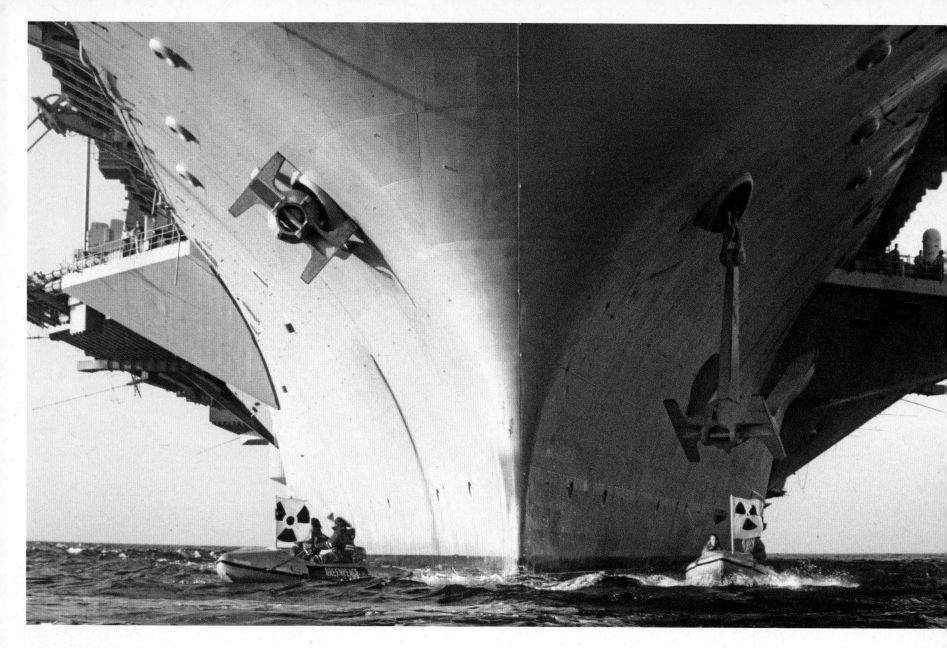

Nuclear-free seas
Greenpeace protests against the
increasing number of nuclear-armed
warships plying the world's oceans,
such as US aircraft carrier EISENHOWER
in Spain
9 June 1988

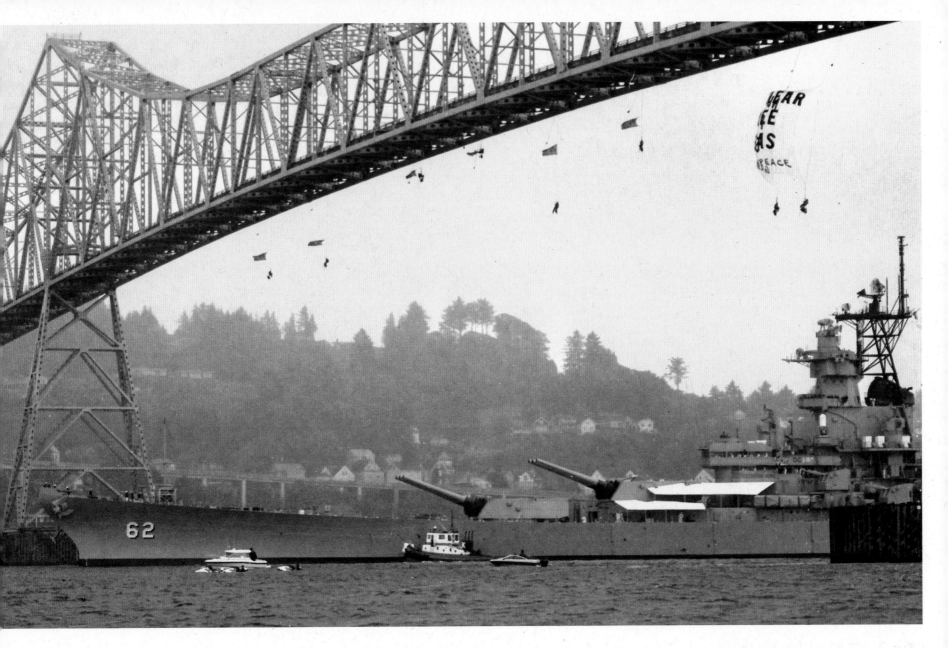

Nuclear-free seas
Protest against nuclear weapons on
the seas in Oregon/U.S.A. at the Astoria
Megler Bridge over the Columbia River
9 June 1988

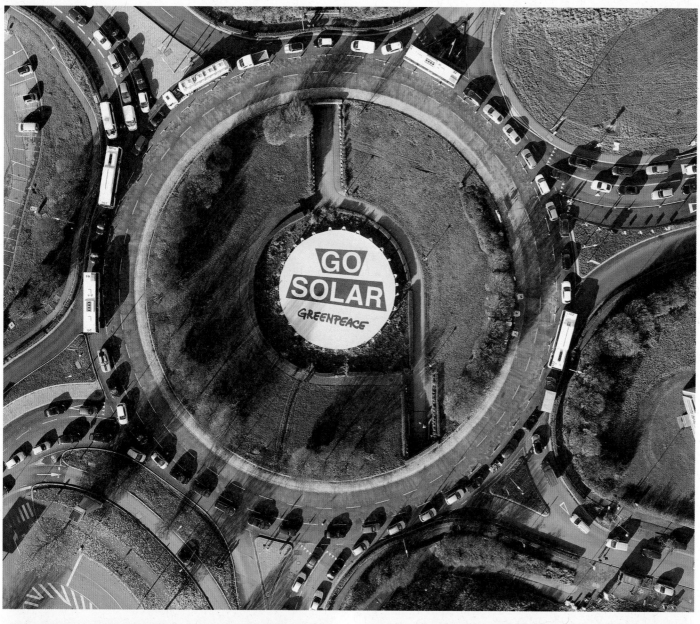

Sunrises in the capitals of Europe
»Go Solar« – no more fossil fuels is the motto of the sunrise actions in many cities, including Brussels, Berlin, Barcelona, Luxembourg, and Pernik in Bulgaria (bottom of next page)

Giant sun in Paris

Sunrise action around the Arc de Triomphe during the Paris Climate Conference. Greenpeace activists create the image of a giant shining sun using environmentally friendly water-based paint. We want to remind politicians and governments of their responsibility to finally tackle climate change and protect the climate with clean solar energy, instead of fuelling it with energy generated by burning coal, oil and gas

11 December 2015

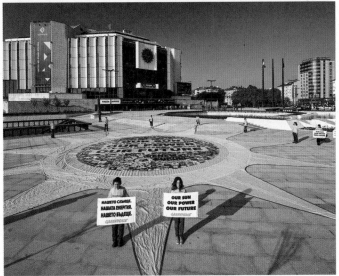

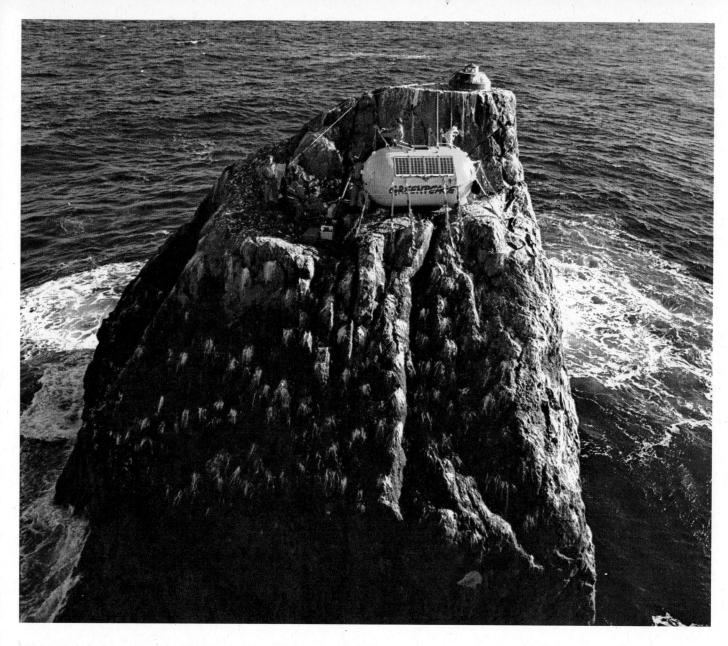

Coal ships bring climate change
Climate coal action in Valencia, Spain.
Even in rough seas, we protest against
the huge coal transport ship FRONT
DRIVER and its climate-damaging cargo
16 November 2007

Waveland – a new state is emerging
Greenpeace occupies the small rocky
island of Rockall in the North Atlantic
for six weeks to draw attention to
the rapidly increasing volume of oil
production in the oceans, which is
endangering the sea and the climate.
Four activists live in a survival capsule
and proclaim the new state of Waveland
1 June 1997

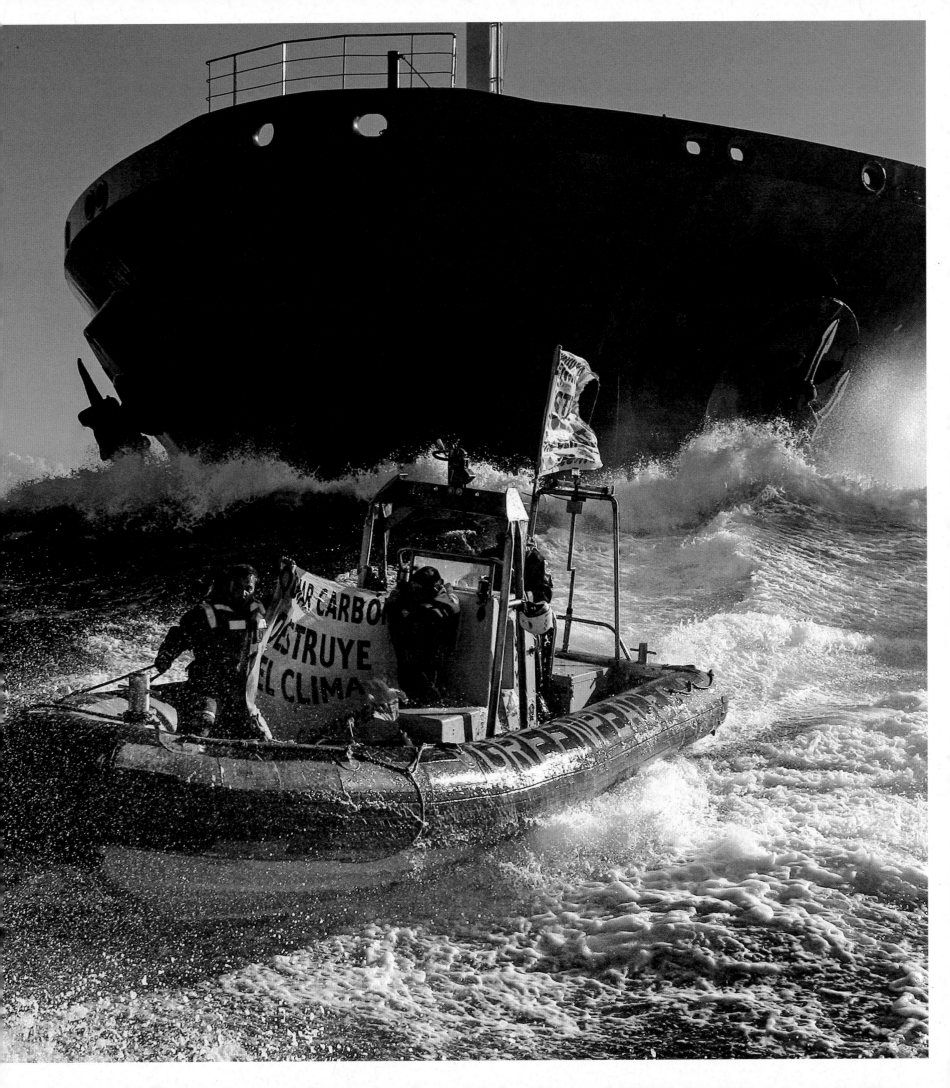

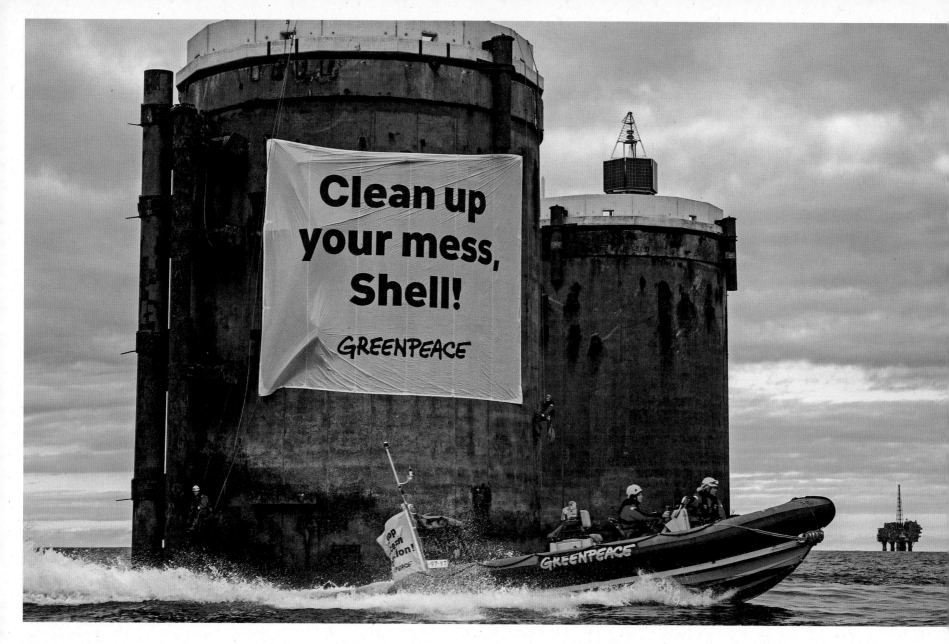

Shell's garbage dump

Once again, Shell aims to simply abandon parts of the decommissioned oil platforms »Brent Alpha« and »Bravo«, which potentially still contain thousands of tonnes of oil, in the North Sea, and once again not dispose of them in an environmentally responsible way. Our Greenpeace activists from the Netherlands, Germany and Denmark stepped in and called on the company: »Shell, clean up your mess!« and »Stop Ocean Pollution«

14 October 2019

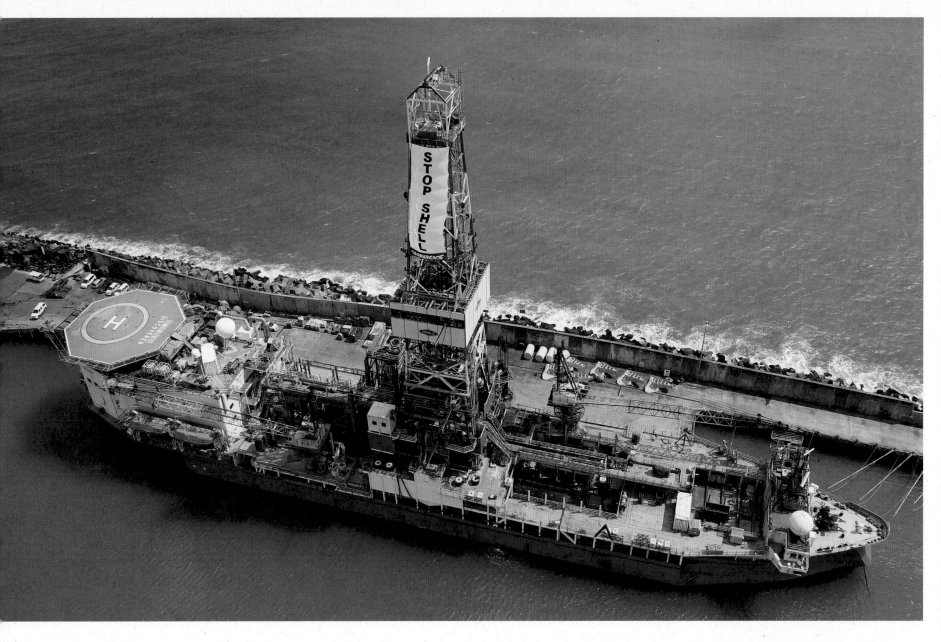

Shell – aclimate criminal

Shell's environmental and climate crimes
continue. The irresponsible corporation
planned to bring a huge drilling ship
from New Zealand to the remote Arctic,
threatening the global climate as well as
the coast of Alaska. Greenpeace activists
and the actress Lucy Lawless occupied
the ship to prevent it from leaving port.
They were equipped with survival gear
and enough supplies to last several days
24 February 2012

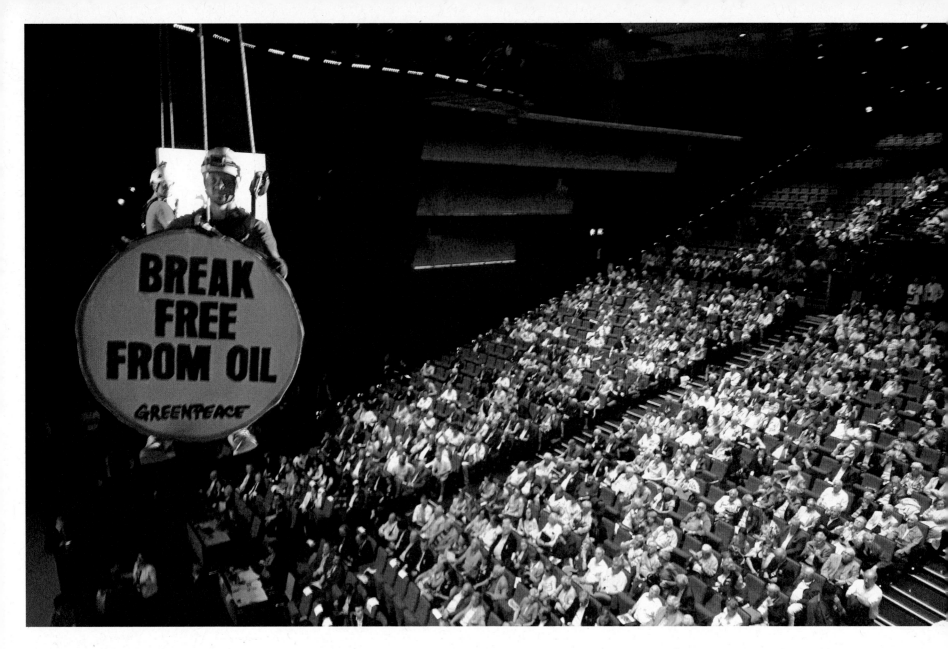

Oil company Total not interested in coral protection

The executives at Total are very surprised by the sight of Greenpeace activists at their general meeting in Paris. Our protest exposes the oil company's plans to explore for oil in the Amazon estuary, despite the fact that it is home to one of the most biodiverse areas on earth, with even a unique coral reef being recently discovered. 250 activists attended the creative action in and outside the building to let Total know that we, Greenpeace, will not give up

1 June 2018

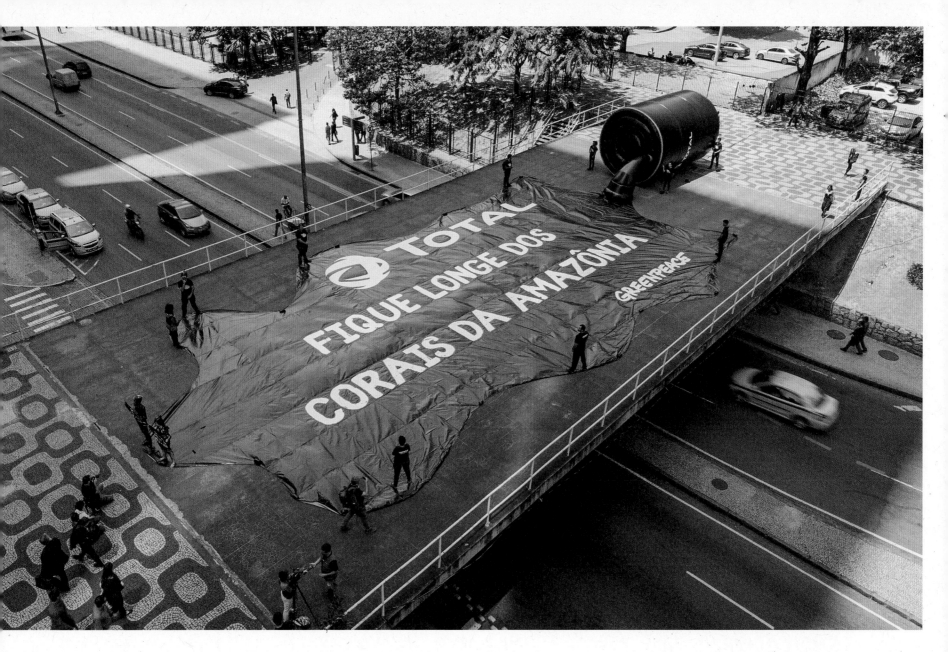

Another protest in Rio
Total employees in Rio de Janeiro are
also being educated and urged to resist,
because the fascinating Amazon coral
reef is in danger
28 September 2017

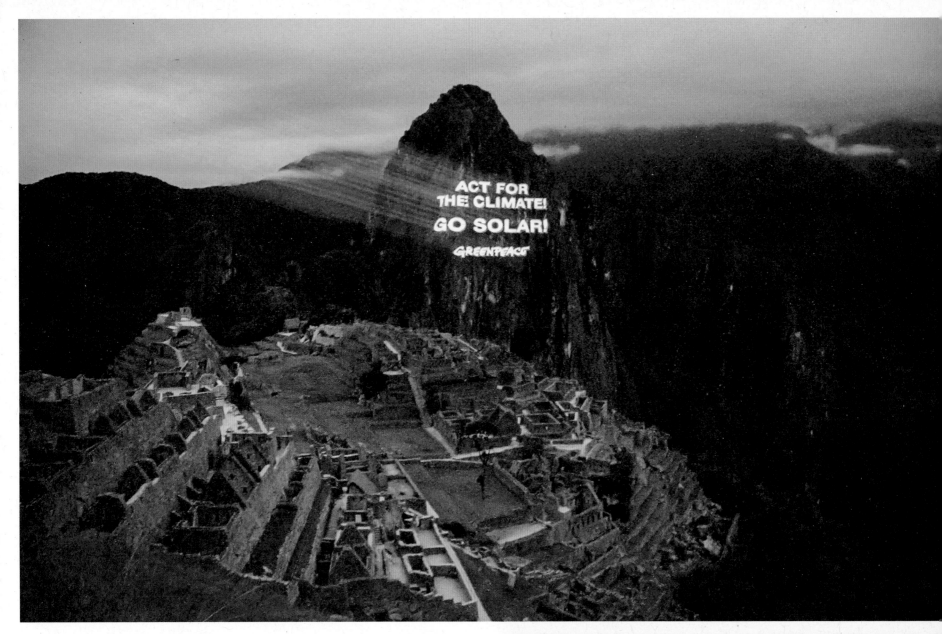

Projections – a brightly-lit protest

High-efficiency projectors can be used to deliver messages without entering sensitive historic cultural sites.
The message in lights at the Inca site of Machu Picchu in the Peruvian High Andes – to back regenerative instead of fossil energies – is a warning to participants at the climate negotiations in the Peruvian capital of Lima
30 November 2014

Secret documents

The contents of documents about European-American trade agreement TTIP, kept secret by politicians due to the fact that it is very problematic for the environment, are projected onto the Reichstag in Berlin after they were leaked to Greenpeace. They are now finally accessible to all the people affected by them
2 May 2016

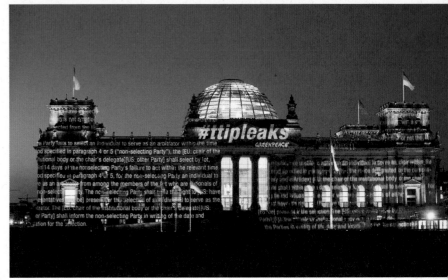

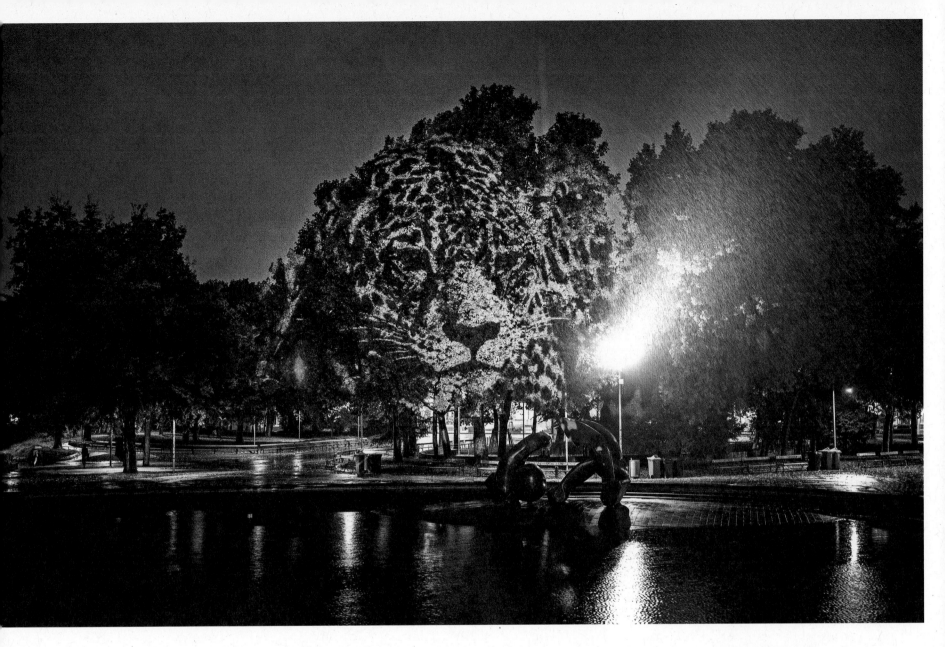

The jaguar of Vienna
In the trees in a park in Vienna, three-dimensional projection technology creates the image of a jaguar to draw attention to the destruction of the Amazon rainforest. Because Europeans, with their consumption of meat and soya (primarily as animal feed in factory farming), bear a massive share of the responsibility for the destruction of the largest and most species-rich rainforest on earth
14 October 2020

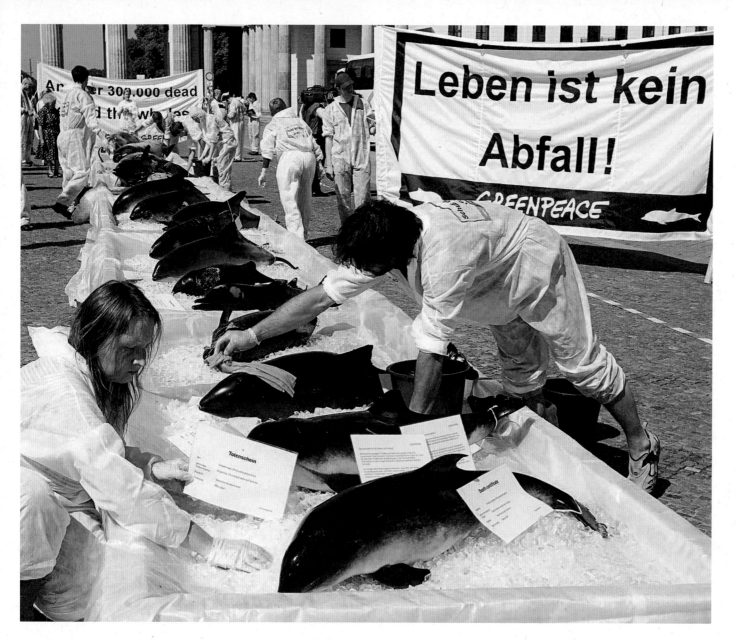

Death in the North and Baltic Seas
Dead whales that suffocated in fishing nets are also washed up on the coasts of the North and Baltic Seas time and time again. The delegates and politicians at the meeting of the International Whaling Commission in Berlin must finally face up to this problem, because an estimated 300,000 small and large whales die in great pain in the world's oceans every year
20 May 2007

World Ocean Day
»Yes – to responsible fishing« is the message that we in Senegal, together with local fishermen, are sending to the country's politicians on World Ocean Day. After all, large industrial fishing fleets from abroad are mercilessly exploiting fish stocks and destroying the livelihoods of local people
8 June 2013

The whale of Santiago de Chile
The nine-metre whale, made entirely of recycled material, plays a key role as a symbol of hope for a better world at the huge demonstration to mark International Women's Day in Santiago de Chile
8 March 2020

As the International Whaling Commission meets in Chile, a thousand children and adults form a giant heart around an inflatable whale to show that they want the future of the giants of the sea to be ensured
13 April 2008

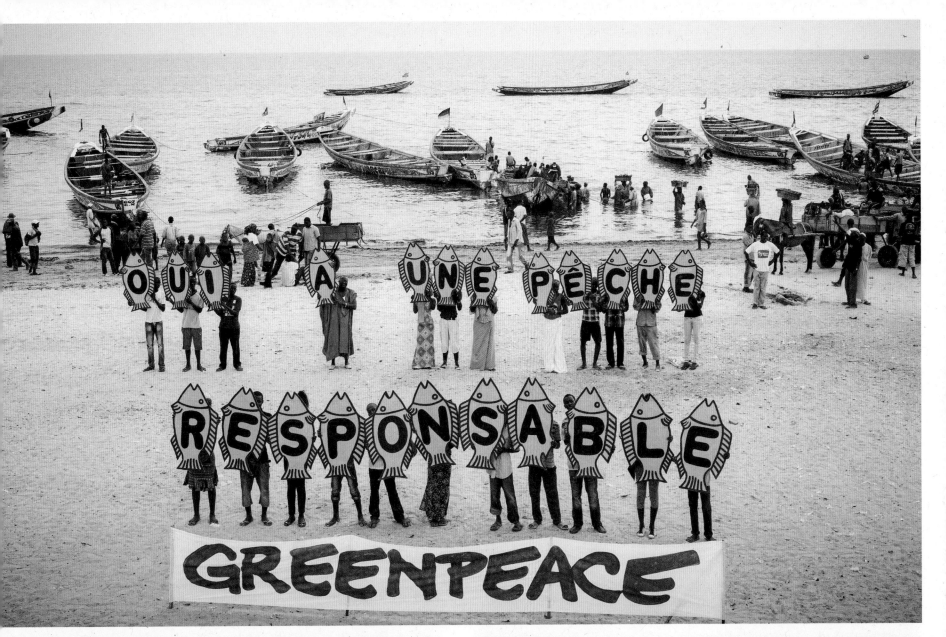

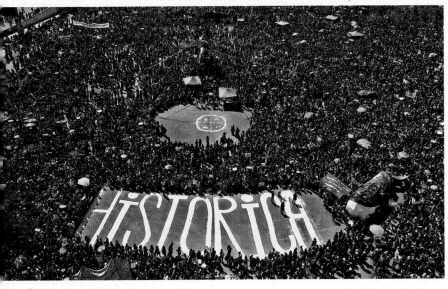

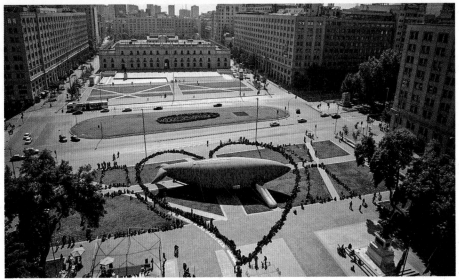

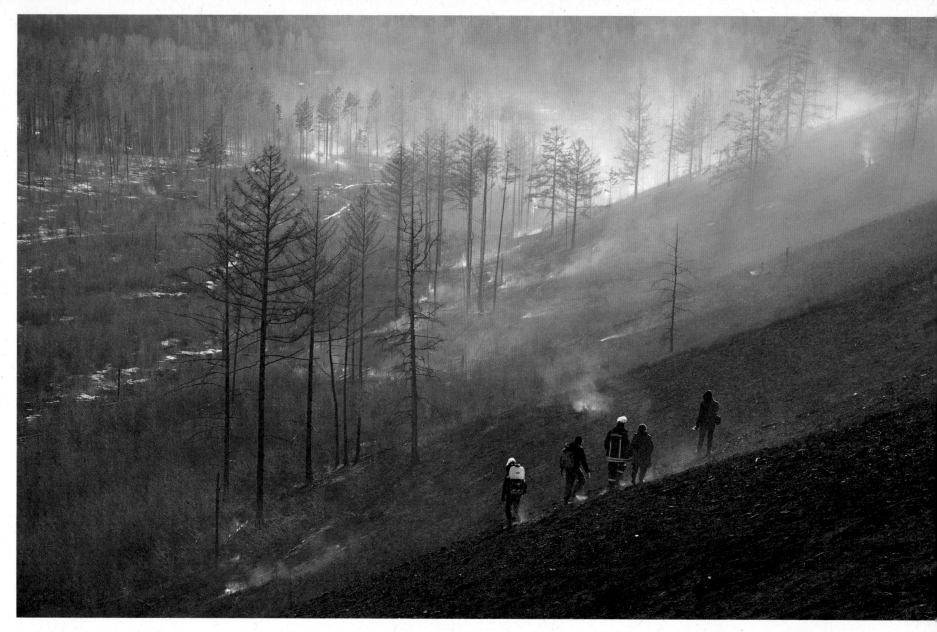

Fire at Baikal

The forests of Russia – from the border of the EU to the Far East, the largest area of forest on earth – have regularly caught fire for years. The reasons for this are the grass fires, in many cases deliberately set, that get out of control, carelessness, and the ever-increasing climate change that is drying out entire regions. At Greenpeace in Russia, we have firefighting experts on staff who have established and trained a network of local volunteer firefighting teams as an important measure to prevent the spread of many fires. Increasingly affected is the region around the Baikal Lake World Heritage Site
8 April 2016

Indonesian forests are burning too

Greenpeace firefighters are helping local fire departments, like this one in the Riau region, to stop the devastating fires. The fires are deliberately set: slash-and-burn agriculture clears land for new oil palm monocultures and for paper production. This is not only killing Indonesia's biodiverse forests, but is also releasing many millions of tonnes of CO_2, further fuelling the dangerous climate crisis
1 August 2009

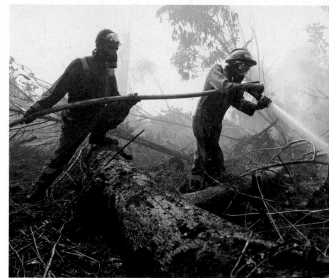

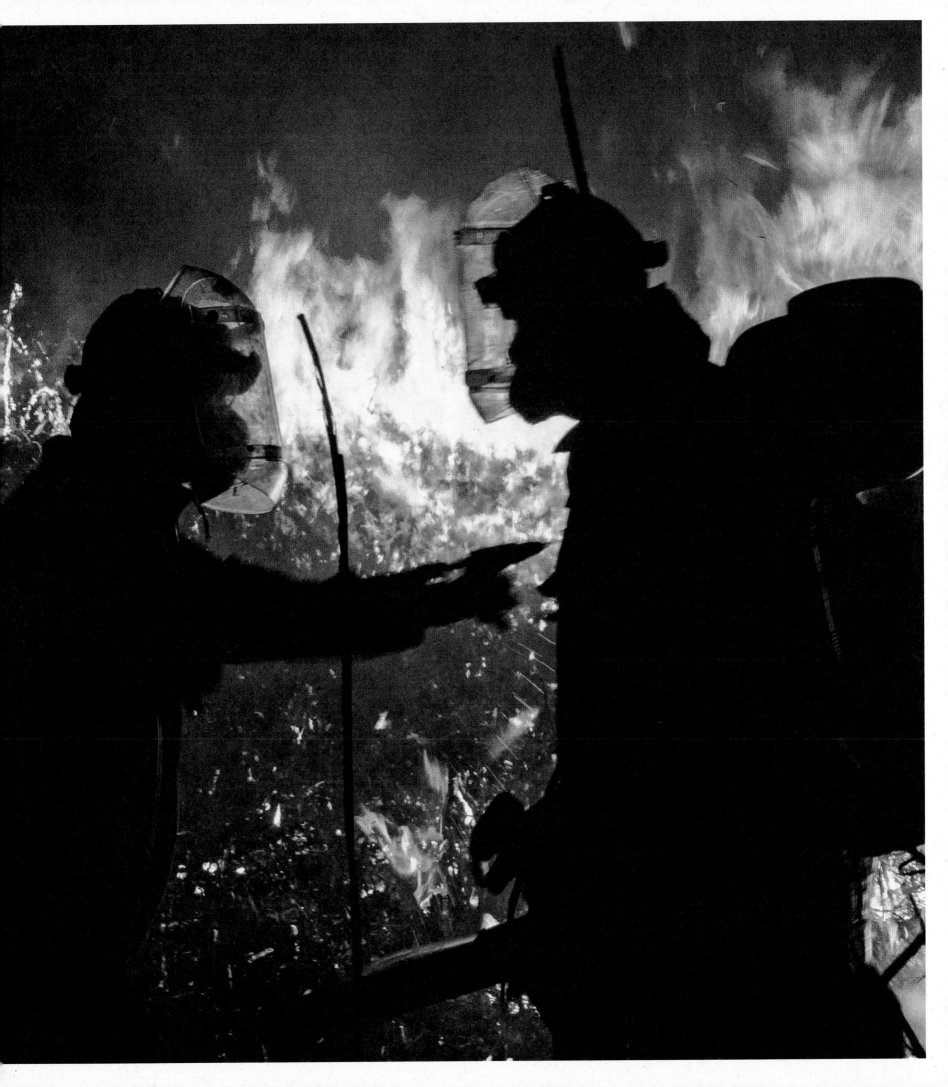

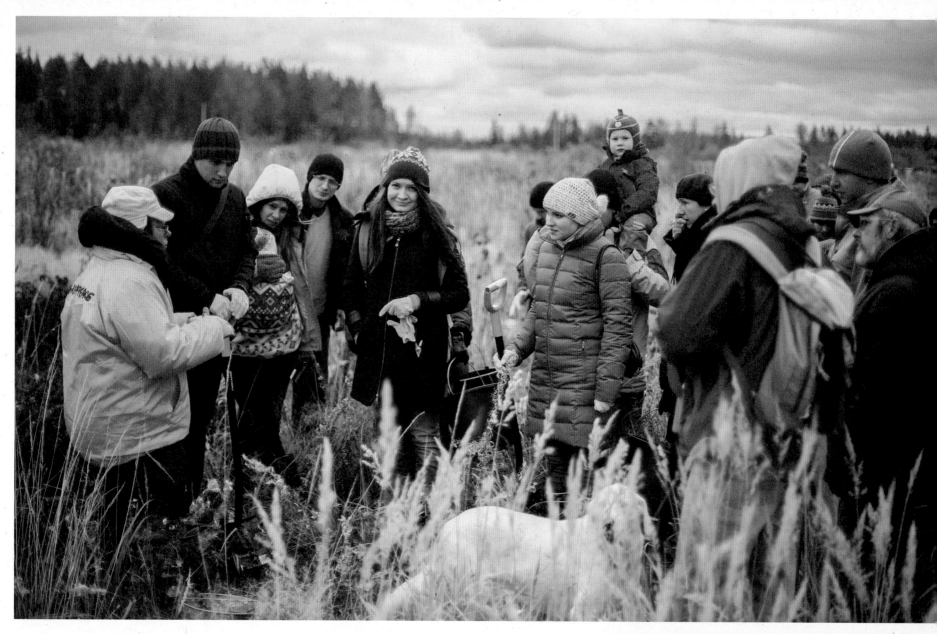

Planting forests – a wonderful project
»Kids for Forests« is a forest awareness and reforestation programme in Russia that has been running for many years; created by Greenpeace, it has already been held with thousands of students from more than 2,000 schools participating. The children learn about and experience the significance and important functions of forests by visiting them. They also collect tree seeds, raise their own saplings, and plant several hundred thousand trees each year. In this way, the children create new forests

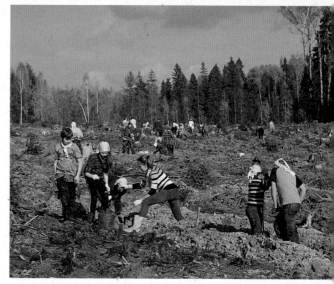

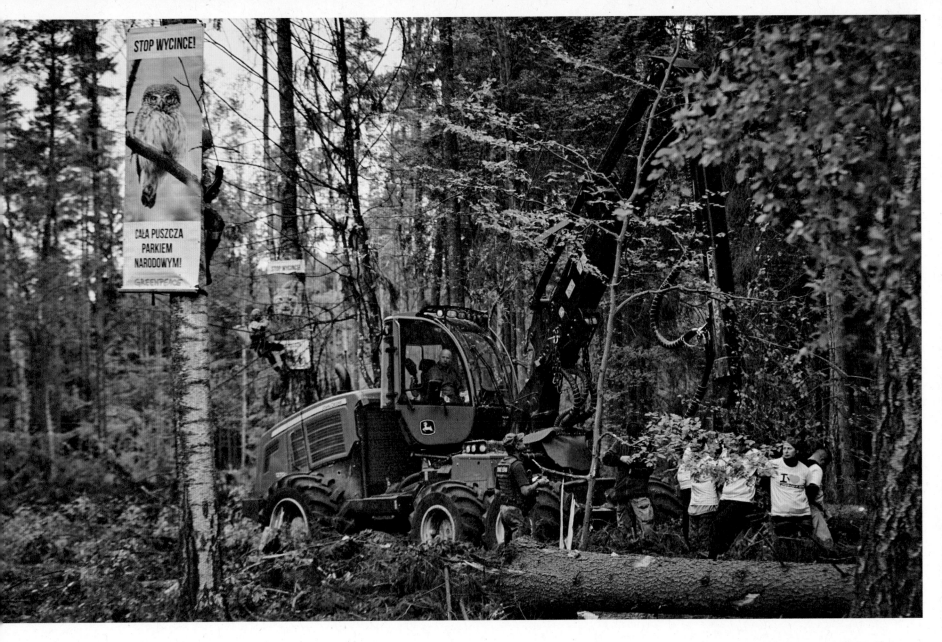

Destroying forests – a bad business
One of Europe's last natural forests, the Bialowieza forest area on the Polish-Belarusian border, continues to be cut down. This is why brave Greenpeace activists are standing up in opposition to the deforestation and chaining themselves to the destructive timber harvesting machines
30 May 2017

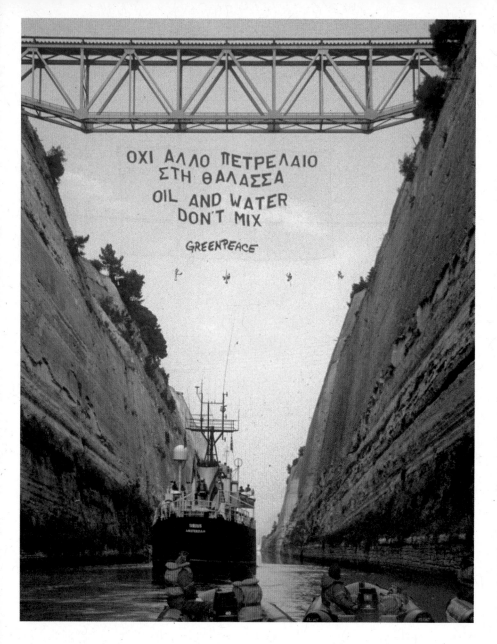

Protest against oil
Courageous climbing action in the
Corinth Canal – oil pollution in Greece's
waters was already a serious environ-
mental problem more than 30 years ago,
but one that was not taken seriously by
politicians and industry managers
4 April 1991

Finally, clean air
... demanded by activists in Cameroon
as part of the global movement for clean
and healthy air to breathe – for us hum-
ans and all of our fellow creatures
13 February 2020

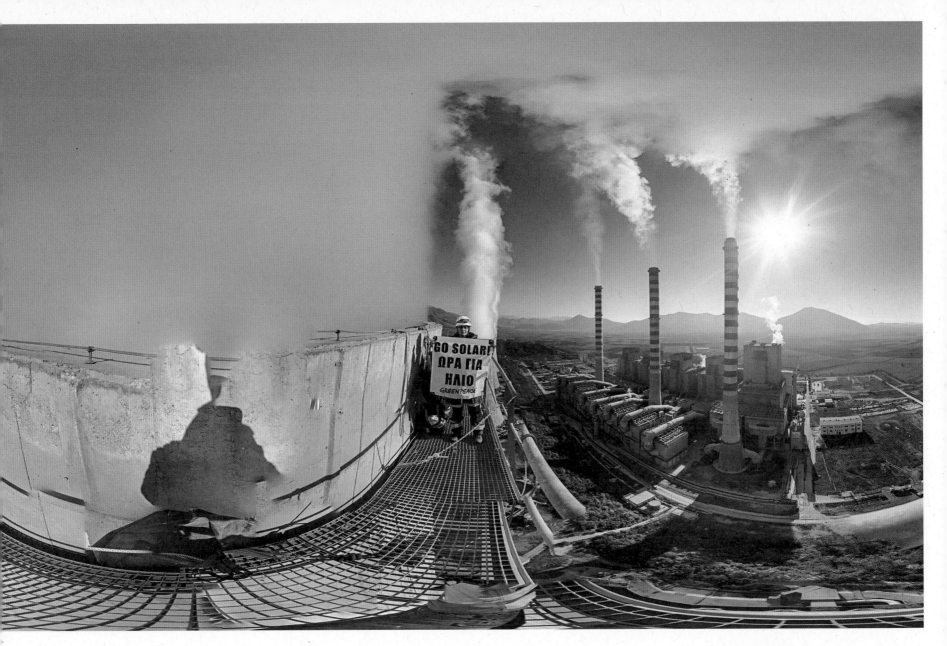

**Agios Demitrios –
Greece's dirty power plant**
The brown coal-fired power plant
was Greece's biggest climate polluter,
and the government was making no
real effort to put an end to this
environmental poisoning and finally
lead sunny Greece to a clean future
using solar energy
9 December 2015

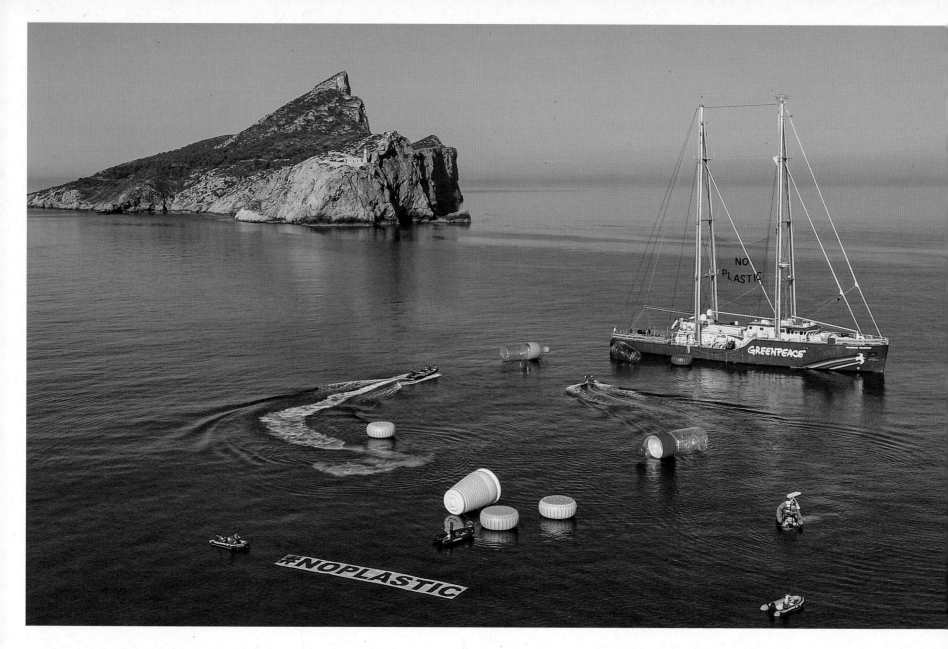

Plastic – the garbage problem
The Mediterranean, like many seas and coasts, suffers due to enormous plastic pollution, in particular due to disposable products. To make the invisible visible, the crew of the RAINBOW WARRIOR displays oversized specimens (made from recyclable material) of the most common single-use plastic items found on beaches: bottles, cups, lids and straws
12 June 2017

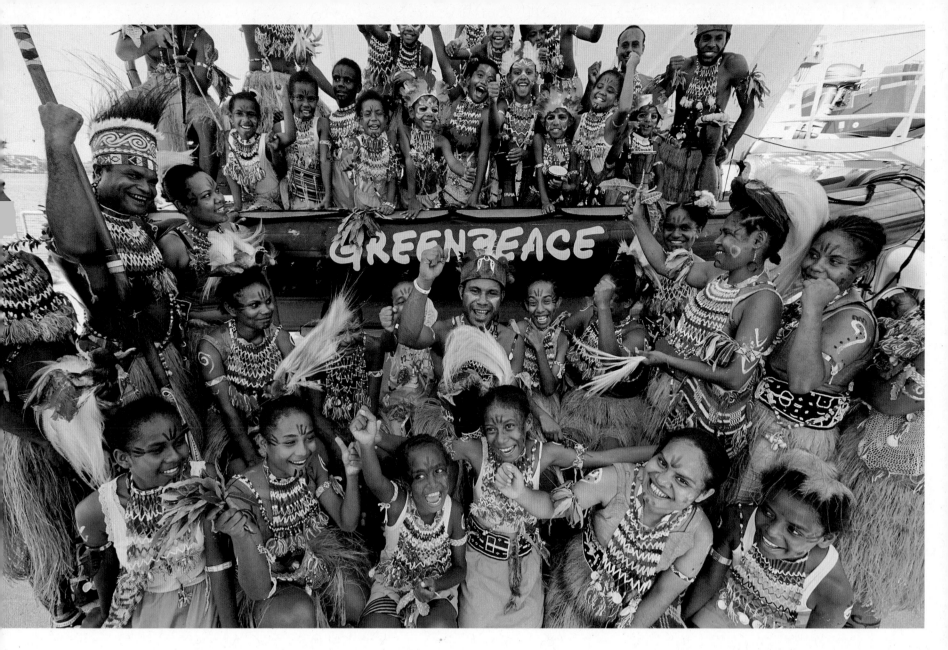

A warm welcome
... awaited our ship, the RAINBOW WARRIOR, and its crew when it reached Jayapura in 2013 during an extended tour of Indonesia to draw the world's full attention to endangered wildlife in one of the most animal and plant species-rich regions on earth
9 May 2013

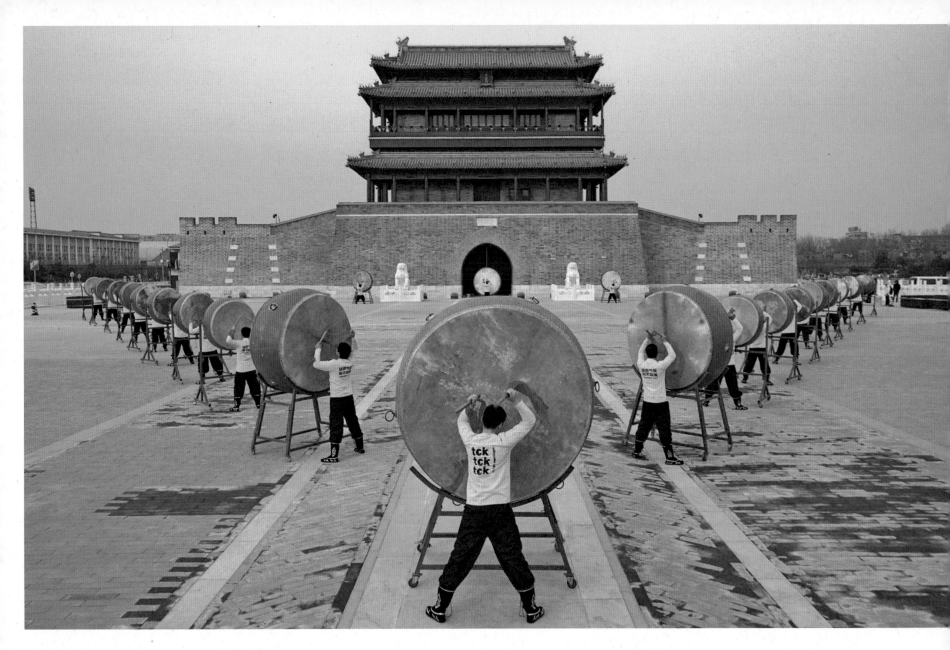

Global Day of Action
... for the crucial 2009 climate summit
in Copenhagen. From Beijing as well,
traditional drummers sent their call
to Denmark, and to the heads of state
gathered there to finally adopt a
binding and truly effective climate
protection plan
12 December 2009

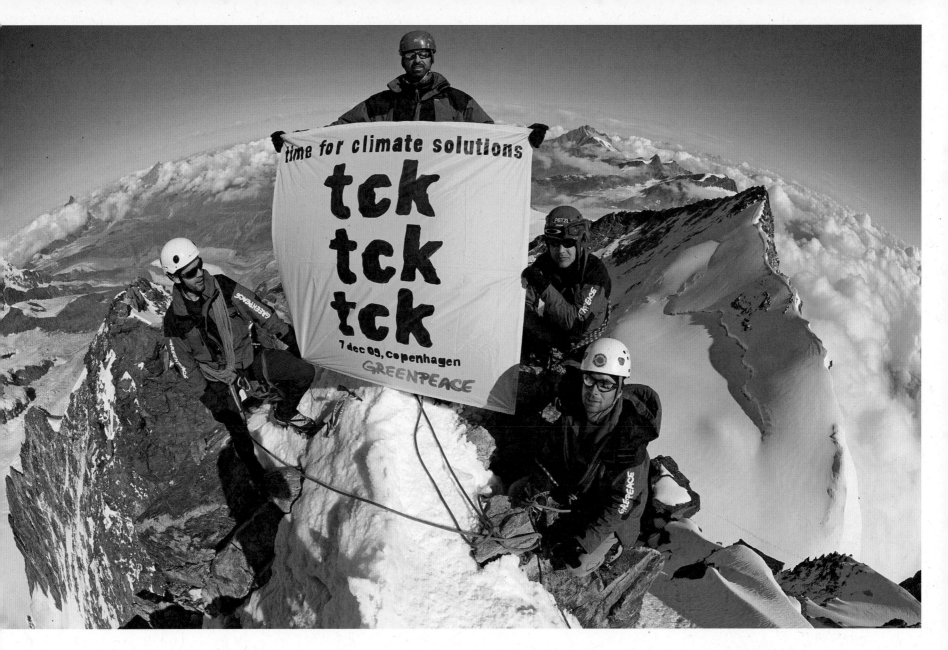

This is the summit
Throughout 2009, protests and actions
are held all over the world to admonish
the responsible heads of state, such
as the one held here on the summit
of Monte Rosa in Switzerland exactly
100 days before the start of the
climate summit
23 August 2009

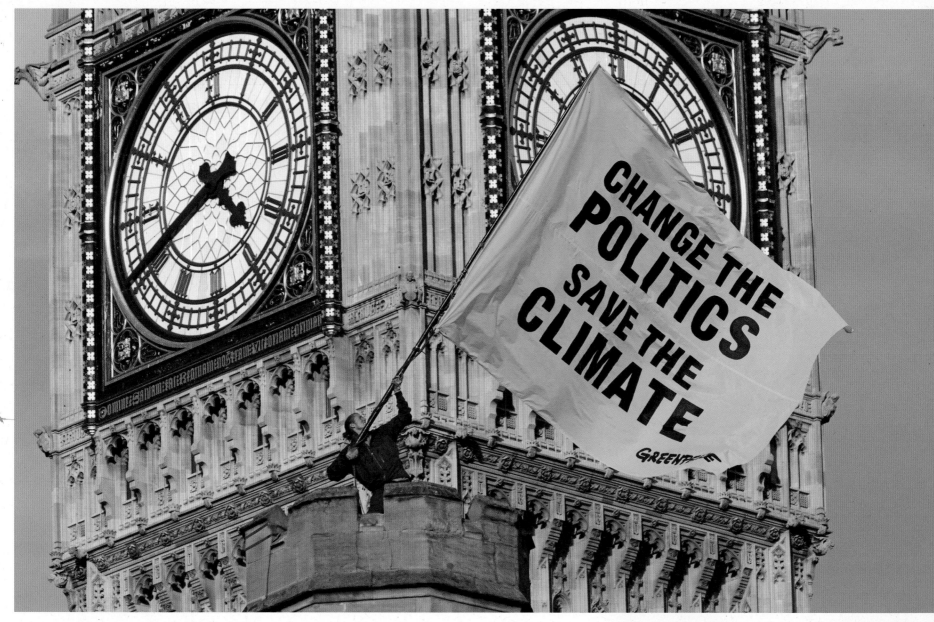

London, Tokyo, Sydney, Moscow
... and in many other major world cities, the warnings about the upcoming climate summit in Copenhagen continue, with the first goal being to ensure heads of government actually show up in person in Copenhagen, and the second to adopt a binding climate protection plan
April to December 2009

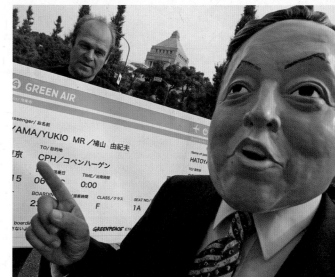

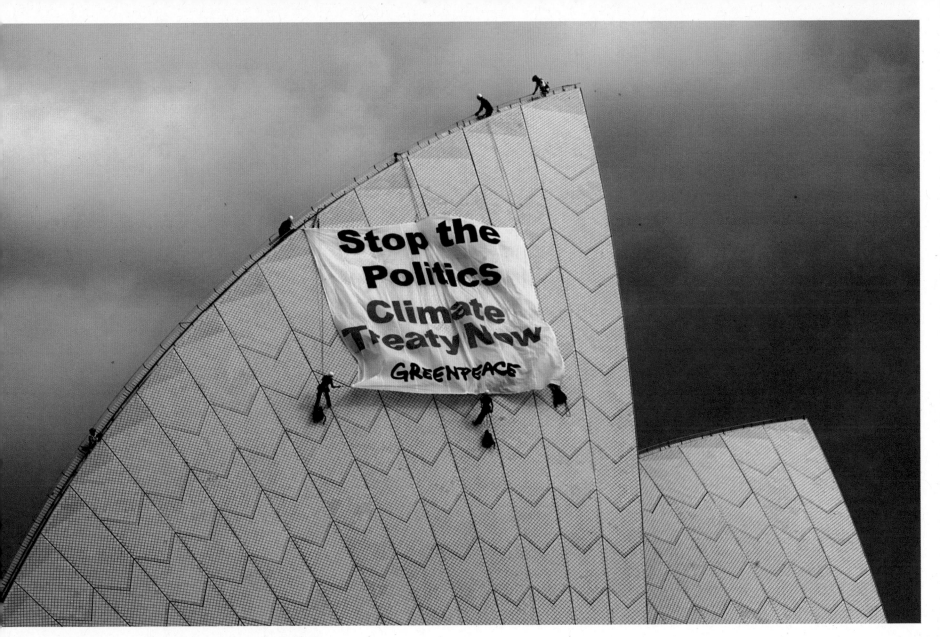

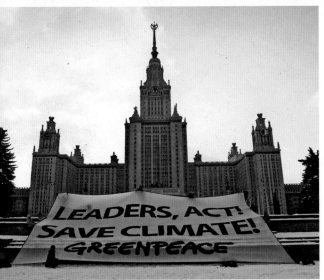

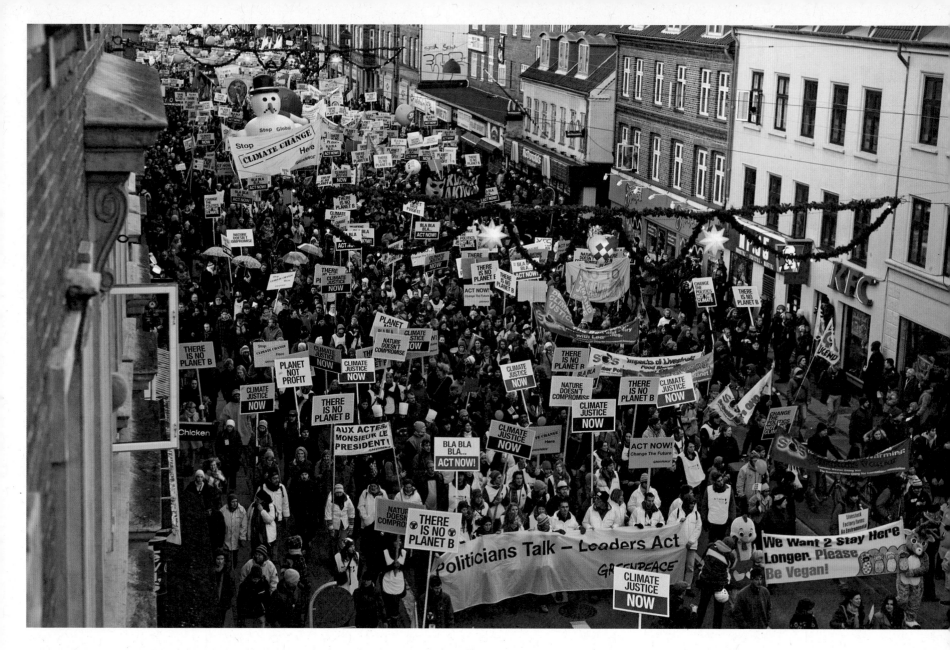

100,000 people
... gathered in Copenhagen on the
same day for one of the largest climate
protection peace marches in history
12 December 2009

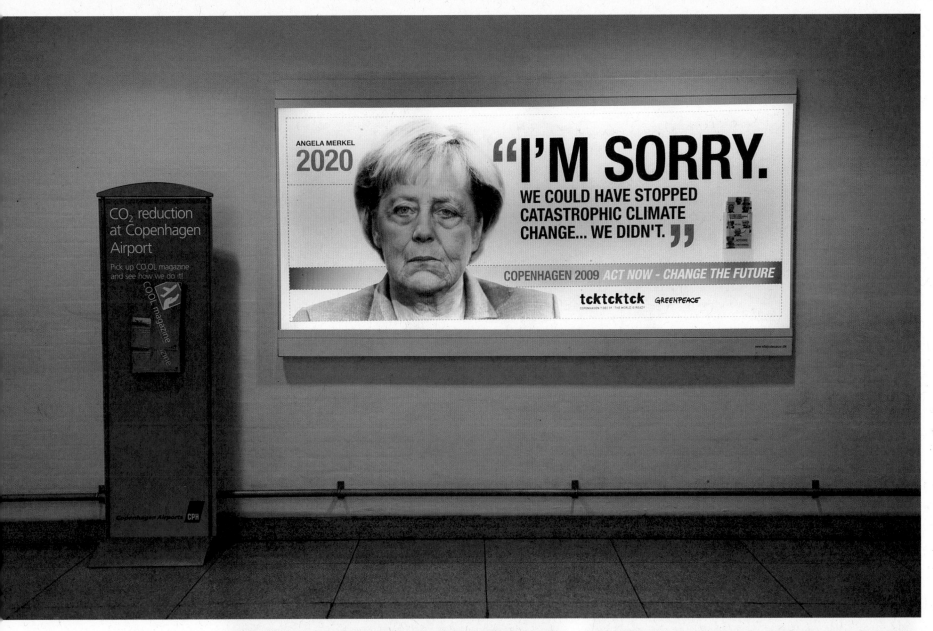

storic failure

was then the only real result achieved
the many heads of state who came
re. As the posters displayed in many
ces in Copenhagen show by depicting
ama, Medvedev, Merkel and others in
e future as they apologise, looking back
the climate summit 2009, after they
d the chance to save the climate but
nply failed to do so

cember 2009

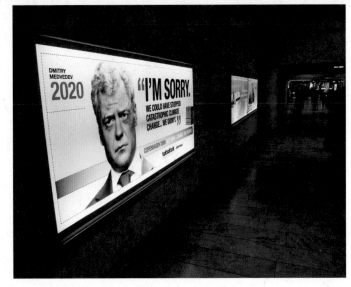

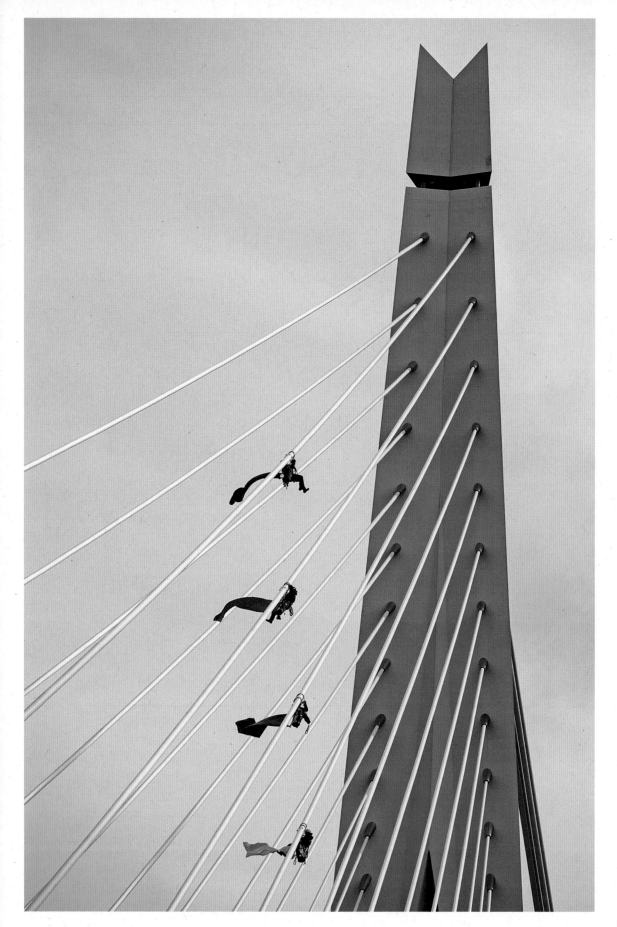

The Netherlands is up to its neck in water
The rise in sea levels due to climate change, much more pronounced than was previously calculated, will hit the Netherlands particularly hard. This is why our Dutch colleagues are warning the government, with their action on the Erasmus Bridge in Rotterdam, to finally take action
13 October 2020

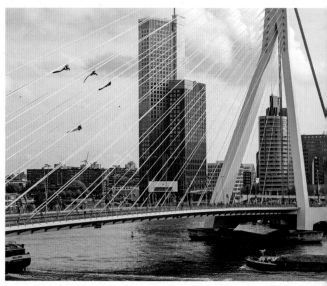

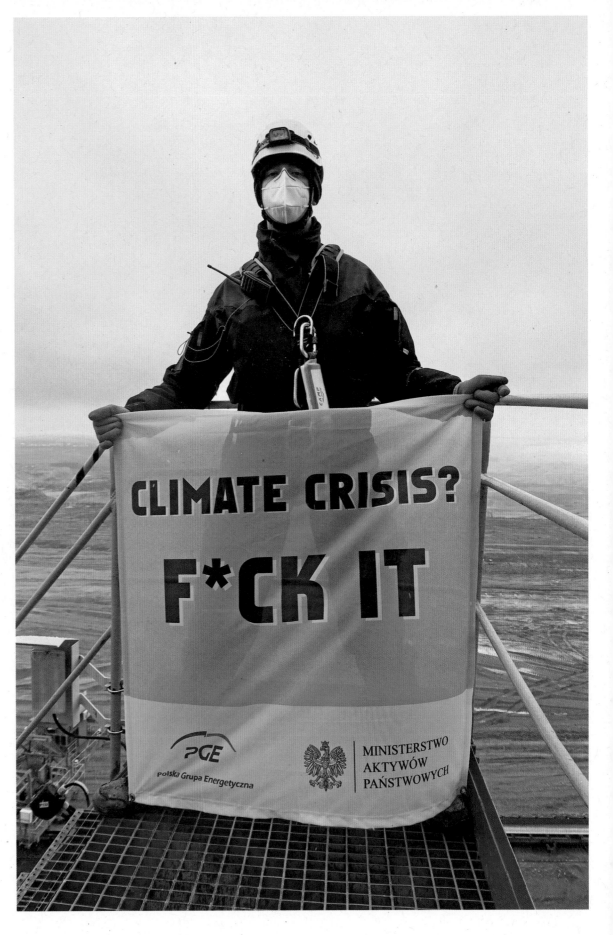

Brown coal is a European climate scandal

Whether in Poland, the Czech Republic or Germany: the worst climate killer continues to be extracted in huge mines, destroying nature and whole villages – as a result of massive environmental and climate ignorance on the part of those politically responsible

September 2020 and March 2021

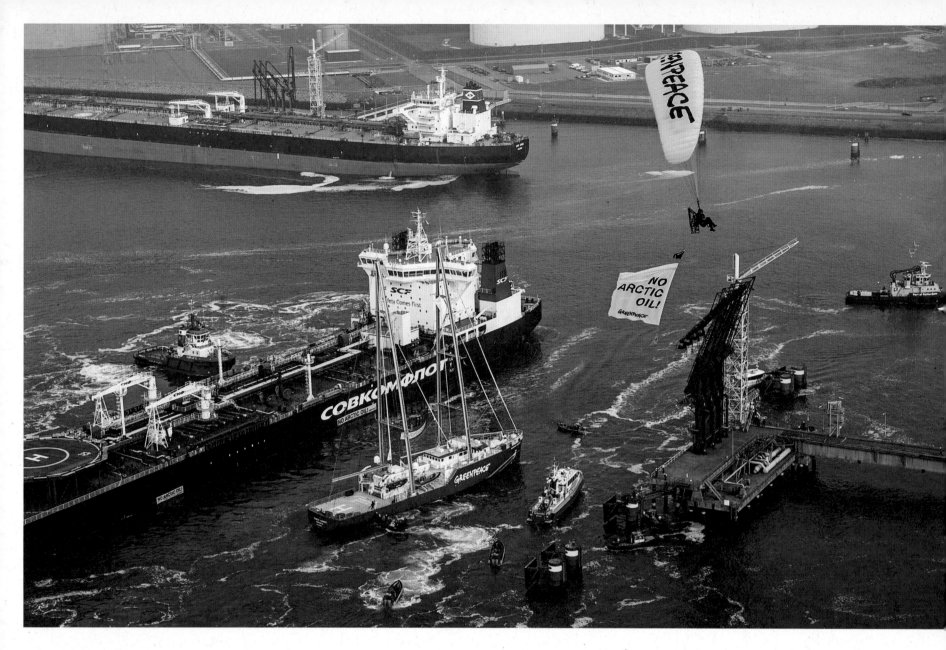

No oil from the Arctic
Massive protests – with rubber dinghies,
paragliders and the RAINBOW WARRIOR –
against the import of Arctic oil by
Russian corporation Gazprom, as the
incoming Russian tanker seeks to unload
its climate-damaging cargo in Rotterdam
1 May 2014

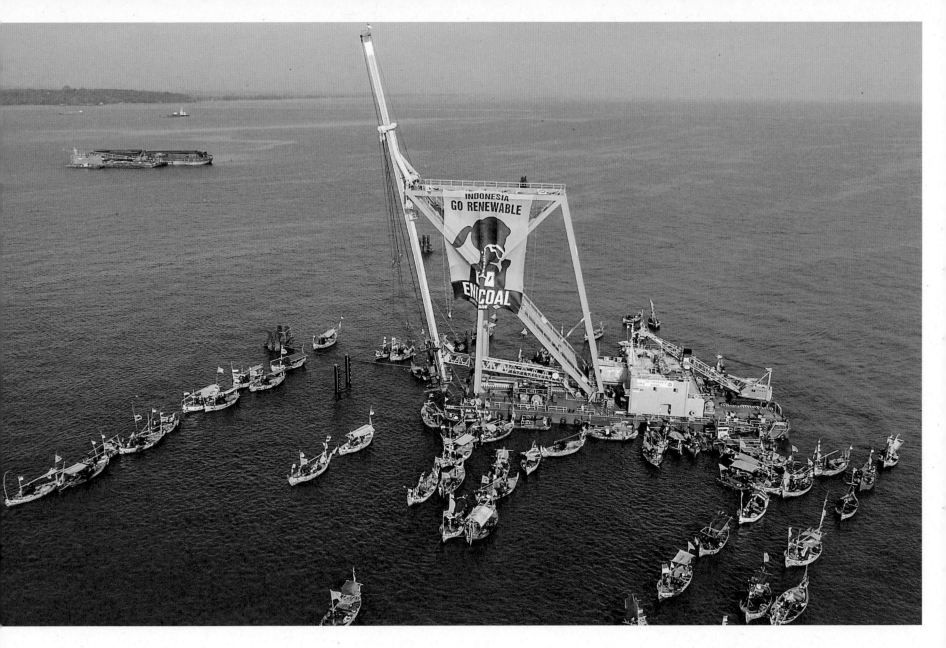

No new coal
A new coal-fired power plant is to
be built in Batang, Indonesia, that would
pose a massive threat to the climate,
but also to local fisheries. A coalition
of Walhi, Jatam, local fishermen and
Greenpeace intends to prevent this at
all costs, and is blocking one of the
work ships that was deployed
30 March 2017

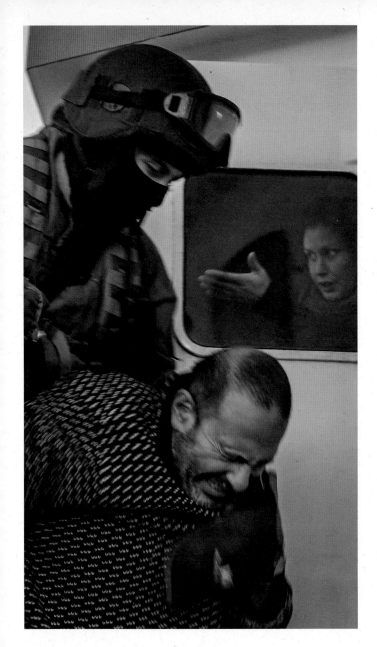

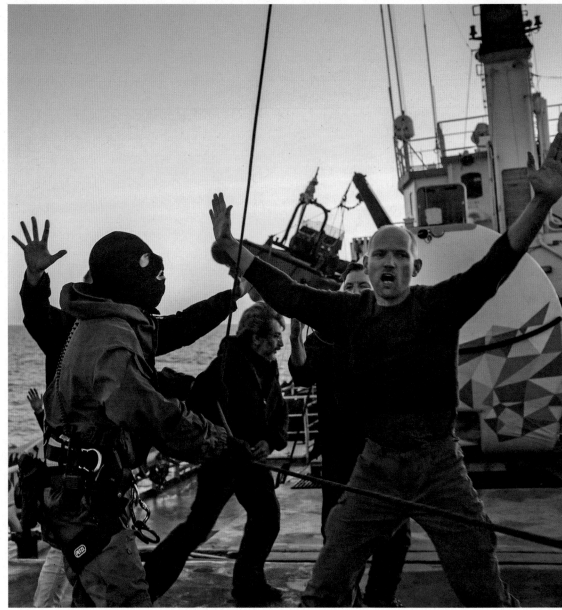

At gunpoint

The peaceful protest against Arctic oil drilling by the »Prirazlomnaya« oil platform owned by Russian energy giant Gazprom in international waters is ended by armed Russian forces – also in international waters. Greenpeace ship ARCTIC SUNRISE is towed away under protest and impounded. The captain and the entire crew are arrested and are due to be charged with piracy. Our 30 colleagues are taken to the Russian prison in Murmansk and later transferred to Europe's largest prison in St. Petersburg, where they are held for more than twelve weeks

19 September 2013

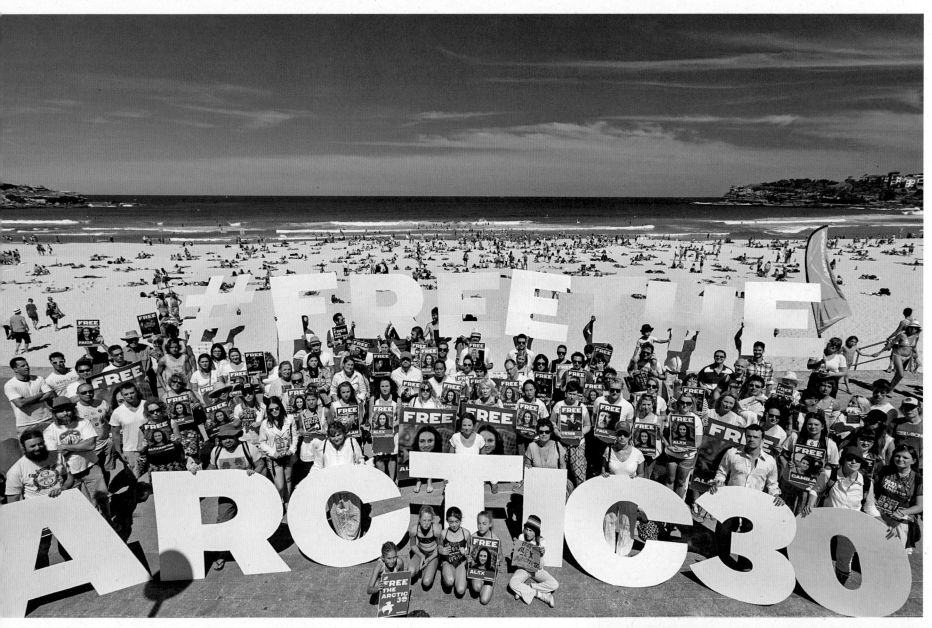

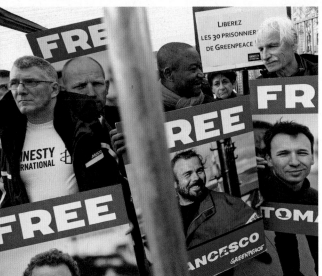

Global protests

Global protests from Canada to Paris to Australia are the massive support we can show for our 30 colleagues and friends who have been imprisoned in Russia for weeks. The International Tribunal for the Law of the Sea demands their immediate release, and later an international arbitration court in The Hague also condemns the capture and seizure of our ship and the imprisonment of our people. Our courageous climate activists are only released from prison in St. Petersburg after almost three months **2013/2014**

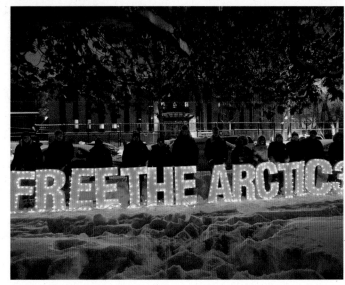

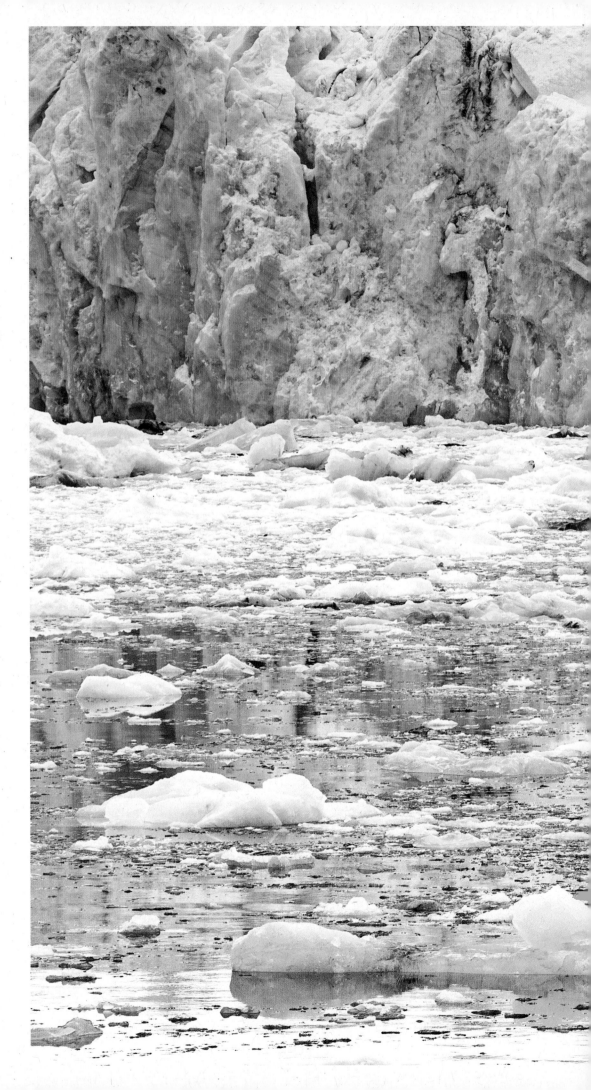

A pianist in the Arctic
Famous Italian composer and pianist
Ludovico Einaudi plays one of his
compositions on a floating platform in
the Arctic ice of Spitsbergen. Over ten
million signatures from around the world
call for the protection of the Arctic as a
unique habitat and an important climate
cooling chamber for our planet
16 June 2016

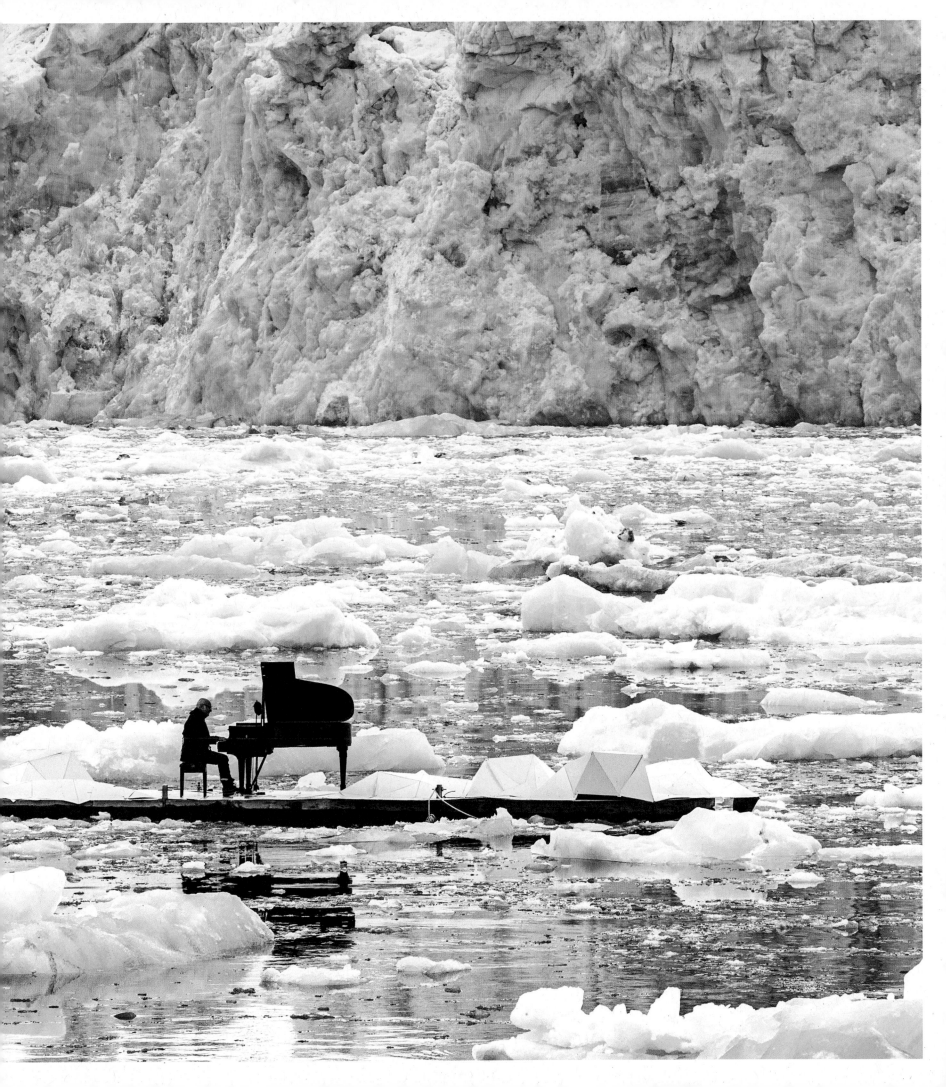

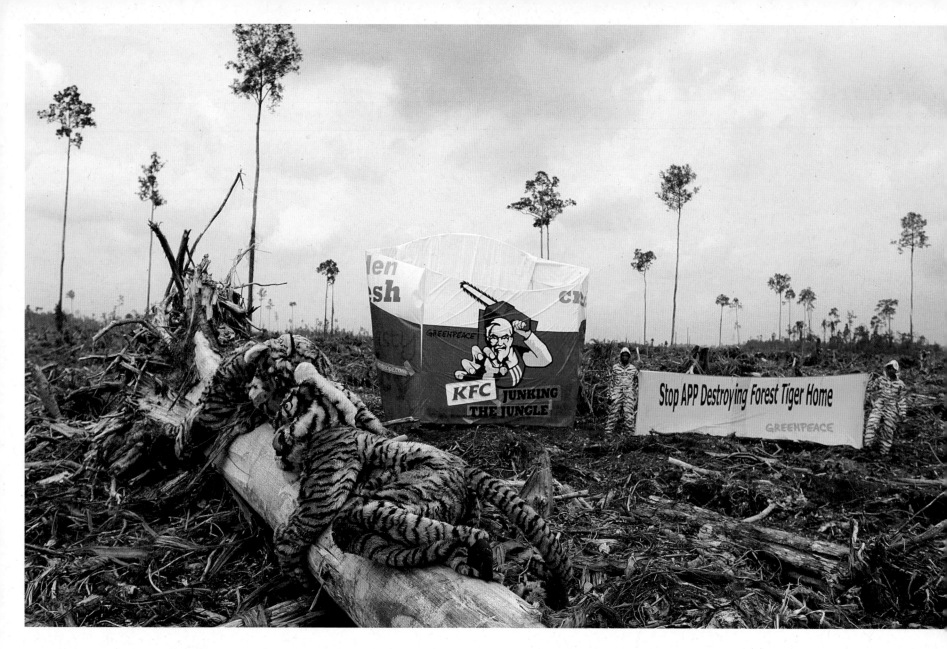

Forest destruction in Indonesia's tiger forests – for disposable paper packaging
The intact forests in Indonesia, where tigers should also be roaming, are being completely destroyed and boiled down to make paper pulp. The company responsible is APP (Asia Pulp and Paper), which uses these species-rich, valuable and unique primaeval forests to produce material which is used in the manufacture of many disposable products, among them the packaging for Kentucky Fried Chicken
30 May 2012

Forest destruction in the reindeer forests of the north – for disposable paper products
Even the last remaining areas of primaeval forest in Europe, such as in the north of Finland, continue to be cleared to satisfy the hunger for paper in Central Europe in particular, and Germany first and foremost. The Finnish state-owned company Metsähallitus is responsible for the destruction of the forest regions, which are an important habitat for the reindeer of the Sami
22 March 2005

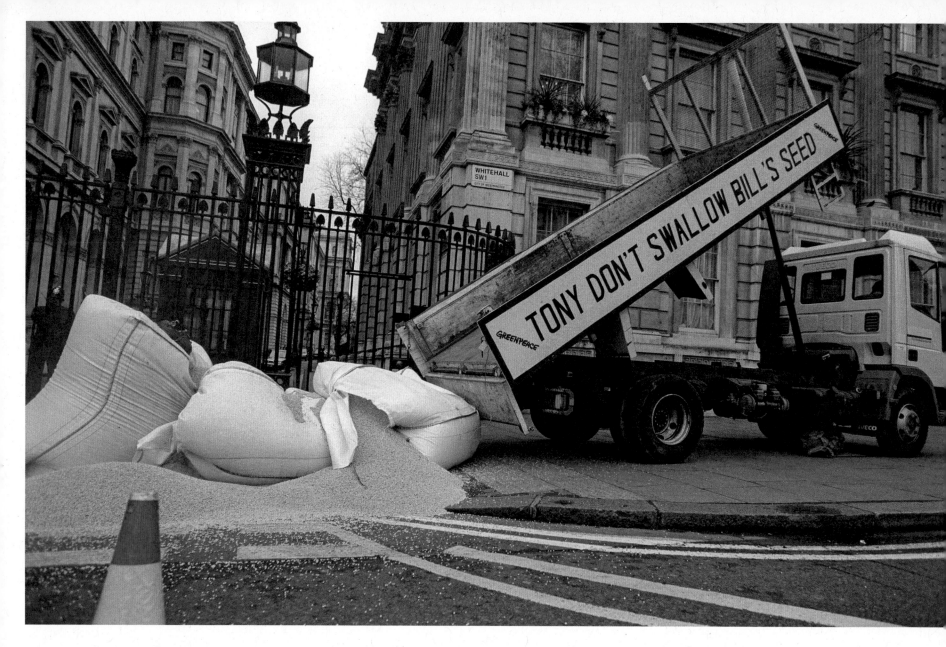

**Tonnes of genetically modified
soya outside 10 Downing Street**
Greenpeace dumps four tonnes of
GM soya in front of the residence of
British Prime Minister Tony Blair.
The goal is to uphold the ban on
genetically modified food due to
incalculable dangers to nature
and health
8 February 1999

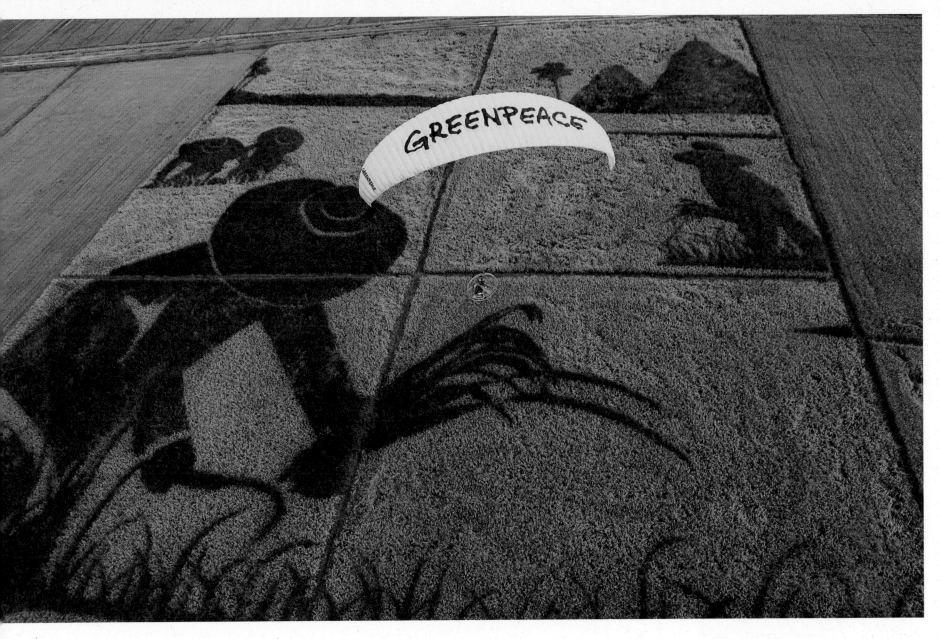

**Rice artwork against
genetically modified rice**
A creative and artistic way of planting of
organic rice aims to support Thailand's
rich heritage of diverse natural rice
farming and warn the government not to
allow genetically modified rice
15 October 2009

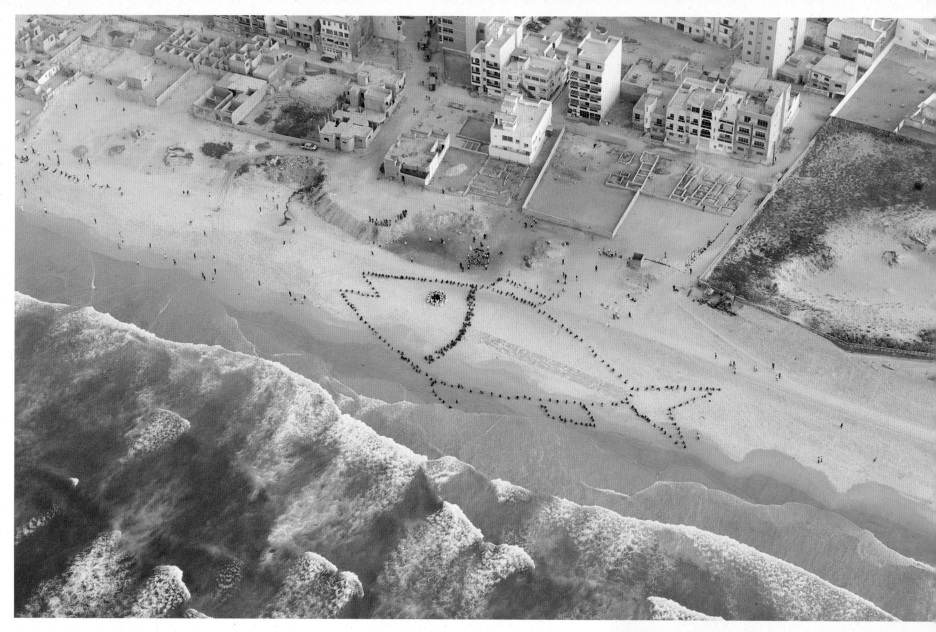

**Banners show the tremendous
dedication and creativity of
many people**
400 schoolchildren join Greenpeace in
raising awareness of the importance of
fish for coastal communities in Senegal.
Livelihoods in fishing communities are
threatened by the uncontrolled and often
illegal activities of industrial fishing
fleets from abroad
19 January 2012

For whales, seals and penguins
More than 140 people in Argentina are
calling for a protected area in Antarctica
using a banner 22 metres in diameter.
This will help protect key feeding
grounds of whales, seals and penguins
from fishing
23 February 2018

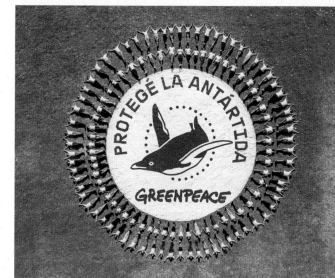

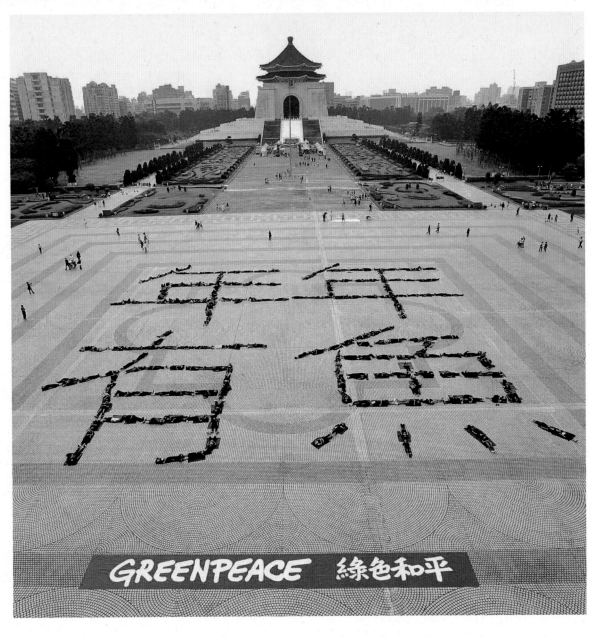

blo Picasso's »Amnesty«
re than 1,500 people – the largest
ing artwork of all time – join forces to
ow support for the Greenpeace acti-
ts scandalously under indictment for
otesting against the illegal import of
hogany from the Amazon
January 2004

Tuna in danger
In Taiwan, too, fish resources, in
particular the formerly plentiful tuna
stocks, are threatened by massive
overfishing and are even in danger of
collapsing completely
23 September 2012

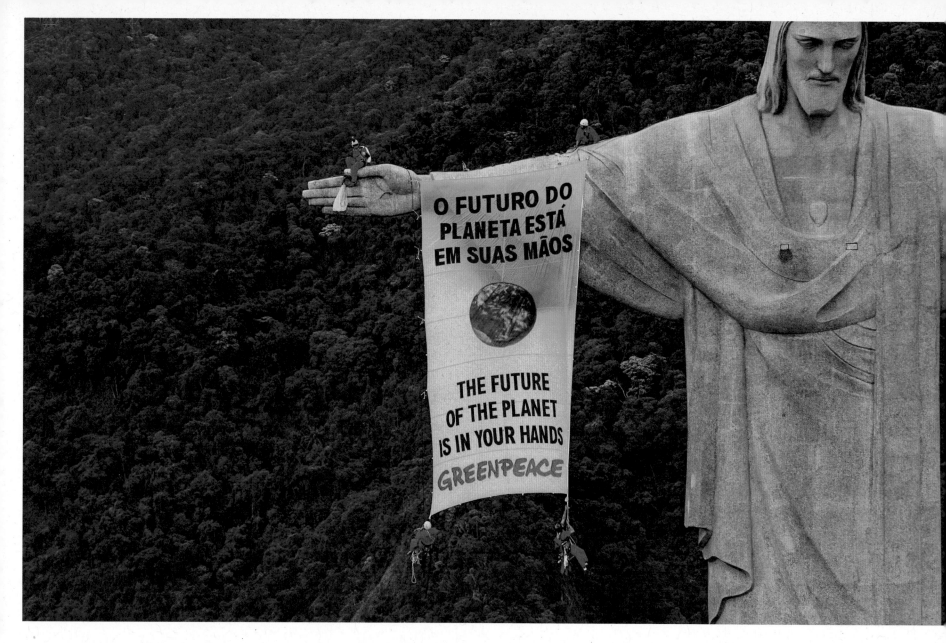

UN Conference on Environment and Development (Rio Conference 1992)
In 1992, representatives from 178 countries met in Rio de Janeiro at the UN Conference, also known as the Earth Summit or the Rio Conference, to discuss issues relating to the environment and development. There, the concept of sustainable development was recognised as a guiding principle for the international community, and a consensus was also reached that economic efficiency, social justice and the protection of the natural foundations of life are equally important when it comes to survival, especially as these issues all intersect.

Fourteen years later, the Conference on Biological Diversity is held in Brazil to discuss the preservation of biodiversity. The omens are not good, as there are no concrete proposals on the table for how to prevent the advancing extinction of species. Greenpeace urges the representatives of the international community to finally take action
16 March 2006

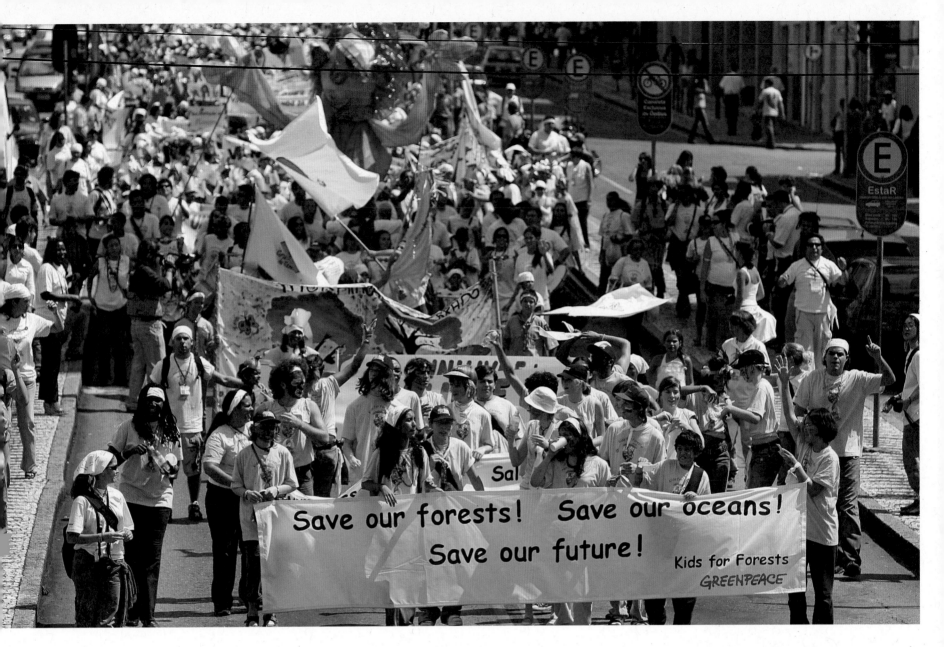

Samba parade for the preservation of biodiversity
More than 2,000 children and young people from the international Greenpeace »Kids for Forests« project, the Brazilian scout community and the Uni Livre project start a colourful samba parade in front of the Convention of Biological Diversity (CBD) in Curitiba (Brazil). The Kids for Forests are demonstrating for the preservation of biodiversity and the protection of the last primaeval forests
29 March 2006

100 percent criminal

An investigation by Greenpeace Brazil discovered an illegal clear-cut extending to more than 1,600 hectares. The Amazon rainforest has been destroyed here for the sole reason of planting more soya, much of which, processed into cheap animal feed, ends up in the factory farms of Europe and North America. Greenpeace Brazil drew attention to the criminal deforestation. Only a few Brazil nut trees were left standing, as cutting them down could have resulted in heavy fines, but even these die very quickly because they are so isolated and exposed to the wind, heat and a lack of water. After a few hours, the banner is destroyed by the head of the agricultural association using an SUV. He is accused of large-scale forest destruction by the environmental protection agency IBAMA
6 March 2006

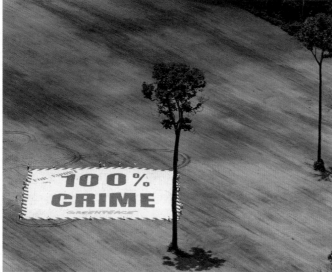

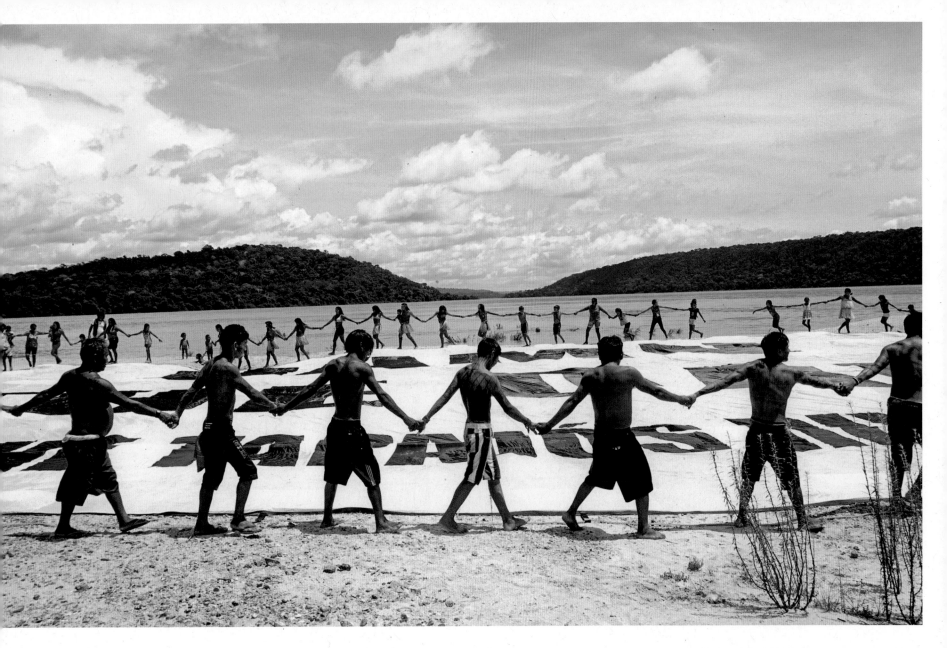

Damn the dam
Greenpeace and the Munduruku tribe are campaigning against the construction of a huge dam on the Tapajós River in Brazil's Amazon state of Para. The dam would flood huge areas of forest – more than 700 square kilometres – and threaten the Munduruku's home. The campaign succeeds, and the dam is prevented from going ahead when environmental agency IBAMA refuses to issue a permit
18 March 2016

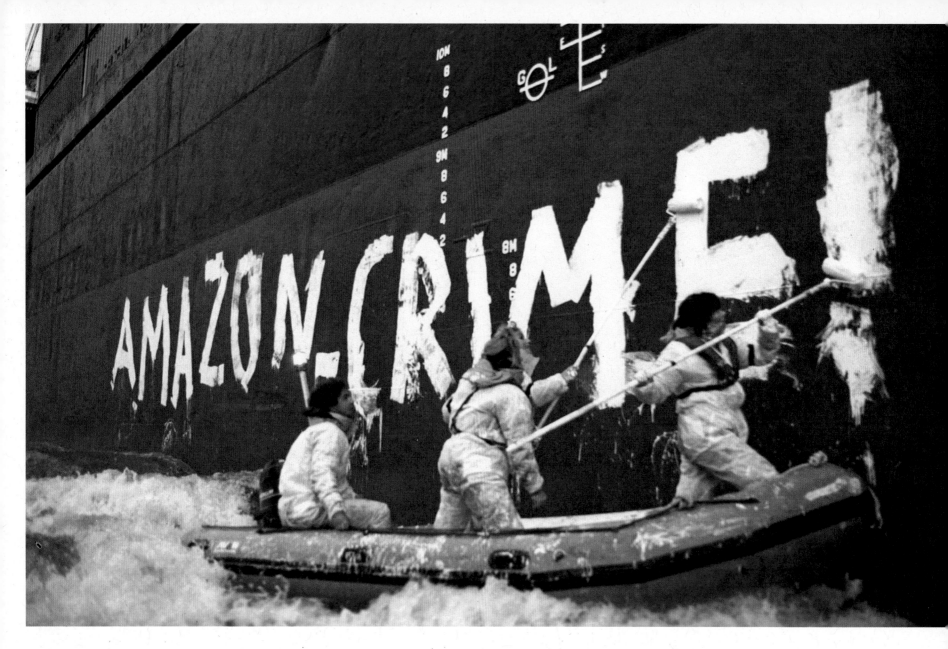

»Crimes against the Amazon«
… is painted on the incoming ships
that bring timber, often illegally logged
in the Amazon, to various industrialised
countries. This trade needs to be
stopped for good
26 June 2000

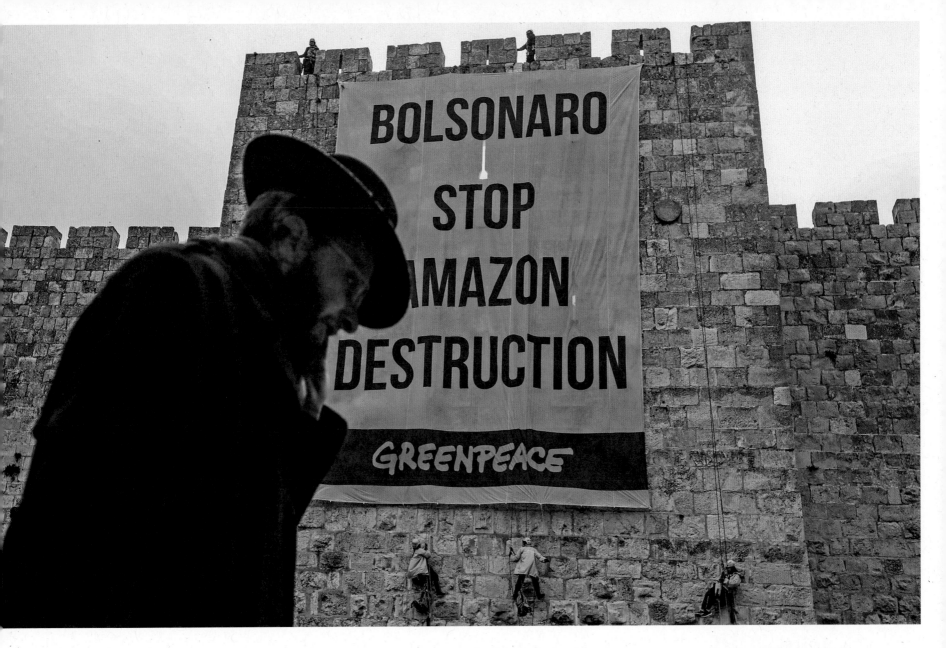

Protest against President Bolsonaro in Jerusalem

On the occasion of Brazilian President Bolsonaro's visit to Jerusalem, Greenpeace volunteers unfurl a huge banner calling on him to stop the destruction of the Amazon. The climbers rappel down from the old Ottoman city wall across from the King David Hotel, where President Bolsonaro and his entourage are staying, to hang the 140-square-metre banner. Bolsonaro and his environment minister bear the main responsibility for the dramatic destruction of the Amazon rainforest, the most biodiverse forest on earth, where thousands of square kilometres of living space for many indigenous communities are lost every year
1 April 2019

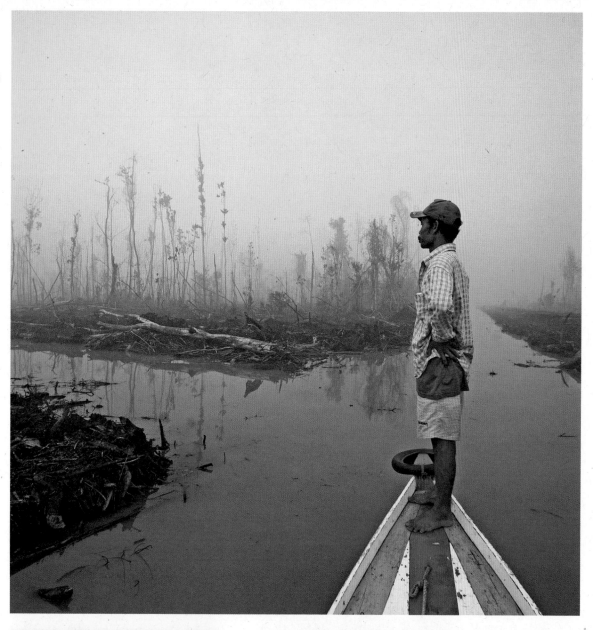

Mass extinction for palm oil
The ruthlessness of palm oil concerns and politicians' failure to take action against them are a catastrophe for the earth. Every year, the fires set in the Indonesian moor and turf rainforests alone not only cause the deaths of an unimaginable number of animals, destroy symbiotic communities that are thousands of years old, and wipe out countless species of animals and plants, but also release up to 1.8 billion tonnes of climate-damaging greenhouse gases – meaning that up to four percent of the worldwide greenhouse gas emissions are coming from less than 0.1 percent of the earth's land area
4 October 2007

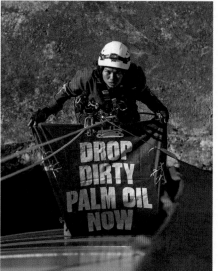

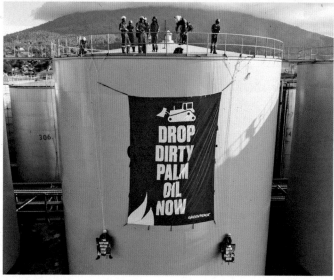

Action at the Wilmar refinery in North Sulawesi, Indonesia
30 Greenpeace activists from Indonesia, Malaysia, the Philippines, Thailand, the UK, France and Australia occupy a palm oil refinery owned by Wilmar International, the world's largest palm oil trader – which means it plays a key part in increasing or reducing the destruction of the world's forests. The group is a supplier to major brands such as Colgate, Mondelez, Nestlé and Unilever
25 September 2018

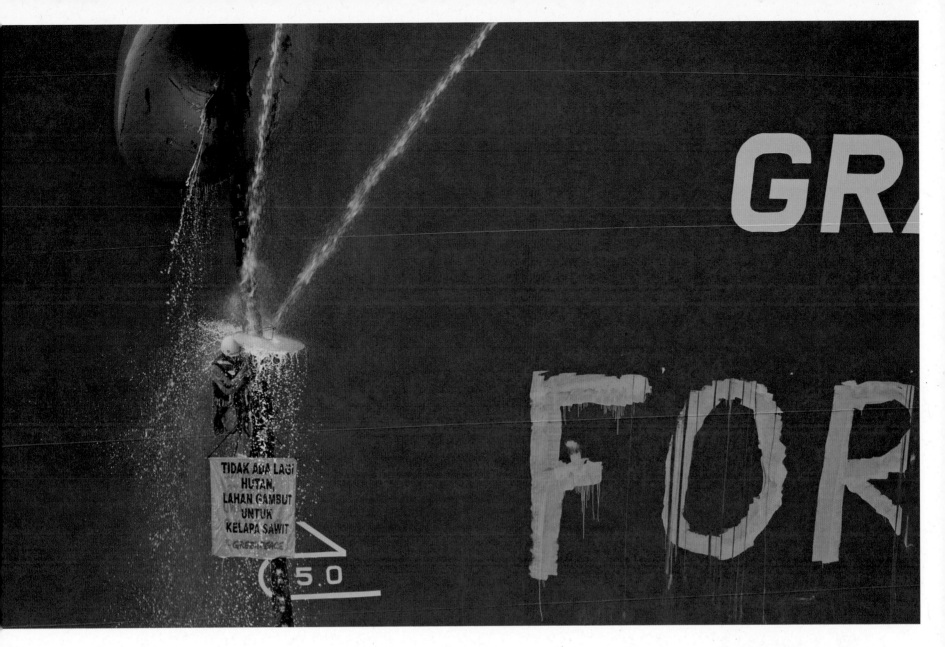

GR

FOR

TIDAK ADA LAGI
HUTAN,
LAHAN GAMBUT
UNTUK
KELAPA SAWIT
GREENPEACE

5.0

**Action against a palm oil ship
in Indonesia**
The crew of Greenpeace ship ESPERANZA
occupy the tanker for 24 hours and
paint the words »Forest Crime« on the
bow. The ship, carrying 27,000 tonnes
of palm oil for the Wilmar company, is
held up as it departs for its destination
of Rotterdam in the Netherlands.
Greenpeace is protesting against the
pulp and paper and palm oil industries'
destruction of the unique peat forests
of the Kampar Peninsula, which are so
important for climate protection, and is
calling on the Indonesian government to
impose a moratorium on deforestation
10 November 2008

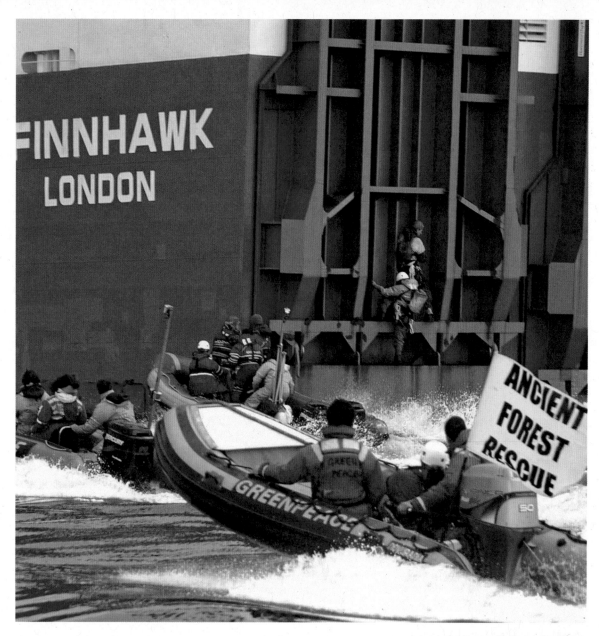

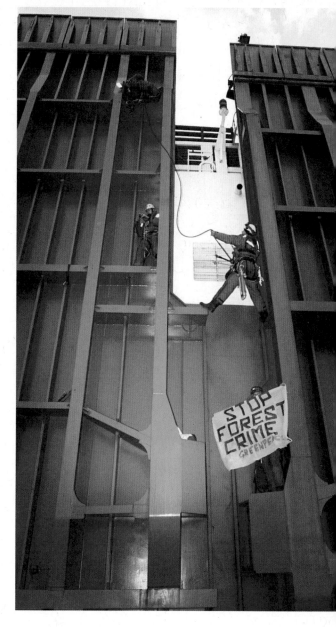

Finland's last primaeval forests end up as magazines

Greenpeace not only defends forests where they grow, but also where they are consumed. The last primaeval Nordic forests are still being turned into pulp and paper for export. This makes the powerful pulp and paper importers, as well as end users such as large magazine publishers, equally responsible for the loss as those who cut down the forests
2 May 2003

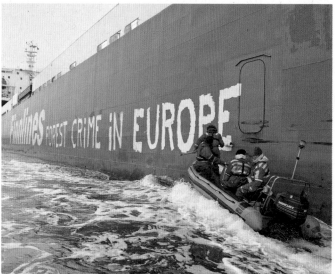

»

The disappearance of the last coastal rainforests

At the famous Niagara Falls on the Canada-US border, a climbing action draws attention to the ongoing destruction of the last coastal rainforests in Canada and Alaska
22 September 1998

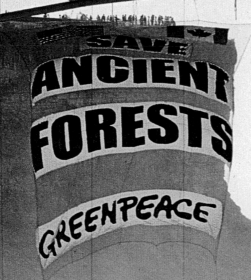

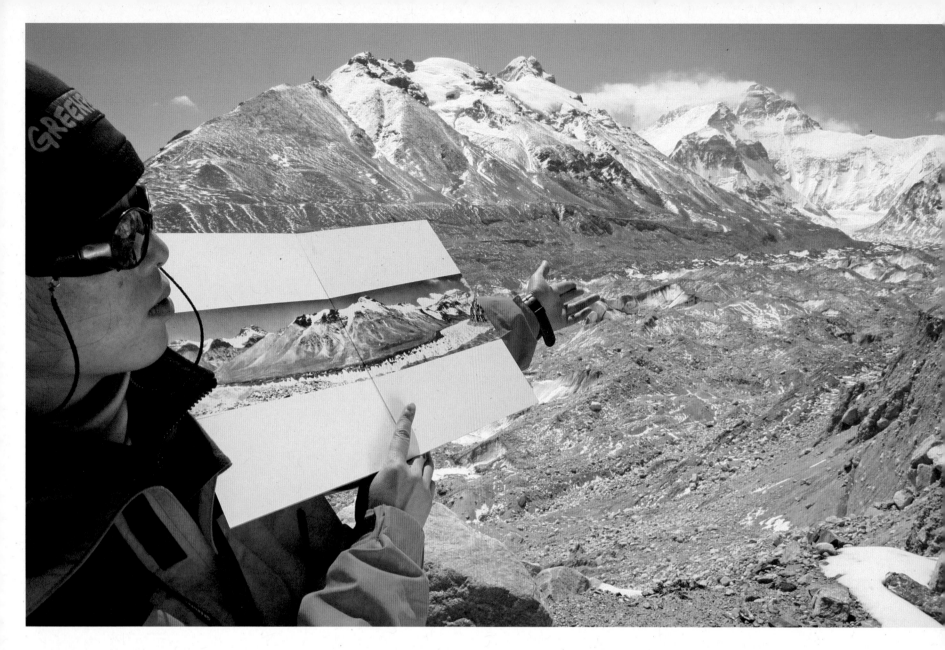

Himalayan glaciers are melting

Climate change is affecting all areas of the world, and is even showing up in measurements in many places. Alarming quantities of meltwater have been observed in glacial areas in the Arctic and Antarctica in particular, and the same goes for glaciers in mountains worldwide. The Himalayas are particularly severely affected. A team from Greenpeace China shows the rapid retreat of the Rongbuk glacier, which is causing serious water supply problems as it feeds the major rivers of India and China

29 April 2007

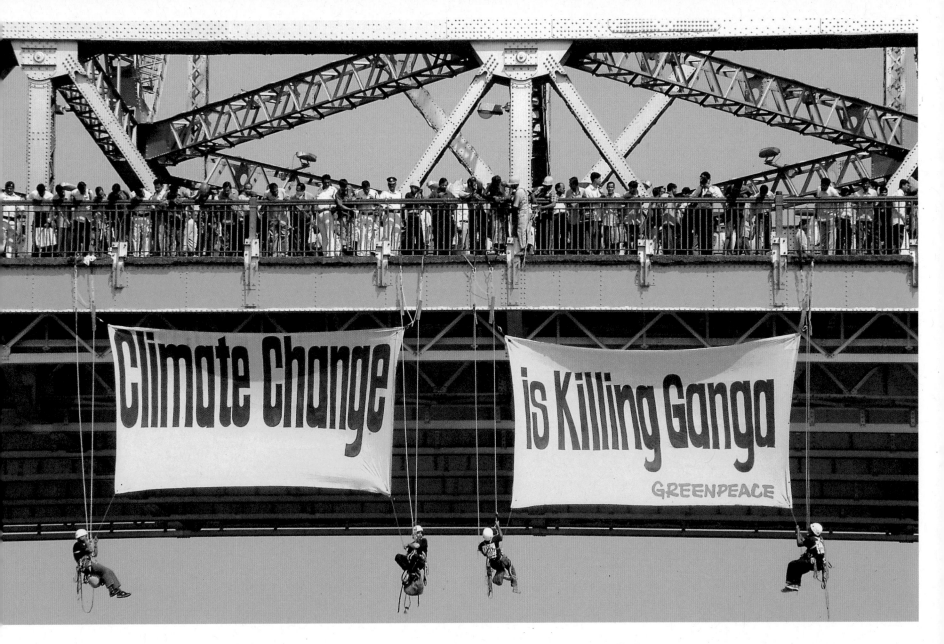

**Climate change threatens
the Ganges, India's lifeline**
Greenpeace is sounding the alarm as
one of the most dramatic impacts of the
climate crisis is already a life-threatening
reality for India: the rapid melting and
disappearance of the Himalayan glaciers.
Asia's major rivers, fed by the Himalayan
glaciers, are already experiencing signi-
ficantly reduced water inflows. Extensive
droughts are the result, threatening crops
and food supplies in many parts of the
densely populated subcontinent
22 November 2006

Icy temperatures at the South Pole
With their extreme weather conditions and icy temperatures, the polar regions are of particular biological and climatic importance – and also present a challenge for us, as in the case of the campaign against Japanese whaling in the Southern Ocean
1 March 1995

Nearly three million at the North Pole
In the international Arctic project, young people from many nations set out on a Greenpeace expedition to the North Pole, where they sank 2.7 million digital signatures placed in a special capsule on the seabed directly above the geographic North Pole to show support for the protection of the Arctic
4 April 2013

⟰
Ice crust
The deck of our Greenpeace ship
on its way to Antarctica, covered in
thick ice
1 December 1992

»
World Park Base
Greenpeace built its own Antarctic
station, the World Park Base, from which
it successfully fought for protection for
the Antarctic continent and protested
against the pollution and degradation
caused by the many Antarctic stations
between 1987 and 1991. After an
intensive worldwide campaign lasting
seven years, a conservation agreement
was eventually reached for the entire
Antarctic continent which, among other
things, prohibits the mining of raw
materials and created the very first World
Park – all activities on the continent are
now exclusively for the benefit of science
and peace. The purpose of our Antarctic
station was fulfilled, therefore our World
Park Base was completely dismantled
and all material carefully removed from
Antarctica
1 February 1989

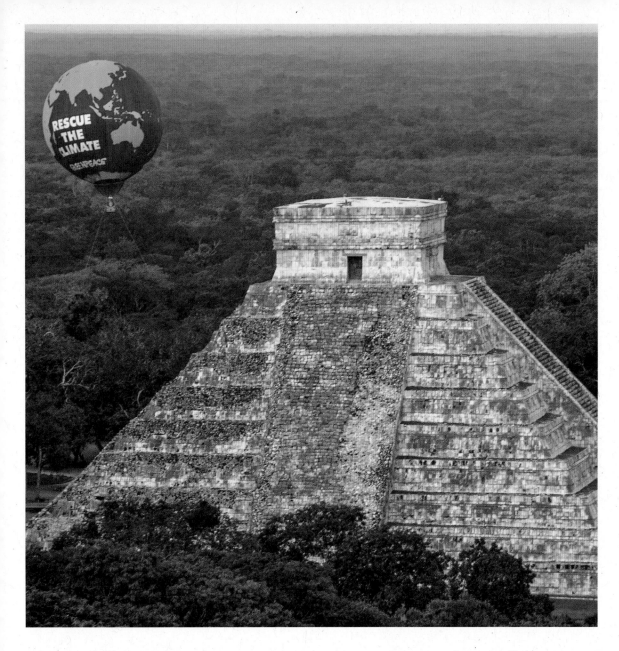

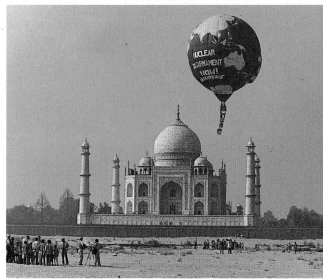

Greenpeace above the Taj Mahal
Above the world heritage site of the Taj Mahal in India, our TRINITY crew protests against planned nuclear bomb testing in India, for more consistent and faster disarmament, and for peace
12 June 1998

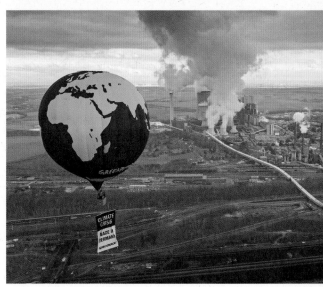

Greenpeace balloon TRINITY
In a climate protection action, our balloon TRINITY soars above one of the old Maya temple in Mexico, location of the 16th Climate Protection Conference. After the historic disappointment of the previous year's summit in Copenhagen, this provided the opportunity to finally set the right course for the protection of the climate and future generations – but once again, nothing but declarations of intent were to come out of it
28 November 2010

Germany – the worst climate polluter in Europe
Of the ten largest emitters of carbon dioxide in Europe, eight are coal-fired power plants, and seven of them are in Germany, such as the brown coal-fired Niederaussem power plant near Cologne, the third largest emitter in Europe. Even though the German government under Angela Merkel likes to portray itself as a climate saviour, the situation is actually the embarrassing and completely unacceptable opposite, because it could do so much yet does so little
12 December 2018

0 balloons over Hamburg

th this spectacular flight of
0 balloons, we called on the German
vernment to stop boycotting
mate protection; in this case, above
e motorway near Hamburg, we
mpaigned for much greater energy
iciency and a »speed limit that is
tter for the climate« of 120 km/h on
torways. Mike Howard is only one
three pilots worldwide who fly
ese cluster balloons. The balloons
e reused after the flight

August 2007

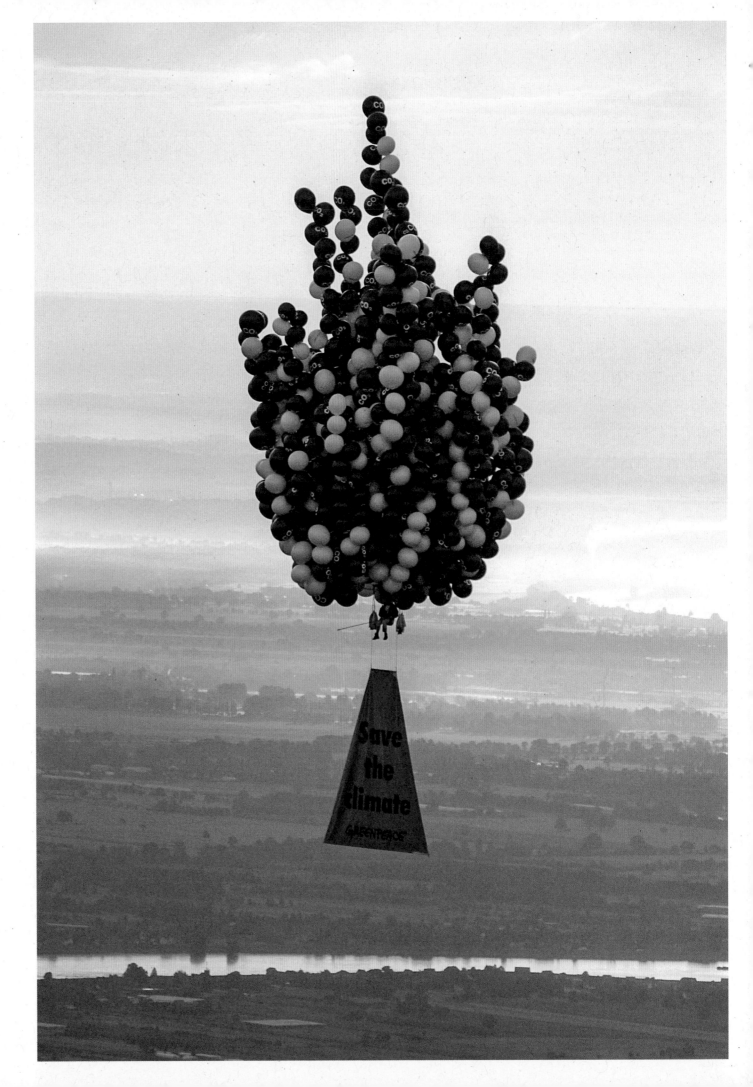

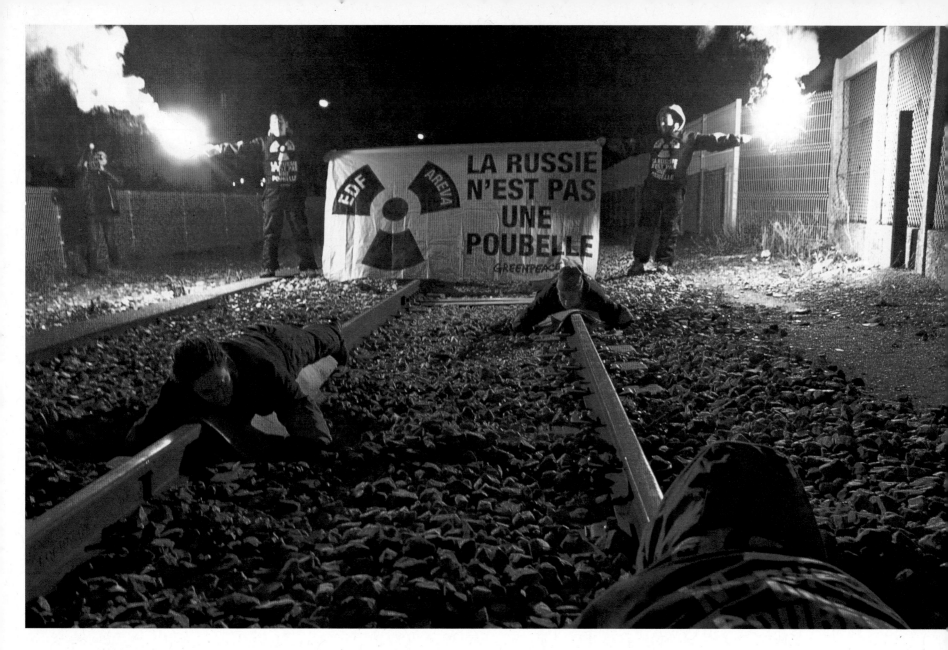

Simply disposing of nuclear waste in Russia

Western states and nuclear companies are still trying to get rid of the dangerous nuclear waste as easily and cheaply as possible, and are now asking Russia to simply store the waste in their country in exchange for hefty payments. But Russia is not a nuclear waste dump, and this is what these actions are protesting in Cherbourg, France, and in Belgian waters on the Russian transport ship KAPITAN KUROPTEV, which transports radioactive waste from France to Russia. A Greenpeace investigation in 2021 found that exports of nuclear waste to Russia have restarted after an eleven-year hiatus
**8 April 2010 and
24 January 2010**

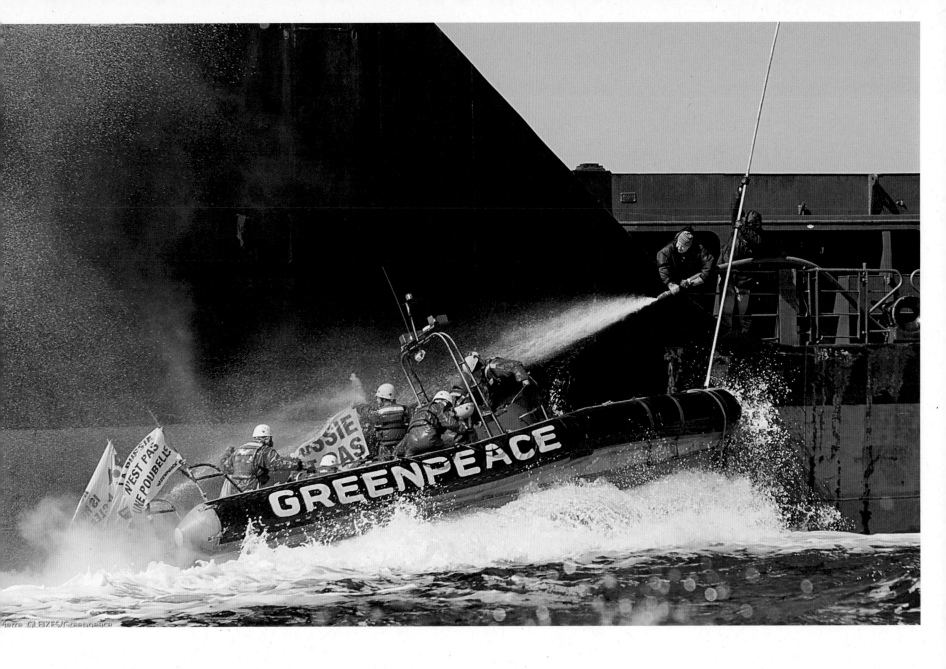

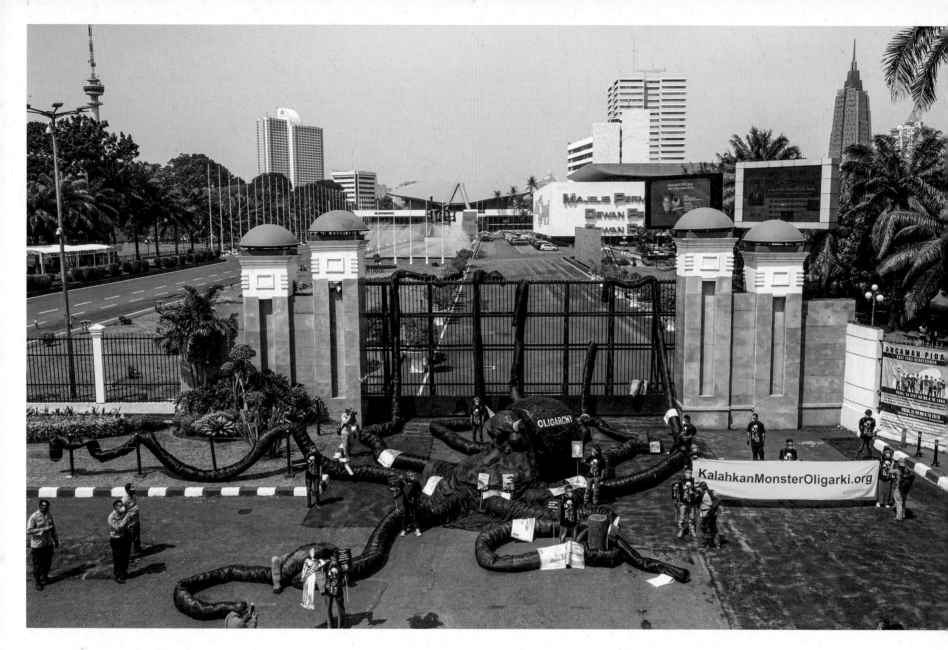

Oligarchy Monster in Jakarta
A giant »oligarchy monster« installed
at the parliament building in Jakarta.
The octopus shaped monster is seen
latching onto numerous dimensions
and aspects of citizens' lives: energy,
agriculture, freedom of speech, the lives
of indigenous peoples, as well as the
weakening of the Corruption Eradication
Commission (KPK). The activity, part of a
peaceful protest by Greenpeace, marked
the first year since the problematic
Omnibus Law on Job Creation
(UU Cipta Kerja) was ratified
5 Oct 2021

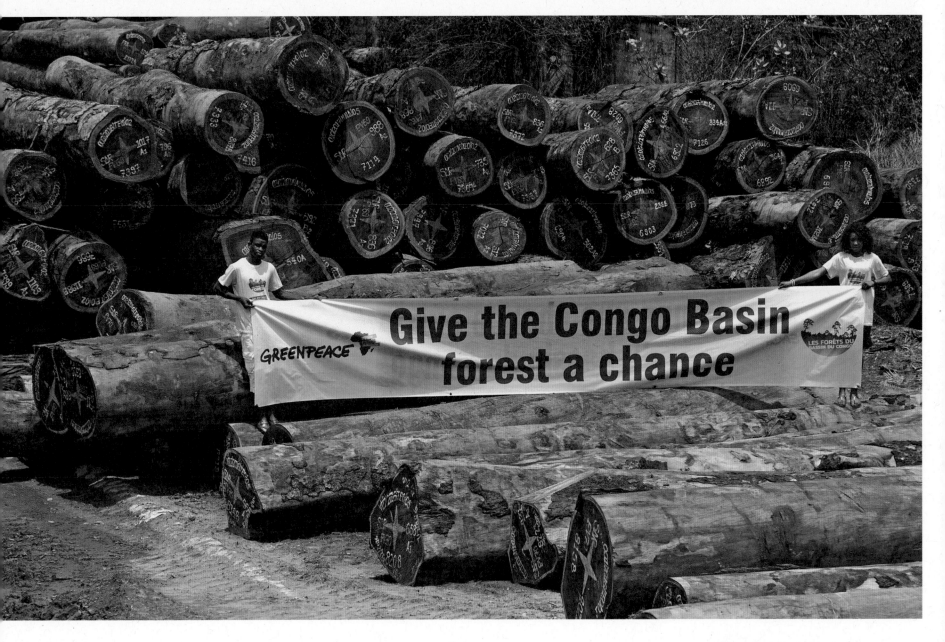

Africa's forests
Africa's rainforests are disappearing at a rapid pace – unsustainable forest management, illegal trade, corruption, and the influence and unscrupulous greed of many Western and Chinese corporations are leaving no chance for the forests and those who actually live from and with them
1 November 2017

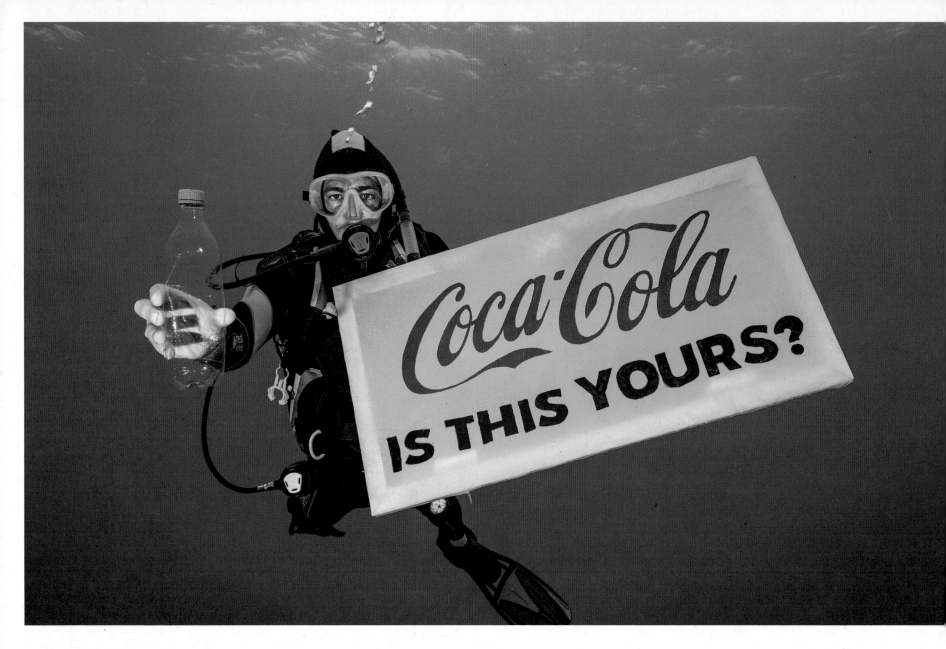

Coca Cola's toxic legacy
A Greenpeace diver from ship ARCTIC
SUNRISE holds up a bottle made by Coca
Cola. Our ship has sailed the giant plastic
vortex in the North Pacific, which now
had an area of 1.6 million square kilo-
metres, 40 times the size of Switzer-
land. It is home to an unimaginable
80,000 tonnes of plastic waste, which
will remain in the environment for up to
600 years, threatening nature, wildlife
and humans
2 October 2018

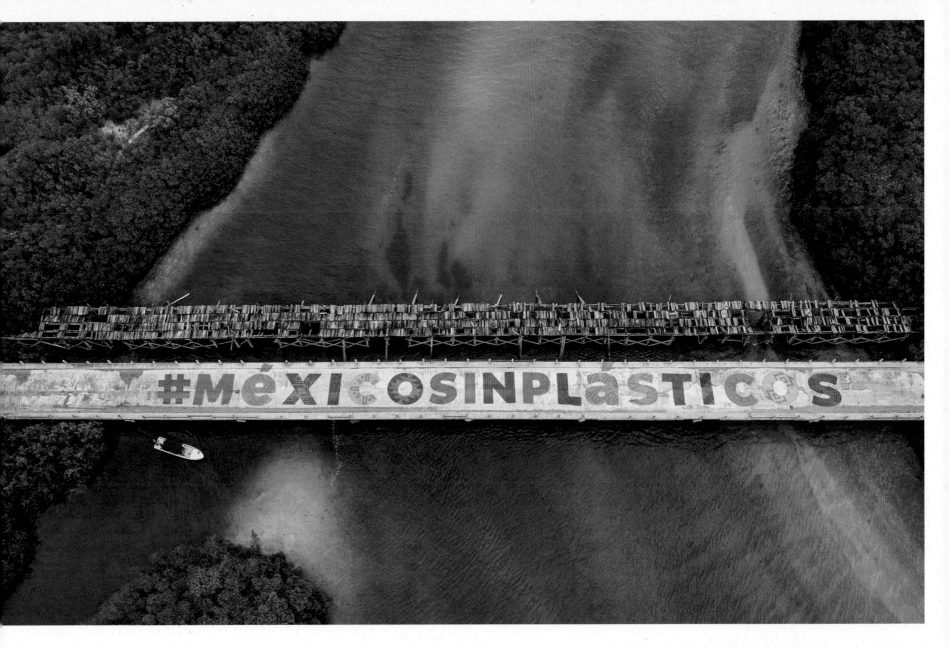

Mexico suffers from plastic waste
Even in areas under protection, plastic pollution has become a major problem. Plastic threatens natural habitats and rare animals, such as here in the Sian Ka'an nature reserve in the Riviera Maya district. Greenpeace calls for a »Mexico without plastic«
21 November 2019

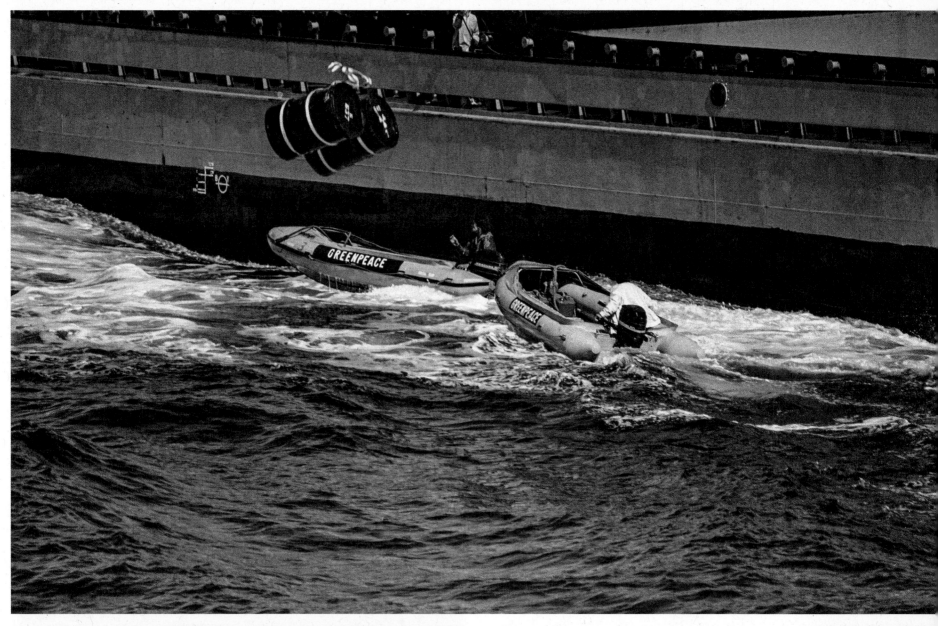

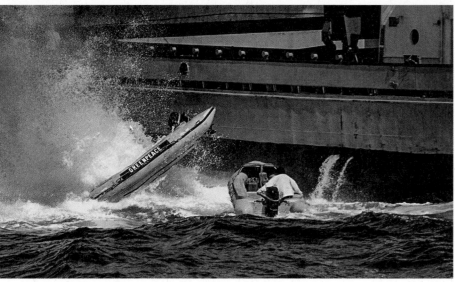

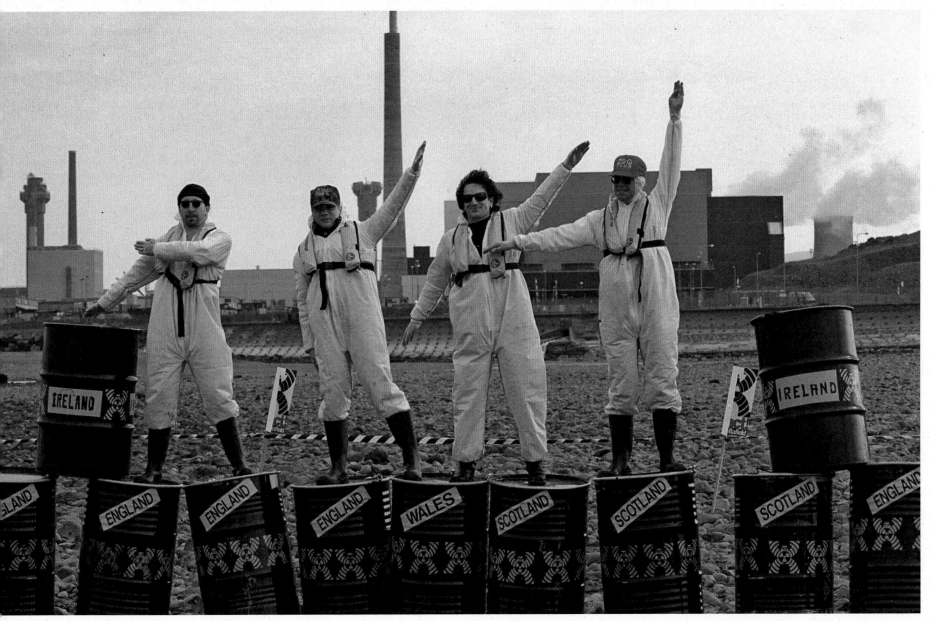

Simply dumping nuclear waste in the sea

The idea was to get rid of the controversial and highly dangerous waste in an easy (and, of course, particularly cost-effective) way – by simply dumping it in the sea, hidden from the eyes of the public. In doing so, the crews transporting nuclear waste don't even shy away from endangering and injuring the inflatable crews
6 September 1982

U2 vs Sellafield

The Irish rock band supports Greenpeace in its protest against the proposed Thorp (Thermal Oxide Reprocessing Plant) in Sellafield, U.K. The Sellafield nuclear complex (formerly Windscale) has been a dangerous nuclear site since the 1950s due to frequent nuclear incidents
20 June 1992

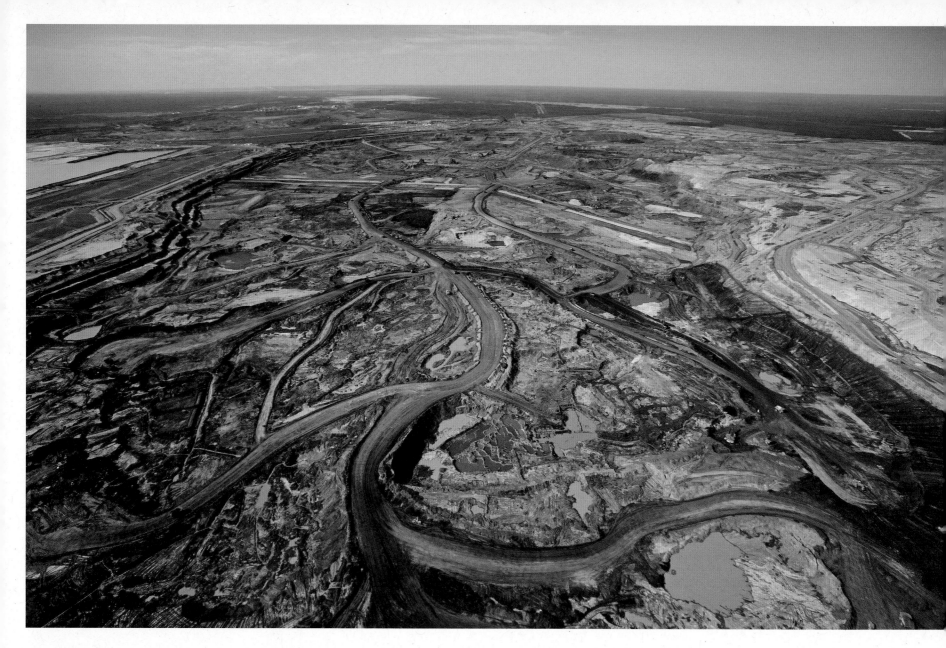

Drama in Canada's north

It sounds so innocuous – oil shale and
oil sands – but it's arguably the dirtiest
method of extracting oil. In Canada, a
little-known environmental disaster of
a huge magnitude has been taking place
for around 20 years. The layers cont-
aining only a little oil, which are found
under the forests and bogs in the north
of the province of Alberta, are being
extracted with a huge consumption of
energy and great destruction of nature
by simply pushing the forests and bogs
together and dissolving the little oil from
the layers of earth with about five times
the energy expenditure – while using an
unbelievable quantity of chemicals that
make water toxic
20 July 2009

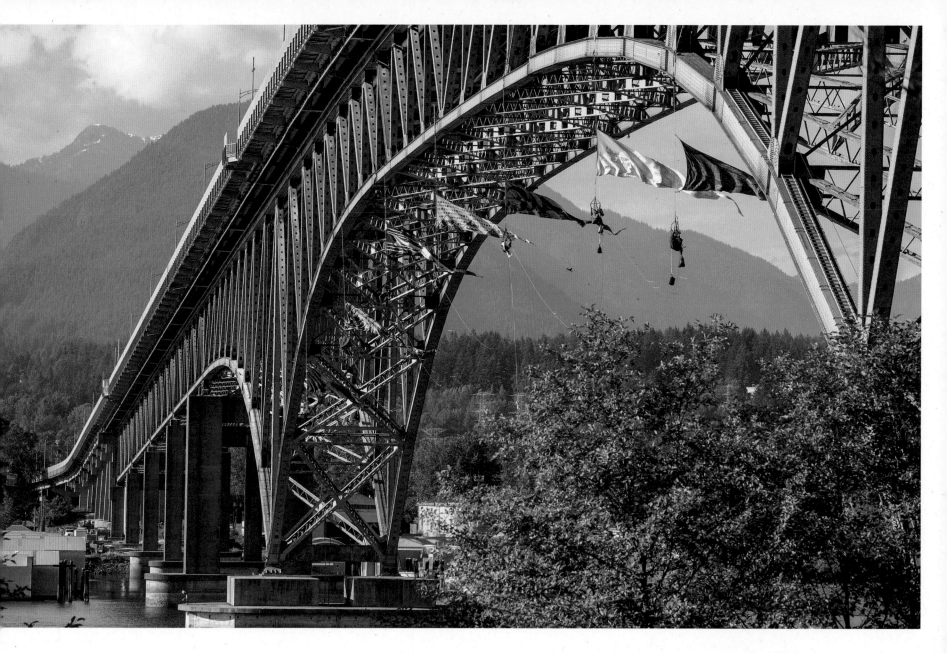

Stop the tankers
Greenpeace has denounced the
environmental disaster in northern
Canada over and over again for many
years now. Climbers block the Iron
Workers Memorial Bridge in Vancouver,
under which tankers must pass for the
oil from mining the oil sands. The
blockade is part of a growing campaign
against a proposed pipeline project and
the expansion of tanker traffic to further
fuel the extraction of oil sand
3 July 2018

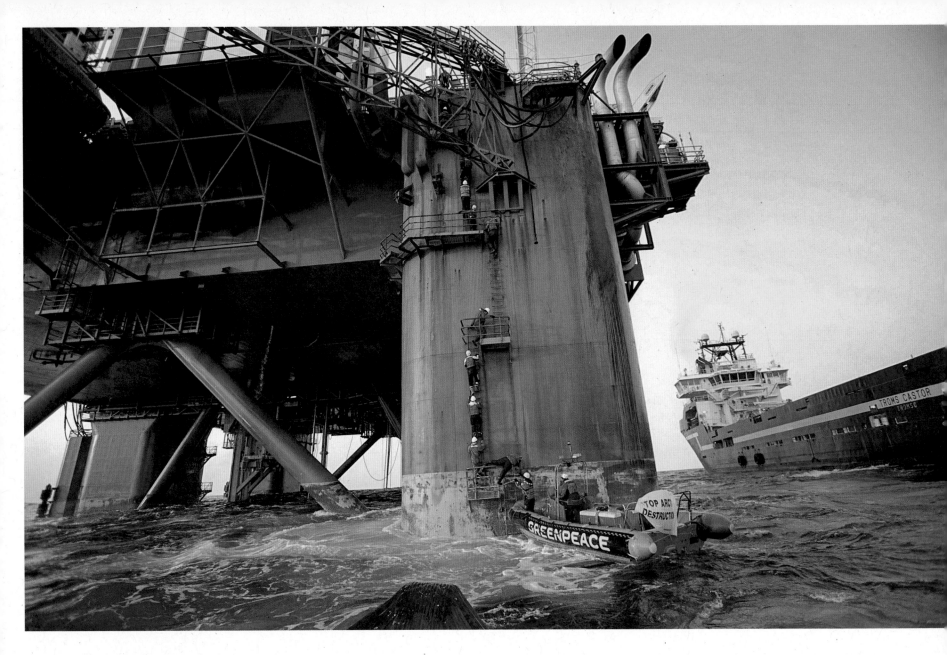

Into the Arctic without a plan
Activists climb onto the huge »Leiv
Eiriksson« oil platform 180 kilometres off
the Greenland coast – from five inflatable
boats launched from Greenpeace ship
ESPERANZA. The team climbs ladders to
the accommodation deck to speak to the
person in charge of the platform. We de-
mand a copy of the rig's oil spill manage-
ment plan, as its operator, Edinburgh-ba-
sed Cairn Energy, has refused to publish
it – which is against all industry norms,
and despite the unique danger to nature
and the environment that drilling for
oil represents in pristine Arctic waters,
where it is almost impossible to clean up
contamination from oil spills
4 June 2011

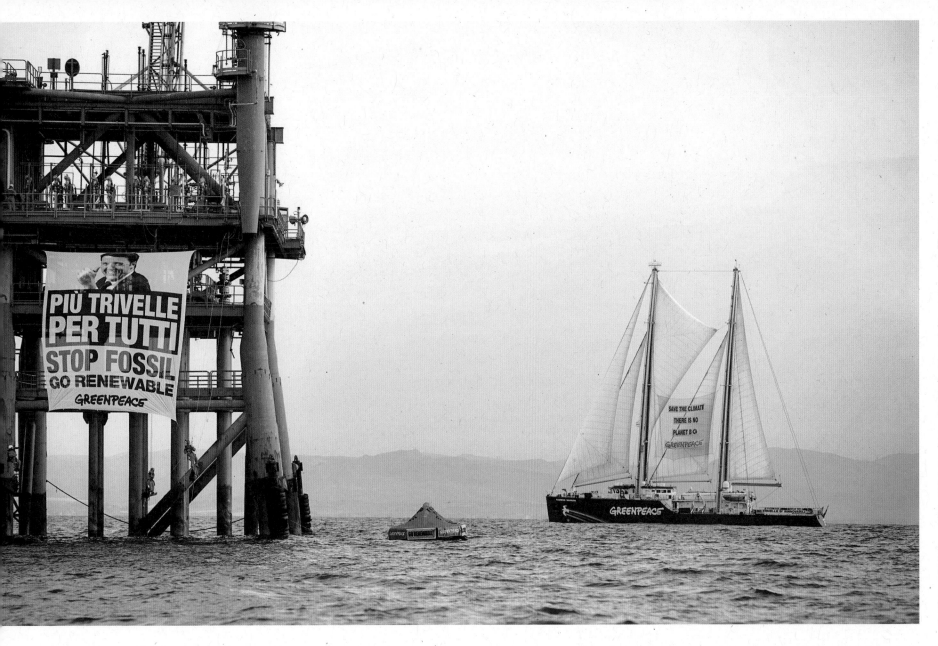

More dirty oil, please – for all of us
Action on the »Prezioso« oil rig in Italy:
activists from the RAINBOW WARRIOR
occupy the offshore platform of Italian
oil company ENI off the Sicilian coast.
We want to confront Italian Prime
Minister Matteo Renzi with the satirical
message »Piú trivelle per tutti«
(»Even more oil production in the seas
for all of us«) and the demand »Stop
Fossil, Go Renewable«. Greenpeace is
protesting against an Italian government
decree that incentivises offshore drilling,
and is also calling on Renzi to finally
support urgently needed, and more
ambitious, renewable energy targets
within the EU at a meeting
14 October 2014

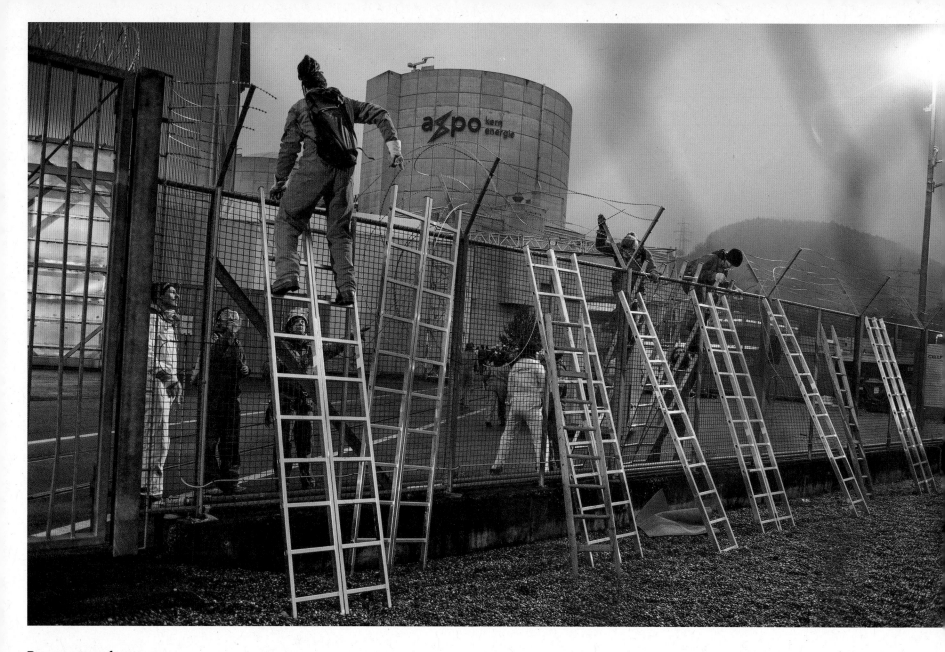

Dangerous nuclear power plant in Switzerland

Around 100 Greenpeace activists from six different countries climb onto the Beznau nuclear power plant site. We are calling for the immediate closure of the 45-year-old power plant, because it has massive and unacceptable safety deficiencies. The plant's location means that an accident could have consequences for the entire European continent
5 March 2014

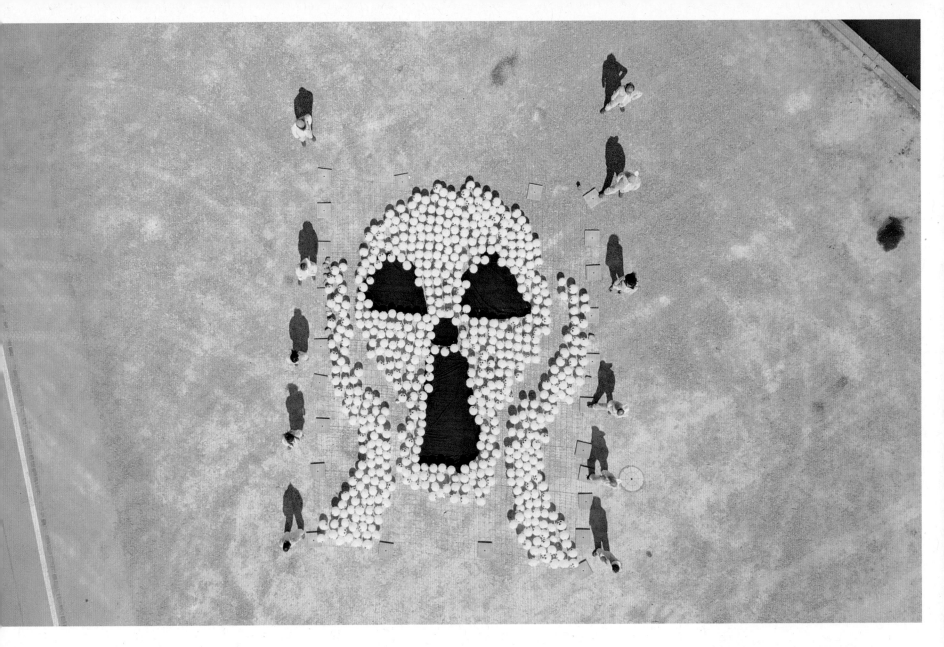

The Scream against dangerous nuclear power

Edvard Munch's famous painting »The Scream« is used to draw attention to the dramatic consequences of the planned amendment to the Swiss Nuclear Power Plant Energy Ordinance. The proposed increase to the limit value, an important safety threshold, in the event of an earthquake was to be increased one hundredfold – from 1 to 100 millisieverts (mSv). This would signify an extremely dangerous dose that ignores all medical recommendations and which would have very serious health consequences
9 April 2018

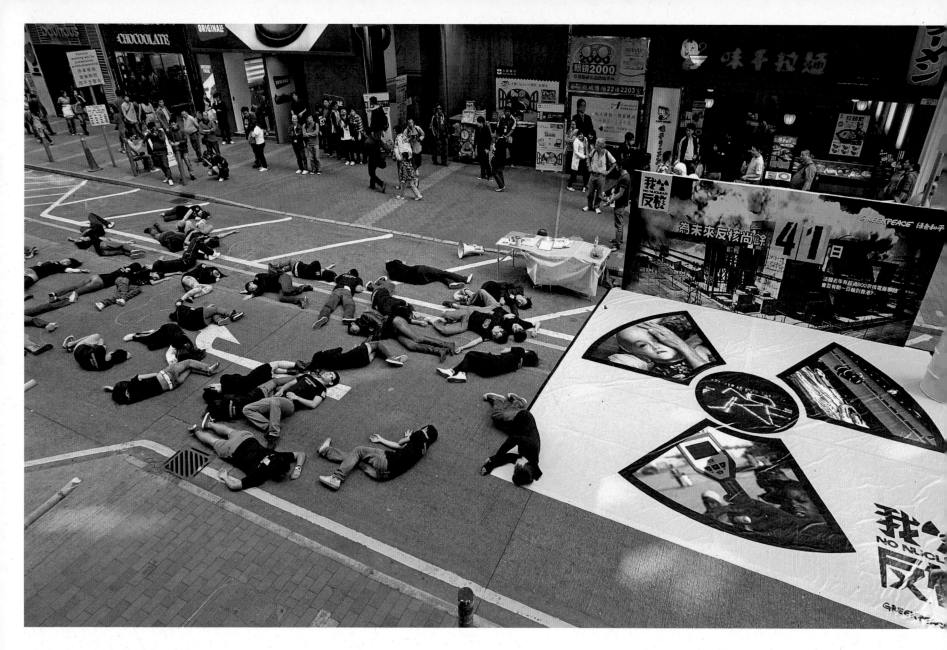

Sudden death in Hong Kong
Greenpeace activists stage a »sudden death« on the streets of Mong Kok, Kowloon, in Hong Kong. The protesters wanted to draw attention to the Hong Kong government's dangerous plans to increase the city's supply of electricity from nuclear sources even further, despite devastating accidents like the one at the Chernobyl nuclear power plant in 1986 and the fact that nuclear waste will continue to pose a danger for hundreds of thousands of years
31 October 2010

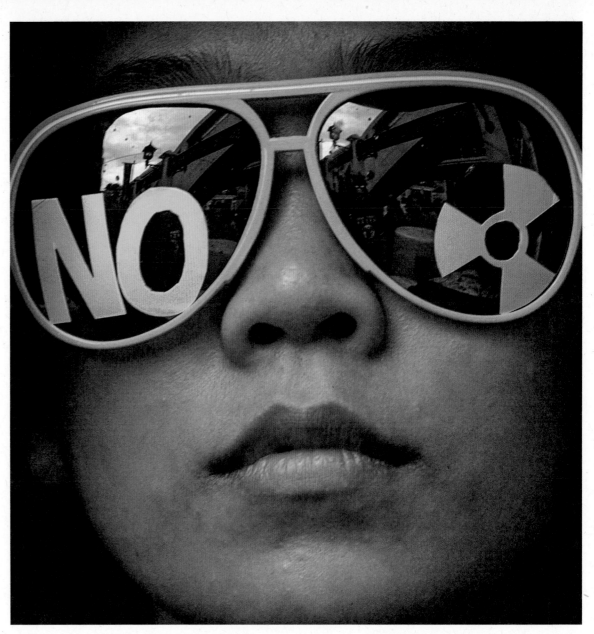

Nuclear power remains an unsafe, incalculable threat

In many countries around the world, the fight to phase out nuclear power remains a necessary one, despite the many deadly accidents, the ultimately unsafe technology, and the irresponsible accumulation of nuclear waste with a half-life of hundreds of thousands of years that will affect future generations. Greenpeace will therefore continue to denounce nuclear energy as the wrong way to go. Energy generated using renewables is the only justifiable, viable and clean solution for our times
20 November 2008

Legal environmental poisoning
On a five-week tour of the U.K.,
Greenpeace calls for an end to the
legal poisoning of the environment due
to authorised discharges of chemical
effluent into the natural environment.
A drainage pipe is blocked through
which, as is permitted by law, poisonous
chemicals including highly toxic mercury
and organic chlorine compounds are
discharged into the River Wyre at
Fleetwood in north-west England
16 September 1992

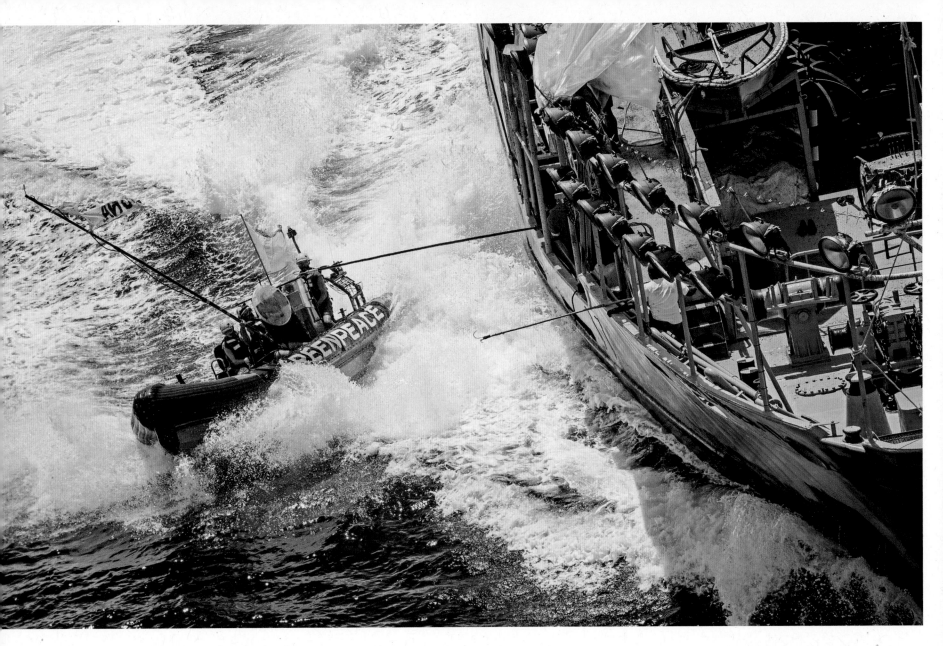

Overfishing and human rights violations by the fishing industry
Commercial fishing vessels such as the one pictured are active on oceans around the world. But there is a darker side to the fishing industry with some operators accused of illegal and destructive fishing practices, as well as serious human rights abuses on their vessels
25 May 2016

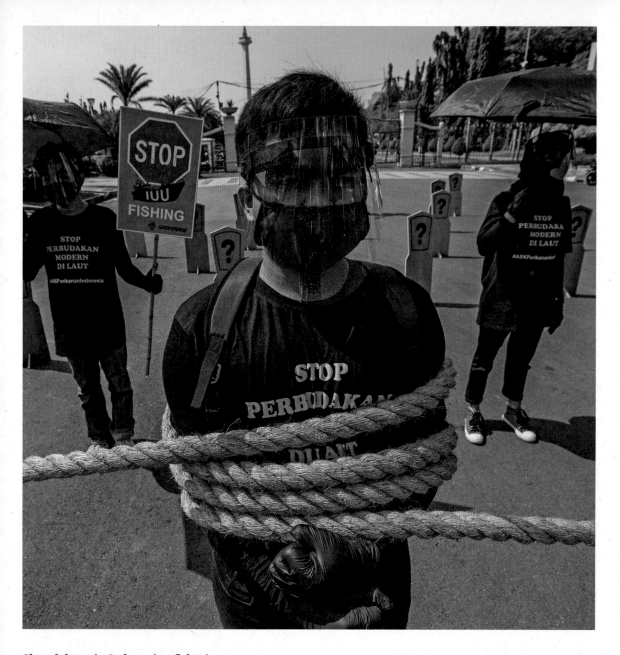

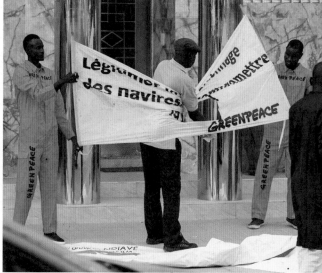

Slave labour in Indonesian fisheries
Research by Greenpeace, in cooperation with the Indonesian Migrant Workers Union, reveals massive human rights violations and forced labour in Indonesian fisheries which is nothing other than outright slave labour. Cases of workers dying on the ships and their bodies simply being thrown overboard have also come to light. Greenpeace is turning to the Indonesian President with a report and a call to finally take action and put an end to these practices
27 August 2020

Peaceful protest to be suppressed
An employee of the Agency for Maritime Affairs in Senegal is trying to quash Greenpeace's peaceful protest. We are demanding that the recalculation of the quotas for industrial fishing fleets proceed more quickly. The recalculation process has already dragged on for more than two years, and not only are the seas still being overfished, but the livelihoods of small-scale fishermen and fishing communities also continue to be threatened
9 April 2018

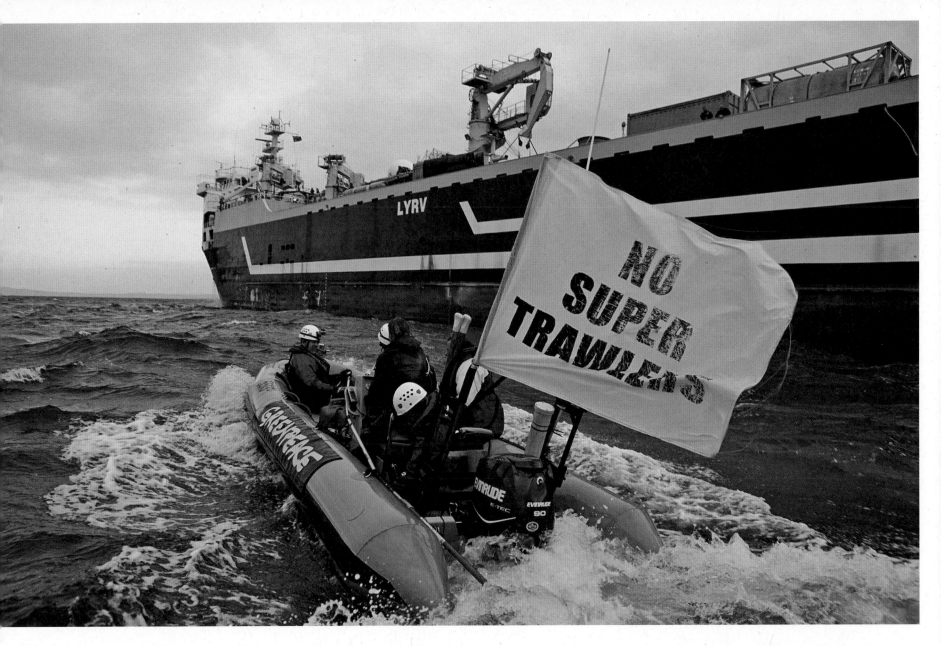

Retiring the monster ships

Monster factory ships known as »super trawlers« overfish the seas with gigantic 600-metre-long nets. Greenpeace Australia activists fought to prevent the FV MARGIRIS, which belongs to a Dutch corporation and is the second largest fishing vessel on earth, from accessing Port Lincoln in South Australia. The campaign was successful and the ship was prevented from entering Australian waters, and legislation was introduced limiting the access of super trawlers
30 August 2013

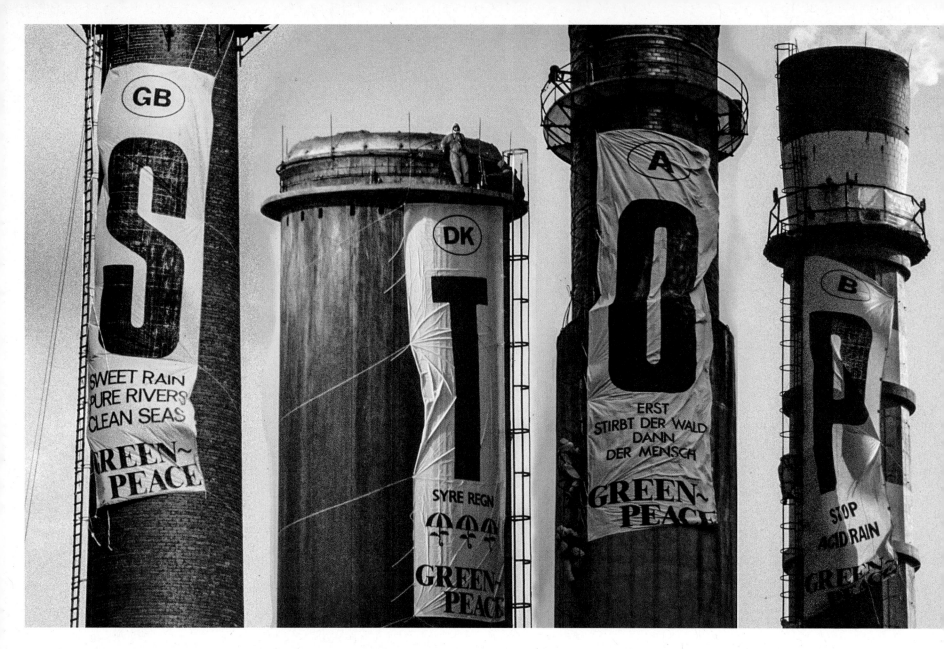

Acid rain photomontage

Composite image of four actions to protest acid rain, which were held on the same day. During International Acid Rain Week, Greenpeace activists from Austria, Belgium, Czechoslovakia, Denmark, France, Germany, the Netherlands and the U.K. occupied the chimneys of oil refineries and coal-fired power plants to draw attention to the major problem of acid rain, which is caused by the sulphur dioxide emissions produced when burning coal, oil and gas.

The banners hung by Greenpeace form the word »STOP«. The sulphur content permitted in fuels was then reduced significantly by legislation in many countries, which also required filter systems to be installed in combustion plants. Acid rain could be curbed to some extent, in contrast to the climate-damaging effects caused by the continued burning of fossil fuels. Therefore, today's demand to »stop burning coal, oil and gas as quickly as possible« is the only logical consequence **2 April 1984**

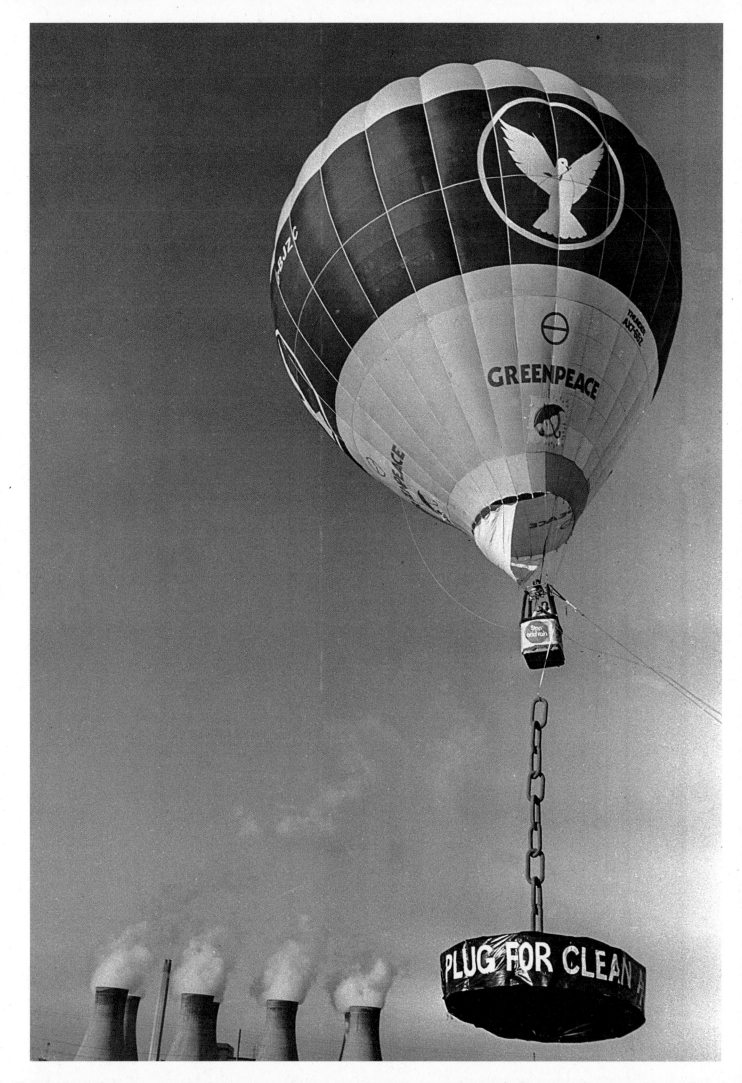

...ugging the burning of coal
...e Greenpeace balloon with a giant
...g flies over the Eggborough coal-fired
...wer station in Yorkshire (U.K.), with an
...peal an end to the pollution caused by
...phur emissions, among other things,
...m burning coal, which damages the
...vironment, forests, and human, animal
...d plant life
...eptember 1987

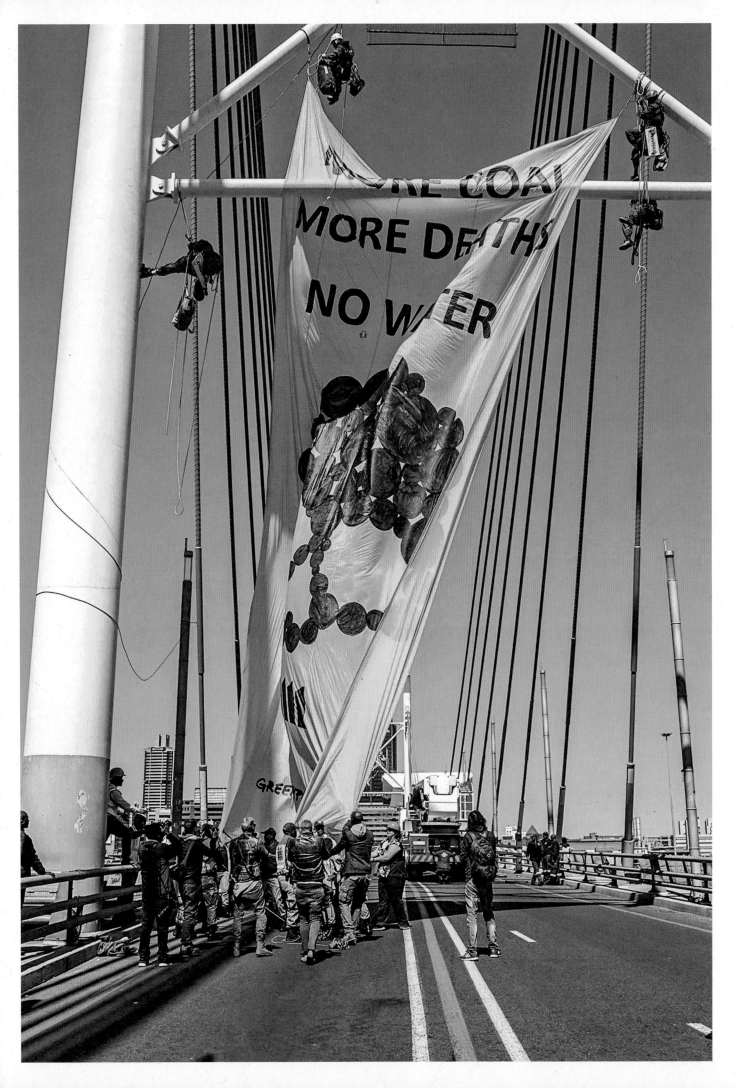

Nelson Mandela also loved the environment

On the famous Nelson Mandela Bridge South Africa, Greenpeace joins the Life After Coal campaign to protest against the South African government's plans t build new coal-fired power plants.
In his inauguration speech on May 10, 1994, Mandela shared his love of nature and said »each time one of us touches t soil of this land, we feel a sense of perso nal renewal. ... We are moved by a sens of joy and exhilaration when the grass turns green and the flowers bloom«
28 August 2018

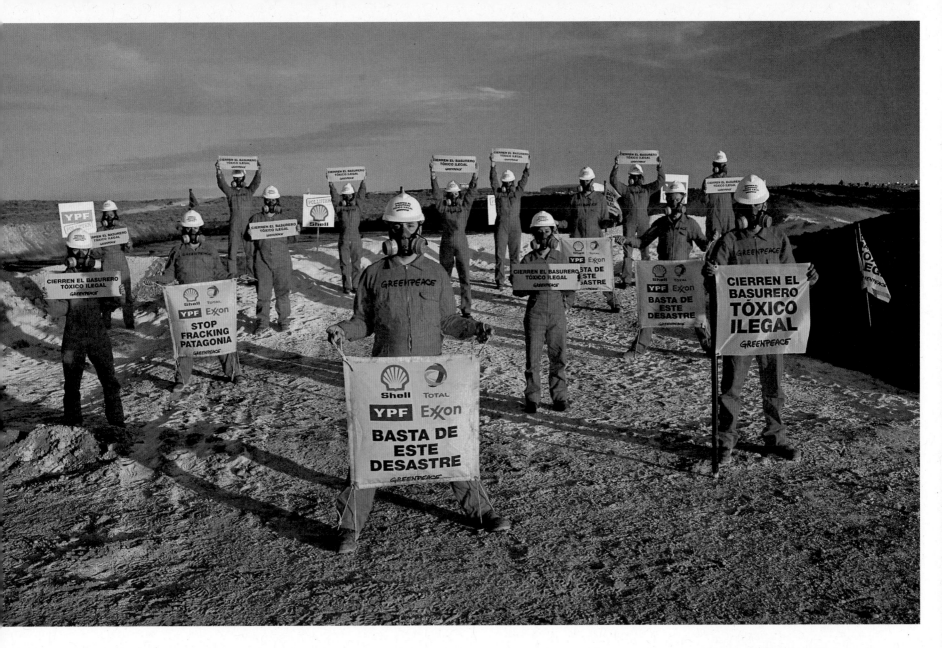

**Total and Shell's toxic legacy
in Patagonia**
Fracking is an extremely destructive
way of extracting gas resources and a
particularly serious environmental issue
in Patagonia, one of South America's
most extraordinary natural areas. Oil
companies Shell and Total proposed
to leave the inconceivable amounts of
heavily contaminated waste water they
produced in the environment
27 February 2019

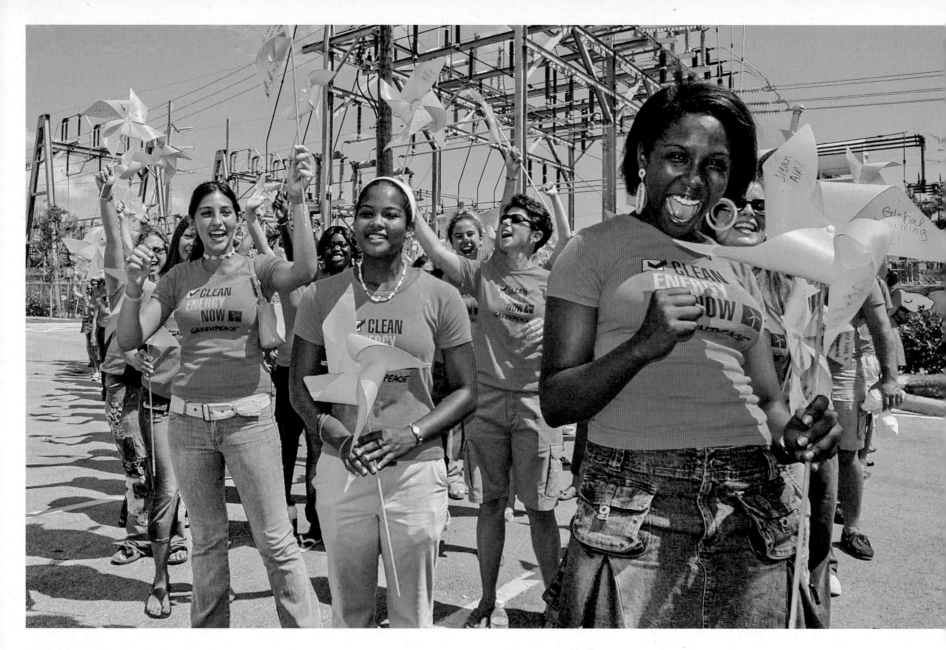

Students demand clean energy
Students at the University of Miami in Florida protest during a debate between President George W Bush and candidate John Kerry. They are calling for investment in renewable energies such as solar and wind, and a move away from dirty alternatives such as coal and oil
29 September 2004

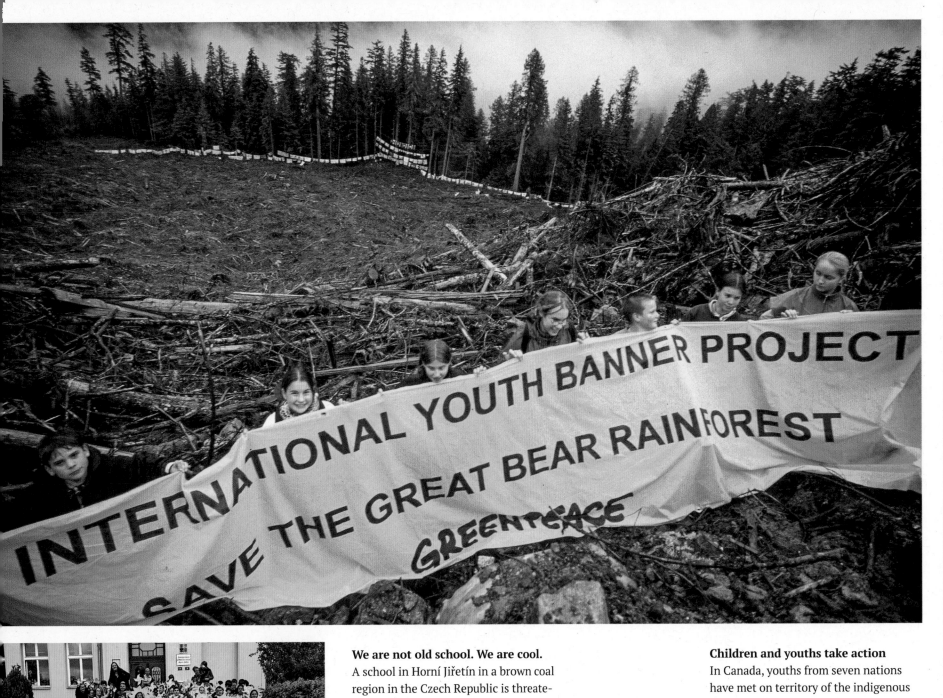

We are not old school. We are cool.
A school in Horní Jiřetín in a brown coal region in the Czech Republic is threatened by destruction from the encroaching open-pit brown coal mine. The school is demonstrating that it doesn't need coal, installing solar panels with the help of Greenpeace, gaining its autonomy from the coal-fired power supply
24 May 2017

Children and youths take action
In Canada, youths from seven nations have met on territory of the indigenous Nuxalk Nation, and – supported by hundreds of other young people from all over the world who sent them handmade banners – are campaigning for the preservation of the Great Bear Rainforest and the land claimed by the Nuxalk Nation, which continues to be destroyed by timber companies with the approval of the government
24 August 1998

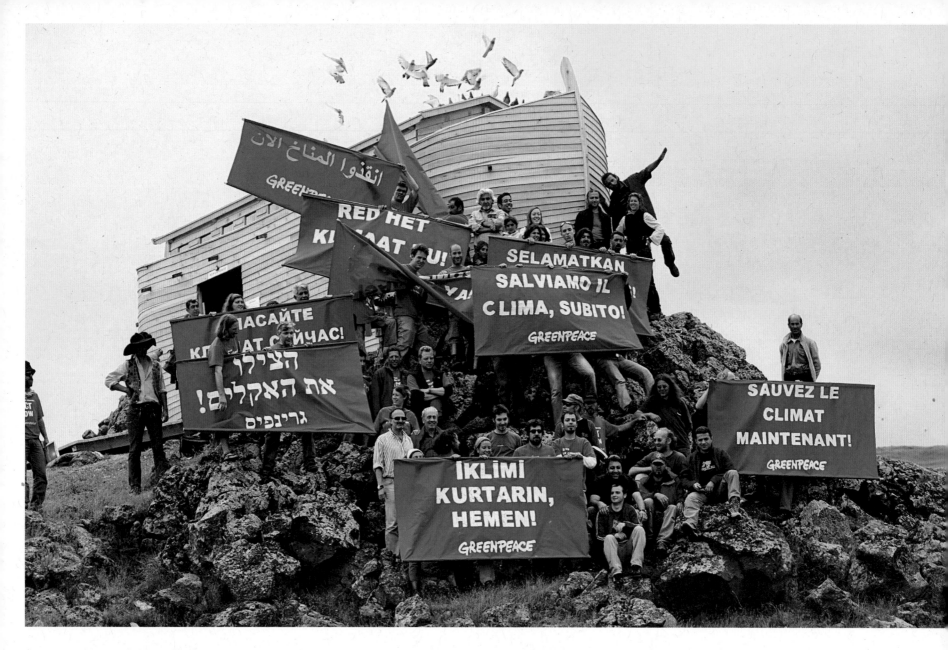

Climate protection with Noah's Ark
With a handmade wooden sculpture
of Noah's Ark located 2,500 metres up
the 5,137-metre-high Mount Ararat in
Turkey, activists call on the governments
of all nations to finally take climate
protection seriously
31 May 2007

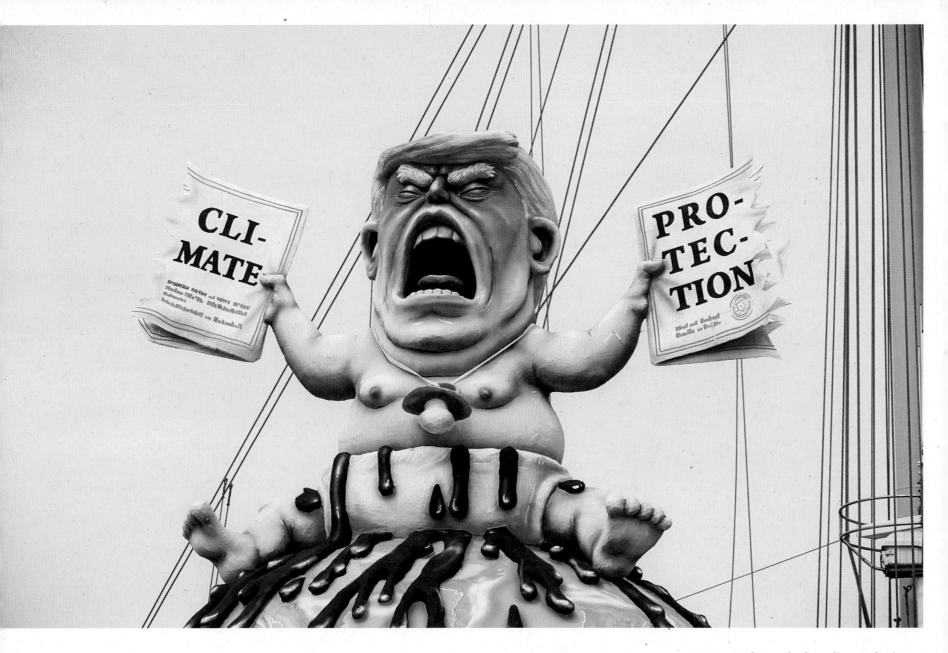

Trump last – the last climate denier
In the run-up to the 2017 G20 summit,
US President Trump still vehemently
denies the existence of man-made
climate change – contrary to all scientific
data, findings and claims – and thereby
torpedoes the Paris climate agreement
7 July 2017

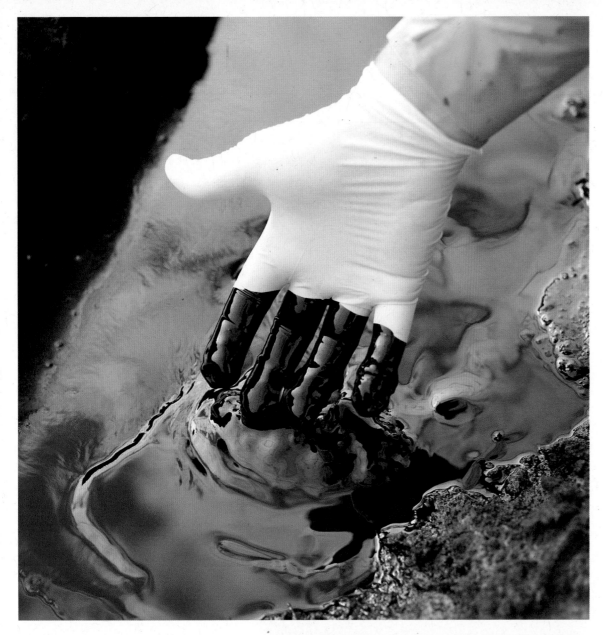

Russian oil spill disasters
In Russia's Komi Republic, daily oil spills
are a reality. The constant leaks from old
and broken pipelines are contaminating
entire landscapes with oil
12 September 2011

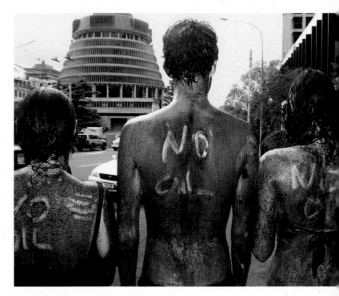

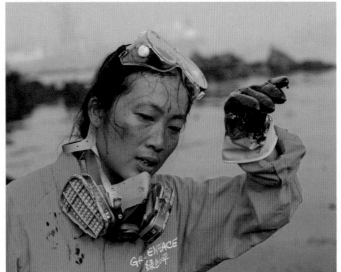

Chinese oil spill disaster
Greenpeace activists help clean up after
the Dalian oil spill caused by a pipeline
explosion
23 July 2010

The age of dirty oil must end
In New Zealand, oil-smeared activists
hold a protest outside the seat of govern-
ment in Wellington against then Energy
and Resources Minister Gerry Brownlee's
reckless plans to continue digging and
drilling for dirty fossil fuels, and therefo-
re completely ignoring its impact on the
global climate
7 October 2010

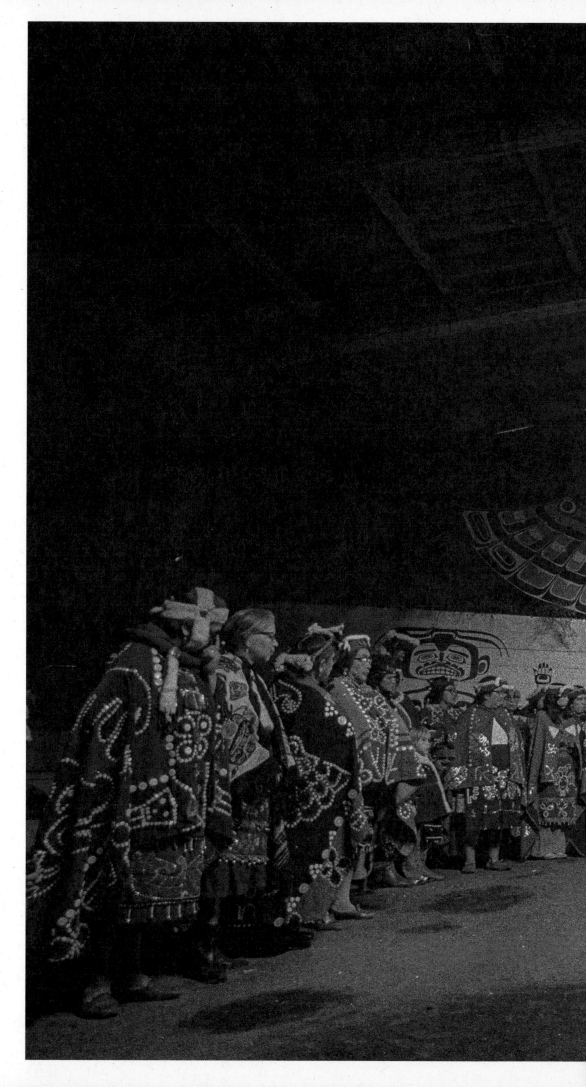

A real honour
On the first Greenpeace Action tour, the
crew stopped at the Indigenous commu-
nity of 'Yalis (Alert Bay) on Cormorant
Island, off the west coast of Canada. 'Yalis
is located in the traditional territory of
the 'Namgis First Nation. Several Kwak-
waka'wakw Nations blessed the Greenpe-
ace activists for their upcoming trip.
On the return trip to Vancouver – after
the US Coast Guard prevented the Green-
peace crew from reaching the Amchitka
nuclear test site – the crew of the PHYLLIS
CORMACK stopped in 'Yalis once again,
where a ceremony was held at the Big
House in their honour.
They received the recognition of the
'Namgis and other Kwakwaka'wakw
Nations for their courage in opposing the
United States military
26 October 1971

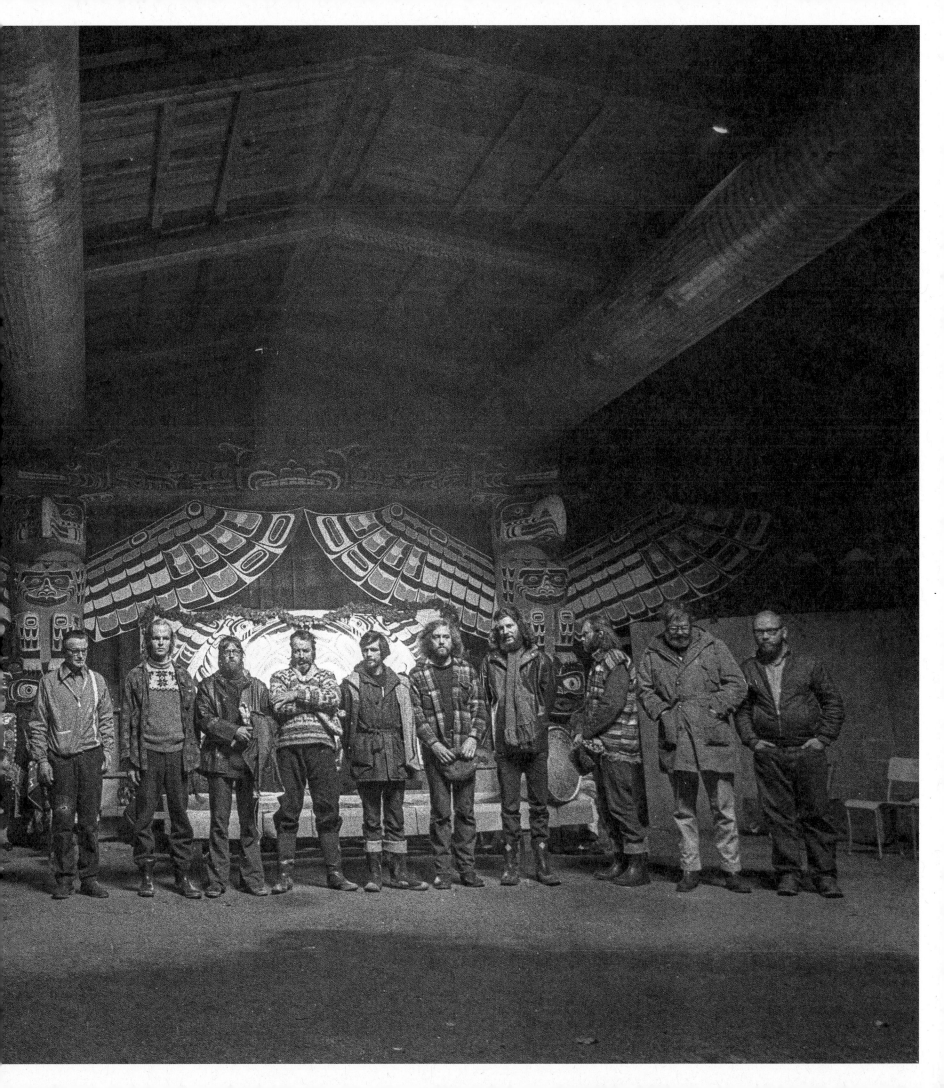

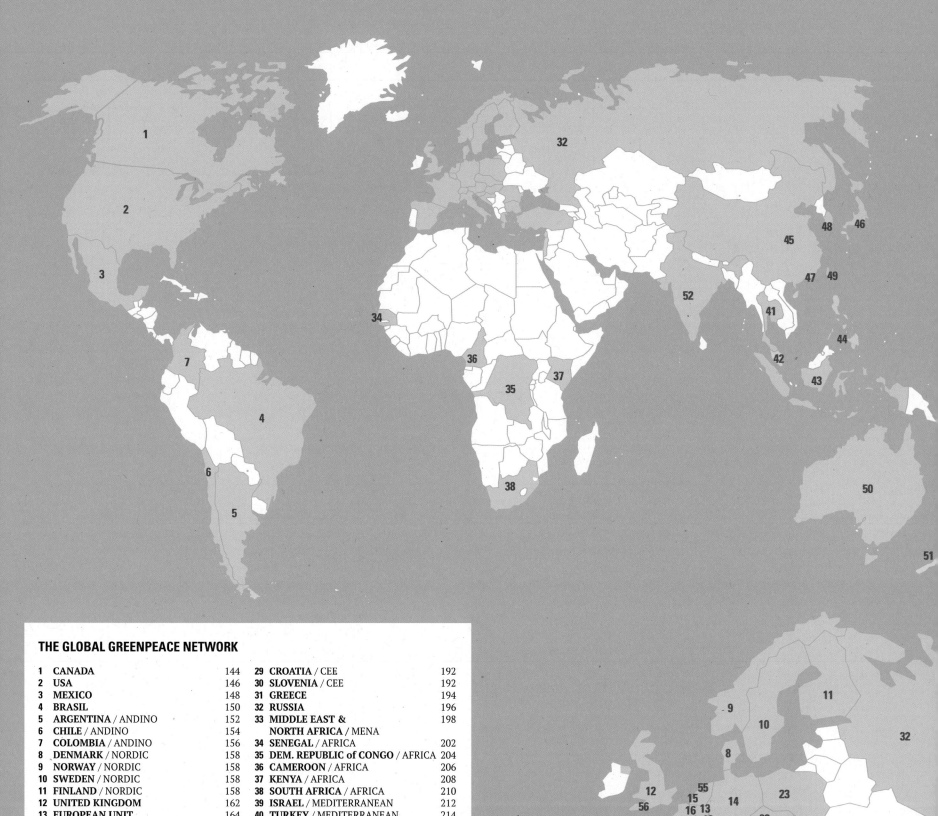

THE GLOBAL GREENPEACE NETWORK

ACT NATIONALLY TO MAKE INTERNATIONAL WAVES

ONE OF THE BASIC PRINCIPLES OF GREENPEACE IS TO LOOK AT AND ASSESS THE TASKS, THE MISSION AND THE CHALLENGES FROM AN INTERNATIONAL PERSPECTIVE, TO ACT INTERNATIONALLY AND TO STAND TOGETHER INTERNATIONALLY – AND SIMPLY BE WHAT WE ARE: A WORLD COMMUNITY, AROUND THE GLOBE.

THIS IS ALL MOTIVATED BY A SIMPLE REALISATION: ENVIRONMENTAL PROTECTION, WHETHER ON LAND, AIR OR SEA, SHOULD AND MUST KNOW NO POLITICAL OR NATIONAL BOUNDARIES, JUST LIKE THE PROTECTION OF LIVELIHOODS AND PEACE ON THIS PLANET EARTH. THIS IS WHY GREENPEACE HAS, OVER THE COURSE OF ITS OWN HISTORY, CONSISTENTLY AND VERY QUICKLY GROWN FROM WHAT WAS ONCE A SMALL GROUP OF NORTH AMERICANS INTO A LARGE INTERNATIONAL NETWORK THAT IS PRESENT ON ALL CONTINENTS AND ALSO TAKES ACTION ON ALL CONTINENTS.

AT THE SAME TIME, THE NATIONAL AND CULTURAL DIFFERENCES ARE ALSO A CONSTANT CHALLENGE, AND ARE BY NO MEANS ALWAYS WITHOUT TENSION. HOWEVER, THE REALISATION THAT CULTURAL DIVERSITY IS AN ENRICHMENT, AND THAT INTERNATIONAL ACTION IS A RECIPE FOR SUCCESS, HAS ALWAYS PREVAILED. IT IS ALSO A SIGNIFICANT PART OF OUR IDENTITY AND HAS ACTU-ALLY MADE OUR SPECIAL, TRUE STRENGTH POSSIBLE IN THE FIRST PLACE. THIS IS EQUALLY TRUE OF THE WORK IN SO MANY INTERNATIONAL FORUMS, PROCESSES AND AGREEMENTS, WHETHER FOR THE PROTECTION OF THE ARCTIC AND ANTARCTIC, FOR THE PROTECTION OF WHALES, THE HIGH SEAS, AND EVEN THE CLIMATE.

FROM OUR NUCLEUS IN VANCOUVER, CANADA, WE HAVE GROWN INTO A GLOBAL MOVEMENT WITH AN INTERNATIONAL NETWORK OPERATING ON EVERY CONTINENT AND ARE NOW ACTIVE IN WELL OVER 50 COUNTRIES. THIS MEANS WE ARE NO LONGER ALONE IN FACING WHAT ARE OFTEN NATIONAL CHALLENGES – QUITE THE CONTRARY, BECAUSE DUE TO THEIR INTERNATIONAL IMPLICATIONS AND DANGERS, THESE CHALLENGES ARE ALSO OPPORTUNITIES.

THE FOLLOWING CHAPTER PRESENTS THE PERSPECTIVES – THE VIEWS – BUT ALSO THE STORIES AND CHALLENGES FROM ALL »GREENPEACE COUNTRIES«: EACH COUNTRY ON JUST ONE PAGE (WE CAN DO SHORT BANNER TEXTS, BUT THIS WAS AN ALMOST INSURMOUNTABLE HURDLE FOR SOME OF OUR AUTHORS) PLUS A NUMBER OF EXCITING IMAGES. ALL THESE REGIONAL STORIES, INSIGHTS, EXPERIENCES, PERSPECTIVES AND VIEWS TOGETHER ARE WHAT MAKE GREENPEACE SPECIAL.

Greenpeace Canada
founded 1970
Where it all began

In 1970, Greenpeace was a half-formed idea in the minds of a handful of peace and civil rights activists in Vancouver, Canada. At that time, ecology was anything other than a widespread idea; universities and high schools did not offer courses in ecology, and no ecological activist groups existed. Conservation groups protecting specific areas – like today's national parks – had been established, but no global activist movement giving a voice to Earth itself actually existed at this point in time.

In 1969, the United States announced a five-megaton thermo-nuclear bomb test on the remote Aleutian Islands. An earlier, smaller test had wiped out wildlife, and the upcoming deto-nation was set to be five times more powerful and destructive.

In Vancouver, a small group of people set out to change the course of these events. They set sail to fight against not only this bomb, but all life-negating nuclear bombs and to create an ecological movement based on the term »green peace« – one that articulated the shared concerns of the peace and ecology movements, and one that stuck in everyone's mind.

Canadians were, at the time, proud of their vast natural wil-derness, and the conservation movement worked to protect it.

In the 1990s, Greenpeace Canada began a 20-year »War in the Woods« in one of the last remaining temperate rainforests on earth. Located on Canada's central west coast, the campaign was a historic, multi-stakeholder collaboration among busi-nesses, Indigenous communities, and environmental groups. In February 2016, the stakeholders announced that an agree-ment had been reached on how the Great Bear Rainforest would be managed to preserve biodiversity, old-growth fo-rests, and an economy for Indigenous and other communities.

In 2007, Greenpeace Canada began its »Tar Sands« campaign, insisting that the world's dirtiest oil extraction could not be sanitised and rationalised by the industry. For the next decade, guided by Indigenous leadership, Greenpeace Canada supported non-violent direct action, organised media tours of the tar sands, waged an international campaign against tar sand financiers and oil companies, and opposed new pipelines.

In a 2017 Supreme Court victory, Greenpeace worked with the Clyde River Inuit community to assert their rights to free, prior and informed consent in the run-up to a dangerous seismic blasting project that threatened their cultural iden-tity, and that would limit access to local and sustainable food sources necessary to feed the community. Greenpeace continues to work with Indigenous communities that are asserting their cultural rights and protecting their lands and waters from environmental destruction. Greenpeace has petitioned the Canadian government to implement the UN Declaration on the Rights of Indigenous Peoples and to respect Indigenous rights to free, prior and informed consent for development projects in their territories.

Fifty years after that first campaign ship departed Vancouver for Alaska, Greenpeace now organises campaigns throughout the world. The long battle to save Earth from ecological calamity continues. Canada can be proud of giving the world the gift of Greenpeace and the idea that people can fight to protect our Earth and all her creatures.

»A trip for life and peace«
was the message brought by the crew of the PHYLLIS CORMACK – sailing to protest nuclear bomb test 4,000 kilometres west of Vancouver (right)
15 September 1971

Kinder Morgan emergency rally in Montreal
A massive demonstration including First Nations leaders, local artists and thought leaders, was held in Montreal against a new tar sands pipeline and tanker project, that poses significant threats to marine life and the availabili of clean drinking water (bottom)
27 May 2018

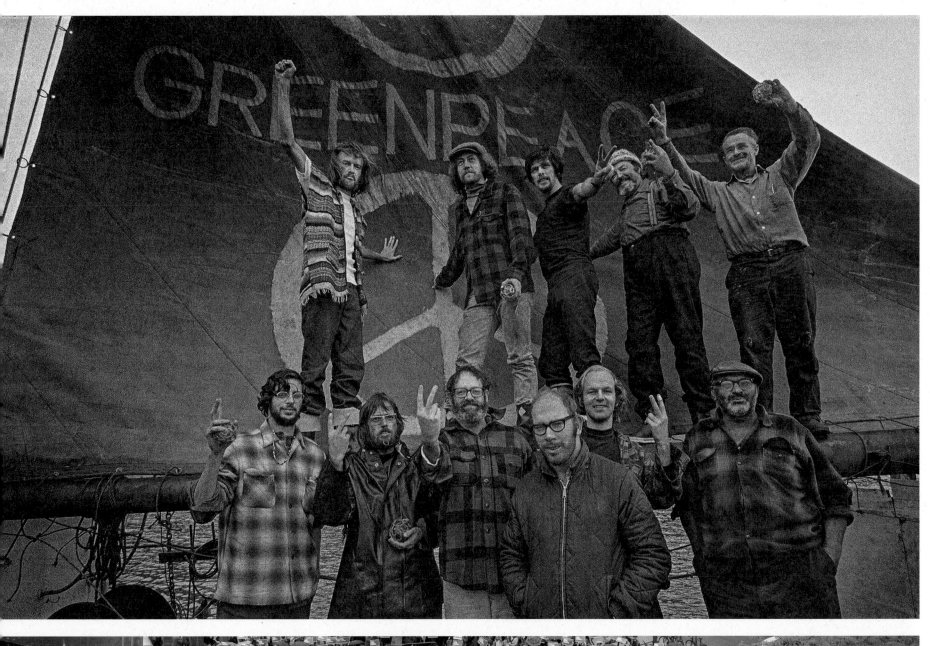
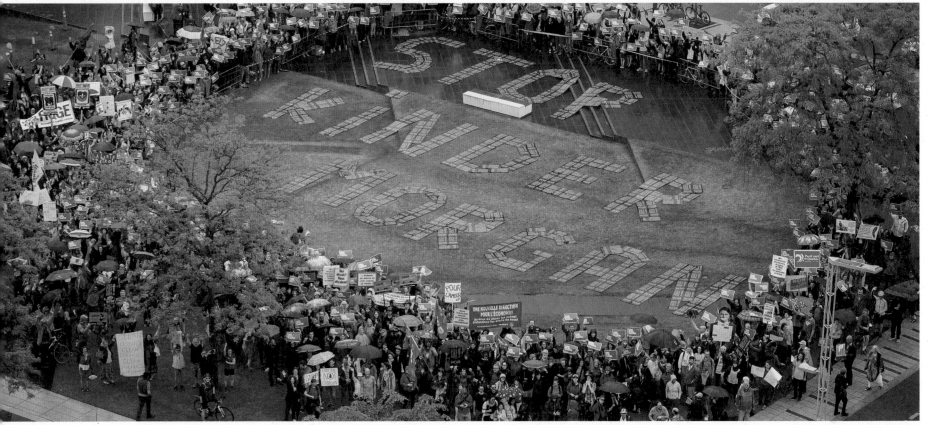

Greenpeace USA
founded 1975
Action warehouses – boring from the outside, but a beating heart on the inside

Among the many things that makes the experience of working for, or volunteering with, Greenpeace unique in the U.S.A. are our warehouses. These buildings that sit in relatively anonymous areas – one is just outside the nation's capital of Washington, D.C., and its partner is in California's beautiful Bay Area – attract absolutely no attention at all. From the outside, they are boxy, industrial buildings, the type you would expect to be filled with cardboard boxes or washing machines waiting to be shipped.

But inside, they are the beating heart of Greenpeace in the U.S.A.

Greenpeace USA.'s warehouses are workshop and training venues, art studios and community centres. On any given day or evening, visitors might find volunteers creating banners, or artists painting murals, or Greenpeace activists coming together from across the country, or even the world, to plan the next great campaign moment. Or it could be a day that we spend figuring out just how many polar bear costumes we have stored away.

From training courses in climbing to screen printing workshops and routine maintenance on any number of Greenpeace vehicles and vessels, the warehouses are creative hubs and imaginative collaborative spaces where hard work is being done. They are also one of the ways Greenpeace in the U.S.A. strives to meet its responsibilities as a large organisation in a community of dedicated grassroots activists and changemakers.

We have opened our doors to provide space for other progressive, like-minded individuals and organisations, giving them a place to build their own ideas and plan their own transformational moments. In these busy places, these warehomes, we make room for other voices to grow and for new movements to emerge.

The warehouses are a crossroads, a place where each of the more than 150 individuals who do the everyday work of Greenpeace in the U.S.A. will spend at least a small part of their lives, where we can be reminded, regardless of whether our role is that of a climate expert or volunteer organiser or content creator or data wrangler, that we're all part of something much larger. We're creating nothing less than a new tomorrow. A tomorrow free from the toxic pollution and willful destruction caused by fossil fuel dependency.

Inside these walls, we're working with others to bring about a green and peaceful future where no-one will find their opportunities limited by systems that perpetuate cruelty, hatred and bigotry. We're imagining the next big mind bomb, the creative moment that will inspire and excite people to act and engage.

Together, we're writing the next chapter of a 50-year history, all inside a pair of unremarkable-looking buildings at the opposite ends of a very large country.

Kayaks against Shell's drillship
Kayak activists are protesting near the Shell drillship Polar Pioneer in the Shell No flotilla, »Paddle in Seattle« protest. Shell planned to drill for even more oil in an irresponsible way in the sensitive Arctic ecosystem
16 May 2015

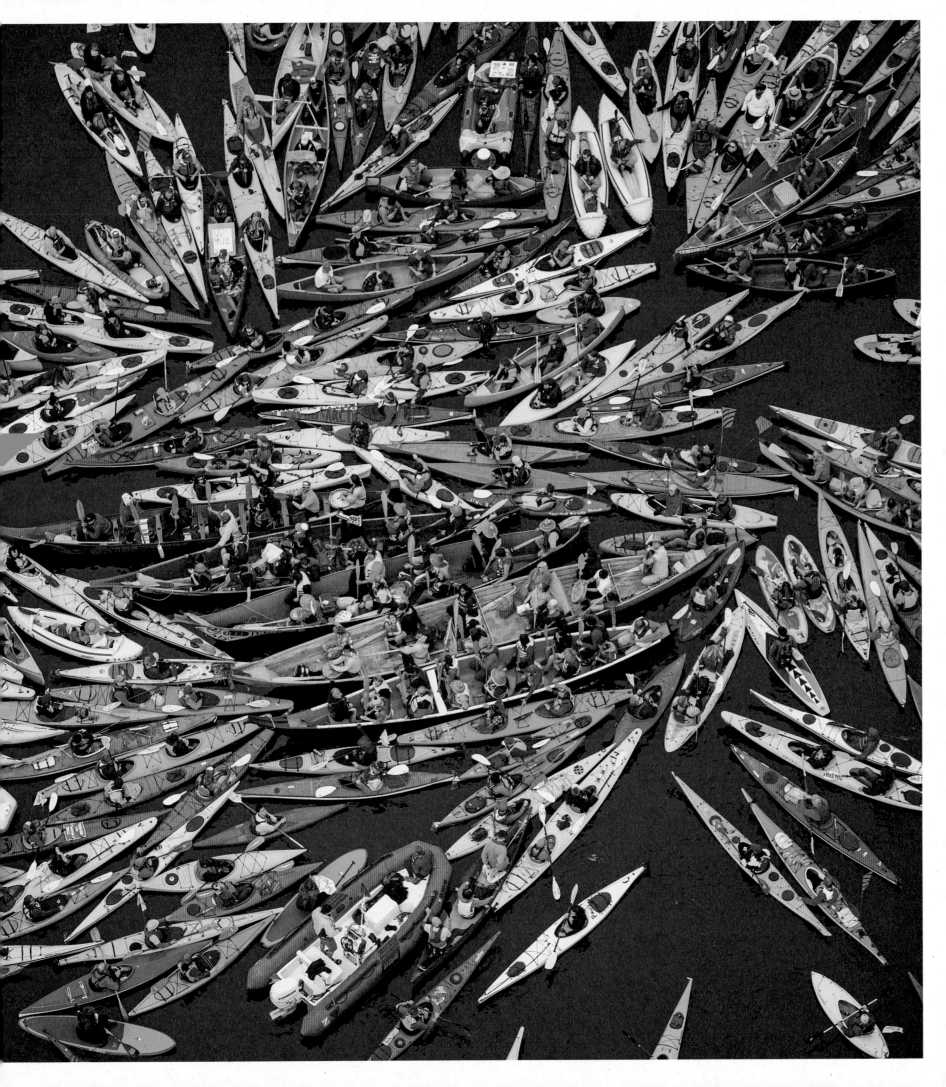

Greenpeace Mexico

founded 1993

From protecting corn, prevention of plastic pollution and an Urban Revolution

Greenpeace opened its office in Mexico in 1993 as part of a regional project called »Greenpeace Latin America« and has been intensely active since then, documenting the country's serious environmental problems and calling for a change and for solutions to ensure a green and peaceful future for all of us. The first campaigns we carried out in the country drew attention to the increasing levels of toxic industrial pollution, exacerbated by the then-new free trade agreement between the United States, Canada and Mexico, poor air quality in the nation's capital, and the threats and risks posed by the state-owned nuclear power facility.

Mexico is where corn originated. Following its domestication, Indigenous communities diversified corn across the American continent, generating over 600 native varieties that are used for different food, cultural, social and medicinal purposes. Protecting all that diversity from genetic engineered (GE) varieties of corn formed the core of the longest campaign that Greenpeace has carried out in Mexico. Since 1999, our campaigners have exposed illegal imports and sowing of transgenic seeds, as well as the fact that domestic authorities and food producers have neglected to inform the public about the use of GE seeds. Twenty-two years later, Mexico finally passed national regulations to protect native corn varieties from the gene flow from GE corn, as well as to phase out the use of the dangerous pesticide glyphosate from the fields.

Our campaigns for a revolution in our urban spaces, to connect healthy food with healthy land, and to combat the avalanche of plastic pollution are all aimed at the causes, not the symptoms.

By calling for an Urban Revolution, we have kept sustainable cities, and the air quality crisis in cities, at the forefront of the public's attention. Actions such as placing a mask and oxygen tank on the statue of Diana Cazadora in Mexico City featuring the message »The air in Mexico KILLS« reminds the public to demand clean air and clean public transport for the entire country.

These activities have empowered and given voice to diverse groups not only in blaming the dominant fossil fuel-based modes of transport, but also helping to shift the mentality in society and expose the invisible threat that every single person in the city faces.

Painting a picture of a better world extends to the work being done to promote healthy food and healthy land – a campaign calling for a change of the existing industrial agricultural system towards a more sustainable, ecological, and environmentally fair one.

With our work on plastics, Greenpeace Mexico is changing the narrative by pointing out that currently only individual acts will make a difference, and by bringing the corporations that deliver products in single-use plastic back into the spotlight, where they belong. This work is helping to shift the conversation to the legislative process, promoting the approval of an extended producer responsibility law. This attacks the problem from both ends – asking people to reduce single-use plastics while demanding corporate giants change their packaging and distribution policies.

Greenpeace Mexico continues also to campaign against deforestation and industrial meat production in the Yucatán Peninsula in partnership with Mayan communities, against plastic pollution, for the protection of pristine and natural conservation areas, and of course climate change.

World Water Day protest against poisoned rivers
With full protective equipment, we are warning about the increasingly dramati contamination of many of Mexico's rivers, which are being poisoned with industrial and agricultural sewage – su as the Santiago River near the Salto de Juanacatlán waterfall, one of the most polluted rivers in Mexico (right)
22 March 2012

Nuclear? No thanks!
We are protesting on the new Mexican Senate building, 78 metres high, while a police helicopter circles in the sky. Currently, Mexico's energy authorities are demanding that the nation's nuclea energy capacity be increased over the next 15 years (bottom)
11 April 2011

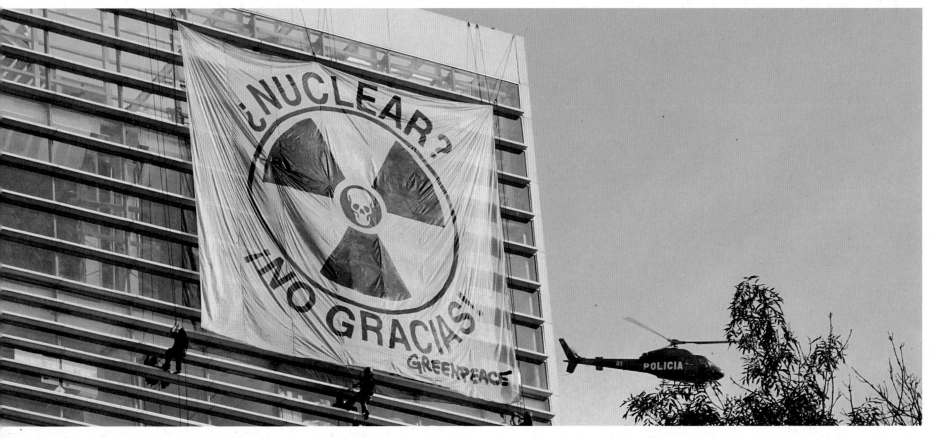

Greenpeace Brazil
founded 1992
Saving the forests of the Amazon, a global treasure, today is the key to the future

We have spent more than 20 years working to protect the Amazon forest and its people from the forces that threaten its very existence, such as major national and international agribusinesses and the oil industry; these threats still remain highly relevant today. But what if Greenpeace had never even tried to protect the tropical forests? What scenario would the world be facing now?

When we first arrived in the Amazon, information was scarce. It was Greenpeace that sounded the alarm and called the world's attention to what was happening on the ground: the demand for mahogany, the »green gold«, opened the door to predatory logging practices and large-scale economic exploitation of the Amazon. After an intense campaign, mahogany was listed as a protected species, which resulted in drastic changes to how the production, transport and trade in timber is managed.

Our investigation of illegal logging allowed us to help the Deni Indigenous people to demarcate 1.6 million hectares of rainforest they claimed as their homeland. The Deni are an Indigenous group living in semi-isolation in a very remote part of the Amazon, whose land was sold illegally to a Malaysian logging company without their knowledge. After waiting for more than 10 years for the government to recognise their rights to the land, the Deni took matters into their own hands. After an intense campaign supported by Greenpeace, the rights of the Deni to their territory were finally acknowledged.

A few years later, we partnered with local communities to create the largest extractive reserve in the Amazon – the Forever Green (Verde Para Sempre) Reserve in the state of Pará.

At the time, the Amazon was facing a crisis due to rampant deforestation. Between 2004 and 2005, the rainforest was being destroyed at the second-highest rate ever recorded. Once again, Greenpeace sounded the alarm, exposing how the rising demand for land for the cultivation of soya and for cattle grazing was destroying the Amazon.

Following a vociferous outcry from people all over the world, who were demanding action to protect the rainforest, industries were forced to respond. Pressure from us and our partner organisations lead to a moratorium on soya which obliged companies to not purchase soya from farmers who clear new areas of the rainforest, use slave labour, or threaten Indigenous lands. Together with effective measures to fight deforestation – such as inspections of fields by environmental agencies and the creation of protected areas – the »Zero Deforestation Agreements« that were reached with the soya and cattle industry resulted in deforestation rates decreasing by 80 percent in the years that followed. It is incredible what can be accomplished when we work together!

More recently, Greenpeace has partnered with the Munduruku Indigenous people due to the government's plans to construct a series of five megadams in the region, which would have a huge impact on both the Munduruku people and the rainforest with its wealth of biodiversity. After the loss of the Xingu River to the Belo Monte dam, the cancellation of the licensing process for the São Luiz do Tapajos dam was a major victory that demonstrated that together we can save the heart of the Amazon. Beat by beat.

It has been an intense journey with many achievements along the way, of this there can be no doubt. It is comforting to see that a few of them have, in fact, created a lasting legacy for the Amazon and its people. Yet it is hard to celebrate these achievements considering that this beautiful forest and its people are still facing so many threats to their existence – with many of them posed by those who are actually obliged to protect our environment: politicians. It is time for us to come together and blaze a new trail – to create an alternative future that honours our biodiversity and that recognises the value of the Amazon and its peoples. Saving the forests today is the key to a better future.

Either we all win or we will all lose. We have to make the right choice.

Support for the Indigenous people
Our Amazon campaign is being developed and run with the close involvement of Indigenous first nation with the aim of preventing the planne dam on the Tapajos River, exposing environmental crimes, and demarcatin the land that is inhabited by the Deni
March 2016, January 2001 and August 2003

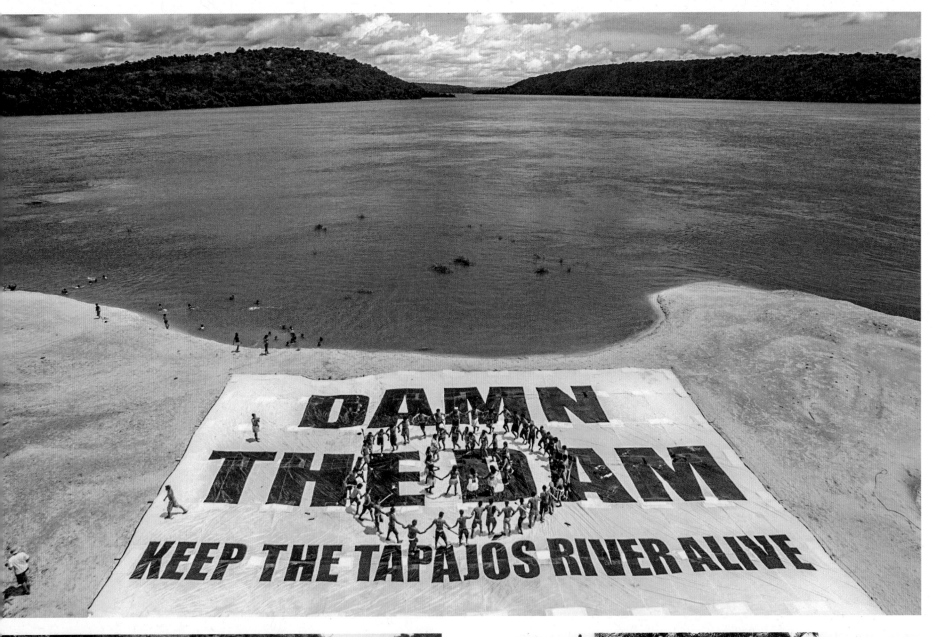

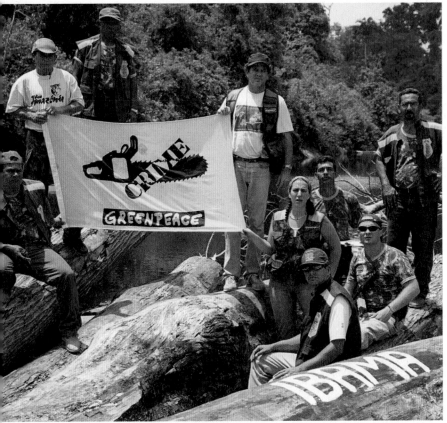

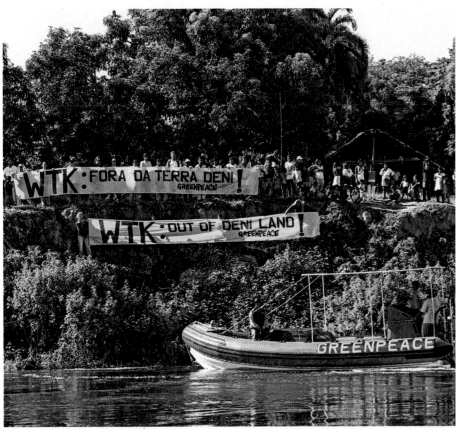

Greenpeace Andino / Greenpeace Argentina
founded 2012 / founded 1987
Protecting our fascinating nature, from Patagonia to the Andes, with people power

Greenpeace Andino brings together our interdisciplinary and multicultural work teams from Colombia, Chile and Argentina. We defend the environment, promote peace, and together with more than hundreds of thousands of other people involved, we pressure companies and governments to make the right decisions. All of which means we are seeking to influence public policies and inspire change in our countries.

GREENPEACE ARGENTINA
founded 1987
»THE GREEN JAGUARS OF ARGENTINA«
The history of Greenpeace in Argentina officially began on 1 April 1987. A year earlier, the most devastating nuclear accident in history had occurred in Chernobyl, Ukraine. For this reason, ending the use of nuclear power was one of our main focal points when we started out. Activists from Greenpeace Andino educated the public on the risks of nuclear waste dumps and the importation of nuclear waste from other countries.

Of course, the climate crisis is another key focus for Andino. We have worked to promote clean energy solutions, such as solar and wind, for more than 30 years.

With the support of one and a half million Argentines, we were able to have the Forest Law passed – guaranteeing that the national budget must make a minimum share of funds available for reforestation and the conservation of native forests. We also prevented a planned nuclear waste dump in Chubut, and oil exploitation in the Calilegua National Park.

Together with the work being done by more than 70 environmental and community organisations, we successfully pushed for the approval of the Glacier Preservation and Periglacial Environment Law that regulates mining activity to protect glaciers, the country's main water reserves – a important milestone. Moreover, we worked to stop unsustainable fishing practices and to have the first marine conservation measures introduced. We have been fighting to protect our wetlands and the Argentine Sea, and we opposed the dumping of toxins in seas and rivers, while also promoting the Zero Waste Law, which manages urban pollution in the city of Buenos Aires.

Activists from our offices joined the fight to stop Shell from drilling in the Arctic. After more than three years of campaigning and with the support of seven million people around the world, we »motivated« Shell to abandon its plans to drill for oil in this globally important and unique area This saw Shell forced to abandon a project in which it had already invested as much as US$ 6 billion.

Our work, and maintaining our trajectory, is something that is made possible by the more than 165,000 supporters who help us with their monthly donations, and allow us to remain independent – both economically and politically – as well as the hundreds of people who donate their time to the cause. They are all part of our national volunteer community, which is active in the provinces of Buenos Aires, Salta, Rosario, Córdoba, Bahía Blanca, Mendoza, Mar del Plata and Posadas.

Not only this – we can also rely on the efforts of tens of thousands of cyber activists who participate in our social network campaigns by signing and sharing our petitions.

The human jaguars
The Jaguars – a rapid response team of Greenpeace activists dressed as jaguars are defending Argentina's most important forests from the destructive practic of the agricultural industry, in particula the cultivation of soya (right)
24 August 2005

The obelisk of Buenos Aires
Greenpeace activists scaled the obelisk to demand that President Macri comply with the National Glacier Law, and clos the Veladero mine operated by Canadia gold mining giant Barrick Gold (bottom left)
9 June 2016

Unregulated Fisheries
Greenpeace Andino protested against the lack of regulation for the fishing industry in the South Atlantic in the po of Montevideo, Uruguay. Greenpeace Andino uncovered that the port regula hosted vessels that fish in the unregula ted waters beyond Argentina's exclusiv economic zone (EEZ), including some with a history of illegal fishing (bottom right)
26 February 2019

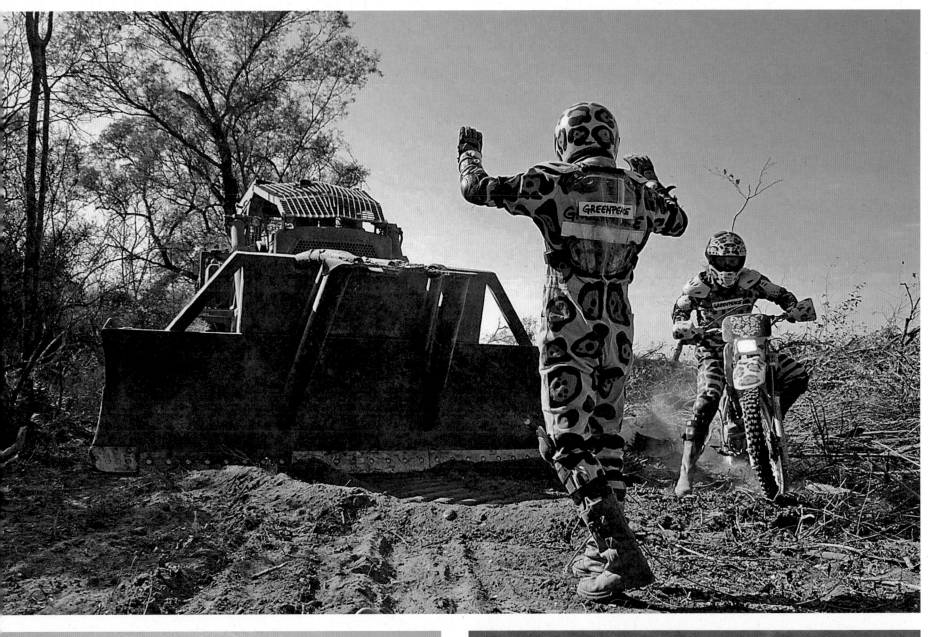

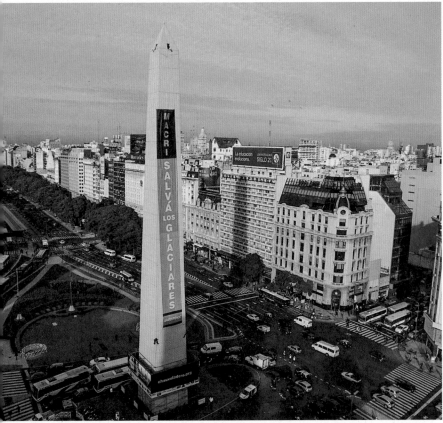

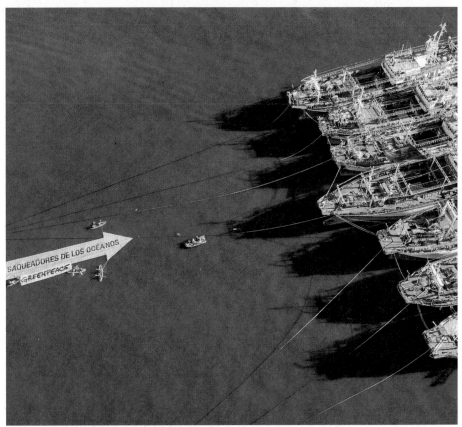

Greenpeace Chile
founded 1990
The longest country on earth – full of environmental problems

Greenpeace in Chile has focused its campaigns on the country's most serious environmental problems. The first struggles were fought to stop one of the largest factory ships in the world – the American Monarch – from entering Chilean waters and threatening marine resources with its highly destructive fishing practices, to stop the environmental crimes committed by of the wood chipping industry from destroying our fascinating native forests, turning them all into woodchips, and to prevent overseas exports by companies such as San José, Trillium, Cascada and Forestal Sur.

In 1995, more than 400,000 of our active supporters signed our petition and joined the global community in protesting the French nuclear tests in the Moruroa Atoll in Polynesia. In 1996, Greenpeace stopped the installation of industrial incinerators in the Valparaíso Region, close to Santiago.

During the early 2000s, we developed new campaigns such as »the Right to Know«, and managed to motivate the Chilean government to publish the first Pollutant Emissions and Transfer Registry report. We followed this with a call for a ban on persistent organic pollutants (POPs) – and as a result, the Chilean government signed the Stockholm Convention prohibiting the twelve POPs known as »the dirty dozen«. After several years of campaigning, we stopped the Alumysa megaproject by the Canadian-based transnational company Noranda, which intended to install an aluminium reduction plant in the Aysén area of Patagonia in southern Chile, with unknown consequences for Patagonia's unique natural paradise. We also stopped illegal logging of ancient larch trees in the Alerce Andino National Park. Our campaigns made the government declare the country's exclusive economic zone whaling-free, and to establish the ecosystem-based approach outlined in the Convention on the Conservation and Management of Fishing Resources on the High Seas in the South Pacific Ocean as a fundamental pillar of fisheries management.

In 2010, Greenpeace, together with other environmental organisations, successfully prevented the Central Termoeléctrica Barrancones megaproject. After years of work as a member of the Patagonia Defence Council, Greenpeace in Chile had the HidroAysén project legally stopped after an »order not to innovate« was issued in court in 2011. In recent years, we helped with the foundation of the Glacier Republic in 2014, which provides legal protection for glaciers; a victory against the HidroAysén project was achieved in the same year – blocking the construction of five megadams on the Baker and Pascua rivers in Chilean Patagonia – a very important victory.

In 2018, the law that prohibits the use of single-use plastic bags throughout Chile was passed, which represents an important milestone for a zero-waste future.

In 2021, within the process to draft a new constitution for the country, we are staging our »Suelta El Agua« (Free the Water) campaign, guaranteeing access to water as a human right, and recognising it as a vital element for ecosystems and nature. The power of the people will make it possible to establish the right to water in the new constitution as a common good.

More than 100,000 people have signed a petition in support of Greenpeace Chile's »Without plastics« movement – a campaign that reached more than 11 million people, and has aroused keen interest in this urgent environmental problem.

Canadian mining company destroys Chilean glaciers
The Canadian company Barrick, the world's largest gold-mining company, ruthlessly operates its gold mines in the glacial regions of the Chilean Andes. We climbed the façade of their corporate offices in Chile and demand the immediate cessation of these destructive mining practices in the valuable glacial region (right)
14 May 2015

Climate emergency in Chile
At the Laguna de Aculeo, Greenpeace draws attention to the climate emerge and demands urgent and ambitious action on climate change. The image o the lake shows a time when the Lagun de Aculeo was full of water and rich in biodiversity. In just a few years, it has run dry, and thereby illustrates the wo impacts of the climate crisis (bottom le
27 November 2019

Giant whale in feminist march in Santiago
To honour International Women's Day, the women of Greenpeace Chile joined thousands of other women in a march in Santiago, arriving at the Plaza de la Dignidad with a nine-metre-long life-si whale made of 100 percent recycled ma rials. The whale, an emblematic symbol the environmental struggle, was accom nied by more than 200 employees, frien members and activists of the environ mental organisation bearing the messa ge: »The extractivist crisis is a feminist cause«. As women in Greenpeace, they explain, »we are giving a voice to natur which is reflective of what has happene to women throughout history. Just as w men did not, for a long time, have a voi nature does not have a sympathetic and empathetic voice on the part of human either«, they state (bottom right)
8 March 2020

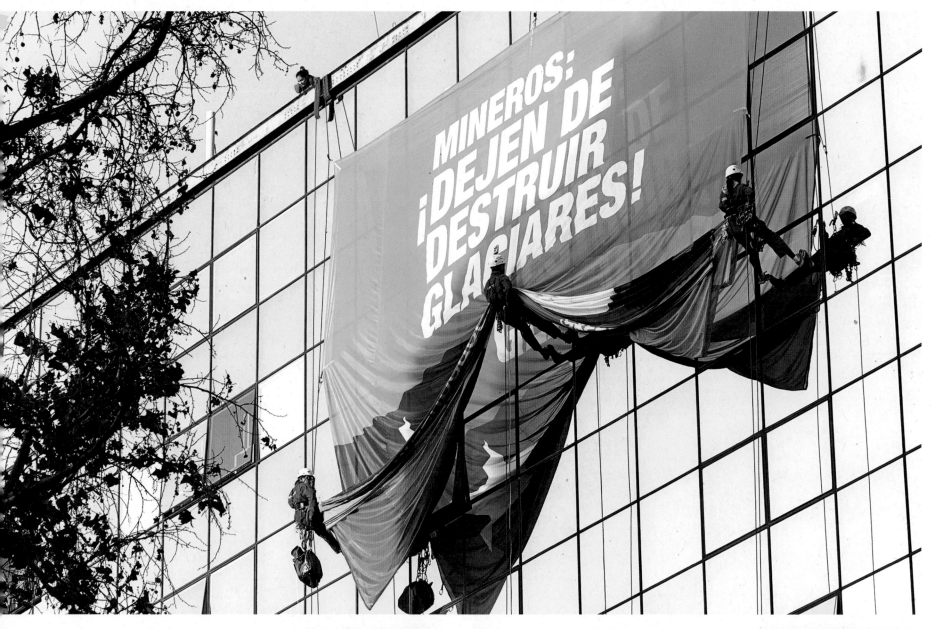

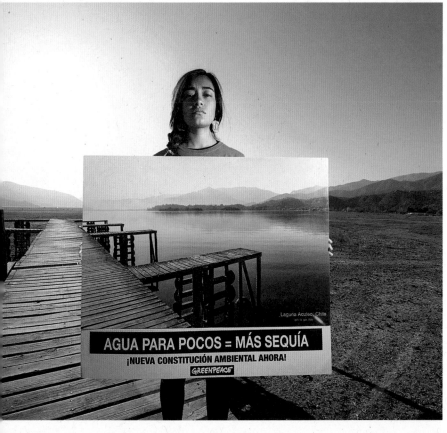

Greenpeace Colombia
founded 2011
Columbia's famous moors – a symbol of the need to protect the climate and biodiversity

When we first started operating in Colombia, Greenpeace attracted hundreds of people interested in learning more about the organisation and joining the team of volunteers. The first campaign focused on the climate crisis, and was launched the same year that the 15th International Conference on Climate Change was held (and ultimately failed) in Copenhagen, Denmark.

One of Greenpeace's ships, the RAINBOW WARRIOR, arrived in Cartagena two years later as a prelude to the official opening of our office in Colombia.

We adopted the special Colombian moors and swamps – important for their unique biodiversity and as a large national carbon sink – as a symbol of the struggle to prevent the climate crisis and to highlight the importance of these ecosystems, which led to their protection becoming the focus of our first official campaign. We did so successfully – after all, in 2016, a landmark ruling by the Supreme Court of Justice prohibited mining in these ecosystems – what a great victory.

But despite the work we do together with the people and our supporters, the communities and environmental organisations, these ecosystems remain in danger. And we will not stop denouncing any violations of this ruling which occur.

We have also actively worked to have asbestos banned in Colombia, together with relatives of victims of asbestosis, academics and members of other organisations. After years of struggle, in June 2019, the House of Representatives unanimously approved the Ana Cecilia Niño bill that prohibits the production, use, commercialisation and export of asbestos in Colombia. It was a historic day for our country. After twelve years of trying to eliminate this carcinogenic fibre, we achieved a result that seemed almost impossible when the campaign first got off the ground.

We have been alerting the government, companies, supermarkets and consumers about the country's serious plastic pollution problem. We document and call attention to the large volumes of plastic that are produced, and the amount of plastic waste that accumulates in large cities and along the coasts, polluting and endangering nature. We are calling for supermarket chains – as a first immediate step – stop using single-use plastics in their packaging.

Over the years, we have promoted the use of renewable energy, fought for the conservation of oceans and forests, and staged campaigns against toxic waste. In addition, we are supporting other organisations that are promoting recycling, the use of clean transportation, the cleaning up of rivers, and the protection of key ecosystems.

We also joined Greenpeace's international campaign to defend the Arctic, one of the regions of the world most vulnerable to climate change, oil companies and industrial fishing.

Currently, we are working towards a fundamental paradigm shift in our large cities. We need cities that are more resilient and more sustainable, which is why we are promoting joint actions to ensure that there will be more green areas that help regulate the climate, a fairer, local and cleaner system of food production, and clean mobility to reduce the emission of pollutants from cars and trucks and thereby mitigate the greenhouse effect.

After several months of campaigning, we pushed the city council and the mayor to declare a climate emergency in the capital, Bogotá, thereby becoming the first Latin American city to declare such a crisis. This makes it a pioneer when it comes to real, binding action strategies, and one that is equipped with the budget necessary to promote the well-being of its citizens, health, and the protection of the environment.

March against plastics in Bogotá
Hundreds of protesters gathered in the heart of the capital to warn about the serious environmental consequences that plastic pollution is causing. According to the Greenpeace Columbia each Colombian uses 24 kilograms of plastic per year (right)
11 November 2018

»Break Free« activity at a coal mine in Colombia
Greenpeace, along with farmers from the Pisba community, hold a protest in Páramo de Pisba, calling for the cessation of mining in this delicate ecosystem. The group occupied a coal mine pit head, demanding »Mining-free moors: time is running out«. This action is part of a global movement called »Break Free«, which seeks to speed up the shift to an era of renewable energie leaving dirty energy production based o fossil fuels, such as coal and oil, behind (bottom left)
18 March 2017

Asbestos brings death
We are demanding that members of parliament approve the »Ana Cecilia Niño« legislation. To make the urgency of the calls to ban the carcinogen asbestos visible, our activists climbed the bridge on Avenida El Dorado – our large and most daring action in Colombia to date. »Congressmen: we all pay their cowardice. Colombia without asbestos« In 2019, the law against asbestos was finally approved – what a great victory and relief (bottom right)
18 April 2018

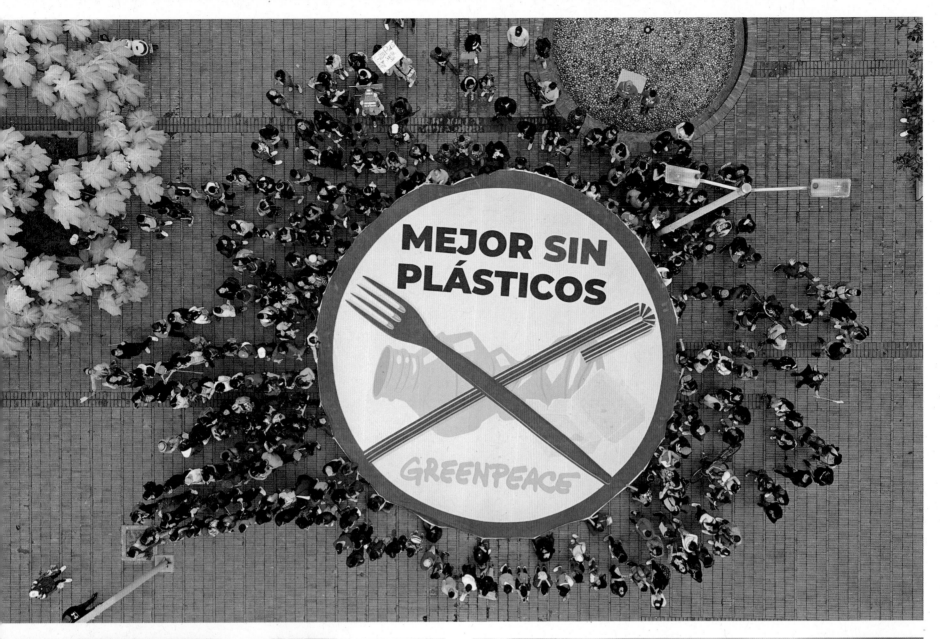

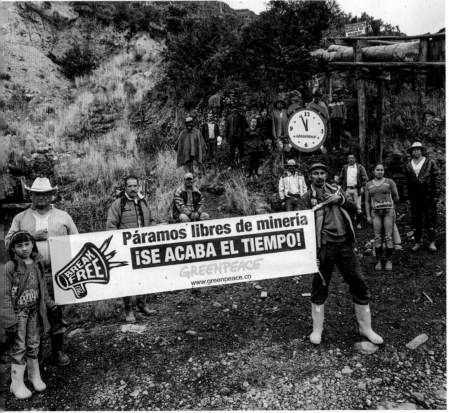

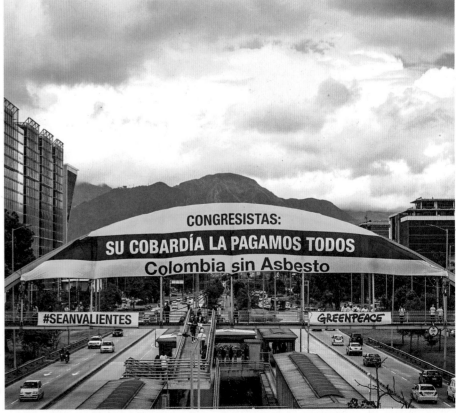

Greenpeace Nordic
founded 1980 (in Denmark)
Fundamentally changing the mindset in the frozen north of Europe

Situated in the far-flung reaches of the frozen north of Europe are the Nordic countries. Greenpeace has offices in four of them – Norway, Sweden, Finland and Denmark. All four nations are small, relatively sparsely populated welfare states, with rich natural resources.

With its long coastlines, high mountains, deep forests, lush meadows and icy tundra, Nordic nature is both rough and delicate. It's also in dire need of protection. In the Arctic Circle, climate change is felt and seen every day. Ever-warming temperatures are melting the sea ice, endangering nature, the oceans, and even local ways of life. More densely populated areas have only a little untouched nature left, and that which remains is continually decreasing. The Nordic people's close relationship with their natural surroundings, combined with years of increasing threats against nature and the environment, has given us plenty of experience with action, civil disobedience and campaigning to influence lawmakers. And while we have a long list of victories for our Nordic environment, new and old threats mean there is still much to do.

Despite being major fossil fuel producers, replacing almost all our old growth forests with industrial plantations, and consuming resources as if we had four planets, the Nordic countries are often seen as role models with regard to the environment and climate. Even with this continued destruction and overconsumption, the current Danish and Finnish governments have some of the strongest climate goals in the world, and Norway is leading the world in electric car usage. These contradictions say something about the Nordic region and our global ambitions. We hold our governments to account and take action when governments fail to fulfil their promises.

Our biggest challenge is to create a genuine mind shift around what is possible and what we should strive towards. Our societal goals need to reach beyond sustainability ambitions, such as lowering our emissions and reducing our environmental impact, into seeing ourselves as active parts of nature, and playing a positive role. When it comes to welfare, we in the Nordic countries have achieved something that many countries in the world are striving for. Not only do we have good living conditions, but also a responsibility to be at the forefront of a global green transition, and to show the world that well-being is possible without overconsumption of natural resources. Restoring ecosystems, enhancing biodiversity, a quicker phase-out of oil and gas, and balancing the climate need to be the central goals leading the way to a welfare society that fits within the planetary boundaries.

Changing this fundamental mindset while ensuring that the societal transition is socially and economically fair – this is certainly a challenge.

Arctic
The »Save the Arctic« campaign is a major chapter in Greenpeace history. To protect the Arctic from destructive industries such as oil drilling and unsustainable industrial fishing, the campaign employed a wide range of tactics, from breaking up the partnership between toymaker LEGO and Shell, and participating in high-level political meetings, to confronting the oil companies on the ground when they were moving their oil rigs to the high north. Research into and documentation of the rapidly changing Arctic and its wildlife has also been conducted over the years (top)
10 April 2016

Finland
Greenpeace Nordic staff are joined by hundreds of activists in demanding climate action on the steps of Finland's parliament (bottom left)
6 March 2019

Denmark
»Politicians talk – leaders act«. Four activists paid an uninvited visit to a state banquet hosted by Denmark's Queen Margrethe II for world leaders attending the COP15 UN Climate Conference in 2010. Their peaceful protest and direct message made them world famous, as they were held in custody for 20 days. Unfortunately, the politicians only talked and the COP15 was considered an epic political disaster to prevent the global climate crisis (bottom middle)
17 December 2009

Russia
Our Finnish activist Sini Saarela sends her greetings from the courtroom in Murmansk, Russia. She was one of the Arctic 30 activists who were arrested during a peaceful protest against Russia oil company GazpromNEFT's plans to launch the world's first offshore oil production facility in the Arctic (outside Russian territorial waters). After intense campaigning and with international support, all our activists were finally released, and controversial drilling in the Arctic became a global hot topic (bottom right)
21 October 2013

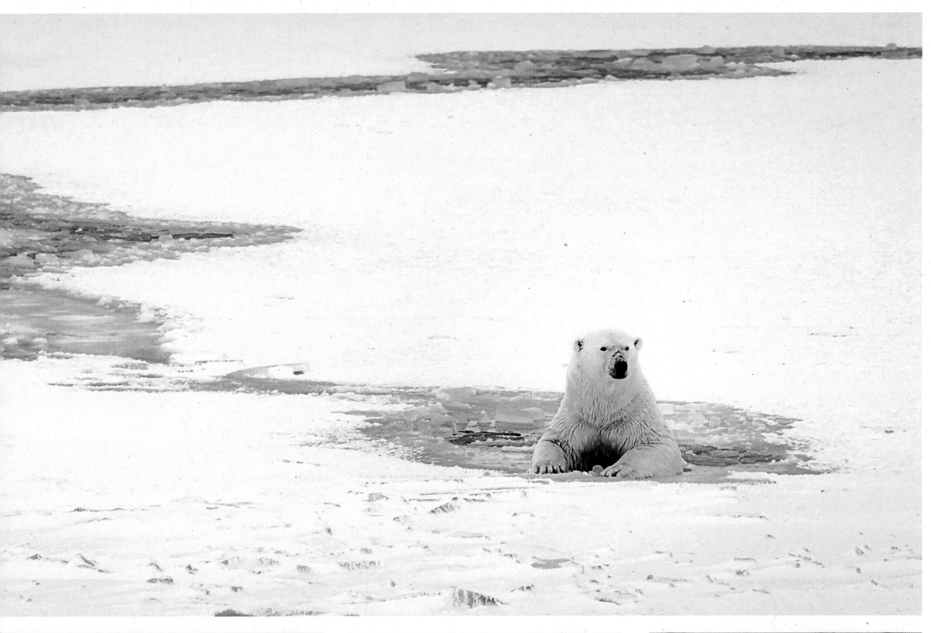

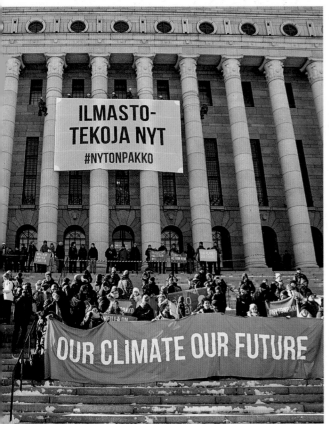

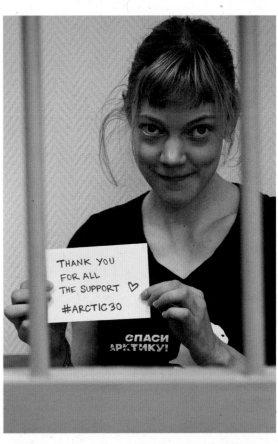

Denmark

It all started in Legoland... Tiny LEGO activists protested in the Danish theme park, demanding that it cut ties with Shell and help »Save the Arctic«. As a major fossil fuel company, Shell had been using LEGO's brand in a partnership to secure more public goodwill, with Shell-branded LEGO sets being sold around the world. The miniature protest was followed by a global campaign, a viral YouTube video and our Greenpeace supporters asking LEGO to stop associating with the oil company. After three months, Lego finally decided to terminate its long-time relationship with Shell. Later, the oil company abandoned its plans to drill for oil in the Arctic (top left)
2 July 2014

Finland

»Our Land Our Future« says the banner in Sámi language, held by Jussa Seurujärvi, Sámi reindeer herder from Muddusjärvi. For years, the indigenous Sámi people have fought against the exploitation of Sápmi, their homeland, which today is situated in the northern parts of Finland, Sweden, Norway, and Russia. Greenpeace has actively supported the fight against industrial land use that is severely impacting the Nordic environment and the Sámi culture (top right)
3 February 2019

Nordic

In 1993, Greenpeace conducted a monthlong occupation in protest against Shell's plans to dump the oil platform Brent Spar in the North Sea. Two years later, public support for the Brent Spar campaign pushed Shell to agree to dismantle the oil tank and loading platform on land instead of dumping it in the sea. The campaign also led to OSPAR's decision in 1998 to ban any dumping activities in the north-east Atlantic (bottom left)
20 June 1995

Norway

Along with a wide coalition of NGOs and individuals in Norway, Greenpeace Nordic took the Norwegian state to court over Arctic oil drilling in 2016. After four years of battle in court, as well as in the court of public opinion, the Supreme Court ruled in favour of the state. However, a majority of people in Norway are now in favour of leaving oil in the ground for climate reasons, largely due to the broad campaign surrounding the legal case (bottom 2nd from left)
18 October 2016

Norway

In 2016, Statoil, the Norwegian state-owned oil company now called Equinor, sold its assets in Canadian tar sands after years of pressure from Greenpeace and allies. We brought this project to the Norwegian parliament, to Statoil workers, to the Norwegian people and professional investors, and forced the company to leave what is often referred to as the worst and dirtiest energy project on the planet. This Greenpeace mascot is a parody of the mascots for the 2011 Ski World Cup in Norway, which Statoil sponsored (bottom 3rd from left)
26 February 2011

Sweden

Paris or Preem? The mismatch between the expansion plans for Scandinavia's biggest oil refinery and the nation's environmental goals is a campaign story that may force big oil to retreat. The victory came in 2020 after massive protests from a joint environmental movement, with the RAINBOW RARRIOR blocking the flow of crude oil to the refinery for 62 hours and activists ultimately blocking the crane pumps, halting several tankers on their way to the west coast of Sweden (bottom right)
10 September 2020

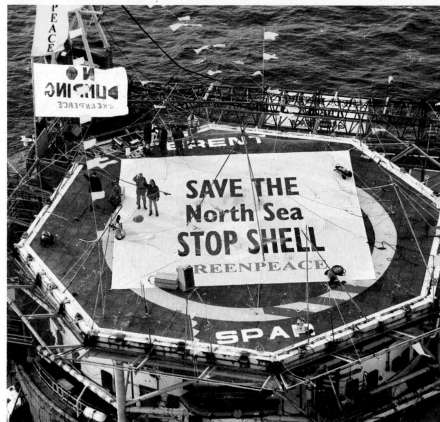

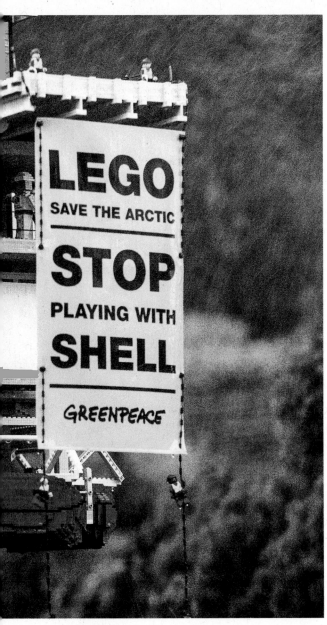

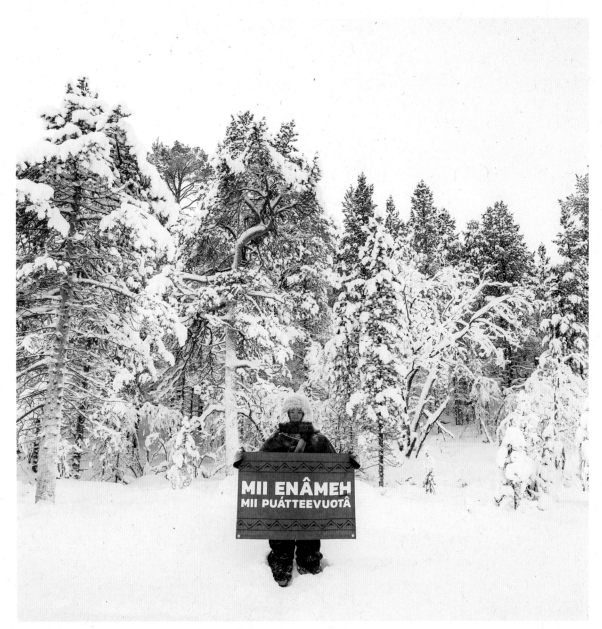

Greenpeace UK
founded 1977
Opposing destructive environmental plans with people power

As the cradle of the industrial revolution and where coal was once crowned king, the birthplace of nuclear power and one of the most heavily deforested countries in Europe, the UK has been in dire need of some radical environmentalism for centuries.

But it wasn't until 1977 that the U.K.'s declining fishing fleet retired a trawler, the SIR WILLIAM HARVEY, which was to become the first RAINBOW WARRIOR. It was also the year Greenpeace U.K. was founded.

As an island nation with a sea-faring history, the UK made a good place to base the coordinating organisation with maritime operation until it relocated to Amsterdam in 1989. Our ships and boats were out campaigning for a nuclear weapons test ban, a whaling ban, and perhaps more importantly for U.K. waters, an international ban on the dumping of hazardous waste at sea. We were thinking, acting and winning globally, revealing what governments and industries were trying to hide by making their crimes against the environment visible on television in living rooms around the globe. It brought the world into a conversation about environmental abuse, including the abuse occurring in remote locations such as the Arctic or the Amazon, and helped us win many of the arguments in national and international forums.

Often, it's the zombie industries that refuse to admit that they are, in fact, dead. Nuclear power has been drawing its last breath for decades but has yet to expire, and even coal, history's greatest environmental polluter, keeps trying to push the lid off its tomb.

Plans to build a fleet of new coal-fired power stations in the U.K. were foiled by a huge activist campaign, with Greenpeace at the forefront of these protests. In 2008, in the wake of the campaign, six of our activists were found not guilty of causing £ 30,000 in damages after shutting down the Kingsnorth coal-fired power station in Kent. The activists won on the grounds that the closure stopped the plant's sky-high carbon emissions from causing climate change, and thereby preventing even worse damage from occurring. The action eventually led the U.K. government to agree to phase out coal entirely by 2025. Today, coal's share in U.K. electricity generation has now shrunk to around 2 percent.

That coal campaign felt like a major win for the climate, and it was. However, this year the U.K. government is debating whether to allow a new deep coal mine to be dug in Cumbria, in northern England. This time, the embarrassment is palpable. Everyone knows all about coal, its dirty secrets have been exposed, and no government minister wants to be seen standing too close to it. The decision about the coal mine is being passed around from politician to politician like the poisoned chalice that it is. And that is the real win. Coal has become toxic in more ways than one.

While pledges and promises from governments and corporations can be broken, and frequently are, and even the law can be changed, our victories come from people power. Countries and companies will always try to slide back into their bad old habits when the media spotlight moves on, but when everybody knows what you're up to and you have Greenpeace on your case, that becomes so much harder to do.

Climate action at Kingsnorth power station
The Greenpeace ship RAINBOW WARRIOR docked outside the Kingsnorth coal-fired power station during an action against Britain's most controversial power station. Coal is the most polluting of all fossil fuels and the largest single source of CO$_2$ in the world. Currently, one-third of all carbon dioxide emissions come from burning coal. The RAINBOW WARRIOR is visiting the United Kingdom as part of the »Quit Coal« tour of the North Sea (right)
29 October 2008

Another one – climate action at Kingsnorth power station
Greenpeace activists closed down Kingsnorth coal-fired power station near Rochester in Kent. They immobilised the conveyor belt that carries coal into the plant by hitting emergency stop buttons and chaining themselves to machinery. A second group climbed the 1,000 steps to the top of the chimney and painted the word Gordon (Brown, the Prime Minister) onto the outside (bottom)
8 October 2007

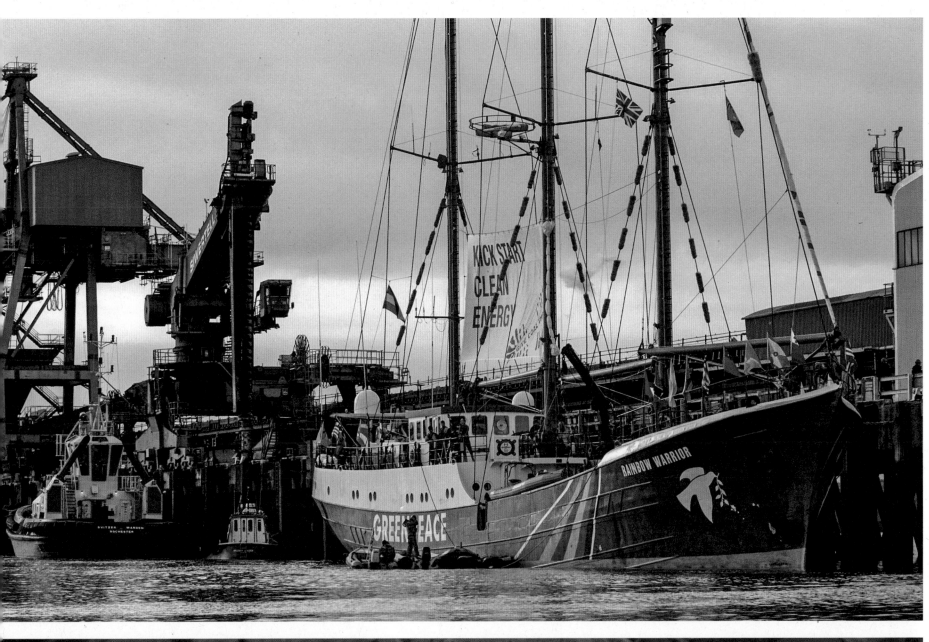

Greenpeace European Unit
founded 1988
Politicians talk – leaders act

Change doesn't come about easily. Nobody knows that better than Sébastien, a veteran of the Brussels political scene. His work for Greenpeace over almost two decades has been relentless, much of it to help slash Europe's footprint on the world's last remaining forests.

From the beginning, protecting nature and forests has been at the heart of the Greenpeace mission. »We are in a unique position, because we have the ability to confront the corporations burning down the Amazon and forcing out Indigenous peoples and local communities, while at the same time holding to account politicians in richer countries for their complicity in that destruction,« explains Sébastien.

Sébastien is one of a small group of political campaigners in Greenpeace's European Unit in Brussels whose job it is to reach the corridors of power where Greenpeace ships and climbers can't go, to challenge the European Union to end the destruction of nature.

Based in the heart of Brussel's European quarter, the Greenpeace EU political team is formed by committed people from every corner of Europe (and beyond), specialising in a variety of fields in which the EU wields power: from energy to farming and transport to economics. They talk directly to EU decision-makers, draft legal briefings and stimulate media exposure to disrupt the cosy relationships between industry lobbyists and politicians, and to build alliances that ensure Greenpeace weighs in against the influence of powerful commercial interests.

»European shops and supermarkets are filled with products that are linked to human rights abuses and the destruction of forests and nature on a huge scale. Governments and the European Union have the power to put an end to this.«

As one of the world's largest economies, responsible for over one third of global trade, the European Union has contributed more to climate breakdown and the destruction of nature than pretty much any other region on the planet. At the same time, thanks to pressure from Greenpeace and others, the EU also has some of the most forward-thinking environmental laws in the world.

The expansion of renewable energy across Europe, and the regulation of toxic chemicals and illegal timber, are only some examples of EU laws with global repercussions that would not have been possible without the work of Greenpeace.

Forest destruction and human right abuses due to EU imports
Greenpeace EU forest expert Sébastien Risso speaks to journalists in Brussels i July 2008 about the need for an EU ban on illegal timber, which had still to be enacted. »European shops and supermarkets are filled with products that are linked to human rights abuses and the destruction of forests and nature on a huge scale. Governments and the European Union have the power, and th responsibility, to put an end to this« **2 July 2008**

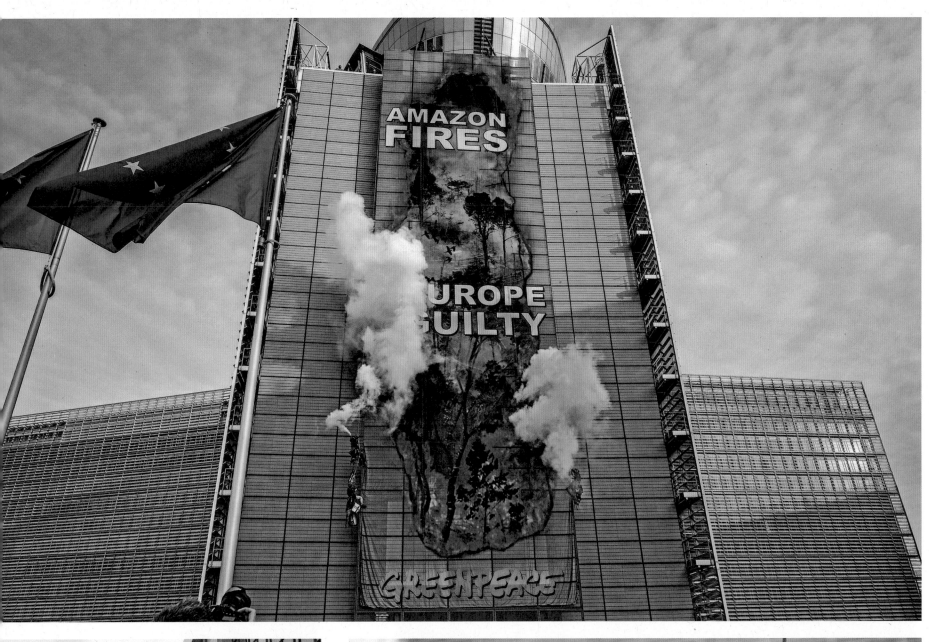

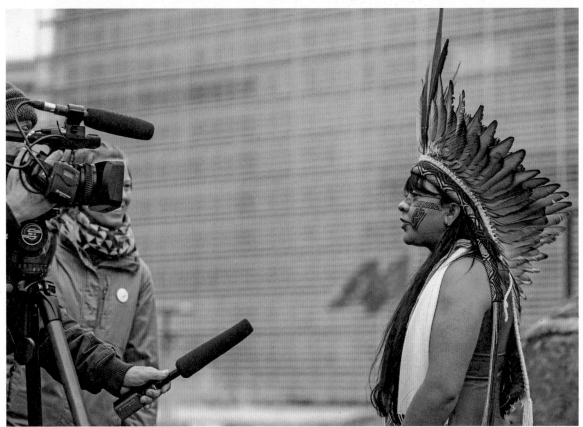

Greenpeace Germany
founded 1980
A committed, courageous movement that has yet to achieve its goal

From a distance, all you could see were two small dots and a large banner with writing on it. Two activists had spent 26 hours hanging from a 35-metre-high chimney at the Böhringer company, through which toxic substances were being released into the Hamburg air unchecked. It was 1981, and this was the second toxic scandal uncovered by Greenpeace within a few months. Like in many other places, there were committed groups in Germany who were no longer prepared to accept the environmental crimes of large corporations and the ignorance of many politicians. The spark was ignited, and with its first successful actions, the young organisation was drawing attention to itself.

A few courageous individuals in rubber dinghies and on chimneys became a movement – Greenpeace – which would become world-famous for its committed resistance.

The courage of many activists has repeatedly made the public aware of environmental crises, and changed its awareness permanently. And as environmental awareness grew in Germany, so did the popularity of the way in which Greenpeace exposes environmental crimes. Not merely protesting, but taking action. Standing up to injustice and destruction, and identifying real alternatives: this is what has distinguished Greenpeace from the beginning, and this in Germany as well. Public backing has enabled it to prevent the sinking of oil platforms, to advance the phase-out of nuclear and coal-fired power, to save forests and protect marine areas, and thanks to the »GreenFreeze«, refrigerators without CFC refrigerants that destroy the ozone layer have been available since the 1990s.

In Germany alone there are now hundreds of thousands of people standing behind Greenpeace, offering us support and solidarity. They are committed to a better, cleaner environment in their own communities. In over 100 cities, volunteers of all ages – from school classes and youth groups to senior citizens – are now involved.

With this widespread support, Greenpeace in Germany has grown into a large organisation and ultimately a genuine movement that exerts pressure on decision-makers with intensive research, courageous activism and intelligent media work. And this pressure is what is needed. The heavy rains and catastrophic climate floods in the summer of 2021, which have brought suffering and misfortune to so many people, must finally have consequences, and as soon as possible. Climate protection is urgently needed, and it must not continue to be postponed to an ever more distant future by other interests, or even pushed aside altogether. The responsibility for the destruction of the environment must no longer be ignored, or even swept under the carpet, by so many politicians and company bosses.

Side by side with other climate and environmental movements, we will oppose this with increasing vehemence – with important successes like this one: at the beginning of 2021, Germany's climate protection law in its current form was declared unconstitutional. This court ruling means that politicians must finally take the right action on climate protection. This gives us hope for a future on a planet that is already burning in so many places, where ecosystems are collapsing, and which is unable to sustain ever increasing greed. A future in which the interests of a few cannot determine the livelihoods of all others. Climate and environmental protection is a human right that we continue to call for, even 50 years later. Now more than ever – giving up is not an option!

From high-risk climbs to highly visible demonstrations held by adults and young people who share a dedication to the cause as in the past, Greenpeace WILL continue to work for the environment and the future of the planet.

Action against highly toxic air pollution
The Böhringer company in Hamburg was releasing highly toxic dioxins into the air, a situation that had to be stopp and so Greenpeace activists climbed th company's chimney, raising awareness and unleashing a wave of indignation. The factory was later closed (top)
25 June 1981

But even 40 years later
the air is still being polluted, by the sar chimneys of coal power plants and by vehicle emissions caused by the failure to implement a sustainable transport policy and the irresponsibility of the ca companies, that cause immense damag to the environment and the climate. Bu it's now no longer just a few activists w are demonstrating: tens of thousands f lowed the calls by the alliance formed by different NGOs during the 2021 International Automobile Show (IAA) i Munich, calling for a phase out of diese fuel and SUVs, and to stop burning oil overall – and demanding a clear departure from car-centred transport politics and give priority to pedestrians, bicycl and local traffic instead (right)
11 September 2021

Nuclear Transport Blockade
protested the dangerous nuclear waste transport through all Germany to the French reprocessing plant La Hague (bottom left)
10 April 2001

Rocks for Life
Granite rocks should protect the marin reserve Adlergrund in the Baltic Sea from destruction by the still legal botto trawls that are destroying the ecosyste of the sea bottom (bottom right)
26 July 2020

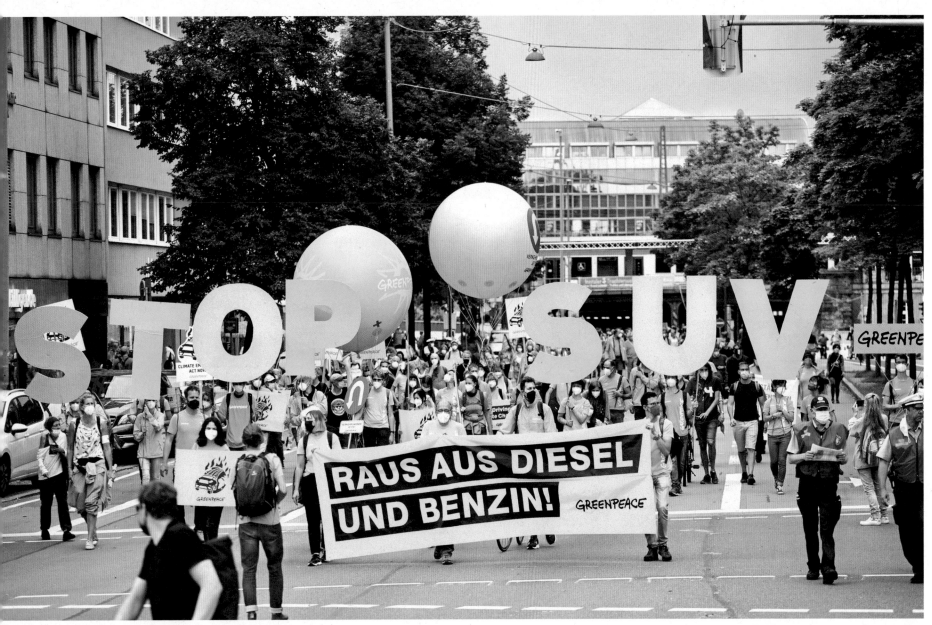

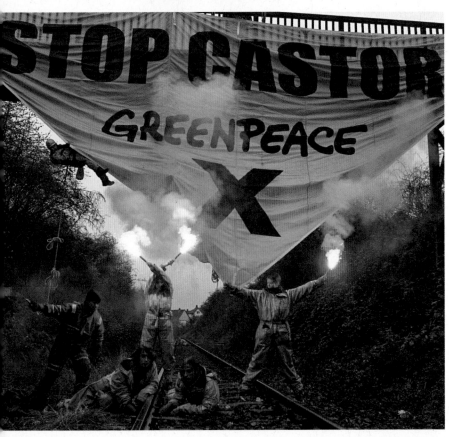

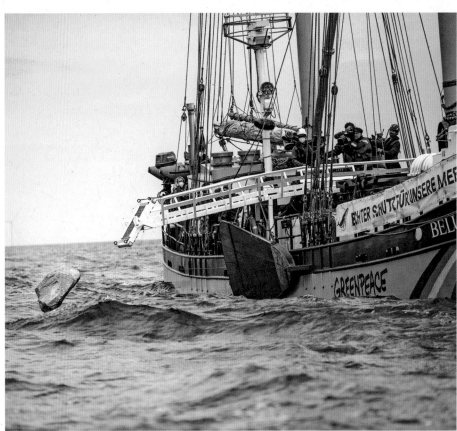

Greenpeace Netherlands
founded 1979
A heart for the sea, while Shell became a fossil

Greenpeace Netherlands has a special place in its heart for the North Sea. Not surprisingly, as it covers our entire west coast and it is our key vacation area, as well as providing the fish on our plates, and it is one of the busiest waterways in the world. What is surprising is that the North Sea is not protected – or, at least, only 0.3 percent was until recently.

One human lifetime ago, the North Sea was a hotspot of biodiversity with basking sharks, dolphins, seals, seahorses, hundreds of different species of fish and even cold-water corals found there. But, due to overfishing and destructive industries, this paradise has been reduced to a sad marine desert in many places. And the meagre level of protection that actually exists is not being enforced, as governments do not keep a close eye on fishermen and companies such as Shell.

Oil and gas companies had permits to drill for fossil fuels in our seas for decades. For years, millions of tons of chemical and radioactive waste were dumped into the North Sea, often less than a few kilometres off the coast. Since it was established, Greenpeace Netherlands has therefore dedicated itself to putting an end to all this destruction; and fortunately, it has done so with results.

Thanks to the impact of our exciting actions also connected to our political work chemical dumping at sea was banned in 1983; a significant first milestone. In 1995, Greenpeace succeeded in forcing Shell to stop dumping their discarded drilling platforms at sea, and instead they had to dismantle and recycle them.

In 2021, the North Sea Agreement was drawn up. One of the most important goals set out within this agreement is that 15 percent of the North Sea must be placed under protection by 2030. That is an area 40 times greater than today's one! This new agreement offers prospects for the rapid development of wind energy, more protection for nature, and less harmful fishing.

The North Sea is connected to all the water on our planet. Currently, only two percent of this global ocean network is protected. And yet there is hope on the horizon: after decades of policy advocacy and actions by Greenpeace, the United Nations is now working on the first Global Ocean Treaty. It is the best chance we have ever had to ensure protection for all the Earth's water, and all the life that depends on it.

In 2021, in a ground-breaking court decision in a climate case against Shell, a Dutch court decided that Shell must reduce its CO_2 emissions by a net value of 45 percent by 2030 relative to 2019. This is the first time a major fossil fuel company was held accountable for its contribution to climate change and has been ordered to reduce its carbon emissions throughout its entire supply chain.

The climate case was brought by Friends of the Earth Netherlands (Milieudefensie), along with Greenpeace Netherlands, other NGOs and 17,379 individual co-plaintiffs. The ruling sends a clear message to the fossil fuel industry. Legal experts expect that the ruling will spark more climate litigation around the world. Different jurisdictions mean different legal avenues, but plaintiffs around the world can and will use the underlying principle that fossil fuel producers have obligations to reduce emissions in line with scientific insights.

Protest at Shell's general meeting
A dinosaur made out of oil barrels at Shell's annual general meeting in The Hague is supposed to show how the second largest oil company is respondi to the environmental and climate crise for which it is partly responsible. We are demanding a rapid exit from the oil business (right)
19 May 2020

Ghost nets cause millions of deaths
Ghost nets – lost, disused or deliberate discarded fishing nets – are salvaged by divers in the Sylt Outer Reef, a nature conservation area in the North Sea, and brought aboard the ARCTIC SUNRISE. An estimated 130,000 dolphins, whales and seals, millions of seabirds and countless other marine animals, such as fish and sea turtles, die each ye in the millions of tons of ghost nets lef drifting in the world's oceans. They have become a huge problem – especial since they continue to remain deadly for up to 600 years (bottom)
12 May 2016

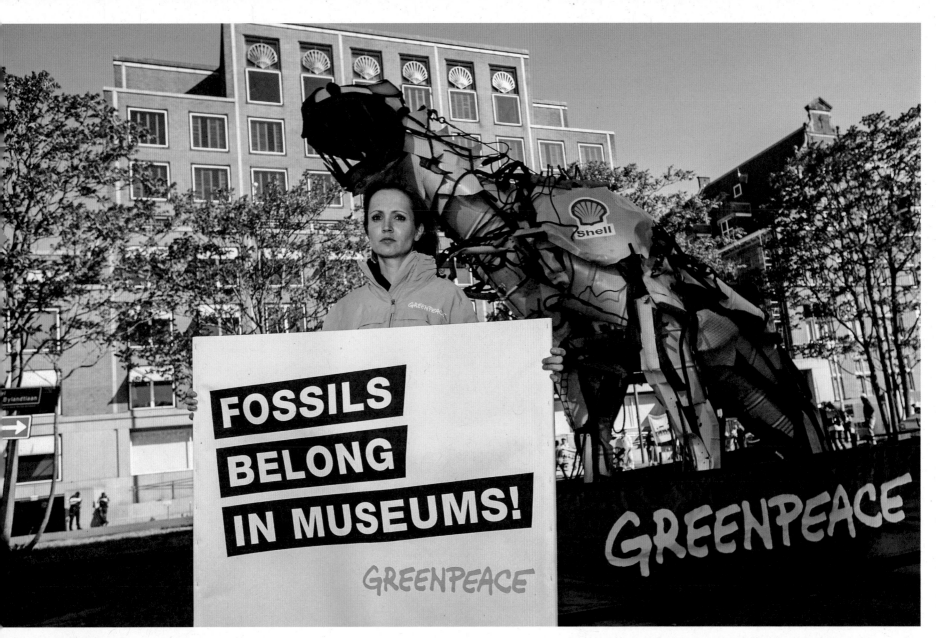

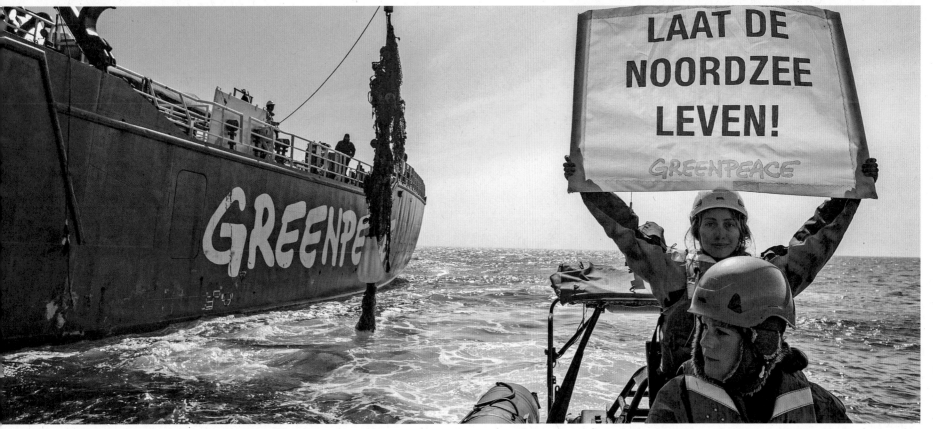

Greenpeace Belgium
founded 1983
In the heart of Europe – fighting for the survival of the Arctic

»Here we go, it's now or never!« The voice crackles over the walkie talkie. Lurking in the stands among thousands of people, the activist on the other end of the line sets off. Opposite, on the other side of the track, just in front of the podium, a small banner slowly unfurls. A scene that will long be remembered is now unfolding.

It is 25 August 2013. Germany's national anthem is playing. At the celebrations to mark the end of the Formula 1 Belgian Grand Prix at Spa-Francorchamps, sponsored by the oil company Shell, all cameras were on Sébastian Vettel, Fernando Alonso and Lewis Hamilton.

At the bottom of the image, what seems to be the Shell logo slowly appears, however the logo has been transformed into half polar bear, half demon. It takes a few moments for security to realise what is happening and to intervene. As the first banner is removed, a second one begins to unfurl under the amused gaze of the pilots.

This was the icing on the cake of a spectacular action in which some 50 people made millions more aware that Shell's oil drilling practices were threatening a wild and unspoiled environment: the Arctic. »It was the most important day of the year for Shell and its public relations,« as Fabien, an activist who was on site, says. »We thought, if they put their image on a platter, drop the platter!«

The small banner was only part of a cleverly put-together series of campaign activities that, in the end, went off without a hitch.

To begin with, two paramotors flew over the start line; shortly before the race was due to begin, a huge banner was lowered down from the main stand, just above the race cars and in front of the VIPs that Shell had invited; on an emblematic corner in the track, a giant logo measuring 15 metres by 15 metres was also transformed into an image that was half polar bear, half demon; and last of all, two activists stepped down from the rooftop to take the podium.

»They were stopped just before they appeared on screen. Too bad. We should always try to remember that the actions by Greenpeace are, first and foremost, only possible with creativity and committed activists, humans who are fighting for an ideal,« as Fabien underscores.

The Shell platter was indeed overturned. Thanks to the extraordinary mobilisation of millions of people both in Belgium and around the world, the multinational ended up abandoning its drilling projects in the Arctic a few years later. Greenpeace Belgium is proud to have contributed to this victory.

Much has happened since 2 April 1984, when Greenpeace carried out its first action in Belgium – protesting against acid rain.

At that first action Karel, the only employee at the time, was assisted by four international activists in climbing a chimney belching out pollution. The group might have been few in number, but they were given help by two young employees of a friendly association, called Eddie and Martin. Both went on to become employees of Greenpeace, and Eddie still works for the organisation today!

The Formula 1 pilots were amazed when a small banner appeared during the ceremony accusing the main sponsor Shell, of endangering the Arctic and the world's climate. The winner reacted with a smile, at least, while security guards and the main sponsor probably did not (top)
25 August 2013

Climate festival in Brussels
Two days before the elections, Greenpeace, together with other climate movements, organised a huge festival to ask future politicians to adopt an ambitious climate policy (right)
24 May 2019

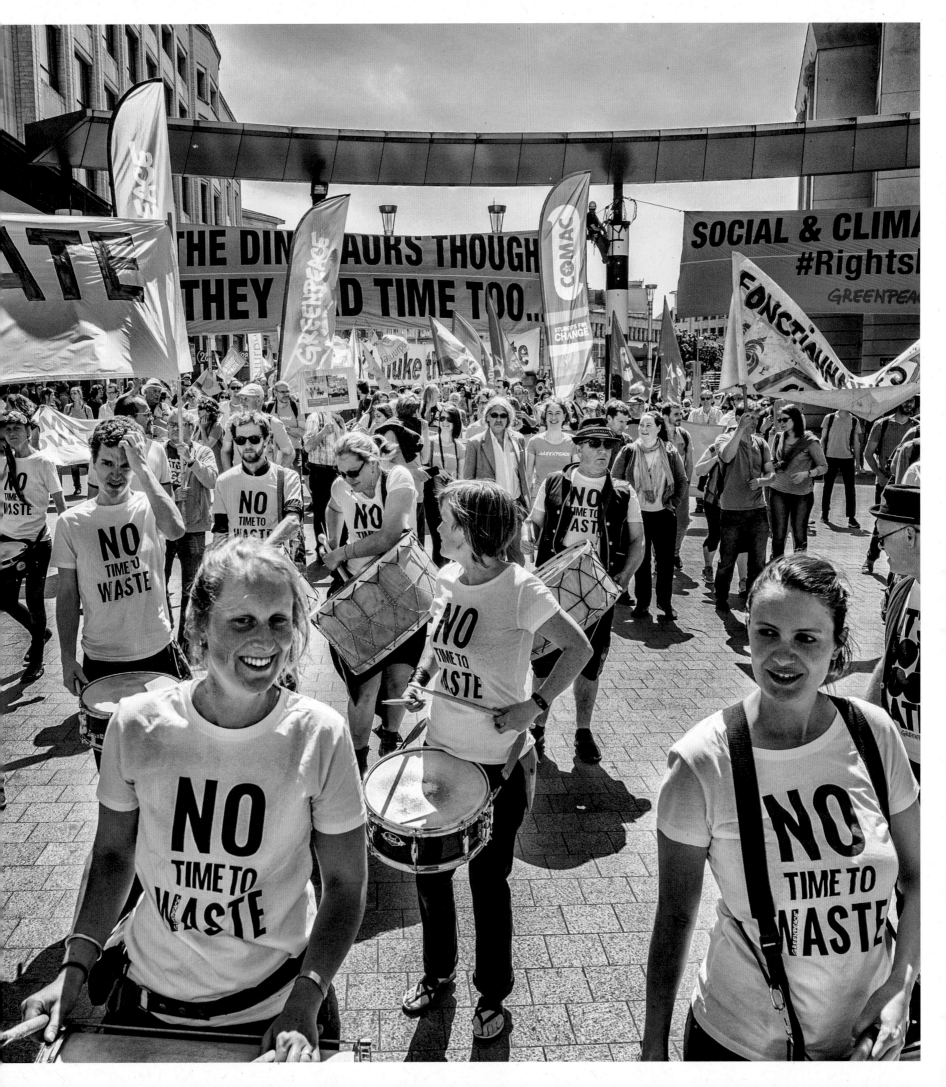

Greenpeace France
founded 1977
You can't sink a rainbow

In 1977, France was carrying out extensive nuclear testing in Polynesia. Meanwhile, in Paris, protests began to grow. Environmentalists got in touch with Greenpeace Canada – which had been founded six years earlier, and had, by that point, experienced regular clashes with the French Navy in the Pacific to expose ongoing nuclear testing. Greenpeace France and Greenpeace UK, both founded in 1977, decided to purchase a retired Scottish research vessel together: the SIR WILLIAM HARDY. After extensive repairs, the ship was operational and renamed RAINBOW WARRIOR. It went on its first expedition in 1978 to campaign against whaling off the coast of Iceland. In 1982, this campaign led to the worldwide ban on commercial whaling.

In 1978, the Cotentin Anti-Nuclear Committee contacted Greenpeace France, as it was fighting against the arrival of Japanese nuclear waste in the region. The RAINBOW WARRIOR crew blocked the arrival of a nuclear waste convoy at the Port of Cherbourg, facing heavy police repression. More actions followed, in particular to combat the dumping of nuclear waste at sea, which was finally banned internationally in 1993. The relentlessness of the anti-nuclear movements became unbearable to the French authorities. In 1985, they bombed and sank the RAINBOW WARRIOR in New Zealand to prevent it from reaching nuclear testing sites in Moruroa. Our Greenpeace photographer and friend Fernando Pereira was killed during the attack. This was a sombre period for Greenpeace France; we had to close down our operations for two years before reopening in 1989. Seven years later, France signed the Comprehensive Nuclear Test Ban Treaty, but the danger of nuclear power is far from banished in a country that still operates 56 reactors.

Greenpeace France has also been very active in defending forests worldwide, being a major player in the push to adopt the EU Timber Regulation. We were decisive in preventing Genetically Modified Organism (GMO) crops from being grown in France, leading to a ban on growing Monsanto's GMO corn. Protection of the oceans is also a recurring theme, with the campaign for the protection of the Antarctic – which

bore fruit in 1991 with the signing of an international treaty – and more recently with the victory against French oil company TOTAL, forcing it to end its oil exploration plans near the mouth of the Amazon, where an extensive coral reef was recently discovered.

In 2015, the French and Luxembourg offices »merged«, focusing on energy, agricultural and financial issues, and demanding a »greening« of the pension funds held in this financial centre.

Emerging from the opposition to nuclear to help promote the energy transition, fighting against climate change, ending industrial agriculture and intensive livestock farming, ending deforestation, exposing the illegal timber trade, the import of Indonesian palm oil or soya from the Amazon rainforests, and overfishing: these are the French office's main battles now, along with other, newer campaigns in favour of climate friendly transport, revegetation of diets, and an in-depth reform of ecologically and socially unsustainable modes of production and consumption.

Peace symbol for Fernando
500 Greenpeace members from 20 countries create a human rainbow peace symbol in the shadow of the Eiffel Tower to commemorate victims o terrorism. Twenty years prior, two bom detonated by the French secret service sank our flagship, the RAINBOW WARRIOR and killed the photographer who was o board, Fernando Pereira. To mark this a niversary, the original crew members ar new activists paid tribute to a colleague killed and a boat bombed in two ceremo nies: one in Matauri Bay, New Zealand, and the other here in Paris
10 July 2005

The whale slaughter must stop
By the end of the 1970s, countless wha were being killed every year by commer cial whalers in all the world's oceans. T first international campaign by Greenpeace aimed to stop this, and proved successful a few years later when the international whaling moratorium was signed, saving so many of these mammals from dying
1 January 1978

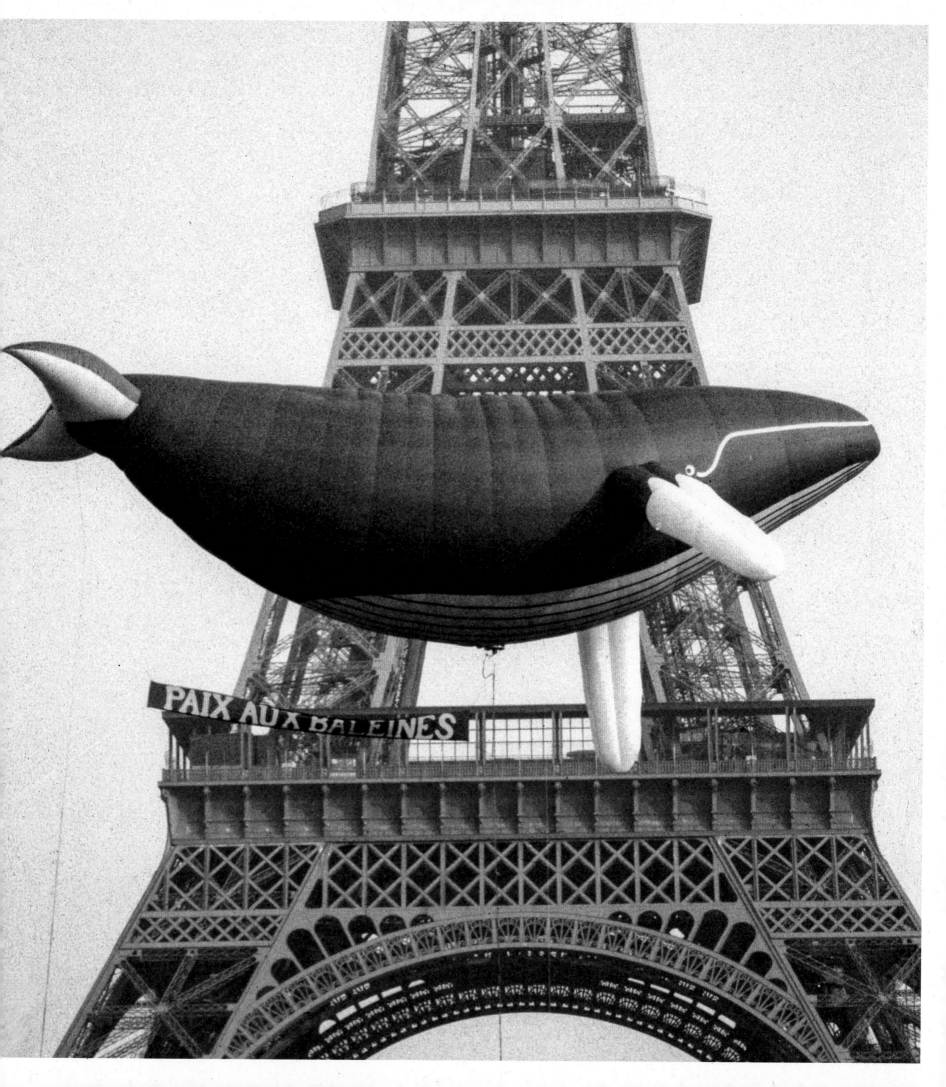

Greenpeace Luxembourg
founded 1984
ExxonMobile – from prosecutor to defendant

It's 2002. The year is slowly drawing to a close, the euro had been Europe's official currency for less than a year, Harry Potter had barely begun his cinematic career, the Rolling Stones released their double compilation album, »Forty Licks«, to celebrate their 40th anniversary as Rock'n'Roll legends – and, one morning in October, more than 700 activists were blocking all the 28 Esso (ExxonMobil) petrol stations in Luxembourg, including the largest ExxonMobil station in the world.

»This is a non-smoking event,« as the protest coordinator said when briefing the activists.

The activists had come from all over Europe, as well as from the U.S.A., Canada, Australia, and New Zealand to protest against ExxonMobile's anti-climate protection lobbying activities – having lent its support to George W. Bush in exchange for his promise to withdraw from the Kyoto Protocol, the precursor to the Paris Climate Agreement.

The activists blocked the pumps all day, defying the chilly autumn weather in the Grand Duchy. »It was a ›once in a lifetime experience‹ – it's not often that we can mobilise hundreds of activists from all the world in Luxemburg,« jokes Martina, who is still with Greenpeace today. »After long months of preparation, it was a great day of action that showed our opposition to climate enemy number 1.«

Taking advantage of a legal ambiguity, the activists could not be removed by the police, who were outnumbered anyway. One consequence of this was that Jean-Claude Juncker, Prime Minister at the time, was considering the introduction of a «Greenpeace law« that would curtail the right to protest! The proposal was widely criticised and was fortunately soon forgotten.

Greenpeace found liable for a substantial fine for having stymied the oil giant's daily operations in Luxembourg. How ironic! After all, the company now finds itself back in court – this time as the defendant. ExxonMobil is being prosecuted for its activities harming the climate, as well as over the consequences its activities wreak on the environment – and biodiversity. The same consequences the company has knowingly concealed and ignored.

Back then, the newspapers called us eco-terrorists when we were, in fact, predicting a future reality that is now hitting us hard.

This protest, and the other endeavours by environmental activists around the world, have shown that ExxonMobil is indeed one of the companies that is, with a complete lack of regard or responsibility, endangering life on earth as we know it. The company has ultimately been identified as one of the »Carbon Majors« (the 100 companies responsible for 70 percent of all CO_2 emissions) and in a lawsuit filed in New York City against the five largest investor-owned oil companies, is now being forced to assume responsibility for the devastating effects that climate change will have on the ecosystem.

Although we were found culpable by a court, and even though the public opinion was against us, we never gave up, and we never will. This is because we are Greenpeace, and this fragile earth deserves a voice. It needs solutions. It needs a change. It needs action.

Mega-protest against ExxonMobile
Climate action and boycott of Esso.
Over 600 activists from around the wor have come to Luxembourg to occupy a Esso petrol stations in the country, including the largest in Europe, to protes Esso/Exxon's collusion with US Preside Bush and Exxon's permanent sabotage of international agreements on climate protection
25 October 2002

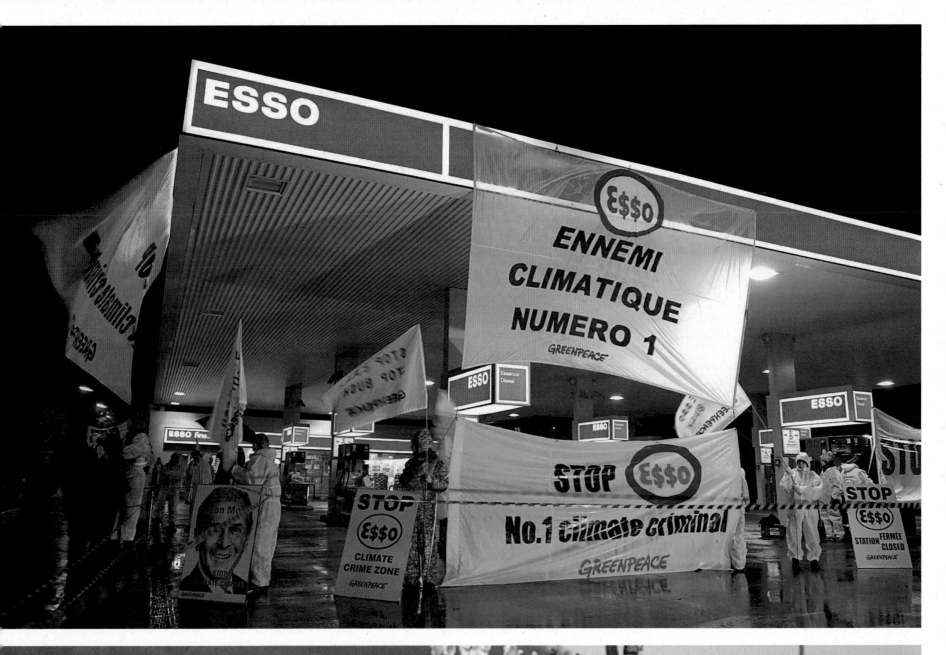
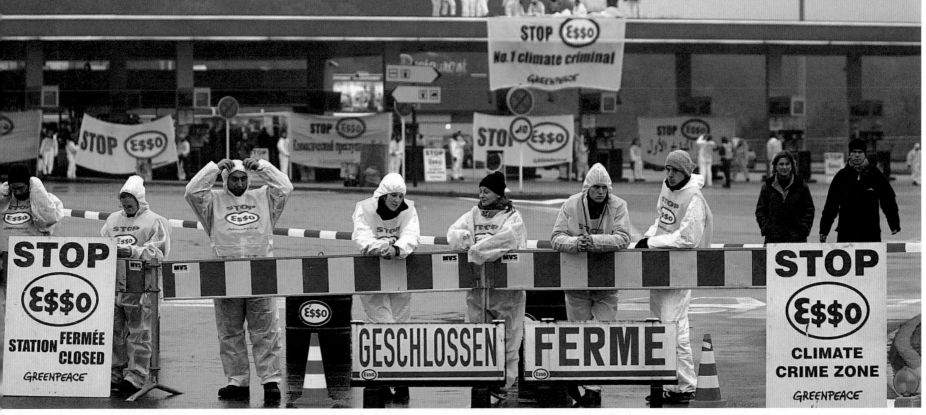

Greenpeace Switzerland
founded 1984
On a rope at the gala dinner

After eight hours, the pressure on her bladder is too much. Muriel has to go – out of necessity – right into her red overalls. This bothers nobody but her, because Muriel is hanging on ropes five meters below the bridge and five metres above the water. Activists mustn't be squeamish. On this day in 1995, they are protesting in the Rhine harbour against the transportation of oil on Europe's most important river. It's one of many campaigns that Swiss Greenpeace activists have carried out in Basel. The Rhine is an important place for the environmental movement. When Greenpeace Switzerland was founded in 1984, the river was a multi-coloured broth polluted by the chemical industry. Today, hundreds of people swim in the Rhine, which is now almost clean, every summer. In between lies more than three decades of struggle against the environmentally harmful machinations of the chemical industry and against toxic landfills, as well as for clean water and purified soil. In the founding years, Swiss Greenpeace climbers, including a female climber, ascended a chimney of the Ciba-Geigy company and held out for 52 hours in freezing temperatures just before Christmas 1984. At the time, Greenpeace was calling for closed water circuits for chemical factories and a halt to the discharge of non-naturally degradable substances into the Rhine.

When Muriel joined Greenpeace, she had no interest in climbing. Hired as a maternity replacement for fundraising activities, she was busy with raising funds and producing brochures. However, fundraising wasn't dynamic enough for Muriel, who grew up in a mountain canton. »We were an active group, a family.« Everyone who worked for Greenpeace was also prepared to take part in an action themselves.

In her work with Greenpeace, Muriel was often inspired by the encouragement she received from unexpected quarters. For example, the climbing crew on the Ciba-Geigy tower received a hot meal from the plant management after they returned to the ground. During a campaign in Paris against nuclear tests, one of the normally tough French policemen whispered to Muriel that he actually supported this protest. His wife was also a member of Greenpeace.

Over the years, more and more support came from Greenpeace's many donors. In Switzerland, there was also interest among project donors and foundations in supporting Greenpeace. Among other things, Muriel organised benefit events in a museum with Basel art dealer and patron Ernst Beyeler. »It always gave Greenpeace supporter Beyeler particular pleasure to invite the upper echelons of the Basel chemical companies that were criticised by Greenpeace,« Muriel says.

In 1992, Muriel's parents were still warning her that if she started working with this left-wing alternative organisation, she would never find another job. And she didn't even have to. Muriel, now 56 years old, is still passionate about her work for Greenpeace and keeps in touch with those donors who contribute generously to its projects. But she now leaves the climbing on bridges to the younger generation. She has hung up her overalls, however her passion for environmental protection remains.

Forest action with timber pie
Greenpeace wishes the editor and publisher of »Facts« a good start. However, the wishes come with a demand to stop the destruction of forests, and to source paper from ecologically sustainable forest management only (right)
5 April 1995

Plastic monster at Nestlé's headquarters in Switzerland
Greenpeace delivers a 20-metre-long »plastic monster« covered in Nestlé-branded plastic packaging to the company's global headquarters in Switzerland. Greenpeace is calling on Nestlé to end its reliance on single-use plastic (bottom)
16 April 2019

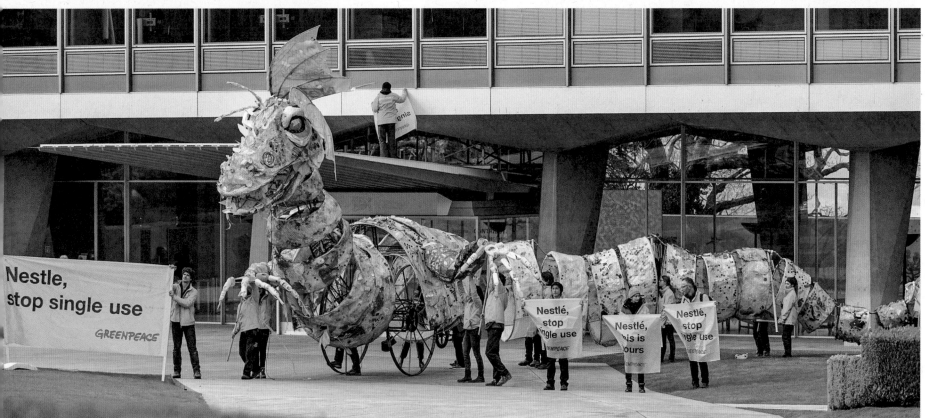

Greenpeace Italy
founded 1986
No nukes, no coal, no oil – entering a sustainable age of transition

David McTaggart, chairman of the board of directors of Greenpeace International, and a key driver in Greenpeace's early years after Bob Hunter's retirement, was also a key advocate for an opening of Greenpeace in Italy – building a bridge to southern Europe and the Mediterranean.

Our first activities in Italy focused on nuclear power: the intervention against the shipping of nuclear waste from the Borgo Sabotino power plant (Latina) to Sellafield; climbing the Colosseum in Rome, and the blitz against the US nuclear submarine base at La Maddalena. The Chernobyl disaster in April 1986 shook the public around the world, and as a consequence of it and various campaigns – a referendum on nuclear power in Italy one year later saw an anti-nuclear victory.

Another referendum in 2011 finally banished nuclear power from Italy. The role of Greenpeace in this victory was pivotal. Following another catastrophic disaster (Fukushima, Japan), five of our activists decide to lock themselves in a »refuge«, acting as if they were in a nuclear emergency and following the security protocols. Their »messages in a bottle«, a giant nuclear waste bin with a view of Saint Peter's Church, and the huge banner unfurled by Greenpeace at the Olympic Stadium in Rome during the Italian Cup final, were milestones in this iconic campaign.

Since its inception, Greenpeace Italia has denounced the trafficking of toxic waste produced by Italian industries, which is being illegally transported to Africa by pirate ships. To save the Mediterranean from the threat of trawling and driftnets, which kill dolphins and sperm whales, campaigners and activists haven't hesitated to confront fishermen and the institutions involved.

When France announced new nuclear tests at Moruroa in French Polynesia, the world was opposed: in Rome, the famous singer Gianna Nannini climbed the balcony of the French Embassy at Palazzo Farnese together with Greenpeace in protest.

Global warming is now recognised as reality, and has rapidly become a top priority for Greenpeace in Italy , while other important victories have also been achieved, such as the progressive banishment of the swordfish driftnets from the Mediterranean, the establishment of a sanctuary for cetaceans in the Ligurian Sea, the prevention of illegal sowing of GMOs in Italy, the moratorium on the use of palm oil causing the deforestation of Indonesia promoted by Ferrero (the producer of Nutella), the more than thirty companies in the textile district of Prato joining the detoxication principles.

The new millennium saw further growth of Greenpeace in Italy, which also spearheaded a major campaign from 2006 to 2014 against coal development plans by ENEL, one of the largest energy suppliers globally, that ended with a tangible shift towards renewables and efficiency. In Italy, the coal phase-out is now planned for 2025.

Our new integrated campaign approach now combines the key areas of »Climate«, »Food«, »Ocean« and »Plastic«. Italy's ecological transition is the goal, with major efforts having been undertaken during the COVID-19 pandemic to influence the recovery plans. The most important target is now ENI, the Italian oil and gas giant, whose plans and activities are the main obstacle to decarbonisation of the Italian economy. We, Greenpeace Italia, have won many campaigns, but there's now an even tougher challenge to face (as for Greenpeace globally): ending the fossil fuel age.

Climate killer ENI
The evening before the shareholders' meeting, we are at and in front of the headquarters of the Italian oil giant ENI clarifying what we think of them: »ENI – Climate Killer«. The floating replica of a melting iceberg in the pond in front of the company's headquarters a testimony to the dramatic impact of t climate emergency (top)
12 May 2021

From Milano to Palermo
»From Milano to Palermo – no nuclear« is what Greenpeace demanded at the Italian Football Cup final between Inter Milano and US Palermo in the Olympic Stadium in Rome (right)
29 May 2011

DA MILANO A PALERMO
FERMIAMO IL NUCLEARE
GREENPEACE

Greenpeace Spain
founded 1984
The lucky number 13 within the global network

Greenpeace first started campaigning in Spain back in 1978, when Spain was still hunting whales without any controls or quotas – at the time, it wasn't even a member of the International Whaling Commission. That year – the same year the Spanish Constitution was approved after forty years of Franco's dictatorship, who was a whale hunter too – Greenpeace's first ship of its own, the RAINBOW WARRIOR, set sail on one of its first missions confronting the whale hunt taking place off the coast of Galicia. The Spanish navy attempted to detain our ship, we managed to evade it. The RAINBOW WARRIOR returned once more in 1980 to stop the whale slaughter. This time, the ship was detained, and the Spanish navy removed the propeller shafts to prevent an escape. The vessel was held at a military dock in the Port of El Ferrol for five months. Greenpeace was creative enough to secretly reinstall the propeller mountains, and escaped. An embarrassing turn of events for the military base! Greenpeace made the front pages of the national press.

Greenpeace returned again in 1982 with another vessel, the SIRIUS, to halt the dumping of barrels containing radioactive waste in the Atlantic. One year later, it headed for the region around the Strait of Gibraltar, where Russian whalers were operating. These first actions had a huge impact. The popularity of Greenpeace surged in Spain, leading to an office being opened in 1984 – the 13th Greenpeace organisation worldwide.

After a few more years of intensive campaigning, the London Dumping Convention signed in 1985 imposed a moratorium on the disposal of radioactive waste at sea, and in 1986, the international moratorium on commercial whaling entered into force with the approval of the International Whaling Commission.

Greenpeace Spain also supported international campaigns against nuclear tests, and to protect Antarctica. We launched a new campaign to help defend the Mediterranean Sea in 1986 with an intense and exciting four-month journey by ship, denouncing the dumping of toxic waste and calling for the creation of protected areas. As we grew in Spain, so too did the number of campaigns. Calls to close nuclear power plants, to end the incineration of waste, stop chemical dumping, phase out fossil fuels, end destructive fishing practices and halt the destruction of coastal ecosystems caused by irresponsible urban planning, to stop plastic pollution, industrial-scale farming, and the sale of illegal wood, and to end the arms trade, are just a few of the issues we have addressed, while also promoting alternatives. Renewable energies, sustainable fishing, cleaner production and responsible consumption are some of the initiatives that have gained a growing importance.

Dozens of actions, some of them emblematic and inseparable from the history of Greenpeace in Spain, have been carried out, such as the blocking of toxic waste outlets in Portman Bay (Murcia), the actions at the Zorita and Garoña nuclear plants, or successive »visits« to the luxury hotel El Algarrobico, which was built in a national park. These actions are always backed up by solid research, extensive reports, advocacy activities and legal proceedings. One highlight among these actions is a highly topical issue: climate litigation against the government.

Environmental education involving camps and training courses in solar energy, forestry, and activism also pursues a common vision: the urgent need to push for a systemic change due to the climate emergency and the loss of biodiversity we are currently facing. The ecofeminist perspective has also been integrated, with its objective of ensuring that life remains at the centre of all activities. We are also involved in many initiatives and alliances with a multitude of organisations and movements.

In 2021, Greenpeace Spain can count 140,000 supporting members and around 2,000 volunteers, and has a staff numbering almost one hundred. Thanks to them, we can still dream of a green and peaceful world.

Turn off the coal
We entered the site of the Meirama coal fired power plant in La Coruña, operated by Naturgy, to demand its closure due to its impact on the climate and on health. One group of our activists occupied the coal unloading area, while another climbed up the cooling tower, planning to create a large drawing to demand that coal be phased out to make way for a 100 percent renewable system (right)
30 November 2018

Casablanca oil platform
should close down
Our ship, ARCTIC SUNRISE, and the symbolic oil on the cloth held in front of the huge Casablanca oil drilling platform, demanded a stop to oil production at sea (bottom)
26 June 2015

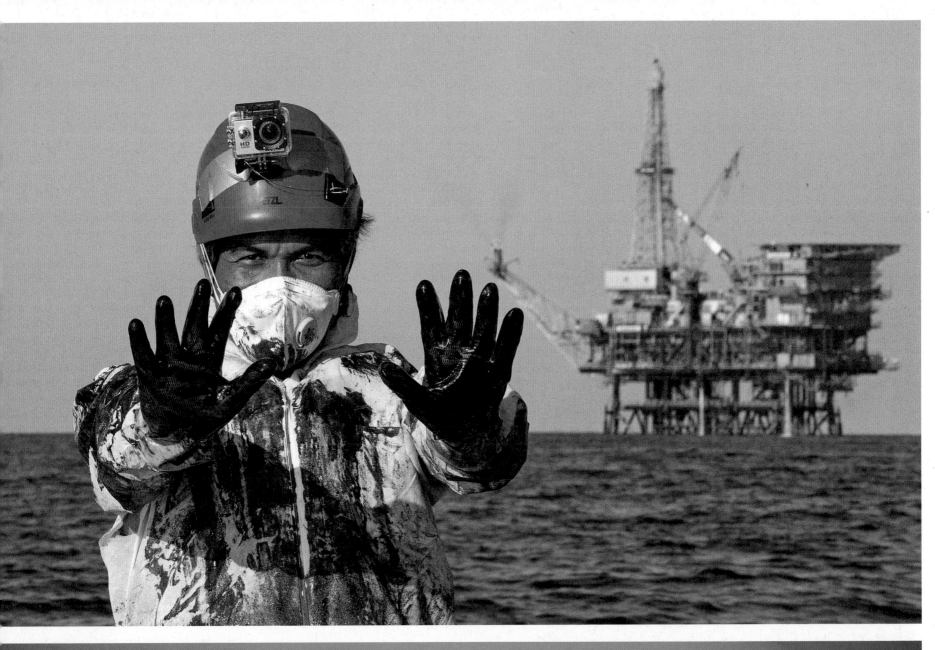

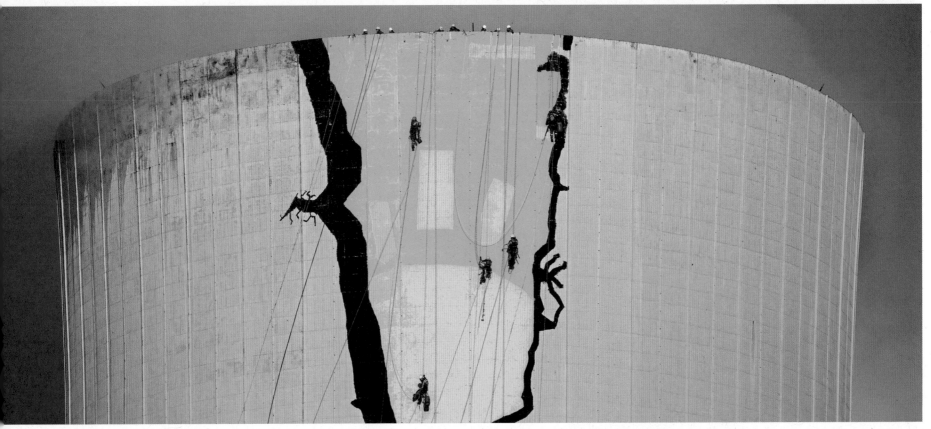

Greenpeace Czech Republic
founded 1991
Coal phase out in favour for a clean and renewable energy future

Greenpeace was active in Czech territory for the first time in 1984 when activists climbed the chimney of a coal-fired district heating plant to draw attention to toxic smoke emissions. At that time, the country was under communist rule, and the activists were shot at by the members of the local militia, before being arrested and banned from the country. Despite the dangerous conditions, Greenpeace prepared more protests, such as the one held at the iconic National Museum building in the centre of Prague to warn against the risks of nuclear energy, just months after the Chernobyl disaster.

At the time, the state of the environment was dire in Czechoslovakia. Smog and haze from coal combustion blanketed northern Bohemia, the forests were dying due to the dangerous emissions, and heavy industry had created many toxic hotspots. The regime tried to conceal the information about the state of the environment – and yet it failed. In fact, protests to demand clean air were one of the sparks that ignited the Velvet Revolution, leading to the fall of communism in Czechoslovakia in 1989. In the middle of a chaotic transfer of power to the new democratic government, a Greenpeace rainbow bus from Austria arrived in the centre of Prague and thousands of people queued to sign a petition against nuclear energy.

In 1991, Greenpeace was officially launched in Czechoslovakia, but two years later, it was split into a Czech and Slovak office respectively after the separation of the two countries. Ever since its beginnings, Greenpeace Czech Republic has primarily focused on toxic pollution and coal.

Greenpeace campaigned against the problematic industrial chemical plants, and in particular against the dirtiest of them all, Spolana. As Greenpeace revealed, Spolana was not prepared for any natural disasters. The flooding that occurred in 2002 did, however, cause a massive leak of hazardous chemicals, as well as explosions. While the company still attempted to deny there were any problems, Greenpeace flew over the site and documented the real extent of the catastrophe.

The biggest problem for the Czech environment has been the massive coal mining and combustion activities – history's greatest environmental polluter – going on for decades and which continue to destroy nature, pollute the air, and fuel the climate crisis – making it the number-one campaign for Greenpeace CZ. After the Velvet Revolution, the situation started to slowly improve, with subsequent Czech governments installing filters into the old coal power plants and setting boundaries for lignite mining in the 1990s. The struggle for the village Libkovice became an iconic symbol of the preposterousness of this devastation, which saw the village being destroyed for a planned expansion of the coal mines. Ultimately, no mining ever occurred there, meaning people were forced to leave their homes behind pointlessly. But, the struggle helped to mobilise the community and prevent any further expansion of the mines. The town of Horní Jiřetín was saved from destruction in 2015 after a long Greenpeace campaign against the coal industry and its plans to expand a mine into the town's territory. Since then, Greenpeace has launched a counterattack against coal, and now is pushing for a complete coal phase-out in favour for a clean future based on renewable energies.

Catastrophic lignite mining
Together with members of the local population, 30 activists from five countrie erect a large banner with the inscriptio »Climate change begins here« at the lar open-cast lignite mine in Northern Bohemia in the Czech Republic. Greenpeace is calling on Czech politicians to share responsibility for protectir the global climate, and to confirm the validity of environmental limits in the mining area. The limits have been vehemently opposed by a mining company that wanted to expand its operations. The Czech Republic is amo the largest producer of lignite in the world, which is the most harmful to the climate of all types of coal (top)
15 February 2007

Toxics in Spolana
We are wearing protective suits and getting ready to take samples of soil potentially contaminated with mercury at the Spolana chemical plant in Neratovice, 30 kilometres from Prague. This is three months before the Spolan catastrophe, in which a cloud of chlorin was released and the plant was flooded (bottom)
6 May 2002

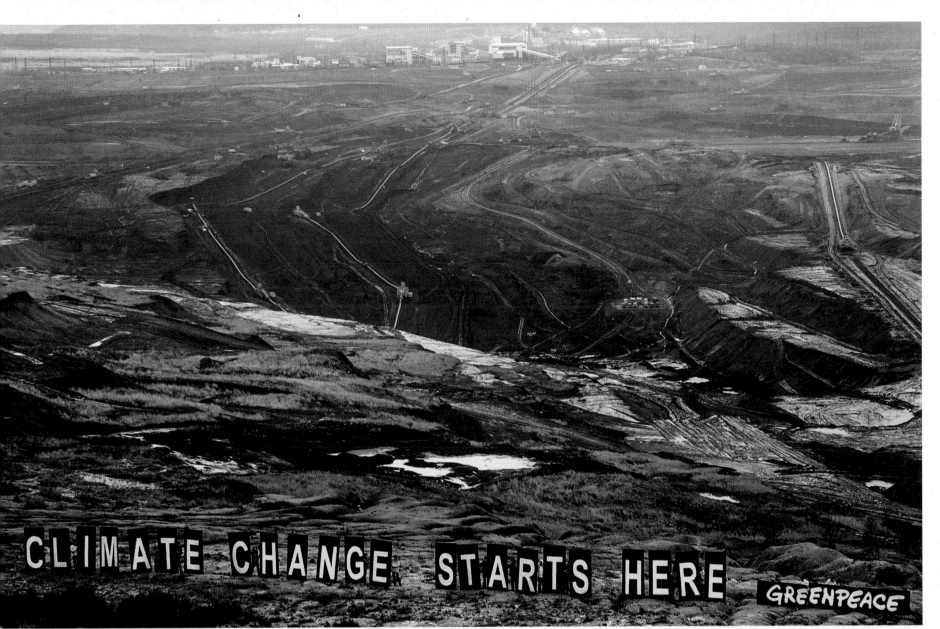

CLIMATE CHANGE STARTS HERE GREENPEACE

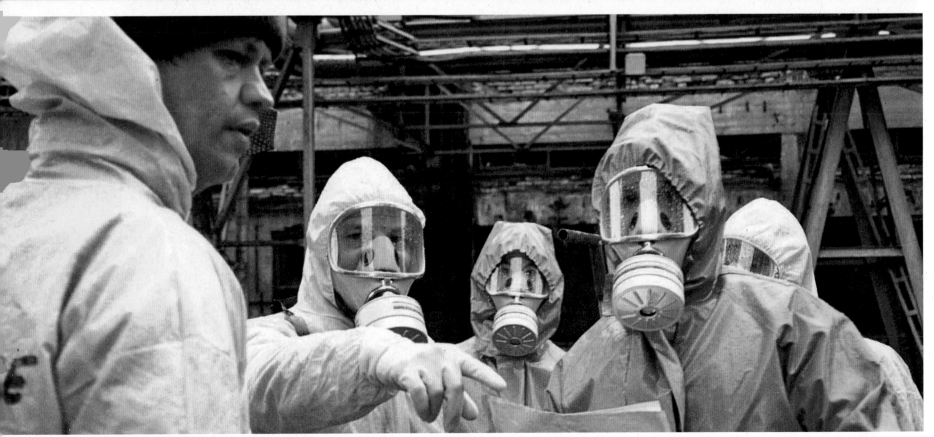

Greenpeace Central & Eastern Europe (CEE)
founded 2000
Eastern Europe – a key to peace and environmental justice for all Europe

Greenpeace in Central & Eastern Europe (CEE) operates in eight countries. We have offices in Austria, Bulgaria, Croatia, Hungary, Poland, Romania, Slovakia and Slovenia. We are supported by 100,000 donors, and campaign as a team of 180 people working hand-in-hand with volunteers and activists.

Starting an organisation from scratch is challenging. Being successful right from the start even more so. Despite many unfavourable conditions for Greenpeace in Central & Eastern Europe, the organisation achived immediate success, allowing it to prepare the ground for bigger, more transformational changes. From saving threatened nature and landscapes, reducing toxic burdens and emissions and banning genetically modified organisms (GMOs), to driving fundamental changes in the energy system, Greenpeace is writing chapter after chapter in an environmental success story for the CEE region. We have achieved many things over our almost 30 years of campaigning in the region. Some of the highlights include:

- *Increasing the protection for the large whales by bringing the CEE countries to the International Whaling Commission voting in favour of these fascinating mammals*
- *Phasing out the use of coal across the region, stopping all new coal projects in CEE*
- *Preventing nuclear expansion in the region*
- *Banning GMOs and bee-killing pesticides*
- *Protecting many valuable natural areas from destructive infrastructure projects and logging*
- *Stopping destructive trade deals*
- *Banning single-use plastic products*
- *Forcing clean-up actions to deal with toxic waste dumps in many countries*
- *Stopping oil drilling in the Adriatic Sea*

Each of our offices has a fascinating history starting in the 1980s, and continuing into the early 2010s. What unites us is that we all want to live in healthy and peaceful countries, where forests flourish, waters are teeming with life, and where once-threatened animals safely roam. We have no doubt that we can only achieve this together!

Clean air for Budapest
The action at the Statue of Liberty in Hungary aims to remind politicians that air pollution has been an extreme problem in Hungary since 2009. Around 13,000 people die each year as a result of air pollution. According to the European Environmental Report 2018, the country ranked second on the list of air pollution-related early measures per capita in the EU
26 February 2019

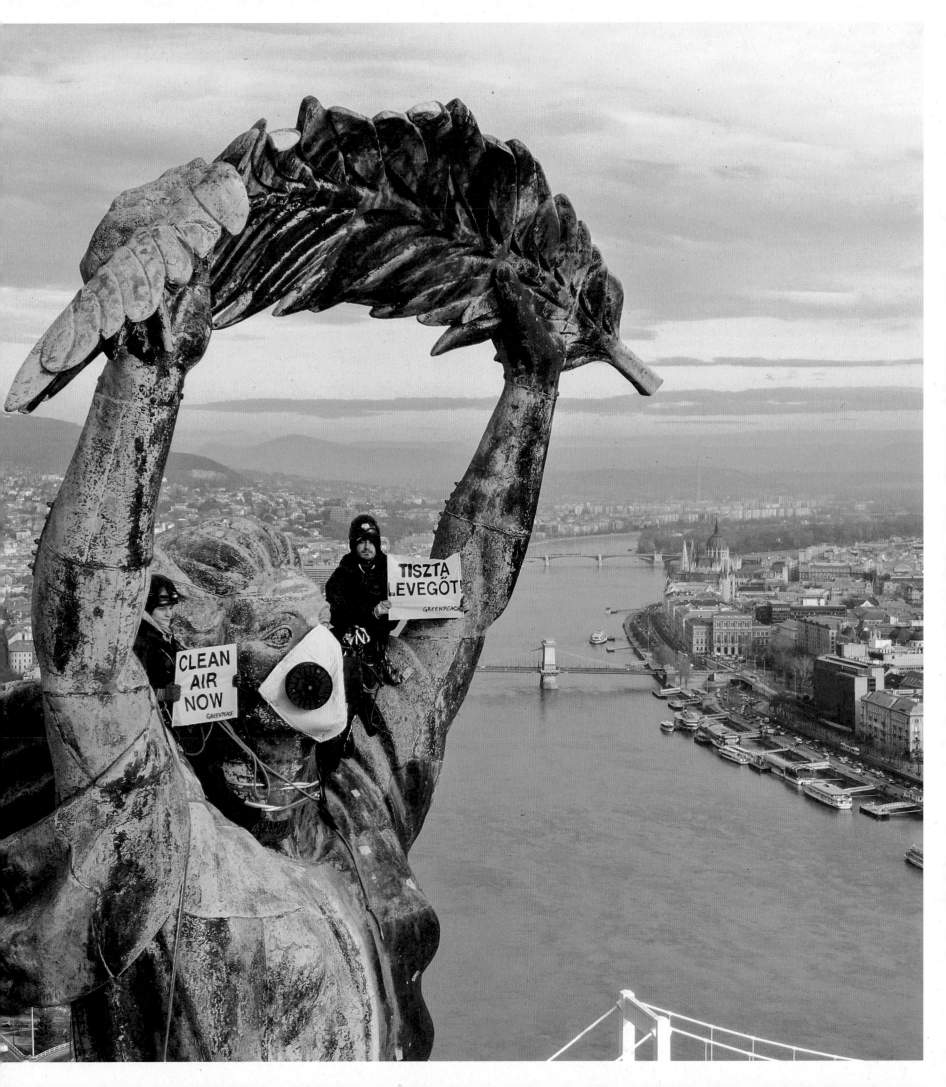

Greenpeace Poland
founded 2004
Full power against lignite and for the protection of nature

Our defining moment occurred in 2004 with the first highly visible campaigning activities that aimed to save the Rospuda River Valley – an area inhabited by endemic species and teeming with biological diversity. Days and nights were spent on the streets of Poland as well as in a forest in freezing winter weather, platformed in a tree in non-violent protest. Looking back, we see how the success of those first moments laid a cornerstone for the organisation that Greenpeace Poland is today. Courageous and innovative direct non-violent actions as well as our unique expertise exhibited in extensive and detailed reports helped us draw the attention of the public and decision-makers to the most important ecological problems we are facing both globally and locally.

When you think of Greenpeace Poland today, what do you see? Any number of cleverly designed actions, such as the one staged against one of the largest climate killers in the EU, whom we took to court demanding a coal phase-out by 2030. We have climbed the highest cooling towers, we have called for climate justice by blocking ministries, and exposed dirty business practices covered in waste, dust and pollution. Or possibly you remember the campaign to save Białowieża Forest and its iconic wildlife – the European bison – which was a campaign that mobilised hundreds of thousands of people to join our activists in shielding the forest from logging machinery with their own bodies. Or maybe you see how we promote environmentally friendly agriculture, taking care of bees and other endangered species, and helping conserve valuable ecosystems. You've seen clearly – we've done all that and are continuing to do much more. Sometimes by ourselves, and sometimes with allies from different coalitions and causes that we are proud to be a part of.

But what we mostly see is Greenpeace as a group, a community or even the beginning of a movement created by different people from all walks of life, with all their stories and experiences – and who act together and dream of a better place to live for all of us.

Greenpeace Slovakia
founded 1991
Coal face out already archived – a giant victory

A Greenpeace office was officially set up in Czechoslovakia in 1991, and two years later it transformed into Czech and Slovak offices as the country split into two parts.

We started out in Slovakia in 1993 as a campaign office with a primary focus on anti-nuclear campaigning. The office attracted quickly young and motivated activists. In 1993, the first activity took place – an information stand and signature collection to petition against the construction of two new nuclear reactors of Mochovce. In the summer of 1994, Greenpeace Slovakia went ahead with its first non-violent direct action, hanging a giant banner from the cooling tower at Mochovce. Many successive activities led to the first success by the Slovak Greenpeace, marked by the European Bank for Reconstruction and Development abandoning the financing of the reactors – along with a subsequent one when the government of Slovakia decided in 1999 to close the oldest two reactors at the Jaslovské Bohunice power plant early.

In 2001, Greenpeace Slovakia officially became part of Greenpeace Central and Easter Europe and started to branch out into other areas – anti-genetically modified organisms, toxins, pesticides, and coal. Among some of the biggest successes enjoyed by the Slovak office were ban on sale of PVC toys, joining the International Whaling Commission, the largest offline petition in history of the country, and successive stops to uranium mining by the Slovak government, as well as becoming the first country in Central and Eastern Europe to announce an early coal phase-out in 2023. Based on recent research published at the end of 2020, Greenpeace is today the most widely recognised NGO in Slovakia.

One of the largest climate killers in Europe
We occupy the Turów lignite mine operated by PGE, the largest Polish energy supplier, due to its lack of a coal phase-out plan and its catastrophic carbon footprint (right)
17 March 2021

Coal – a driver of climate change in Slovakia
Activists climb the winding tower of the Slovak coal accelerator HNB in Nováky. We were protesting against the continu mining and burning of coal in Slovakia (bottom)
28 November 2018

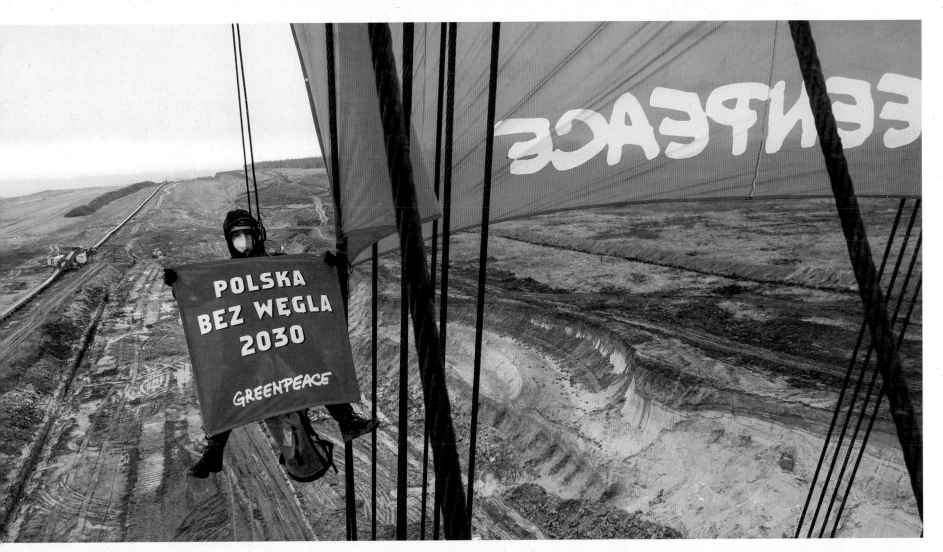

POLSKA
BEZ WĘGLA
2030
GREENPEACE

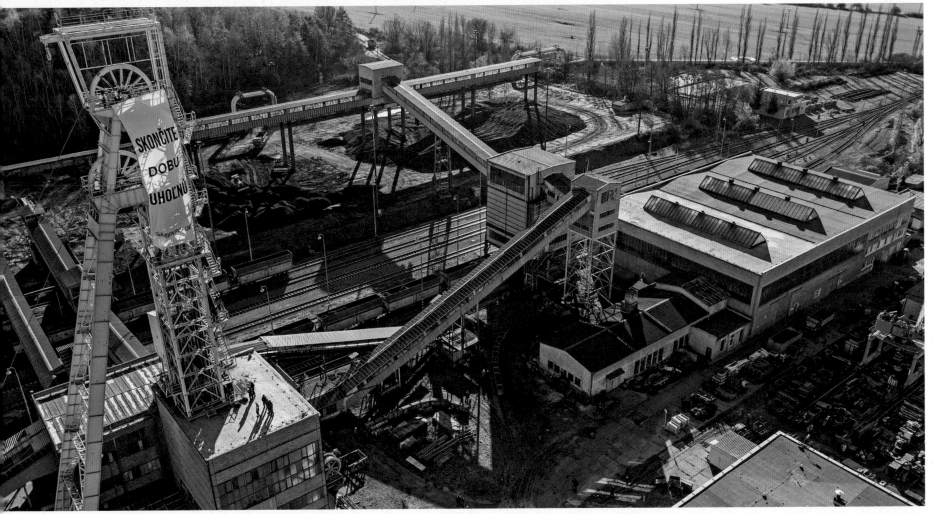

SKONČÍTE
DOBU
UHOLNÚ

Greenpeace Hungary
founded 2002
Fight for whales, an energy revolution and against single use plastic

Greenpeace Hungary started out in 2002 when activists in protective gear carried barrels of toxic water to the entrance of a chemical plant that polluted one of the country's main rivers, the Tisza. The action shed light on the scandalous way the factory operated and forced the company to take action against the contamination. A few years later, we erected barriers on top of a thickly wooded hill to prevent a NATO radar station from being built in a nature conservation area. As a result, no trees were felled, and the government had to scrap its plans.

Ever since we opened our office in Hungary, protecting people's health and the environment have gone hand-in-hand. We contributed to the moratorium on genetically modified organisms and fought for stricter rules for smog alerts and identified illegal industrial toxic dumping sites.

In our work, we promote organic agriculture and farming and fight to protect biodiversity. We expose investments by corporations and by the government which cause harm to the environment. We successfully pushed the government for a coal phase-out by 2025, and we are working hard to prevent any new oil and gas exploration from occurring in Hungary. We are raising awareness about the dangers of nuclear energy and promoting renewables as the only solution at a time of climate and ecological crisis. We are demanding clean transportation, an end of single-use plastics and are campaigning for clean air, clean water and fertile soil so that people can live in harmony with nature.

Greenpeace is the best-known environmental organisation in Hungary, and its petition against single-use plastic bags was the most successful NGO initiative ever in Hungary's history. As a result, the use of single-use plastic bags will be restricted from summer 2021.

We have also contributed to to global campaigns, such as the one to prevent commercial whaling from resuming in 2003, and have been making sure that Hungarians can do their bit to protect oceans, rainforests, the Arctic and the Antarctic.

Greenpeace Austria
founded 1983
Coordination for Central and East Europe

The first Greenpeace action in Austria took place in 1983. And it was highly successful: the dioxin-contaminated trichloro-phenol plant operated by Chemie Linz was closed down.

Although the effects of industrial excesses – acid rain, dead fish in poisoned rivers – were growing noticeably, raising awareness about the need for environmental protection was of central importance in the first years.

The spirit that prevailed in the early 1980s advertised nuclear energy as the technology of the future, promising that the growing amount of radioactive waste was to be eliminated by »clean« waste incineration. Few corporations or politicians were ever held accountable for the destruction of the environment.

Much changed in the spring of 1986 with the nuclear accident in Chernobyl. A radioactive cloud contaminated half of Europe, the debate about nuclear power in Austria ended abruptly, and a new awareness for environmental protection emerged.

In the 1990s, our organisation promoted the successful referendum to ban genetic engineering in Austria. Internationally, a milestone for the environment was reached with the ban on commercial mining in Antarctica. These early successes gave us confidence. To this day, we are fighting for the environment on many fronts: be it for a halt to trade pacts such as EU-MERCOSUR, for the protection of the Amazon or for a climate policy that delivers what it promises.

Environmental protection knows no national borders, and this allowed us to successively expand our activities to the Eastern European region. The Austrian Greenpeace office has acted as headquarters for Greenpeace in Central and Eastern Europe since 2000.

Austrian environmental crimes in the Arctic
Protest against oil drilling by the Austrian oil company OMV near Bear Island in the highly vulnerable Arctic. An intact Arctic is crucial for many global weather and climate processes
7 March 2016

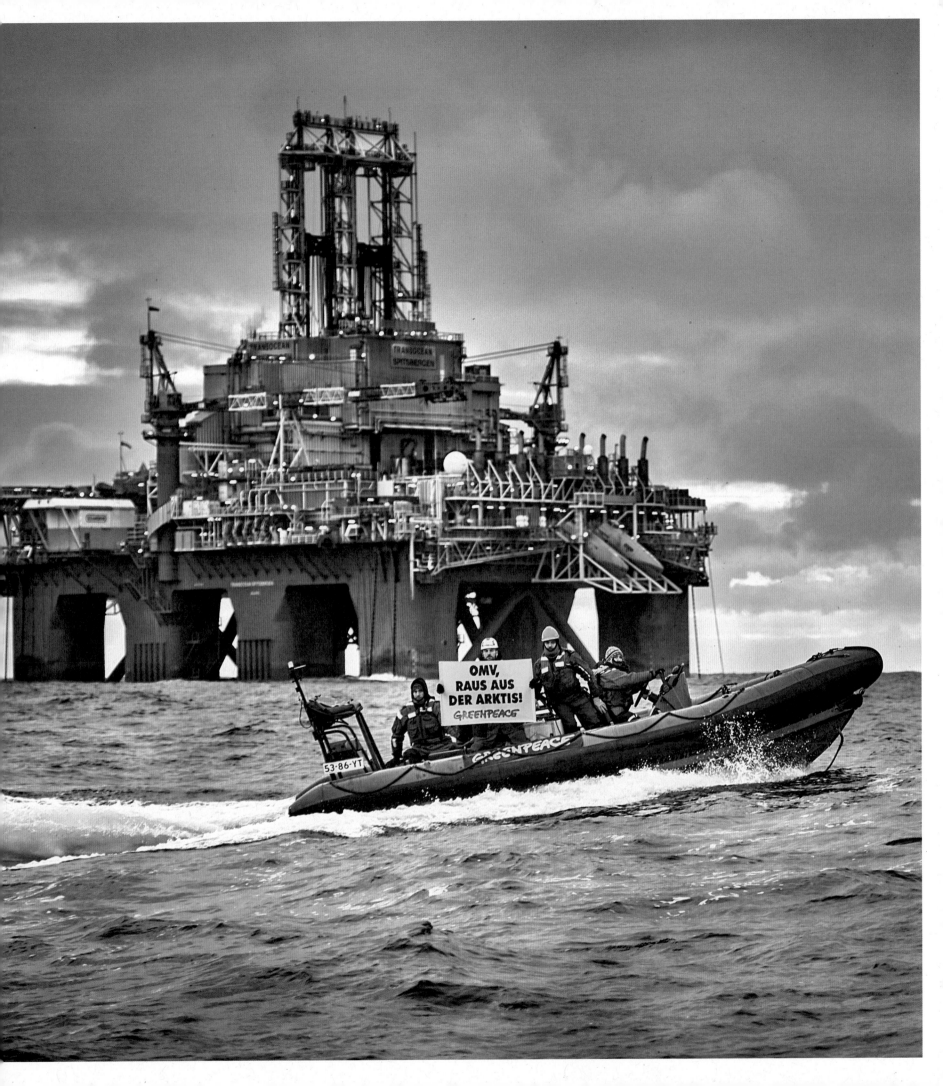

Greenpeace Romania
founded 2007
Following the tracks of Robert Hunter

Greenpeace Bulgaria
founded 2011
Energy revolution is key to protect the climate

Robert Hunter, one of the founders of Greenpeace, once said »Big change looks impossible when you start, inevitable when you finish«. We at Greenpeace Romania remember his words every time we prepare for a high-stakes battle that seems impossible to win. We have been active in Romania for 14 years, running campaigns for forests and biodiversity, the coal phase-out, a just transition to renewable energy, prosumers' rights, and climate and democracy. Over the last one-and-a-half decades, Greenpeace Romania became one of the most high-impact NGOs in the country.

Greenpeace's active presence in Bulgaria started in 2011, even though the small movement that would later become Greenpeace Bulgaria had spent many years supporting the anti-nuclear campaign by a local movement prior to that (seven to be precise). With the help of Greenpeace CEE, a project to construct a new nuclear reactor in Belene could be delayed, and was subsequently cancelled.

The Bulgarian team has been working to protect European seas and to change the Common Fisheries Policy. The office was involved in the campaign for the protection of the bees and to promote ecological farming. It works closely with other Bulgarian organisations on the »Plastic-free« campaign.

The team's main focus has been directed at the transformation of the energy systems since 2014 – moving away from burning coal and other polluting fuels to the use of renewable energy and set up of energy communities.

Our approach when trying to lend credibility to our messages is to be a hero among heroes. Over the years we have, and continue to, make the fate of coal-affected communities better known. One major success we achieved was to involve almost one hundred people living close to one of the most highly polluting coal-fired power plants, located in southwest Bulgaria, to join a court case we launched against the power plant.

The RAINBOW WARRIOR against climate change
As part of the »United for Climate Tour«, our Greenpeace ship RAINBOW WARRIOR stops in Constanța, Romania, to raise awareness about the global climate crisis. The purpose of the tour is to send a powerful message to Romanian and other European leaders about the impact of climate change and the importance of phasing out coal by 2030. While in Constanța, Greenpeace participated in several activities, including a press conference, a guided tour by Greenpeace volunteers, live concerts, and a photo exhibition in front of the ship (right)
29 May 2019

No plastic
… is what is being demanded at the Asparuhov Bridge in Varna, Bulgaria (bottom)
10 August 2017

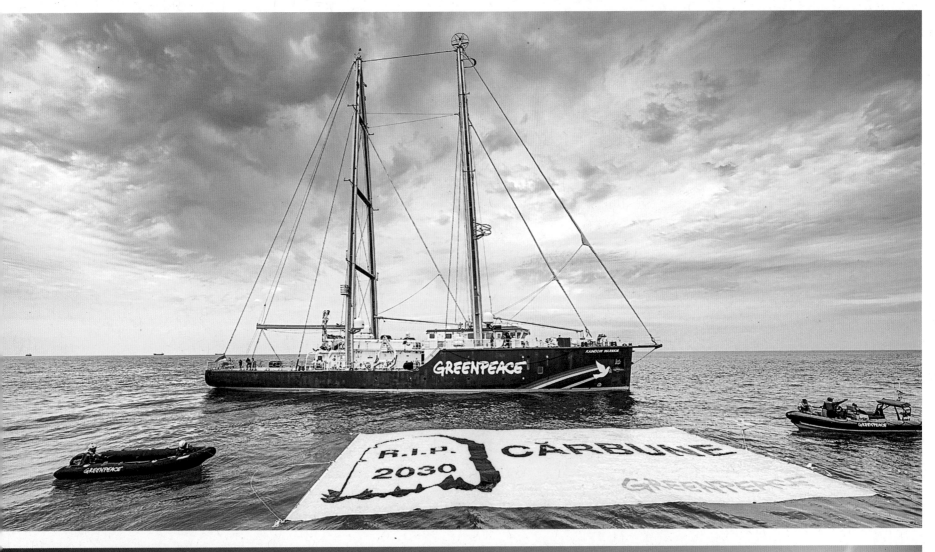

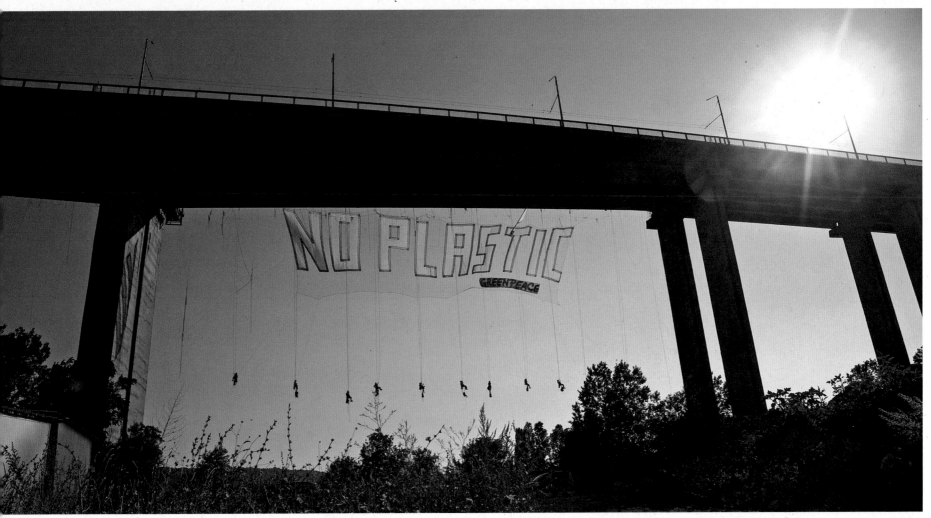

Greenpeace Croatia
founded 2012
Adriatic Sea, the pride of the country, its protection one of our goals

Greenpeace has maintained a presence in Croatia since 2012, when the country was in the final phase of the process of joining the EU. Greenpeace was established as an NGO in Croatia in 2014. The most notable campaign victories by the youngest CEE office were the cancellation of the construction of Plomin C, a planned 500 MW unit at the Plomin coal power plant, and the shelving of major plans to drill for oil in the Adriatic Sea. Since its beginnings, Greenpeace in Croatia has campaigned for sustainable fisheries, climate and energy, protection of the oceans, and urban green spaces, and against oil drilling in the Adriatic Sea and single-use plastics.

In a sunny country with an inexplicable dearth of solar panel installations, the work by Greenpeace Croatia on energy solutions has focused on solar energy, both by advocating solar use with the relevant stakeholders, and bringing media attention to the issue by organising solar tours and holding completely solar-powered screenings or concerts.

Our plastics campaign drew particular interest and encouragement from the public, with tens of thousands of our supporters signing a petition for a national ban on plastic bags. The Adriatic Sea – the country's pride and joy – has a special place in Greenpeace's work in Croatia, whether we are defending it against destructive drilling practices or from plastic pollution – another huge threat that it faces. Access to the sea and several major ports has given Greenpeace an opportunity to campaign with the support of Greenpeace ships, including a visit by the ARCTIC SUNRISE and two visits by our flagship RAINBOW WARRIOR.

Greenpeace Slovenia
founded 2007
Climate protection though an energy revolution

Greenpeace began its journey in Slovenia in autumn 2007, a few months before Slovenia took over the presidency of the EU Council. The project, which focused on the Slovenian presidency of the EU, was implemented together with the Slovenian non-governmental organisation Umanotera, and once the project was over, we decided to continue to maintain a presence in Slovenia. The partnership with Umanotera lasted until the end of January 2011, and Greenpeace has been operating independently in Slovenia since then.

The areas in which we are trying to remain active are numerous, however issues related to climate change and energy transition have truly dominated our activities for the last decade. Each year we also lend our support to global campaigns and bring topics such as plastic pollution, and the need for protection for oceans, the Antarctic and the Amazon rainforest, closer to the Slovenian public.

Projection on »King's Landing«
Greenpeace projects messages against oil drilling in the Adriatic on the Walls of Dubrovnik, known as »King's Landing« in the hit series »Game of Thrones« (right)
25 July 2015

Nuclear power instead of clean renewable energy
Activists block the transport of steam generators to the Slovenian nuclear power plant Krsko before being removed with force by the Slovenian police (bottom)
1 September 1999

Greenpeace Greece
founded 1991
Towards a green and just future

In the 1980s, environmental awareness was picking up in Greece. At the end of the decade, more than 30,000 citizens supported an international Greenpeace petition calling for the protection of Antarctica, finally leading to the signing of a global treaty. This was the final sign that the society was eager and ready to combine local, national and global environmental challenges and work for their solutions. It is against this backdrop that Greenpeace Greece was founded in1991.

Greenpeace became known to the Greek public by calling for an action plan and solutions of the urgent problem of severe marine pollution due to oil spills, pointing out the risks involved, the damage caused, the companies and actors responsible, and the measures necessary to end it.

Since then, we have highlighted the various ways oil is threatening the environment while also making the link with its role and contribution to climate change and the use of fossil fuels, and to introduce the topic of renewables and the need to decarbonise the energy mix and the entire economy, to talk about the need for large scale energy efficiency in almost every sector, from households to heavy industry. Greenpeace Greece also introduced the concept of energy democracy, energy communities, as well as climate justice. We are proud that, after nearly 30 years of systematic work, decarbonisation is a national commitment, energy communities are picking up in popularity, and energy poverty is gaining serious attention.

While we have been paving the way for a transition from oil spills to energy communities, Greenpeace Greece continued identifying cases of major pollution and promoting both alternatives and policies, empowering people to take action and seize control of their health and their lives, while at the same time challenging the current production and consumption models in which profits are valued over human health and dignity. Issues such as toxic pollution, dioxin production, and the release of genetically modified organisms have been introduced to Greece, but also to the country's political agenda because of our work. The same applies to the relevance of our successes and their benefits for the environment, human health and social justice.

After thirty years of our creative and brave actions and after several national crises (economic, social, refugee, and the pandemic), we are at the crossroads at which our society has to decide either to go back or to pave the way – most likely through uncharted waters – towards a green and just future.

We were present at the biggest environmental challenges and we are going to be there whenever this is needed.

The dirtiest … in Greece
Agios Dimitrios is the largest lignite-fired power plant in Greece, and therefore the country's largest polluter – and this despite Greece being predestined for renewable energy and solar in particular (right)
9 December 2015

Anti-war demonstration in Greece
A Greenpeace hot-air balloon painted a a giant globe flies next to the Acropolis with the message »Unite for peace« (bottom)
15 April 2003

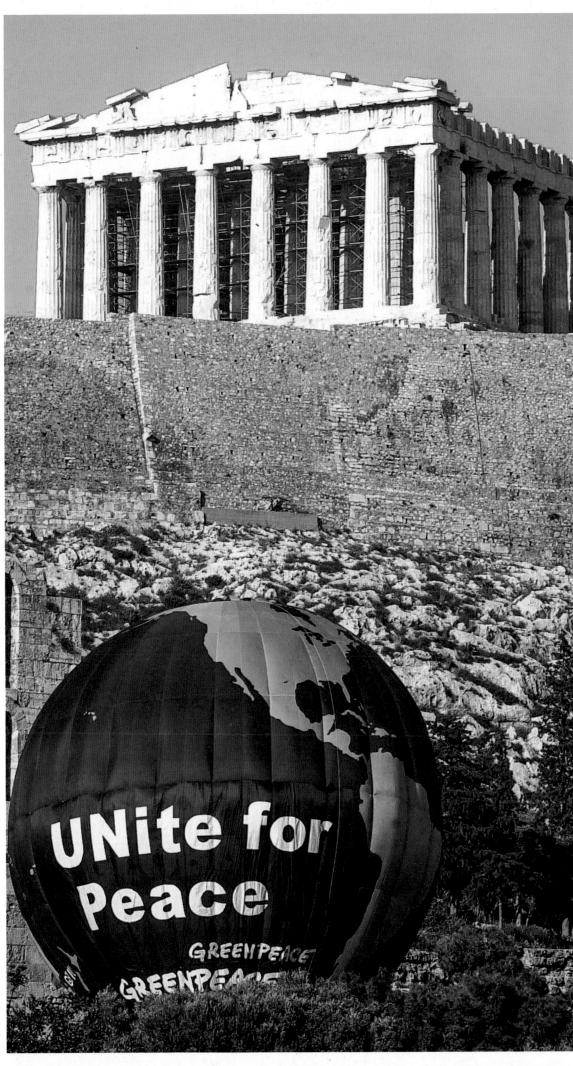

Greenpeace Russia
founded 1992
»Molecules« are stronger than oil

It's 2005 – President Putin has only been in power for five years. And one of our major campaigns is underway: the campaign to protect Lake Baikal, its rare and unique seal population, and the fight against a highly polluting pulp and paper mill. Baikal is the oldest, deepest, and the largest lake by volume on earth – famous all over the world and sacred to the Indigenous population. But its quiet waters seem to attract the most unscrupulous of companies.

Greenpeace was informed by locals about the clear-cutting of forests next to lake, carried out by the state-owned oil company Transneft to construct the Eastern Siberia-Pacific Ocean oil pipeline just 800 metres from the lake's shores – in direct violation of a law to protects Russia's largest surface freshwater reservoir, which is, in fact, also the largest one on earth. Scientists also raised strong objections to the project, warning about the ecological consequences of such actions.

Nonetheless, Transneft somehow managed to obtain a permit for its pipeline. Public protests against the oil company started – united in their opposition to this blatant act of injustice. Greenpeace contributed its expertise, collected signatures, called on famous artists to support the campaign, and held rallies. One rally in Moscow became the largest environmental rally in the last 15 years. People of all generations joined the »Live, Baikal!« campaign, having understood how important it was to stop the pipeline project.

When Semyon Weinstock, the president of Transneft, stated that the population density around Lake Baikal was »one and a half molecules per km^2«, a new spin was soon put on this statement, turning it into »Molecules against the pipeline«. The »molecules« attended protests being held all over Russia: in Nizhny Novgorod, St. Petersburg, Moscow, Vladivostok, Yekaterinburg, Rostov and Irkutsk, where the protests had the most attendees and were held most frequently and even primary school pupils were chanting »Putin, save Baikal!«.

On 26 April 2006, Vladimir Putin met with the regional governors in Tomsk. The president of Transneft held a presentation detailing the pipeline project, certain that Russia's president would approve it. However, the vice-president of the Russian Academy of Sciences countered by proposing that the pipeline be relocated to the north, giving it a safer route. Putin replied, »If there is even the smallest chance of endangering Lake Baikal, then we should think about future generations of Russians.« He took a marker pen and drew a new line on the map, moving the oil pipeline far from Lake Baikal.

It was a victory for hundreds of thousands of concerned citizens. »Molecules« turned out to be stronger than oil.

Today, Greenpeace continues its activities in Russia in highly restrictive circumstances: we can be thrown in jail even if one single person stages a picket. Nonetheless, we need to keep pushing to protect our most valuable natural environments, and to keep calling for a systematic solution to environmental problems. Our experts, together with other organisations, have developed the Green Course, which outlines proposals for one hundred solutions for a green economic recovery and a real transition to environmentally friendly development in Russia.

**Breakthrough album
release in Moscow**
A crowd of people attend the release of the music album »Greenpeace: Breakthrough« in Moscow in the Soviet Union. The aim was to establish a Greenpeace office in Moscow and Kiev respectively, and to promote environmental projects between east and west. Musicians taking part included Annie Lennox, Peter Gabriel, Brinsley Forde, John Farnham, Chrissie Hynde, The Edge, Alanna Currie, Tom Bailey, Karl Wallinger, Gary Chambers, and Jerry Harrison (right)
1 January 1989

The oldest and deepest lake on earth
Lake Baikal, the oldest, deepest and largest lake in the world – around 20 percent of all liquid fresh water on earth is in this lake – must be protected. The unique flora and fauna of this World Heritage site – such as the freshwater seals that only live there, the Baikal seals – was threatened by planned pipeline projects as well as by a paper and pulp mill causing massive water pollution. Our many years of protests and campaigns finally led to success – the pulp mill was closed and the planned pipeline was, at least, rerouted away from the lake (bottom)

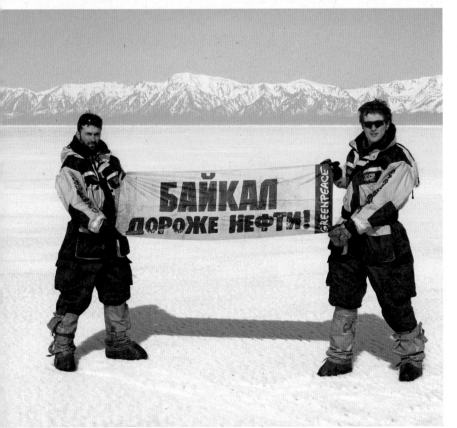

Greenpeace Middle East and Northern Africa (MENA)
founded 2018
A link between environmental and social justice, and societal change

Greenpeace has always recognised the importance of having a presence in the Middle East and North Africa region, and has a long history of activities and interventions in the 1990s, which sought to deliver powerful messages about environmental protection. Building on this history, Greenpeace MENA was officially established in 2018 as a regional Greenpeace organisation, and as the latest and the youngest organisation within the Greenpeace global network, it is one of very few NGOs that campaigns for the environment in the region.

The region is of enormous geo-political importance, not only as it hosts nearly half of the global oil reserves, but also has a key significance for other Greenpeace goals, including our quest to achieve a global energy transition away from fossil fuels to reduce the devastating impact of climate change, by shifting mindsets, and by establishing peaceful, collaborative solutions.

Our operating model is based on activities that do not involve a physical presence in every country in the region by means of digital engagement and collaborating with local allies and frontline communities to run powerful and effective campaigns and build a regional environmental movement. This model has proved to be very efficient, especially in such challenging times as the COVID-19 pandemic. Greenpeace MENA is an organisation from the region working with the region for the region.

Climate action in the region is slowly but steadily growing in quality and quantity, and Greenpeace MENA is acting as a catalyser. Existing movements are becoming more empowered, activists at heart are now finding themselves able to express themself, raise their opinions and take action thanks to new platforms, tools and initiatives. The climate narrative is becoming increasingly mainstream in the media, and the ways that the climate crisis and daily realities and struggles intersect are surfacing. Some influencers are also increasingly willing to be associated with the climate fight to protect their livehoods and the future.

Greenpeace MENA aims to counteract the high social license of the fossil fuel industry in the region by pushing a narrative centred around the social and economic impact of air pollution, as well as one based on solutions.

We aspire to move to a just and more equitable world where people are happier, healthier and deeply connected to one another and the land.

We believe the role of Greenpeace MENA is to establish a link between environmental justice on one hand, and social justice and societal change that we are aspiring to on the other hand. We are working hard to highlight the fact that the various environmental issues we face are not isolated, but are, in fact, a consequence of the current destructive and predatory development model that prevails in the region, which is one that we need to revisit and make more sustainable and just.

»Break Free – Go Solar«
A giant human banner in front of the Hassan II Mosque and the International Fair in Casablanca, Morocco, with a message in Berber, Arabic and English. »Break Free – Go Solar« (right)
29 April 2018

Climate Action in Lebanon
Greenpeace MENA collaborated with Ashekman, a Lebanese Graffiti group, to help supporting the youth climate movement part of Fridays for Future, to send a message to the world »Change you climate« (bottom)
30 October 2016

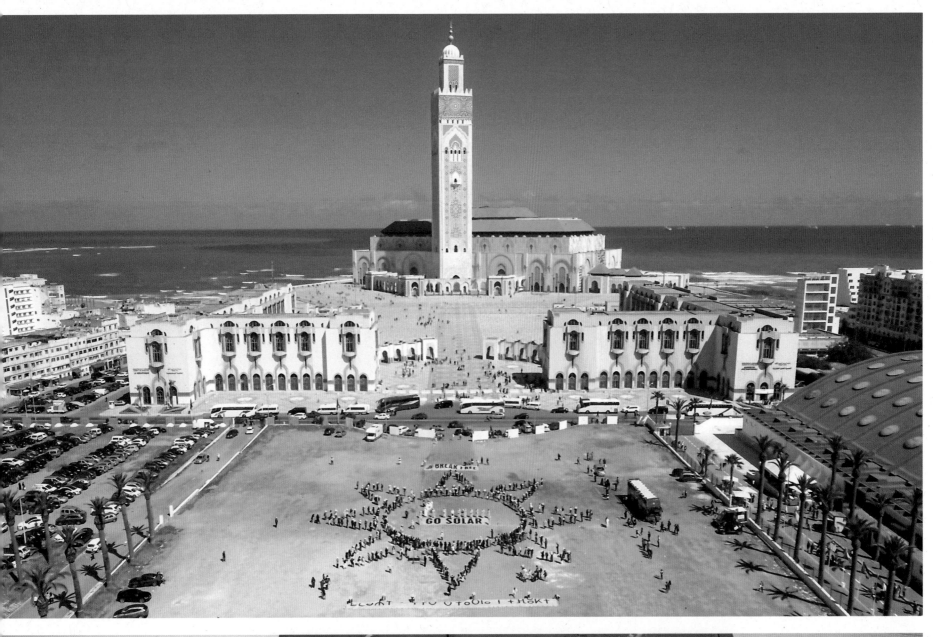

Greenpeace Africa
founded 2008
Seven values provide guidance for the campaigns

Greenpeace has been actively campaigning against illegal logging in the Congo Basin forest since the late 1990s. Currently, Greenpeace Africa operates in five countries: South Africa, Kenya, Cameroon, Democratic Republic of Congo and Senegal.

Greenpeace's vision is an Africa where people live in harmony with nature in a peaceful state of environmental and social justice. Greenpeace Africa has always been more than an organisation. It is a diverse, multinational, multicultural movement comprised of ordinary individuals determined to bring about extraordinary changes necessary to realise a greener, more peaceful future for Africa.

Greenpeace knows that the world needs the African continent's rich biodiversity to be protected if we want to solve the climate crisis, and that leapfrogging fossil fuels to become a global leader in renewable energy is a matter of vision, determination and peaceful collective action.

Our key campaigns are are Climate and Energy (South Africa), Oceans (Senegal), Forest (Cameroon and DRC), Plastic (Pan African) and Responsive Campaigning (Kenya).

Greenpeace Africa's values of ubuntu, courage, integrity, diversity, justice, freedom and transparency, and living with harmony in nature provide guidance for our campaigns and our ways of working. Over the years, Greenpeace Africa has had a huge impact and numerous victories in campaigning for a sustainable and healthy environment.

Up the Congo River
Greenpeace's first extended foray into the Congo River by ship took place from October to November 2017. An open bo day on board the ESPERANZA in Douala attracts enthusiastic school visits. The students were drawing and writing me sages on leaves to adorn a special »Wis Tree« for the protection of the Congo Basin forests (right)
17 October 2017

The drama in the Congo Basin fores
The expedition also aimed to draw atte tion to the dramatic destruction of the Central African rainforests, which are t most carbon-rich on earth – storing mo carbon than the world consumes as fos fuels, coal, oil and gas in three years – and are therefore of huge significance for global climate protection. These forests are rapidly dwindling, despite being the habitat of so many unique plants and animal species, and also providing a livelihood for the many human communities living there. Every second, heavily loaded wood trucks leave the threatened rainforests satisfying the industrial nations' hunge for wood (bottom)
3 November 2017

Greenpeace Senegal
founded 2010
Fighting illegal and unregulated foreign fishing fleets

The office in Senegal opened in 2010 to oppose and fight illegal fishing and overfishing, with Greenpeace having already sailed the West African oceans in 2001, 2006, 2008, and 2010. One key success in Greenpeace Africa's oceans campaign was the cancellation of 29 fishing licences for foreign fleets that were competing with the local fishermen for small pelagic fish in Senegal in April 2012. This victory helped highlight the illegal and unregulated overfishing in the West African waters.

Later on, in 2015, Greenpeace exposed a vast gross tonnage scandal that had been occurring for over 30 years. The Senegalese Minister of Fisheries immediately responded and approved recommendations for an administrative enquiry. This later was translated into ministerial directives on gross tonnage standards, which are currently being implemented. Greenpeace Africa continues to urge the governments of West Africa to ensure that declining fish stocks are managed and protected, first and foremost to feed people in the region, as most West Africans depend on them for their livelihoods.

In 2017, as a result of a joint venture between Greenpeace Africa and the Guinean authorities, three fishing vessels that were illegally operating in the waters of Guinea were nabbed. The vessels were caught with shark fins and illegal nets, and were heavily fined. Furthermore, employees of three Chinese companies were arrested in the West African region during a joint patrol conducted by Greenpeace and local fisheries inspectors. Evidence of various infringements including illegal nets, shark finning, and fishing without a licence were handed over to West African and Chinese authorities.

In the same year, during a joint operation with authorities in Sierra Leone, Greenpeace identified four infractions on fishing vessels. Three of them involved illegal netting resulting in arrests. The findings from just four days of surveillance in Sierra Leone provided further evidence that West Africa needs to improve its fisheries management. The region's marine resources are being depleted at alarming rates, mainly because way too many boats are competing for too few fish, and due to high rates of illegal, unreported and unregulated fishing – often by foreign fleets. This ongoing plunder is a threat to millions of people in the region who depend on the oceans for their food.

Currently, Greenpeace Africa is being guided by and is working with local communities to protect West African shores from industrial fishing fleets that, with no shame and a blatant disregard for local and international laws, are stealing West Africa's natural treasures and wealth and depriving millions of West African people of the most basic source of protein in order to feed industrial farmed animals or produce dietary supplements, cosmetics and pet food products.

As we share in celebrating all these victories, we cannot forget the people behind the success of these campaigns, our donors, supporters, volunteers, communities we have worked with, and last but not least our staff members who have been so very instrumental to making the environmental movement in Africa a reality.

Foreign predators
Greenpeace demonstrates against the 120-metre-long Russian super-trawler MIKHAIL VERBITSKY, with the trawler clearly exemplifying the unsustainable fishing practices by foreign supertrawlers in the region. Foreign fleets, including ones from the EU, are plundering West Africa's waters, while local fishermen are suffering as their own catches continue to decrease. The huge amount of bycatch, including marine mammals such as dolphins, ends up dead or dying in the giant nets. We are campaigning in West Africa to establish a sustainable, low-impact fisheries policy that caters to the needs and interests of small-scale fishermen and the local communities that depend on healthy oceans
21 February 2012

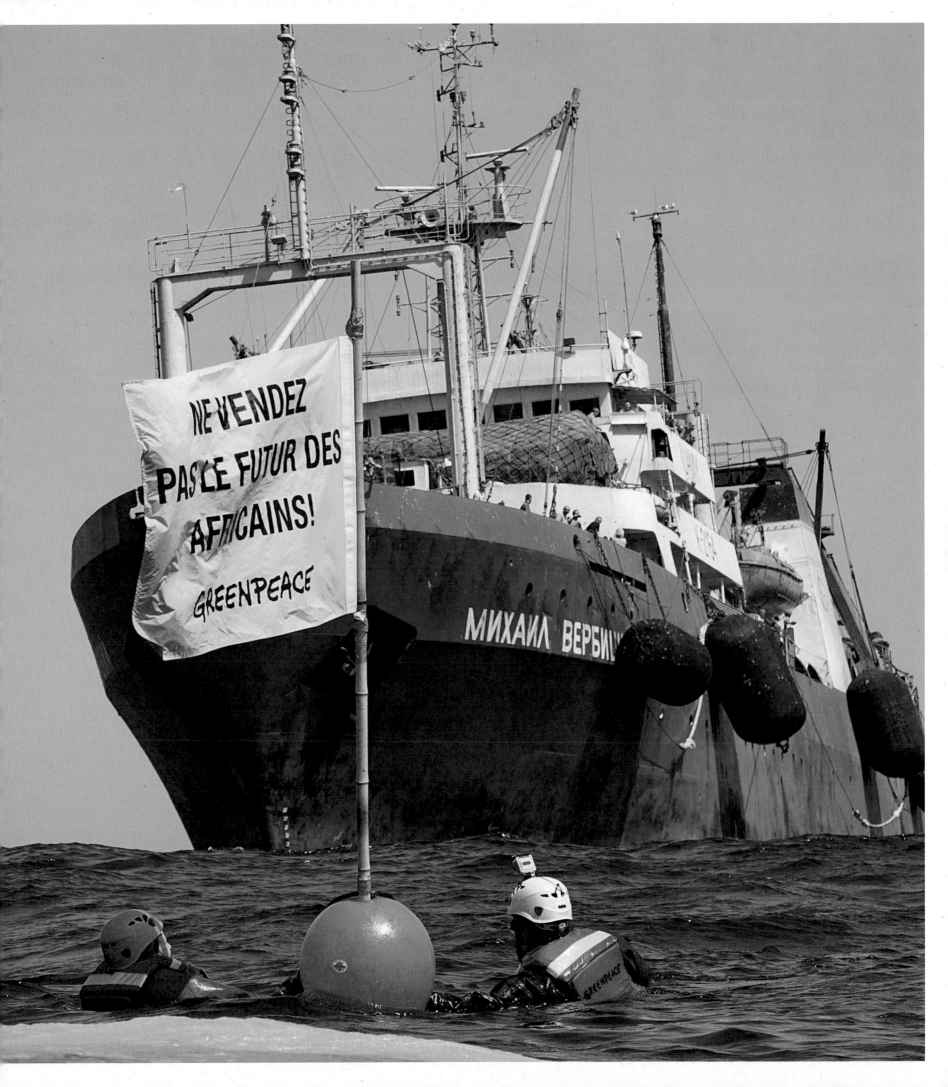

Greenpeace Democratic Republic of Congo
founded 2008
Africa's unique forests need protection

The Kinshasa office in the Democratic Republic of Congo (DRC) was also officially opened in 2008 with the arrival of the Greenpeace ship ARCTIC SUNRISE. Greenpeace has been working closely with local Indigenous communities to protect the Congo Basin forests, which are home to peatlands, from destructive industries and to ensure that local communities are granted their communal land rights.

In 2017, Greenpeace exposed cases in which illegal logging licences had been issued in the Democratic Republic of Congo. This resulted in the DRC government cancelling these licences, upholding the long moratorium on logging concessions which had been in place since 2002. This was after a Greenpeace probe found that the DRC's Minister of the Environment had authorised two logging concessions for an area covering more than 4,000 square kilometres.

In 2018, a group of 30 scientists from all over the world mobilized to fight a proposal by the French Development Agency to prevent the Central African Forests Initiative (CAFI) from being approved. If the proposal had succeeded, this would have resulted in 10 to 30 million hectares of the forest in the DRC disappearing.

Greenpeace Africa has come a long way in the DRC. From a small office shared with the Belgian NGO 11.11.11 to a real organisation; from two consultants in 2007 to seven employees today. Together we stand to protect the largest tropical rainforest in Africa. We will not tire until all illegal logging activities have been exposed and brought to book.

Illegal timber for Europe
A protest at the port of Caen in France. Activists from Greenpeace France uncover a shipment of illegal timber from the Democratic Republic of Congo (DRC) arriving in Caen. Our activists seize a log as evidence. This timber is sold by Sicobois in DRC, and is illegally imported by French group Peltier Bois. Greenpeace is calling on the French Ministry of Agriculture to take appropriate legal action and seize all illegal timber
8 January 2014

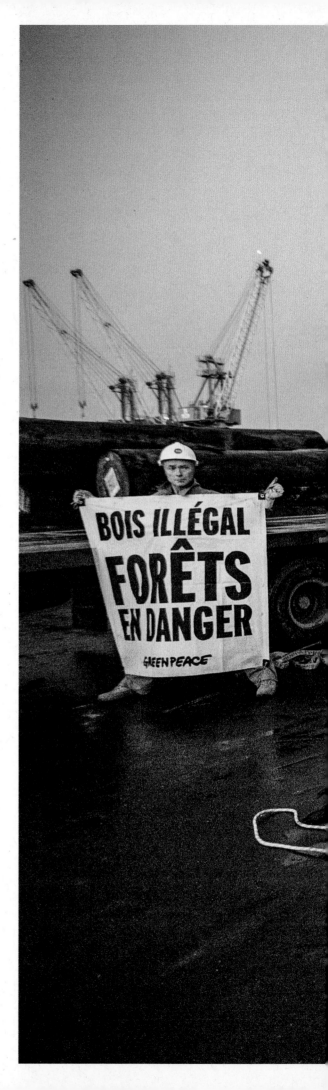

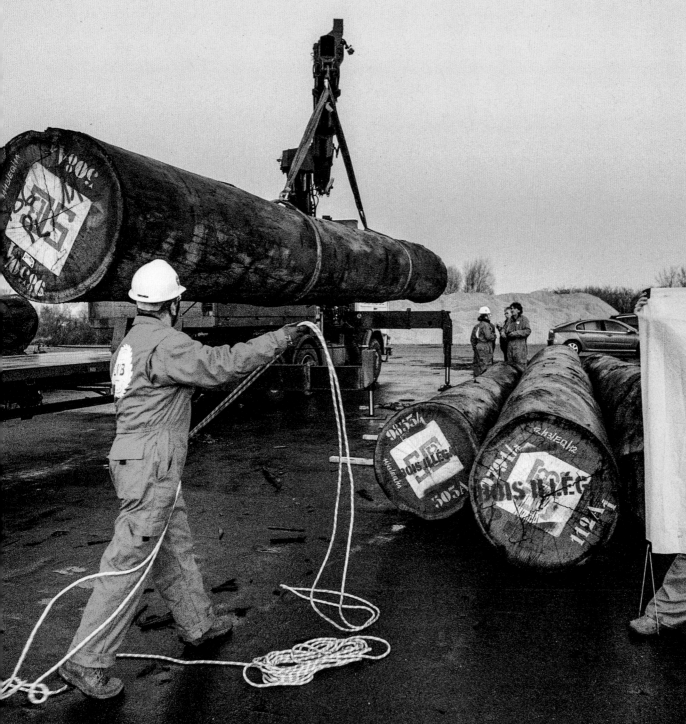

Greenpeace Cameroon
founded 2017
Corrupt foreign companies are destroying the last forests where the great apes live

Even before it opened its office in Cameroon, Greenpeace Africa maintained a consistent campaign presence in the country where Greenpeace Africa's campaigning history began. However, it was only in 2013 that we upscaled our campaign to stop the destruction of forests caused by the palm oil plantation planned by Herakles Farms. The office was officially opened in 2017 in Yaoundé.

In March 2015, Greenpeace Africa published a report on the illegal logging activities by Compagnie de Commerce et de Transport (CCT) and its Dutch trading partner-Fibois BV. Greenpeace later filed a complaint against Fibois BV in a Dutch administrative court due to its non-compliance with the rules defined under the European Timber Regulation (EUTR), and for acting negligently when importing timber from Cameroon. Fibois was thereupon sanctioned by the Dutch authorities in 2017. The court used Greenpeace's meticulous reports as evidence against the timber company.

In 2016, Greenpeace Africa joined local partners in successfully gathering over 18,000 signatures to petition the President of Cameroon to not renew the logging concessions for Herakles Farm in the country's South West Region. This grant was eventually renewed despite our petition, but it did encourage local environmental activists to join Greenpeace Africa in opposing the project.

In 2019, Norway's sovereign wealth fund – the world's largest – divested itself from Singapore-based rubber franchise Halcyon Agri Corporation Limited (Halcyon Agri) due to the financial risks arising from deforestation in the tropics. This also represented a clear call to other investors in Halcyon Agri to divest themselves from it, and the message was also extended to customers of Halcyon Agri such as Michelin, Continental, Bridgestone and Goodyear, asking them to seriously reconsider the contribution that they're making to deforestation in Cameroon — and to sever all ties to Halcyon Agri.

In April 2020, Greenpeace Africa joined a call being made by local people in Cameroon's Littoral Region to immediately cancel government plans to turn an area covering nearly 150,000 hectares of pristine forest designated for a national park into two logging concessions. More than 40 communities surround the Ebo forest and rely on the forest for food, medicine and cultural activities. In 2006, the Cameroonian government designated the Ebo forest a proposed national park, although no decree was ever signed. Thanks to the support of about 30,000 people and the resistance of local communities based around the Ebo forest, the President of Cameroon suspended logging plans in August the same year.

All these victories have presented plenty of challenges. Poor governance, political instability and political interference, and insecurity have posed real threats to the work Greenpeace Africa has been undertaking. However, with the support of communities and like-minded organisations, we have moved past these challenges and towards a just and sustainable future for Africans by Africans.

The crimes committed by the corrupt US concern Herakles Farms and other
Logs from Herakles Farms' palm oil concession. Natural intact forests are being destroyed to clear ground for sheer endless rubber tree and oil palm monocultures, an example of profiteering by large corporations that manufacture products mainly found in western supermarkets. Nature, wildlife, rare animal species, the global climate and local communities are being endangered by these aggressive and short-sighted agricultural practices
23 November 2014

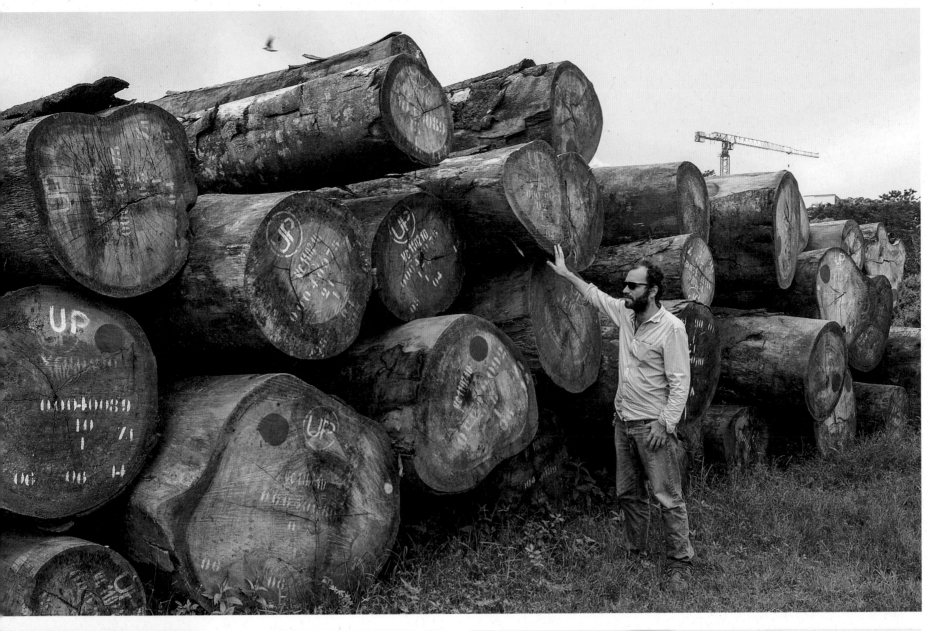

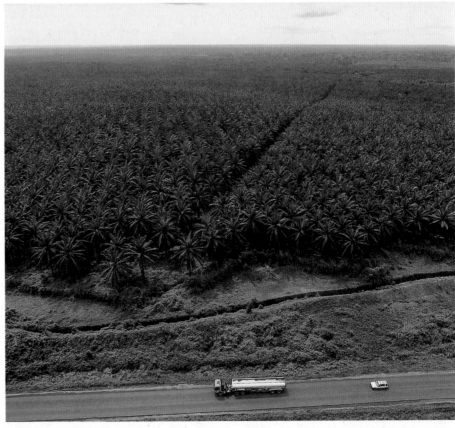

Greenpeace Kenya
founded 2015
A victory against coal and the fight against becoming the U.S.A.'s dumping ground

To diversify the geographical presence as well as campaign issues, a small operational office was opened in Nairobi, Kenya, to support the work of the »Food for Life« campaign in 2015, with just two staff members. Later in 2017, the number of staff grew from two to eleven. The Greenpeace team in Kenya is now focusing its efforts on the increasing problem of plastic pollution, and is joining the anti-coal protests led by deCOALonize, a coalition of more than 10 civil society organisations that is spearheading the efforts to stop plans by Kenya's government to build a 1,050 MW coal-fired power plant at a UNESCO world heritage site, and to oppose coal mining in Kitui (in the eastern part of Kenya).

The coalition's efforts have led to some great developments. In 2017, Standard Bank (Stanbic) withdrew funding for the Lamu coal-fired power plant. This was supported by an initiative led by our partners, 350.org and Save Lamu, which have been at the forefront of the »deCOALonize Kenya« campaign in which Greenpeace Africa has played a major role.

In 2018, Lamu residents were overwhelmed with joy after Kenya's National Environment Tribunal (NET) finally cancelled the licence for the construction of the coal-fired power plant. This was a major victory proving that people's voices matter when it comes to the kind of development they want in their country.

Kenya has been focusing on responsive campaigning since 2020, with one of the major campaigns being the proposed free trade agreement between Kenya and the U.S.A., which has seen the American Chemistry Council lobbying the US government to export plastic waste to Kenya, and to use Kenya as a gateway to other African countries. We have petitioned the Ministry of Trade and urged it not to enter into trade deals that will compromise Kenya's environmental standards and turn Africa into a dumpster.

Africa as another garbage dump for the west

A result of a tremendously destructive American industrial policy – an expanse of millions of plastic bottles in the dried-up Kalamu River in Pont Kyanza (Kinshasa). The U.S.A. intends to abuse Kenya as a hub for chemicals and plastics in Africa – but resistance is growing, and has to grow even larger so that the country can defend itself against these scandalous practices. Together with almost 190 other countries, Kenya has signed an agreement that will make the import of plastic waste from industrialised countries more difficult, and hopefully end it entirely. Significantly, the U.S.A. did not join. The U.S.A. alone exported almost 500,000 tonnes of plastic waste in the first half of 2018, in particular to developing countries
10 October 2019

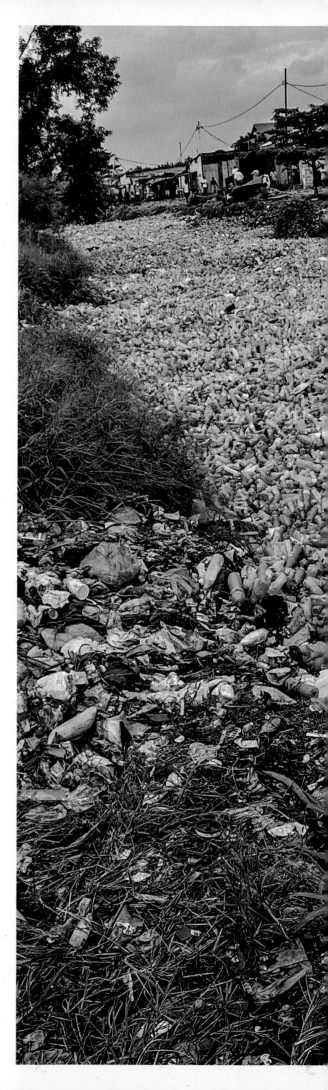

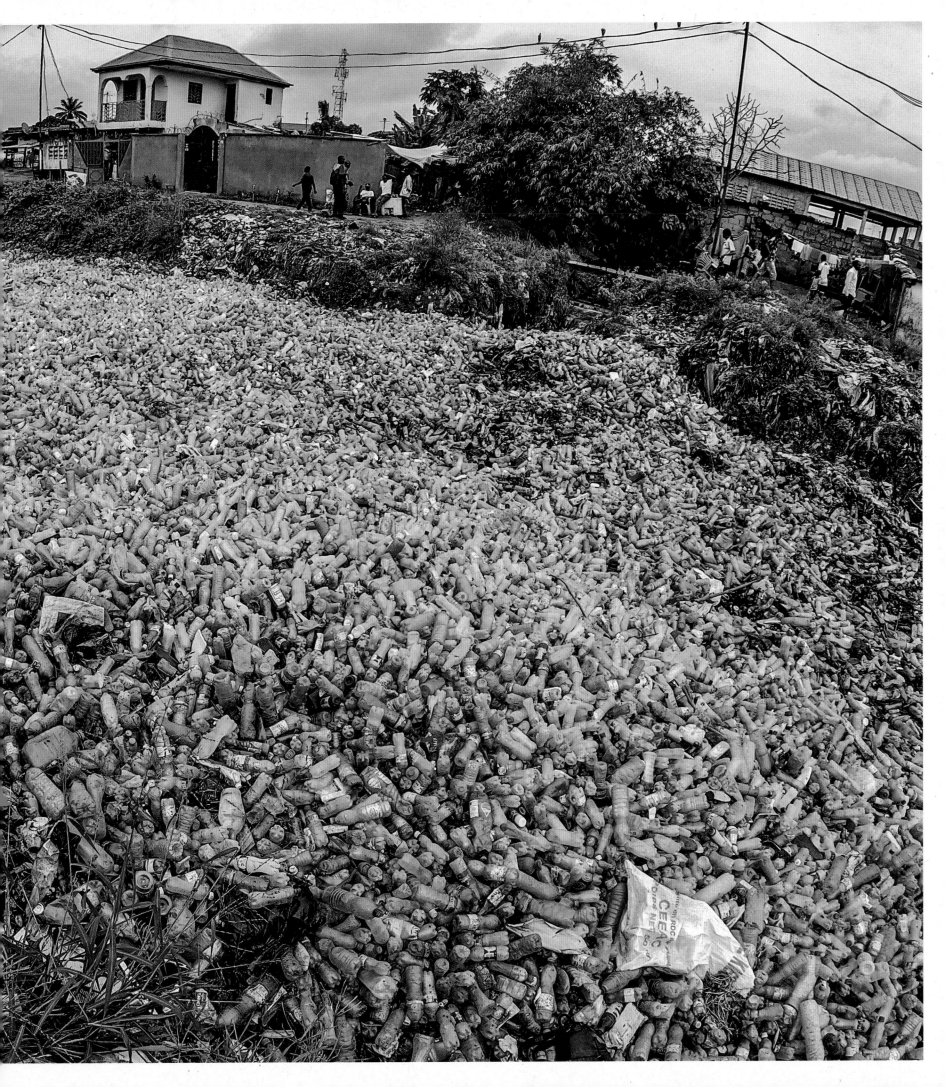

Greenpeace South Africa
founded 2008
All hands on deck for the climate and for clean and renewable energy

The opening of the office in 2008 was organised in memory of freedom fighters at the Pretoria Central Prison, where Nelson Mandela was held before being sent to Robben Island. With 54 staff members, the South Africa office is the largest office in Africa and mainly focuses on climate and energy work.

When Greenpeace Africa started protesting against South Africa's almost complete dependence on coal for energy, we looked like a bunch of rebels with no idea of how economies worked. Government and corporate interests had entrenched a narrative that South Africa had an abundance of coal that had to be exploited in order to »develop«. We challenged that development model with South Africa's unparalleled abundance of renewable energy, a term which meant little or nothing to even the journalists at the time. However, when we dumped coal at Eskom, the media finally took us seriously. Eskom has confirmed all of our concerns around coal, which can only bring ruin, leaving piles of scandals, several incomplete projects, and the normalisation of rolling blackouts as its legacy – all of which has made many South Africans more and more curious about the potential of a Just Transition.

Over the years, our efforts campaigning for a just transition paid off. In 2016, at a roundtable discussion organised by Greenpeace, three of South Africa's top five retailers, Massmart, Pick'n'Pay, and Woolworths, indicated their commitment to lobbying for an enabling framework that will allow for the expansion of renewable energy in South Africa. The move from the retailers was a follow-up action in response to the report »Shopping Clean: Retailers and Renewable Energy« that was launched by Greenpeace in April the same year. In the report, the five biggest retailers in South Africa were ranked in relation to their current investments and commitments to renewable energy.

The report formed part of the broader renewable energy champions campaign that aimed to encourage retailers to commit to a future based on 100 percent renewable energy. Greenpeace Africa successfully crowdfunded enough money to install solar street lights in Diepsloot, an off-grid urban community in Johannesburg. The community received eight solar street lights that are helping its residents feel safer.

In November 2020, South Africa's Department of Environment, Forest and Fisheries (DEFF) made a commitment to pursue criminal prosecution against Eskom for non-compliance with air pollution standards, and for supplying false and misleading information in reports to an air quality officer at the Kendal power station between 2018 and 2019. This followed many months of Greenpeace Africa putting pressure on the department not to grant Eskom a licence to kill.

With most of humanity still reeling from the COVID-19 pandemic, one challenge facing us is to reflect on how to start rebuilding our world in a way that truly protects humanity. Corruption and greed are driving climate change and accelerating the pace of environmental degradation across Africa. We are faced with threats that we have the power to reverse. The question is: how committed is humanity to doing this?

Solar energy cooker in Jericho
Greenpeace shows solar cookers being used at the Jericho community centre while the World Cup final was being viewed. The Jericho project, a solar-power public viewing area for the World Cup, was initiated by Greenpeace Africa, combining entertainment with education a proving how solar power the most viab solution to South Africa's energy crisis
11 July 2010

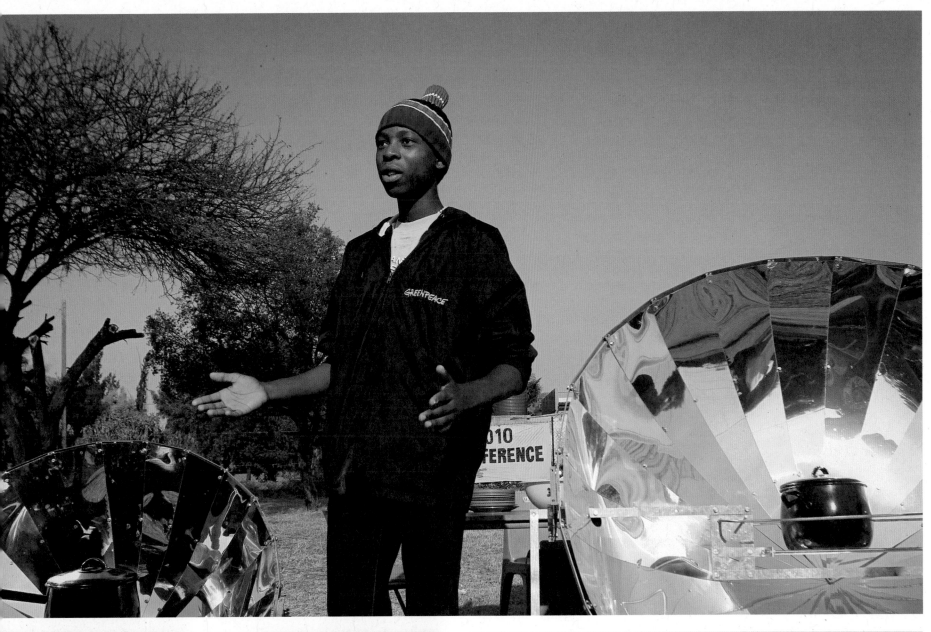

Greenpeace in Africa
people, action, solutions

Greenpeace Israel
founded 1995
A fossil fuel-free future, unity with each other and with the Earth we live on

Israel is known as a vegan-friendly, tech start-up nation. Much progress is continually being made as the country strives to be the best it can be with a bit of chutzpah and coordinated chaos. To the west, it borders the Mediterranean Sea, to the south there are reefs with beautiful corals in the Red Sea, and the precious Dead Sea, the lowest point on land on earth. Israel and the Middle East is already one of the regions most affected by climate change as temperatures continually rise, droughts dry up water reserves, and significant environmental and social changes result from this.

Greenpeace was founded in Israel in 1995 as part of the Greenpeace Mediterranean regional organisation working alongside Turkey in campaigning against a pipeline that would dump toxic industrial sewage into the sea, raising awareness of chemical pollutants and the ecological damage that they would cause. This was the start of Greenpeace Israel's successful environmental campaigning.

Struggling at first, Greenpeace has since become one of the most well-known environmental organisations in Israel. With a small team, standing as one with many dedicated volunteers, our campaigns took action to stop the destruction of rainforests, halt the fossil fuel industries, and raise awareness of plastic pollution, among other issues.

Greenpeace Israel has played a significant role in phasing out the country's reliance on coal, leading to two important victories: in 2010, when our campaigning stopped the construction of a new coal-fired plant, preventing harmful greenhouse gases being emitted onto nearby residents and polluting the atmosphere, and in 2016, when we pushed the Ministry of Energy to decide to shut down of the most polluting coal power plant units in Hadera.

In renewable energy, we have led the solar rooftop revolution, which was launched in 2015, resulting in a tremendous increase in the share of solar energy. Through activism, we bring attention to the environmental impact caused by human interference.

In one of the most impactful actions, Greenpeace volunteers abseiled from Jerusalem's Old City walls to hang a banner calling for a stop to the destruction of the Amazon's rainforests, but also with the backdrop of the Dead Sea to raise awareness of the need to protect the oceans.

In the year 2021, Israel was hit by an environmental disaster. Tar balls were washed ashore all along the country's pristine coastline, blackening the sand and impacting biodiversity. We saw thousands of volunteers from all over the country rushing to clean the beaches – unity amongst the people in the fight for justice and against the destruction of marine life and the environment that we are, unfortunately, rapidly moving towards should no change of direction occur.

Despite all the challenges that may yet arise, Greenpeace Israel continues to campaign for a fossil fuel-free future, moving away from the gas industry and towards clean energy. We look toward a future with optimism, one in which Greenpeace's actions all around the world have made a difference, cultivating respect, conservation, and unity with each other and with the Earth we live on.

Climate camp against oil shale
Greenpeace holds Israel's first climate camp at the proposed location of an oil shale mine. The camp consisted of four days of workshops about oil shale, climate change and activism. 500 people formed a human banner to send a clear and direct message to the Israeli government to stop the dangerous oil shale project (top)
4 October 2012

Mediterranean oil spill disaster – demonstration in Tel Aviv
Following the oil spill disaster that occurred in Israel on 17 February, Greenpeace Israel organised a demonstration in Tel Aviv. The disaster washed up vast quantities of tar balls from crude oil over a 170-kilometre stretch of shoreline, approximately 40 percent of Israel's Mediterranean coast, and caused great harm to animals, including birds and sea turtles (bottom)
6 March 2021

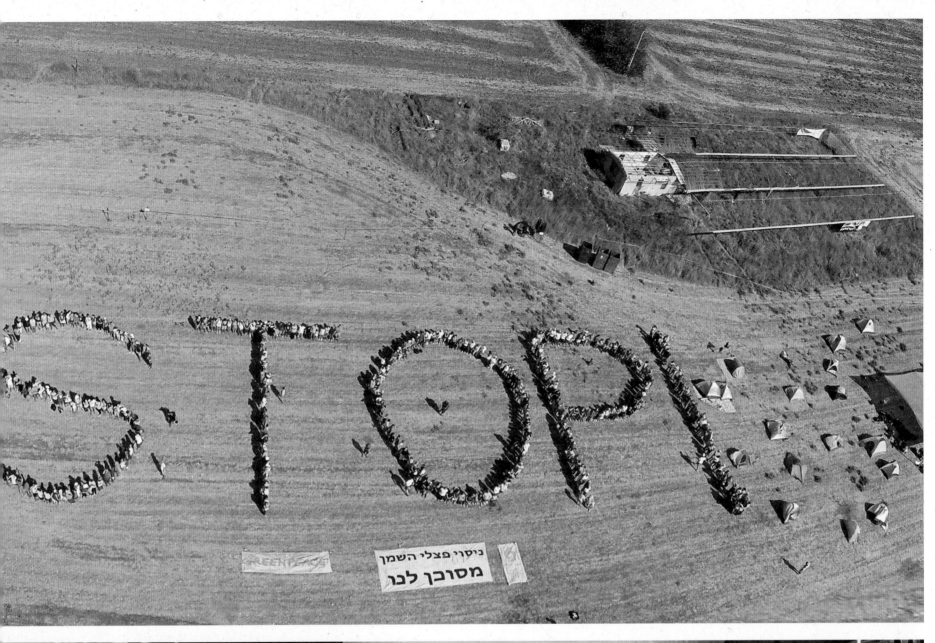

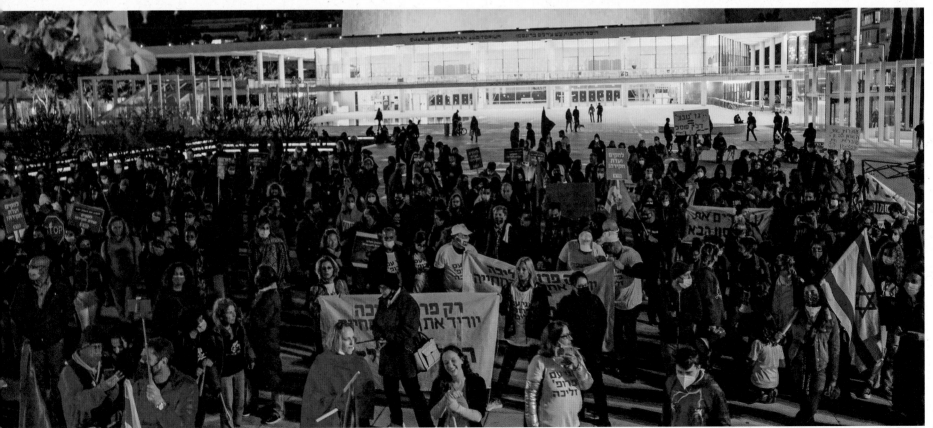

Greenpeace Turkey
founded 1995
How big is your fish?

When Greenpeace Turkey first launched its activities together with a handful of activists in a region plagued by years of political conflict, most people were unaware of the concept of peaceful protests, yet alone global environmental issues.

In the beginning, people regarded us as radicals »who held unexpected, interesting protests« however over time, we have grown to become an organisation that helps set the environmental agenda. In this context, our first significant achievement was stopping the operation of the Akkuyu nuclear power plant in 2002. We are still continuing the fight to prevent this project, which has since been reanimated.

In 2007, we started our campaign opposing illegal fishing and overharvesting. We created our first »fish ruler«, reminding people that there are »No big fish without small fish«. Later on, our fish ruler for consumers showed sizes, as determined by scientists, at which commercially sold fish reach reproductive maturity, asking »How big is your fish?«. It was a bold slogan to use in Turkey! However, we succeeded in directing everyone's attention onto fishing practices, and this in a country that already had a full agenda all the time. We spent months visiting fish markets, wholesale markets and restaurants with our rulers. We took illegal anglers by surprise at night, and compelled the authorities to carry out inspections. We held hundreds of meetings with fishing organisations, the Agricultural Ministry, and scientists, and managed to get them all involved in the project.

The project aimed to establish fair fishing practices, as opposed to the impasse resulting from a lack of adequate regulation. Turkey is surrounded by water on three sides, and both fish and fishing enjoy a historically prominent role in its culture; however, fishing and the future of the seas is being left to the mercy of industrial fishing enterprises and the Agricultural Ministry. While fish stocks were dwindling in Turkish waters, the legal minimum landing size allowed juvenile fish that had not reached reproductive maturity to be caught and sold.

It was the first time that the issue of fishing had been discussed extensively in the wider public with a range of people who had not engaged around this issue before contributing to the discussion. The ruler attracted so much attention that people started to use them while shopping at markets, while restaurants started hanging them in their windows, and fishing companies adopted their use. We worked together with a well-known chef, offering a menu supporting »sustainable fishing«, and our fishing campaign was also featured on popular TV shows.

Before the annual meeting of the Agricultural Ministry at which minimum landing sizes were also to be discussed, Greenpeace set up a »red phone«. Thousands of people called this hotline, demanding that the legal catch sizes be changed in accordance with scientific evidence. This campaign ended up strong-arming the Ministry into changing the final figures!

This meeting also saw us gain the support of small-scale fishing operations against the verbal threats made by industrial-scale fishing enterprises. After a two-year campaign, the minimum landing sizes for the fish species that we prioritised in our recommendations were corrected, and now everyone is aware that they are obliged to measure the size of any fish caught. Of course, the struggle for sustainable fishing practices in Turkey is still being waged, along with campaigns to highlight other key environmental issues with a major significance for people, for nature and the future of mankind.

Our crew on the ARCTIC SUNRISE confronted a fleet of Turkish purse sei[ne] fishing vessels targeting bluefin tuna i[n] the waters near Cyprus. Our ship, ARCT[IC] SUNRISE, is pelted with lead weights by fishermen from the Turkish tuna vesse[l] Cinar Ibrahim, breaking a helicopter window, before our ship was rammed as well. Greenpeace is calling for the closure of the bluefin tuna fishery in the Mediterranean Sea due to severe mismanagement, overfishing and illeg[al] fishing (right)
30 May 2008

Demand for clean air now in Istanb[ul] Air pollution from fossil fuels causes around 4.5 million deaths each year. Th[is] means that while we pay the price of air pollution with our health, fossil fuel companies are raking in massive profit[s]. Yet despite the shocking negligence of these major corporations and the inhumane failure of politicians to take actio[n] people are coming together to fight for future with clean air. Clean air is a righ[t] not a privilege, was the catch cry in Ista[n]bul as well, as part of a global moveme[nt] against air pollution (bottom left)
29 January 2020

Ali Can's story
Ali Can, a 55-year-old man living in Çan (Çanakkale), describes with pronounced sadness in his voice that t[he] population of 800 people in his village has fallen to 80 because of the coal pow[er] plants and the associated health concerns. And he adds: »We're left here to die!« (bottom right)
30 November 2018

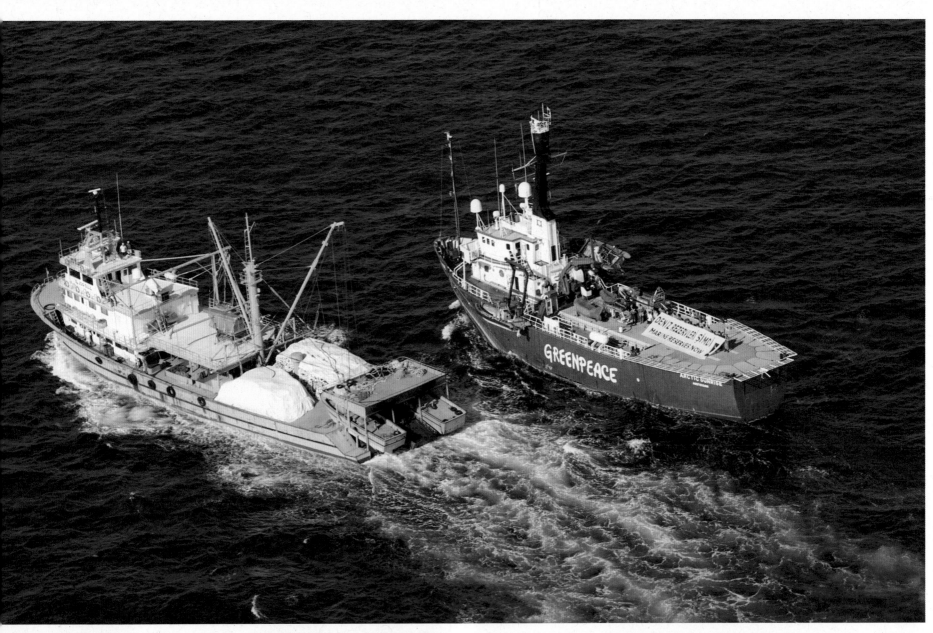

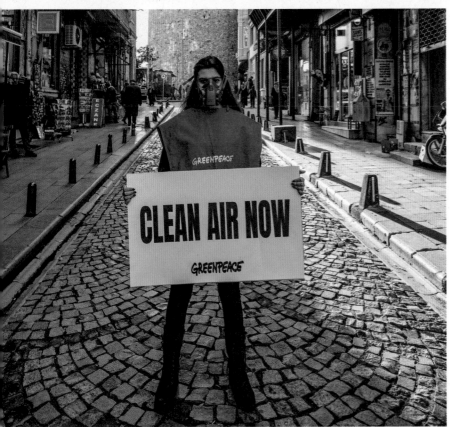

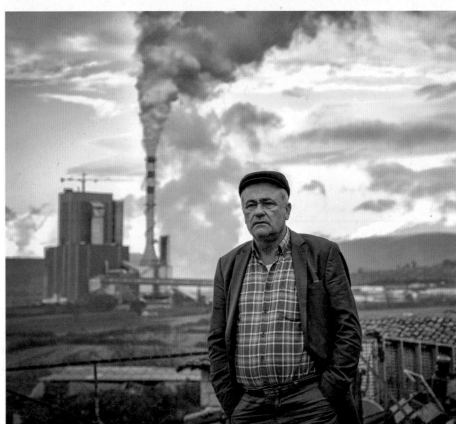

Greenpeace Thailand
founded 2000
The story of local warriors

**»TO KEEP OUR LIVELIHOOD FOR OUR
FUTURE GENERATIONS,
WE HAVE TO GO BEYOND FEAR.«**
Korn-uma Pongnoi

A majority of people in Prachuab Khiri Khan, a province in southern Thailand, make a living from fishing, coconut and pineapple farming, or family-run tourism businesses. And yet the lives they lead now could have been so different had it not been for the community's collective efforts to prevent a take-over by dirty fossil fuel.

In 1996, the Thai government announced plans to build three coal-fired power plants in the province. Local communities questioned the plans, especially due to the lack of public participation and transparency, and why the Environmental Impact Assessment (EIA), was downplayed.

»If a coal-fired power plant would really be good and beneficial, why would no other places accept it?« asked Sureerat Taechutrakul, one of the prominent leaders working with civil groups resisting the project.

Local communities claimed the EIA report had withheld facts about the impact of the development on coral reefs and Bryde's whales living in the area. They also stated that the land had been acquired illegally.

People from all walks of life stood together to protect Prachuab Khiri Khan. They handed letters of demand to city hall, blocked roads, occupied the site of coal plants, lobbied local governments, and attended coal company stakeholder meetings.

At the time, the RAINBOW WARRIOR was sailing to Southeast Asia on a mission for a »Toxic-free Asia«. The vessel stopped in Thailand and let its sails fly like flags in support of the local movements. This marked an important step in Greenpeace's renewable energy campaign, galvanising the bond with the Thai communities by speaking out against harmful government policies. The RAINBOW WARRIOR's visit also sparked debates about the country's energy industry, leading to demands for green and sustainable energy to be included in the country's energy development plans.

And it worked! By 2002, the government had postponed the project for another two to five years. This was followed by an order to move the power plant to a completely new location.

**THIS INITIAL SUCCESS, HOWEVER,
CAME AT A HEAVY PRICE.**
After testifying in Bangkok in an alleged land grab case, Charoen Wataksorn, a leading Prachuab Khiri Khan anti-coal activist, was shot dead as he got off a bus. He was only 37 years old. He died fighting to protect the people, the environment, and all life in the province.

Charoen's death further intensified the people's protests. And the coal-fired power plant project in Prachuab Khiri Khan was finally abandoned for good.

Charoen's legacy lives on today. Despite renewed efforts by the coal industry to gain a foothold in southern Thailand in the years that have followed Charoen's death, we are proud to say that the region still remains free of dirty coal.

We leave the final word to Korn-uma Pongnoi, Charoen's wife, who said, »As the Thai saying goes – ›kill one, and thousands more are born‹ – no matter how strong those in power are, if the local communities stand together, we can win any fight.«

Warm and colourful welcome
Locals from the communities of Thap Sakae, Bonok, Mae Rumphung, Ao Noi and Ban Khrut greet our ship, RAINBOW WARRIOR, and our crew. The people living in the communities were opposing plans for a 4,000 MW coal-fired power station in their area and had clear and understandable concerns about the dangerous air pollution and the effects on global climate change that the station would cause (right)
9 July 2008

Thank you for clean energy
Villagers are celebrating the handover of solar panels that Greenpeace helped to finance and install on two school buildings in Bo Nok and Hin Krud in the province of Prachuab Khiri Khan (bottom)
1 January 2002

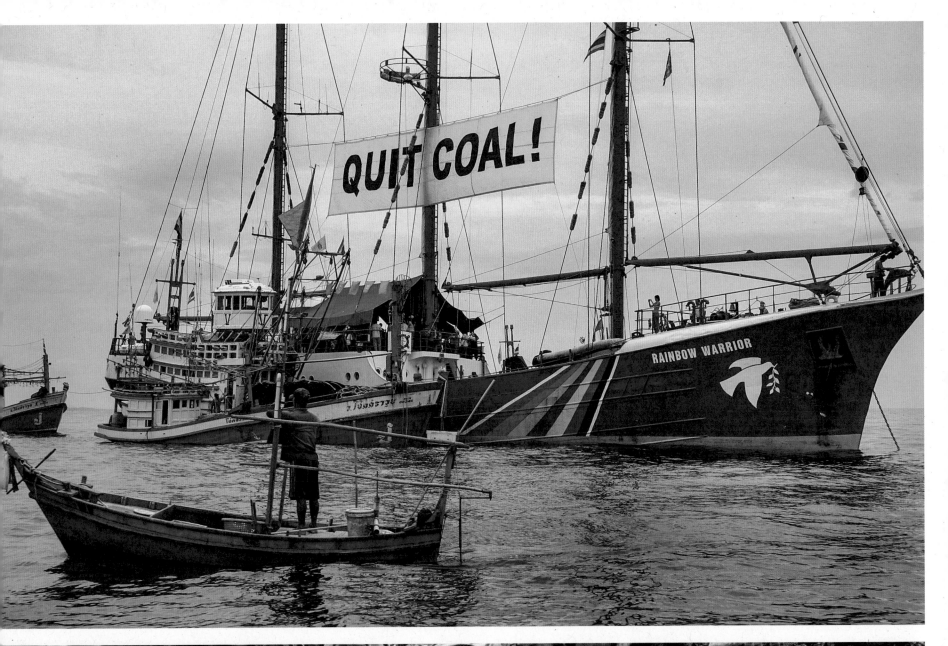
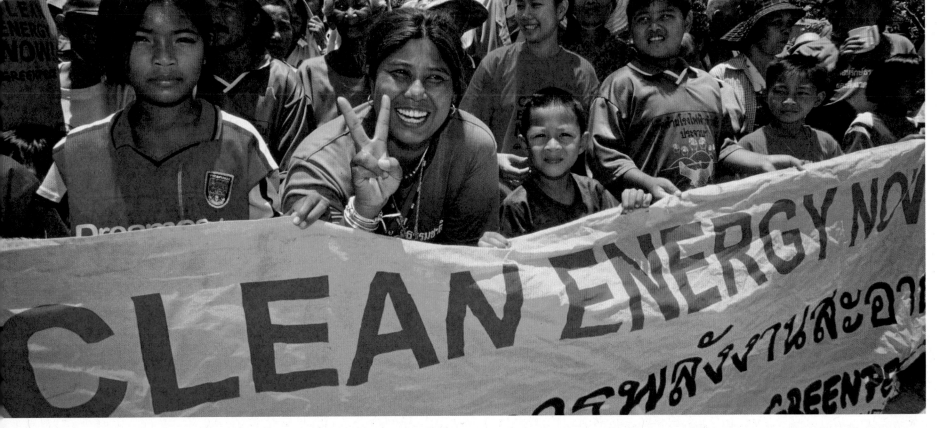

Greenpeace Malaysia
founded 2017
Taking on this urgent challenge together

We may have not been around for the last 50 years, but the pioneering spirit and unquenchable thirst of our founders burns in all those who have grown and become part of our Greenpeace family since the Kuala Lumpur office was opened in 2017. So who better to tell the story of Greenpeace Malaysia than the people who have grown, and experienced many »firsts« along the way, together with us?

»There have been so many wonderful memories with Greenpeace Malaysia,« says artist and long-time volunteer, Lee Hui Ling, who began her Greenpeace journey more than ten years ago with Greenpeace U.S.A. »One of the most meaningful being ›Wings of Paradise‹, a global Greenpeace campaign against deforestation, where we painted a 64-metre mural in Kuala Lumpur. From risky midnight runs on plastic investigations, coordinating the RAINBOW WARRIOR ship tour in Port Klang in 2018, to relentless campaigns against deforestation in Southeast Asia, life has been one adventure after another with volunteers and staff.«

Devarajan Suruthian, better known as »Uncle Adam«, started his journey with Greenpeace as a direct dialogue campaigner in 2017. He was just eight years old when Greenpeace was founded.

»I was told about the existence of Greenpeace's famous RAINBOW WARRIOR ship, but it never crossed my mind I'd be able to see it, let alone go on board! It's when my perspective towards saving our environment changed,« says Devarajan. »It truly inspired me, as I finally understood just how far Greenpeace would go to save our environment. I've always loved outdoor jobs, but little did I know that I was up for sweeter surprises when my teammates turned from being my ›colleagues‹ to my ›family‹.«

Nur Sakeenah Omar (Keenah) joined Greenpeace Malaysia in its infancy. And it all started with a random email in 2015 asking her to be a volunteer.

»Making new friends and vibing with people who get your motivation in life is really fulfilling,« says Keenah. »I was fortunate enough to be chosen to go to Ketapang in 2017, bearing witness to the devastation caused by forest fires, and to board the RAINBOW WARRIOR.«

»I'm now a public engagement campaigner, and two years on, it's been a crazy ride; from joining imported plastic waste investigations and organising non-violent direct actions against unnecessary single-use plastic and unsustainable palm oil practices in 2019 to spur change, to bonding with volunteers through fun, purpose-driven activities such as beach clean-up waste audits yearly. I wouldn't have it any other way!«

For some, the arrival of the RAINBOW WARRIOR in Malaysia represented a key moment, a celebration of ideas, feelings and hard work dedicated to a shared love of protecting the world in which we live. Yet for many Malaysians like Hui Ling, Uncle Adam and Keenah, it was also the renewal of a promise and provided a sense of belonging that reminds us all that it might not always be smooth sailing, but at least we're taking on this urgent challenge together, and this journey will never be a lonely one.

Malaysia's broken plastic import system

Greenpeace Malaysia has been conducting a field study into the broken system of recycling and how it impacts Malaysian society. The findings were shocking: a new »dump site« for plastic waste from more than 19 countries – most of them rich, industrialised countries. The study uncovered illegal practices and blatant violations of law causing environmental pollution and harming people's health. Since China banned plastic waste imports in January 2018, other nations in Southeast Asia – in particular Vietnam, Thailand and Malaysia – have been accepting more plastic waste. Between January and July 2018 alone, Malaysia imported 754,000 metric tonnes of plastic – a weight equivalent to approximately 100,000 large elephants. The waste came from countries like the United States, Japan, the U.K., Australia, New Zealand, Finland, France, Belgium, Germany, Spain, Sweden, and Switzerland

18 October 2018

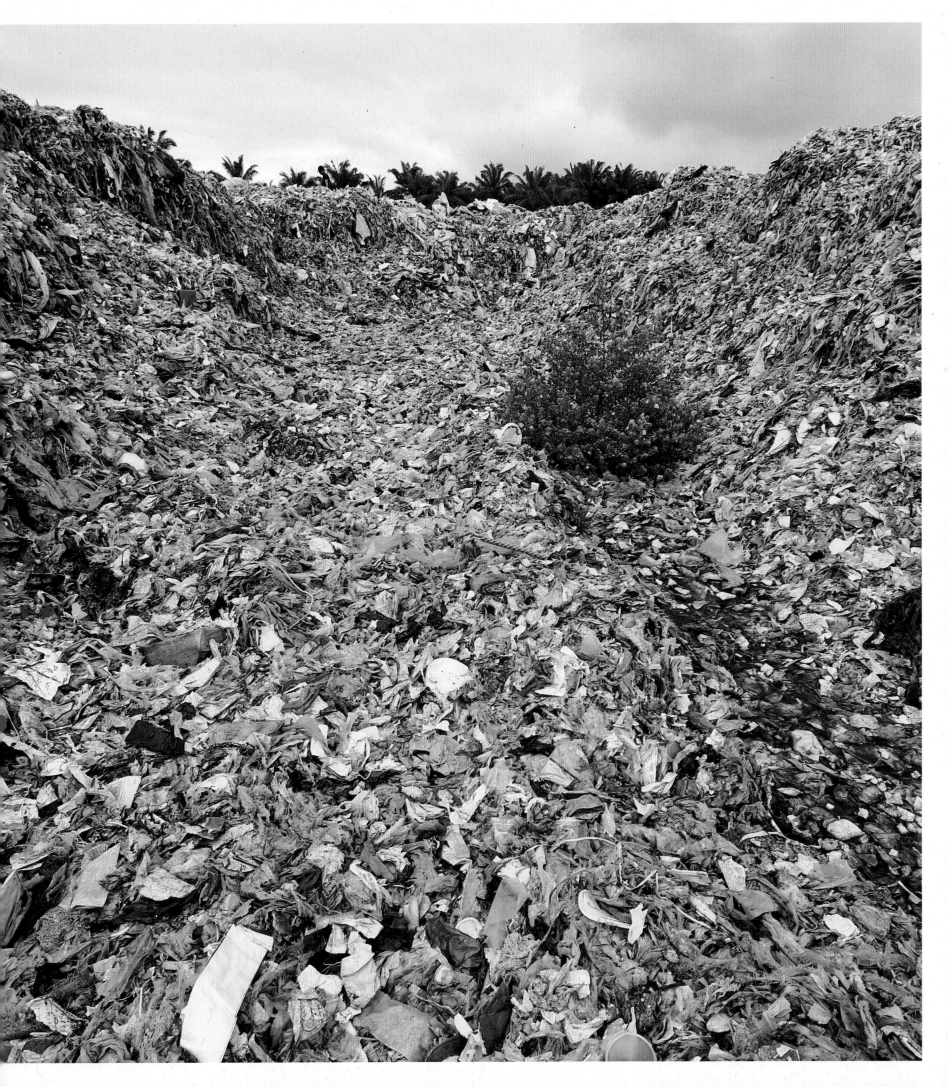

Greenpeace Indonesia
founded 2000
The Indonesian rainforests – a global treasure

Indonesia sits right at one of the epicentres of the global climate and nature emergency that we are all facing.

And here's why: we have the most extensive tropical forests outside of the Amazon and Congo, and the country is a treasure chest of biodiversity – it is estimated to be the home to between 10 and 15 percent of all known species of plants, mammals and birds on the planet. It's also our home, and over the last two decades, we have made it our priority at Greenpeace Indonesia to protect and preserve these wonderful wild natural places, and the cultures and rights of the hundreds of Indigenous communities whose lives depend upon these forests.

For Greenpeace, the protection of Indonesia's rainforests and carbon-locking peatlands, two of the best natural defences against climate change, is an important and even essential part of the global challenge to save our rapidly warming planet.

Indonesia's transition to democracy since the late 1990s has afforded Greenpeace Indonesia the opportunity to create and lead people-powered campaigns to achieve its mission. But this democratic space is, sadly, now dwindling again.

With democracy has come wealth. These riches have been generated by the rapid expansion of Indonesia's thriving pulpwood and palm oil industries, commodities that have helped the country become Southeast Asia's biggest economy. But this growth has a terrible dark side; rapid and devastating deforestation that has led to an increase in toxic, haze-producing forest and peatland fires that will have serious negative consequences for the economy in future as well.

A recent Greenpeace investigation reveals the stark reality. It found that forested areas greater than the size of the Netherlands have been burned across Indonesia in the five years up until 2020, with 30 percent of those fires occurring on pulpwood and palm oil concessions – land granted to major multinational agri-corporations.

However, pressure from Greenpeace and a series of direct, non-violent actions, including the occupation of a palm oil refinery in Bitung, North Sulawesi, by Greenpeace activists and an Indonesian rock band in 2018, did in fact lead to a significant breakthrough – with agri-giant Wilmar International making an important commitment to ending deforestation in its supply chain – and the creation of a new mapping platform to monitor the implementation of these commitments.

Unfortunately, these promises remain empty ones, and we are still yet to see lasting commitments from Indonesia's government and corporations to ending deforestation and illegal burning by supply chains across Indonesia.

But rather than be deterred, we leave you with this thought: you should never underestimate your power as a consumer to demand that the products you buy are free from links to deforestation in Indonesia, or indeed any other part of the world. You can take meaningful action to stop this from happening, be it through boycotts, petitions or joining Greenpeace's non-violent direct actions, wherever you are in the world. With your help and support, we can protect and preserve Indonesia's forests and peatlands, and in turn, help to save this planet, our home.

Complete deforestation in Papua
Smoke rises from burning stacks of wood – responsible for the destruction is a palm oil company. The valuable rai forest was cut down and destroyed enti rely in order to plant a palm oil monoc ture that will supply the palm oil used Western supermarket products and die bought at petrol stations (right)
1 April 2018

Rock on the palm oil silo
The rock band Boomerang takes part in a Greenpeace action at a Wilmar refinery in North Sulawesi, Indonesia – performing on top of a silo belonging to Wilmar in Bitung in order to draw attention to the dramatic level of forest destruction caused by the company (bottom)
25 September 2018

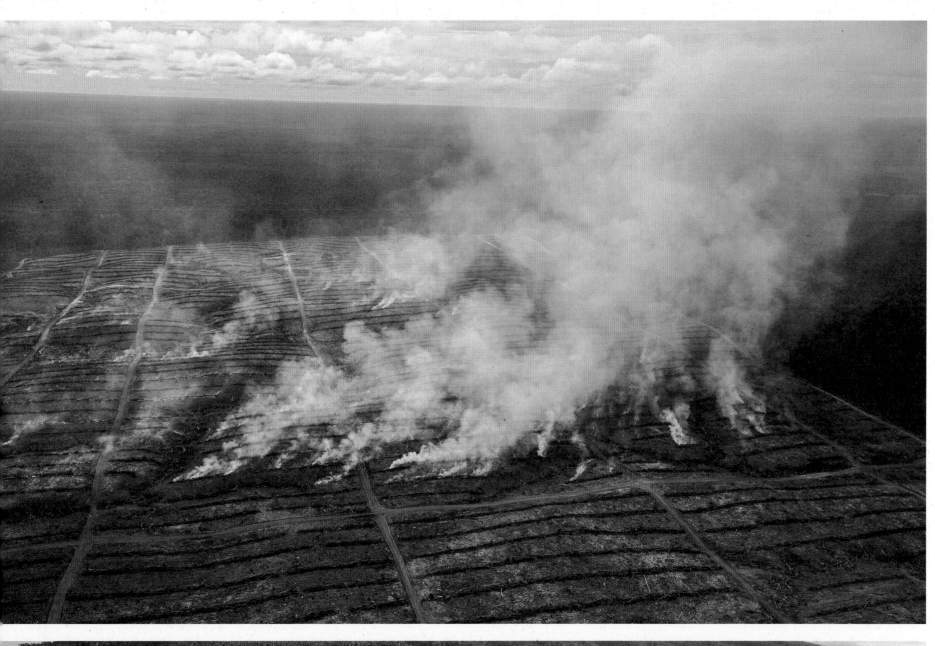

Greenpeace Philippines
founded 2000
Amplifying community demands for climate justice

Greenpeace Philippines was the first office opened by Greenpeace Southeast Asia. For more than 20 years and together with a strong network of community partners, organisations, volunteers, and supporters, we're still at the frontlines in addressing the climate crisis and protecting the environment upon which millions of Filipinos depend for their lives and livelihoods.

Our campaigns have influenced decision-makers by means of important laws, such as the Clean Air Act that bans waste incineration, the Ecological Solid Waste Management Act, and the Renewable Energy Act. We've also worked with broad alliances of civil society organisations to save the Philippine marine environment from illegal fishing and destruction, and to promote ecological food and farming systems.

Our campaigns also created space for people to share the vision of a green and peaceful future. This is not without risks, particularly in the political context of a country where dissent may not always be welcome. But harnessing collective power has successfully brought the people's voices to decision-makers, whether online or in the streets when marching for environmental justice.

AMPLIFYING COMMUNITY DEMANDS
FOR CLIMATE JUSTICE
Our vision is a world without fossil fuels, where Filipinos are empowered to respond to the climate emergency and carve out their own climate-resilient future.

The climate crisis has cost communities their lives, livelihoods, health, and security – violating their most basic human rights. Studies have shown that major fossil fuels are the ones most responsible for this crisis. However, no one is holding these companies accountable.

Together with a broad coalition of local groups, workers, activists, and concerned citizens, we made the Philippine Commission on Human Rights (CHR) investigate the role of major carbon polluters in violating human rights. This was the first investigation of its kind in the world, and the testimonies given by climate survivors, scientists, and experts allowed the world's biggest repository of evidence relating to corporate responsibility for climate change to be gathered.

The campaign also inspired young people in particular. In 2020, after typhoon Goni wreaked havoc in the southern province of Bicol, youth climate advocates called on the government to declare a national climate emergency on the basis of corporate accountability, and to include this in the nation's COVID-19 recovery plan.

A #BETTERNORMAL FOR PEOPLE
AND THE PLANET
Our youth-led »#BetterNormal« campaign brought together young people from different parts of the country to present their agenda of sustainable solutions to local and national government leaders. At a time when the country is contending with a shrinking democracy, the project has helped encourage collective action, providing a solutions-based avenue for environmental activism. It's also aimed at helping catalyse systemic change by mobilising citizens to bring back better economic, social, and political systems. Instead of reverting to tired, business-as-usual systems that have led to the climate crisis and global inequality, true global recovery must aim to transform economies and societies.

Together with the youth and our allies, we are continuing to expand this movement and inspire even more Filipinos to act together on intersecting issues such as health, economic recovery, and democracy, and to realise our vision of a better world for the people in a post-pandemic world.

Protest at Shell
»Shell, stop burning our future« – should challenge the multinational fossil fuel giant Shell to show accountability for their role in the climate crisis, their responsibility to prevent the worst scenarios, heed the call of climate-impacted communities for justice, and start a rapid and just transition to phase out fossil fuels (right)
20 September 2019

National Youth Congress
Young leaders from all over the Philippines held the seedlings to symbolise their call to the presidentiables to prioritise food and Ecological Agriculture in their electoral agenda during the national youth congress on food, nutrition and ecological agriculture. The youth congress was organised by Greenpeace as part of #IAmHampaslupa campaign, which engages with Filipino youth to help shape the country's programs and policies towards safe, healthy and sustainable food and agriculture systems.
25 November 2015

SHELL, STOP BURNING OUR FUTURE

#CLIMATEJUSTICE GREENPEACE

78
CRUDE OIL

Greenpeace East Asia Beijing Office
founded 2002
Solution-oriented environmentalists

One of the key changes the world has witnessed over the past 50 years has probably taken place in China.

The programme of reform and opening up in China in 1979 had one primary goal: economic development. Between 1979 and 2004, China achieved an – for some parts of the world, this was shocking – average annual GDP growth of about 10 percent. At the same time, this »miraculously« fast growth was taking its toll. In 2000, more than 12 percent of the country's arable land was contaminated with heavy metals, over 42 percent of the rivers were so polluted that the water was not safe for drinking, swimming or even fish farming, and people in over 60 percent of the cities were breathing dangerously polluted air.

In 2005, the Chinese people's share of carbon emissions reached a level that was higher than the world average. That year, China passed the Renewable Energy Law aimed at encouraging growth in wind and solar energy. Greenpeace, after less than 3 years in Beijing, was the only non-governmental organisation consulted by China's legislators on the early drafts of the law.

Over the past 19 years, Greenpeace's small team has grown into an office with 90 colleagues, doing independent investigations, documentation, exposure, actions, public engagement and policy advocacy on China's various environmental issues. We have challenged state-owned coal giants to stop their environmental crimes, have pressured major brands and retailers in the tea industry to quit highly toxic pesticides, and urged China to upgrade its national air quality standard. While pushing electronic giants as Hewlett Packard and Lenovo to minimise the use of toxic materials, we have also urged internet giants such as Baidu, Alibaba and Tencent to take more responsibility for the climate. Globally, backed by solid investigations from China, colleagues at Greenpeace from around the world pushed more than 70 international fashion brands to detoxicate the textile industry. The Greenpeace team in China put themselves at the frontline of major environmental accidents, including the Dalian oil spill in 2008 and the Tianjin chemical blast in 2015. Our independent investigations and documentation have earned both international recognition and domestic respect. Greenpeace has turned itself into an incubator for new generations of solution-oriented environmentalists, and social enterprises dedicated to making China, as well as the rest of the world, cleaner and safer, by means of renewable energy and sustainable agriculture as well.

Today, China is the world's largest carbon emitter, but is also the largest renewable energy producer, developer, and investor. With Chinese overseas investments expanding into more countries, and with China's new commitments to achieving carbon neutrality before 2060, the nation has an historic opportunity to show its dedication to ecological leadership, and to support other developing countries in finding a sustainable development model. This new, green and peaceful path is what the Greenpeace team in China, as part of an part of a global network, want to help China, and the rest of the world, to follow. After all, the role that China plays on the global stage is likely to be one of the biggest changes the world has yet to witness in the coming 50 years.

China's hidden disaster
The Dalian oil spill occurred when two pipelines exploded when unloading an oil tanker, spilling an estimated 90,000 tonnes of toxic oil into the Yellow Sea – and nobody seemed able to report about it
20 July 2010

Greenpeace Japan
founded 1989
Doing what is good for the earth

Greenpeace Japan is united by its maxim of »Act today for the future«, along with their objective of preserving the earth's bounty for children 100 years from now.

The first major activity by Greenpeace Japan was in 1993, when it revealed the site at which Russia was dumping radioactive waste in the ocean surrounding Japan. The shocking images from the dumping site were reprinted all over the world, prompting an international public outcry. This pushed Russia to announce that it would stop its dumping practices. In November the same year, the meeting of the parties to the London Convention adopted a historic resolution that banned the dumping of radioactive waste in the ocean. This was an outcome that gave Greenpeace a whole new reputation, especially in Japan.

In 1998, Greenpeace Japan launched a campaign to ban the use of vinyl chloride (PVC), which can emit extremely toxic dioxins, in children's toys. Working together with parents' associations, we put together an effective campaign organised around our catchphrase of »We don't need PVC toys«. In 2003, regulations governing PVC toys came into effect under the Food Sanitation Law.

We have also been drawing attention to the problems associated with commercial whaling since the 1970s as part of our mission to protect the marine ecosystem, and have been informing the general public in Japan about the fact that Japan is the only country that continues to hunt whales at high sea in the Southern Ocean.

In the immediate aftermath of the incident at TEPCO's Fukushima Daiichi Nuclear Power Plant on 11 March 2011, a radiation survey team was dispatched to the area, and the first radiation survey to be conducted directed a focus on the village of Iitate and the surrounding area. Despite being exposed to high levels of radiation, most of the villagers in Iitate continued living there. When the high radiation levels were subsequently reported in the international media, evacuation orders were issued for the area, including Iitate. Our survey of radiation levels in the ocean and analyses of seafood at five major supermarkets encouraged AEON, the largest supermarket chain in Japan, to declare that it was adopting a »zero tolerance« policy towards radioactivity.

In 2011, the global »Detox Campaign« also called on Japanese clothing manufacturers to reduce their use of hazardous chemicals to zero. A few years later, the campaign proved successful when one company finally announced a 99.8 percent rate of compliance with standards regulating the release of toxic pollutants.

»Doing what is good for the earth« shouldn't be an occasional activity - instead, it is something we should all be doing as a matter of course on a daily basis: in our everyday lives, in business, and in policymaking. In order to help society to put this into practice, Greenpeace Japan, as an »action-based NGO«, is working together with people from all over Japan who share the same concern for the environment. Developing detailed proposals on the basis of scientific evidence, and taking a hands-on approach, represent the key activities at the heart of our endeavours as we strive to ensure a diverse and peaceful future unaffected by the threat of climate change.

TEPCO must act
In the run-up to TEPCO's general meeting in Tokyo, Greenpeace calls on TEPCO, the operator of the nuclear reactors in Fukushima in Japan, to fina make real efforts to support the victims of the nuclear disaster. It also demande that TEPCO treat the water at the nucl disaster site in Fukushima Daiichi, whi has been contaminated with radioactive substances, instead of returning the Kashiwazaki-Kariwa nuclear power pla to operation
26 June 2014

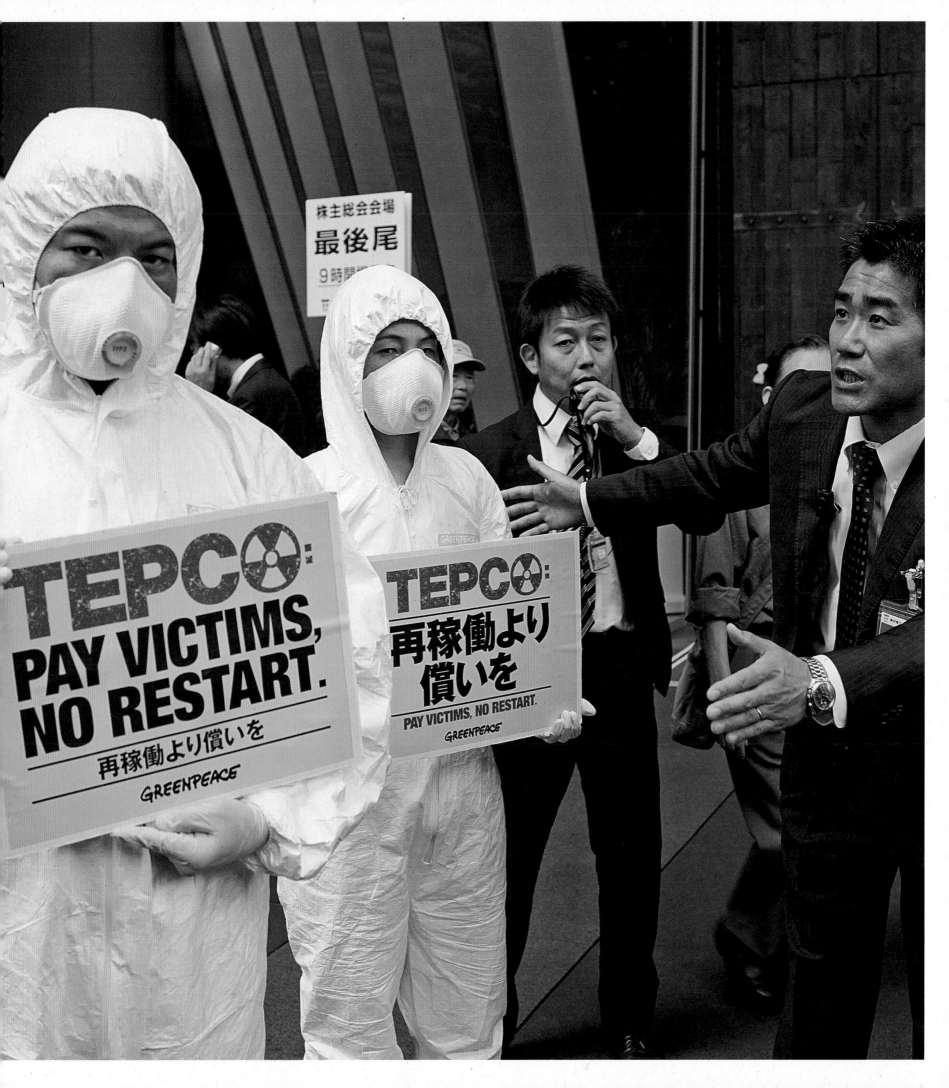

Greenpeace East Asia Hong Kong Office
founded 1997
Save Lantau Island

On 14 February 1997, Greenpeace was officially registered as a non-profit charity in Hong Kong and became the 33rd member of the Greenpeace's global network. This very first East Asian office was started up by a seven-person team. After 25 years, the Hong Kong office is close to having a staff of 100.

Our first NVDA – Non-Violent Direct Action – was to »Stop Toxic Trade« and took place in September 1997 at the Kwai Chung Container Terminal. Government experts ended up going to check the containers shipped from Australia to mainland China via Hong Kong, and which held illegally imported toxic waste. The campaign pressured the government of the Hong Kong SAR into banning all import and re-export of hazardous wastes in 1998.

Since 1997 we have performed a series of actions and activities to fight climate change, to stop toxic pollution, to ensure food security, to end illegal deforestation, and to defend the oceans. Positive changes achieved include the 2011 announcement by the Chinese government to suspend any commercialisation of genetically engineered rice, which marks a victory in the seven-year campaign that started in 2004.

More than 30,000 Hong Kong citizens signed up to Greenpeace's »No Nuclear Hong Kong« campaign in the 2010s as well, expressing their opposition to the government's proposal to increase the share of nuclear power to 50 percent of the city's energy mix by 2020.

In 2015, the »Save the Vaquita« campaign's undercover investigation exposed market players in a global and illegal trade in marine wildlife, driving vaquitas – a very rare small cetacean (porpoise) that lives only in the Gulf of California in Mexico – to extinction. Under public pressure, authorities stepped up law enforcement and successfully prosecuted the businessmen who profit from these illegal activities.

More recently, a local campaign with global significance is »Save our Lantau«, which we launched in 2020. More than 140,000 people (as of early March 2021) have signed up to show their support in demanding the government to stop the controversial »Lantau Tomorrow Vision« project, a plan to build artificial islands in the central waters of Hong Kong. The campaign is ongoing as of 2021, and we are determined to call for sustainable development planning, and to protect of our valuable and beautiful environment.

Save Lantau Island
Two paragliders from Greenpeace Hong Kong fly over Lantau Island in Hong Kong, urging the government not to go ahead with the »Lantau Tomorrow« reclamation project, which could cause severe environmental damage to Hong Kong's largest island
30 September 2020

Greenpeace East Asia Seoul Office
founded 2011
Pushing and promoting change

The history of Greenpeace's activities in South Korea started in 1993 with a campaign opposing nuclear power plants, and subsequent campaigns against whaling and overfishing.

Ever since the South Korean office opened in Seoul in 2011, it has consistently maintained its »No nuclear« standpoint, calling for a ban on new nuclear plants. In 2013, Greenpeace activists climbed up Gwangan Bridge in Busan calling for the expansion of the radiation emergency planning zone. In 2016, we joined the 560 Citizen Litigation Group in filing a lawsuit against the Nuclear Safety Commission, pushing for a stop to the new nuclear power plants in Busan.

Another campaign aims to stop the Japanese government from dumping radioactive water into the Pacific Ocean, with more than 80,000 people having already joined the campaign.

The Korean office can also boast major achievements in its renewable energy transition campaign. We have been pushing IT companies to switch to 100 percent renewable energy since 2015. As a result, Naver, South Korea's largest online platform, has promised to use 100 percent renewable energy as well as Samsung Electronics to power all its facilities (including manufacturing plants) in the United States, Europe and China by 2020.

In addition, the Seoul office has been campaigning to phase out motor vehicles with internal combustion engines, promoting its »Climate Participation« campaign to the government and the political community, which aims to identify countermeasures against climate change, and pursuing its »Dangerous Coal Investment« campaign to halt coal investments overseas.

In 2012, we released a report assessing and comparing the sustainability of practices by three canned tuna companies in South Korea and launched a »Good Tuna« campaign. It successfully prompted South Korea's Ministry of Oceans and Fisheries (MOF) to investigate illegal fishing and to close regulatory loopholes for its distant-water fishing fleet, and also resulted in an amendment to the Ocean Industrial Development law. We have been working with the community campaigners from »Ocean Defender« to protect the Southern Ocean and to continue to push for the expansion of maritime sanctuaries.

»Plastic-free« has had a huge impact on the Korean public. In 2016, we published details of the pollution caused by the use of microbeads as a component of cosmetics, which led the Ministry of Food and Drug Safety to prohibit the production, use and sale of cosmetic products that contain microbeads. In 2019, we exposed the illegal export of plastic waste to the Philippines, and also launched a campaign to reduce the use of single-use plastic packaging, which targeted large supermarket chains. In 2020, Lotte Mart, one of the largest supermarket chains in Korea, announced that it will cut its consumption of single-use plastics by 50 percent by 2025 – making it the first in Asia to do so.

The Seoul office has grown rapidly and can boast any number of achievements, not least raising awareness about environmental issues, and will continue to launch effective, creative and innovative campaigns to engage with the public and win their support in pushing for and promoting all the other changes that are so urgently necessary.

A sand whale calls
A large sand humpback whale on Haeundae Beach in Busan, South Korea shouts »Stop illegal fishing! Protect the oceans«. South Korea was listed on the preliminary list of IUU (illegal, unreported and unregulated fishing) countries by the United States because of the government's lack of efforts to eliminate illegal fishing
19 October 2019

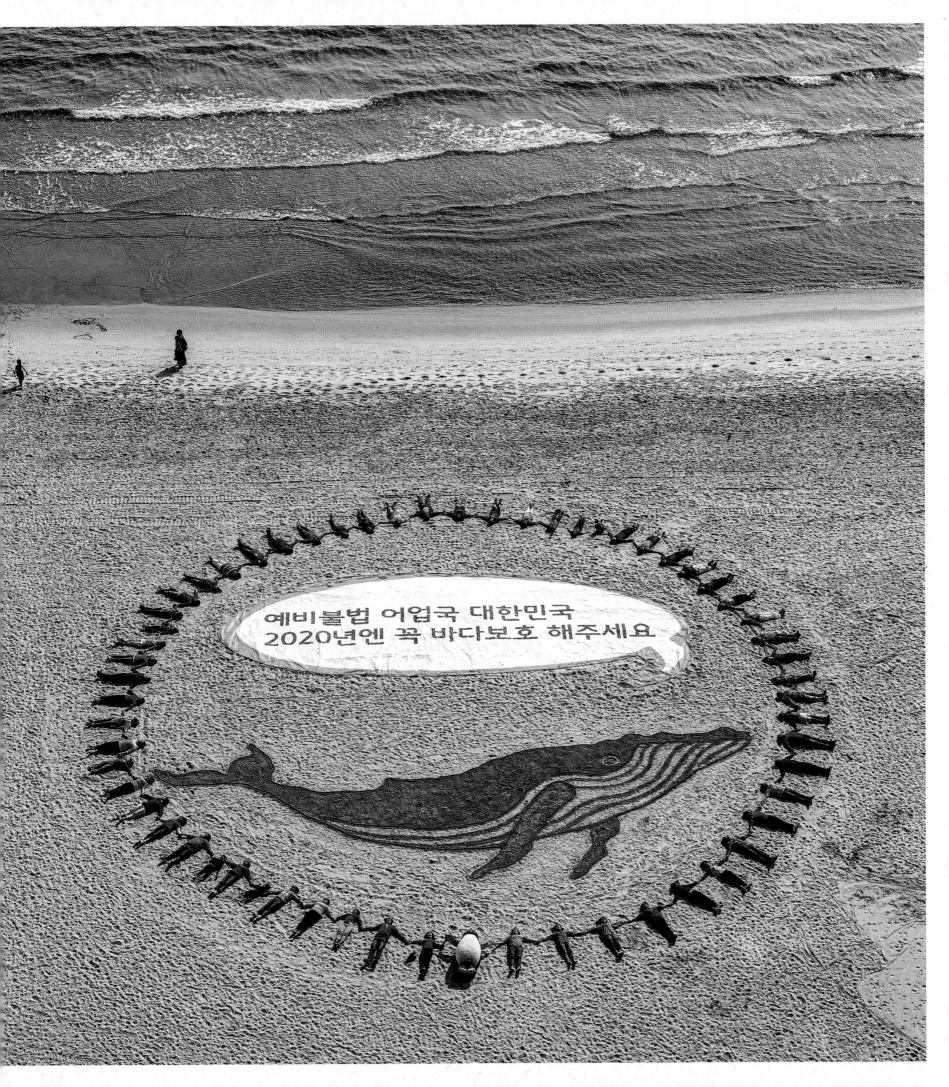

Greenpeace East Asia Taipei Office
founded 2010
No plastic, no coal – but clean oceans, healthy forests and fair labour

In June 2010, Greenpeace was officially registered in Taiwan, with sustainable distant water fishery being the key objective of its first campaign. Field investigations and reports allowed Greenpeace to expose the reality of overfishing, illegal transshipment, and the huge bycatch resulting from industrial fishing operations. In collaboration with other Greenpeace offices, we continue to expose the scourge that the forced labour of fishermen from Indonesia represents, and how it relates to the international export market in the U.S.A. All in all, the campaigns aimed at the relevant corporate and government entities in Taiwan have increased the pressure to protect our oceans and ensure basic rights for vulnerable workers.

Over the years, we've fought against the use of toxins in food, water, fashion, as well as responding to global campaigns to reduce air pollution and deforestation, to protect the Arctic and the world's oceans – raising our profile with the public and resulting in offices being set up in two more cities, Taichung and Kaohsiung – allowing us to reach more potential members and encourage community involvement.

After a series of campaigns to raise awareness about plastic reduction, the government finally announced a ban on microplastics in 2016. In 2018, coastal debris screening was carried out for one year; and from 2019 on, we began to target nine major retailers to encourage them to reduce their use of single-use plastics, advising them to implement reuse and refill systems – a campaign that received support from more than 150,000 people.

Tackling the climate emergency is also a top priority for us. In 2018, with more than 120,000 people having signed a petition, we successfully stopped the planned upgrades to the Shenao coal-fired power plant. In 2020, we revealed that bulk electricity users are responsible for 30 percent of all carbon emissions in Taiwan, and that the energy transition will play a fundamental role in realising net zero emissions by 2050.

After 11 years of hard work, and having started out with a small donor base, we now have more than 84,000 donors, 210,000 supporters, and 685,000 subscribers on social media. This enormous growth only makes us more determined to protect the environment, and continue the fight for a sustainable future.

Climbing against coal
Greenpeace climbers successfully conve
a message against the planned expansio
of the Shenao coal-fired power station.
The power plant pollutes the air and
harms the climate
14 September 2018

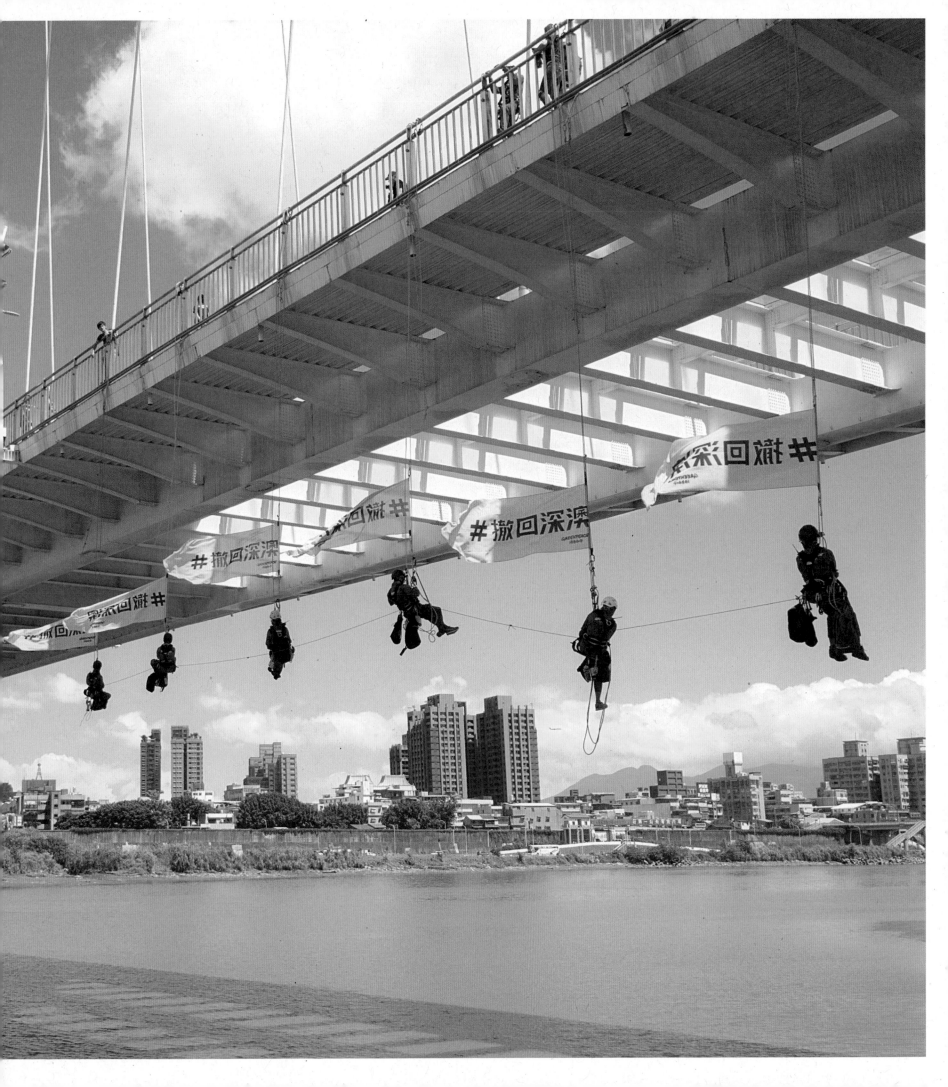

Greenpeace Australia Pacific
founded 1977
To make a green peace

Covering almost 20 nations and three of the world's great oceans, Greenpeace Australia Pacific has a truly vast remit of astonishing natural and cultural diversity. On land, it spans the rainforests of Papua New Guinea, the deserts of the Nullarbor, and the ancient Woolemi wilderness. At sea, it extends to the coral cays of the Great Barrier Reef, the spectacular island nations of the Pacific, and the icy waters of the Great Australian Bight.

The story of Greenpeace in this region began in Albany in 1977, when five activists – Canadian Bob Hunter, Australians Jonny Lewis and Tom Barber, Jean Paul Gouin from France, and Aline Chaney from the U.S.A. – spent several weeks in an inflatable vessel in an attempt to bring an end to local whaling operations. No whale has been hunted from Australian shores since 1979.

Other epic campaigns in the region followed. In the Pacific, Greenpeace staunchly opposed nuclear testing and intervened to attempt to prevent any blasts from occurring. In 1985, 300 Rongelap residents from the Marshall Islands, whose homeland had been badly impacted by radiation, were relocated by the RAINBOW WARRIOR. Nuclear testing in the Pacific finally ended in 1996.

The long southern coast of the Australian continental land mass faces Antarctica, where Greenpeace has worked to have the southern continent declared an international marine protected area. The Protocol on Environmental Protection to the Antarctic Treaty to protect the Antarctic environment was adopted globally in 1991.

Crucial to the environment and the societies of the Pacific are the giant tuna shoals that inhabit the region's waters. Beginning in the 2000s, Greenpeace spent many years campaigning against globally active industrial fishing corporations, and advocating the introduction of less destructive fishing practices.

As climate change emerged as the most urgent threat to the world in the 1990s, coal — the number one driver of global warming – became the primary focus for Greenpeace Australia Pacific. Over most of this period, Australia relied on coal for domestic energy generation while also being the world's number one coal exporter. In 1994, Greenpeace Australia vs Redbank Power Company represented the world's first-ever climate litigation. Since then, Greenpeace has pursued a relentless campaign to end the use of coal for good. Today, with major corporate energy users switching to 100 percent clean power by 2025 and state governments establishing renewable energy zones, the end of coal is finally in sight.

In 2017, global energy companies were lining up to open the waters of the Great Australian Bight as a new oil province. Following a sustained campaign by Greenpeace and its allies, the exploration plans were put on ice and the Bight remains safe from drilling.

From those small beginnings in Albany in 1977, the abundance of whales swimming past Sydney Harbour is testimony to what is possible when people work together for the good of each other and the good of the planet. Today, with climate damage taking a severe toll on Australia and Pacific Island nations, the spirit of the RAINBOW WARRIOR has never been more determined to prevail through the storm – and to make a green peace.

A flotilla of kayaks
A student-led flotilla of kayaks, sailboat, paddle boards and surfboards set sail from Apollo Bay harbour to send a clear message to the oil companies that they with their greed for oil – are not welcom in the Great Australian Bight. The flotill was organised by a 15-year-old student from nearby Apollo Bay College (right)
23 November 2018

Catastrophic coral bleaching
is affecting the Great Barrier Reef.
The reef is currently experiencing its second major bleaching event in two years. In March 2017, Greenpeace Australia Pacific reported on this tragedy an called on the international community to refrain from using coal as a source of energy, because it is one of the main drivers of global warming and therefore of coral die-offs as well (bottom left)
17 March 2017

**Activists »flood« the beach
to protest pipelines in Fiji**
Pacific Island Represent activists organ sed a spectacular demonstration in Fiji protest against Citibank's investments oil pipelines. As part of the action, blac tee shirt-clad protesters swarm across the shores and into the ocean to replica an oil spill (bottom right)
7 July 2018

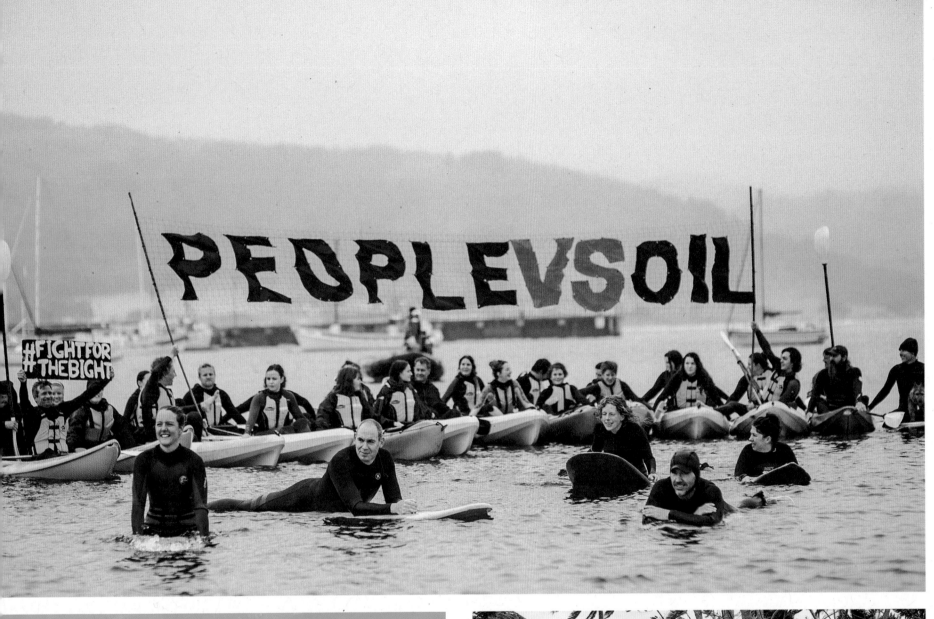

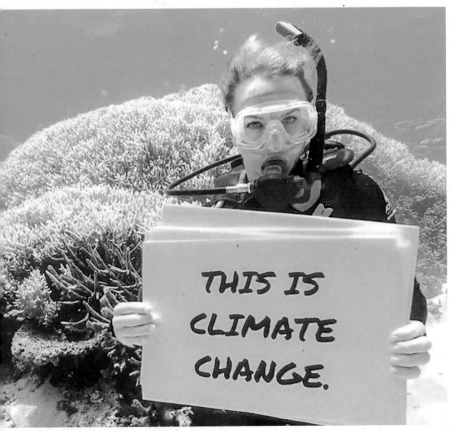

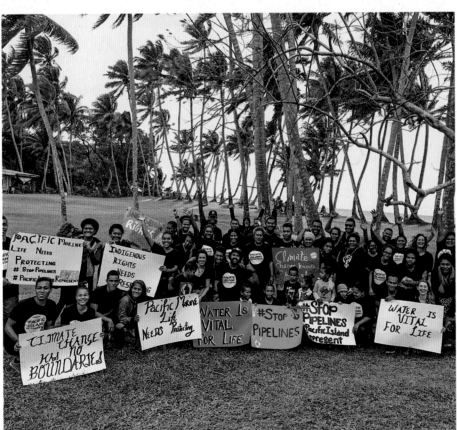

Greenpeace Aotearoa
founded 1974
Making waves through five decades of action

Greenpeace Aotearoa is a small, strategically important office based on the island of Te Ika-a-Māui, Aotearoa / New Zealand. It's southern latitude meant the office played a pivotal role in both the World Park Antarctica and Nuclear Free Pacific campaigns, and was one of the first to be established. In 2020 the office changed its name to Greenpeace Aotearoa. The small Greenpeace office has a long-held reputation for »punching above its weight« through strong alliances, good strategy and perseverance. Here's a story from the final months of a 7 year campaign to stop deep sea oil which well captures the nature of Greenpeace Aotearoa.

It was the height of audacity: repurposing a pocket-sized mail boat, painting a rainbow on the front, and then tracking and confronting a 21,000-tonne oil prospecting vessel. The aim: to bring an end to offshore oil exploration in Aotearoa. It is a story, and a decade-long campaign, that defines the special nature of Greenpeace Aotearoa.

The campaign against deep sea oil began in 2010 when the New Zealand government signed a contract with Brazilian oil giant Petrobras. With the horror of the »Deepwater Horizon« disaster in the Gulf of Mexico still fresh in everyone's minds, the oil prospecting deal provoked a wave of protest led by iwi (indigenous Māori tribes), which Greenpeace soon joined. Other multinational oil companies also tried to get in on the act: Anadarko, Statoil, Chevron, and OMV. All would be repelled by one of the most tenacious campaigns in living memory.

Huge seismic blasting vessels were repeatedly met by the protests of flotillas of ocean-going waka (traditional Polynesian sailing canoes), small boats, and yachts. On land, hundreds of thousands were mobilised to hold marches and hikoi (an Indigenous communal walk or march), and this at oil industry events, at parliament, on beaches and online. Yet still the oil vessels kept coming.

Seven years in, the fight against »Big Oil« had reached a crucial crossroads. New Zealand's government had passed a new law known as the Anadarko Amendment preventing protestors from being within 500 metres of any oil vessel, with penalties including prison time. Against this turbulent backdrop came an idea for an action that was daring, could defy the odds, and was based on resilience and a culture of »doing it yourself«.

With the latest seismic oil vessel fifty miles offshore and our local marine capacity limited to inflatables, it became obvious that we needed a bigger boat – so we put the call out to our supporters for help. In little more than two weeks, we had crowdfunded NZ$ 100,000, allowing us to purchase a vintage ex-postal vessel, in which we set off in formidable seas to find and confront the vessel we dubbed »The Beast«.

Risks for those on board the Greenpeace boat, TAITU, included chronic seasickness, severe weather, and possible jail time. What they were hoping for, however, was a tipping point in the campaign against deep sea oil. And that's exactly what happened. They found the ship, breached the 500-metre exclusion zone – deploying kites and three swimmers – and caused the vessel to swerve off course. Once back in port, the TAITU three were discharged without conviction. Another blow for the oil industry and a major turnaround in the campaign. The new Labour-led government announced a moratorium on oil permits. Oil companies started packing up and leaving. And in a final push aided by school strikers and others protesters, we drove the last oil giant, OMV, out of Aotearoa, staging a blockade of their headquarters that ended with a mass macarena, and leaving behind a museum of oil. A campaign of attrition, fought over ten long years with fearsome allies, had made life untenable for »Big Oil«.

The end of oil
In the year marking Greenpeace's 50th anniversary, the last oil drilling and oil production rights outside New Zealand's oil industry heartland of Taranaki were renounced. The confrontation with the offshore oil companies operating in the background was an important turning point that made this victory over oil possible. Greenpeace Aotearoa is now focusing on the industry that is having the greatest impact on New Zealand's environment: industrial dairy farming
9 April 2017

You can't sink a rainbow
The Greenpeace flagship was blown up and sunk in 1985 by agents from the French secret service, killing our dear colleague and a great photographer, Fernando Pereira. The ship had been used to protest nuclear testing in the Pacific Ocean. Matauri Bay is now the final resting place of the RAINBOW WARRIOR, where the local hapū (subtribe), Ngati Kura, watches over it. Despite the loss of the ship – or possibly because of it – a global movement has emerged around all the people determined to defend the environment – also part of Fernando's legacy (bottom)
11 July 1985

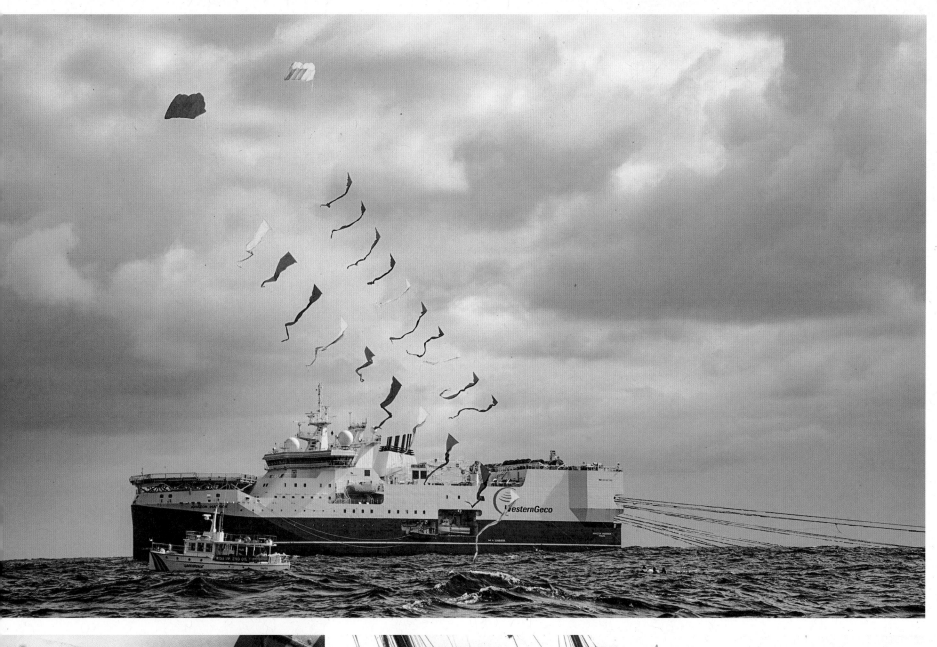

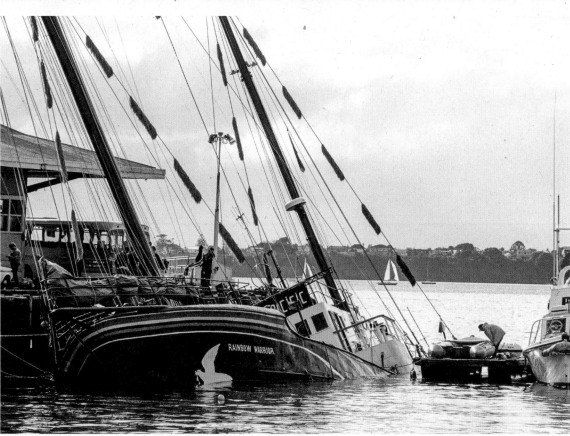

Greenpeace India
founded 2001
Immense challenges for more than a billion people

Our story dates back to 1995. A group of concerned citizens of India, along with their friends from various Greenpeace organisations, came up with the idea of Greenpeace India. The organisation was formally registered in May 2001. From then to now, the journey of two decades has been a story of interesting tales, as with most things in life.

The initial phase was marked by a range of campaigns against Genetic Modified Organisms (GMO) and toxic waste, and for the protection of Olive Ridley turtles on the coast of Odisha. We also had the milestone of 20,000 donors joining the campaigns by Greenpeace India by the year 2009, and making it as much an Indian organisation in all senses as a global one. The second decade for Greenpeace India was equally varied, with the organisation having gained strength based on a better network of allies, volunteers, donors and staff experience – the organisation expanded its campaign horizon. Along with our allies, we ran an extensive campaign opposing the Nuclear Liability Bill, a rooftop solar campaign, campaigns to promote safe food, sustainable agriculture, »Junglistaan« (an anti-coal/forest protection/community campaign) to the »Circles of Solidarity« project (stories of farmers and migrant labours) and now its »Detox City« mobility campaign.

Greenpeace India campaigns have not just influenced the government's policies, but also had an impact on the behaviour of people, including our supporters and donors, especially when surveys showed that environmental/climate issues were not yet a top priority. Some of the recommendations on the issues that Greenpeace India worked on were also frequently included in the election manifestos drafted by political parties. And at times, we also stopped governments from making decisions that were detrimental to the ecosystem. Our work made headlines and, at times, rocked the political sphere too. It exposed the greenwashing attitudes of politics and corporate entities. We have made a significant mark in the environmental space locally as well as globally.

The fact that Greenpeace's campaigns have become a people's movement has not been welcomed by the nation's political forces. In 2015, the Ministry of Home Affairs offloaded a Greenpeace India activist from her London-bound flight when she was on her way to talk to British members of parliament about the violations of forestry law in the Mahaan forests by a U.K.-based company. That same year, Greenpeace India's bank accounts were frozen and foreign contributions were annulled. This forced the organisation to suspend some of its campaigns, and let go of its committed staff. Since then, Greenpeace India has been subjected to harassment and baseless legal threats.

Despite the continued attacks, Greenpeace India stands strong, along with its more than 700,000 supporters. The courts have issued landmark verdicts and have clearly indicated that dissent cannot be muzzled in a democracy. Our supporters keep us inspired and strongly engaged. They have always stood together with us through the toughest times.

The COVID-19 pandemic has left the world shattered. It has caused immense hardships for millions of people worldwide. Greenpeace India also considers this disruption also as an opportunity to revisit lifestyles and adopt sustainable practices, and contribute to building a future that is green, just and equitable.

Greenpeace India's vertical garden is called Garden City 2.0. As Shivani Shah, senior campaigner for Food for Life, Greenpeace India, says: »The aim of the project is to create awareness about separation and composting. The first step necessary is to separate the waste and compost the wet waste, and once this has been done, to give it t farmers for use as organic fertilisers as second step. This will ultimately ensure that less chemicals are used to grow the food we consume, which will benefit the environment too« (right)
15 October 2017

»Clean Air Now« action in New Delhi Greenpeace India organises a flash mob at Dilli Haat in New Delhi to raise public awareness about air pollution – its sources, health impacts, and solutions to it. The action is part of a global movement against air pollution (bottom)
16 February 2020

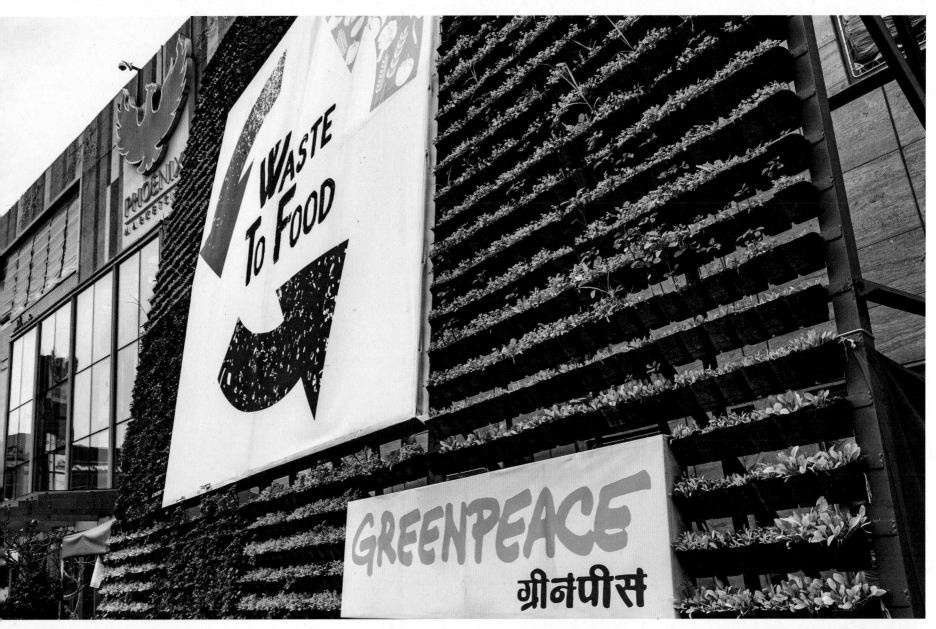

Greenpeace International (GPI)
founded 1979
A global network calling for a radical system change now – for a green and just future for everyone

Greenpeace has its roots in Canada, and its original focus was directed at nuclear testing, operating under the name »The Don't Make a Wave Committee«. In 1979, Greenpeace International was set up and Greenpeace broadened its vision to focus on stemming the tide of environmental destruction on a more general front.

When Greenpeace International was established, offices were already up and running independently in Europe, North America, and Australasia. While GPI had a mandate to provide the movement's overall direction and policy, trustees were nominated by each office for the Annual General Meeting.

The first campaign victory for Greenpeace came in 1982, when the International Whaling Commission voted to ban commercial whaling. In 1984 there was a sad moment, when the Greenpeace ship RAINBOW WARRIOR was bombed by French government agents in New Zealand. But a global wave of support, also rapidly led to new Greenpeace organisations opening and a string of campaign wins. Some of the most prominent were the 1991 Antarctic Treaty, the 1992 UN-led worldwide ban on large driftnets in the high seas, and in 1996, the passing of a global nuclear weapons testing ban.

Greenpeace organisations were then set up in in Latin America, Russia, the Mediterranean, Asia and Africa. While at first Greenpeace tended to operate in these countries from afar, bringing a western perspective, the organisation soon evolved in a way that supported local offices to tailor campaigns to local realities, with local staff implementing them. GPI has now become more of an international secretariat, focused on ensuring a tight strategy across the global network, empowering and supporting the national and regional offices, and operating the Greenpeace fleet.

Fundamental system change, rather than narrow issue-oriented targets, soon became a key focus, and this is why »The Framework« was developed, a guide on how to prioritise

Greenpeace's work for a green and peaceful word, which informs how we communicate our work, how we interact with others and what projects and campaigns we choose. This work is not only reflective of the world outside the network, but also within Greenpeace, as diversity and gender equity have become more widely embraced.

Greenpeace now has a truly global reach and has brought together a dynamic and diverse family of people. Despite all the challenges that form the backdrop to its activities, Greenpeace is exerting its influence, and holding power brokers to account. Greenpeace International supports and enables the whole network and alliances to conduct campaigns which have motivated the Chinese government to take action against the use of pesticides, genetically modified organisms and coal; the Brazilian environmental agency denied Total an oil drilling licence for the Amazon Reef; in the Congo Basin, Greenpeace Africa is actively tackling the intense logging activities, and the associated human rights abuses, that are unfolding there. Greenpeace's campaigns have confronted oil companies in the Arctic, and on streets on every continent. Together with partners Greenpeace pressured the fossil fuel giant BP to make its 2020 announcement that it will slash its oil and gas production over the next ten years, while it has exposed all of Exxon-Mobil's insidious political lobbying, and continues to call out the destruction cause by Shell's pursuit of fossil fuels.

Today, the global network is viewing the climate and biodiversity emergency through the lens of a world that needs radical and fundamental system change now, in a green and just future for everyone – the youth of today and tomorrow, Indigenous peoples and marginalised communities on the climate frontlines, and other living beings that share our beautiful land, waters and sky with us. Greenpeace continues to learn, to confront, to be creative, compassionate and courageous – using hope and people power for a greener, more peaceful planet.

The founding
meeting of Greenpeace International – with everyone in one room and everyon at one table. Still no laptops, no cell phones or even smartphones, but lots c paper and heated discussions (right)
1 November 1979

A powerful alliance
Thousands of people march in the stree of Madrid to demand that politicians introduce ambitious measures to stop climate change. A powerful alliance including Greenpeace Spain, GPI, and Fridays for Future forms the basis of the global movement to fight the climate a biodiversity crisis (bottom)
6 December 2019

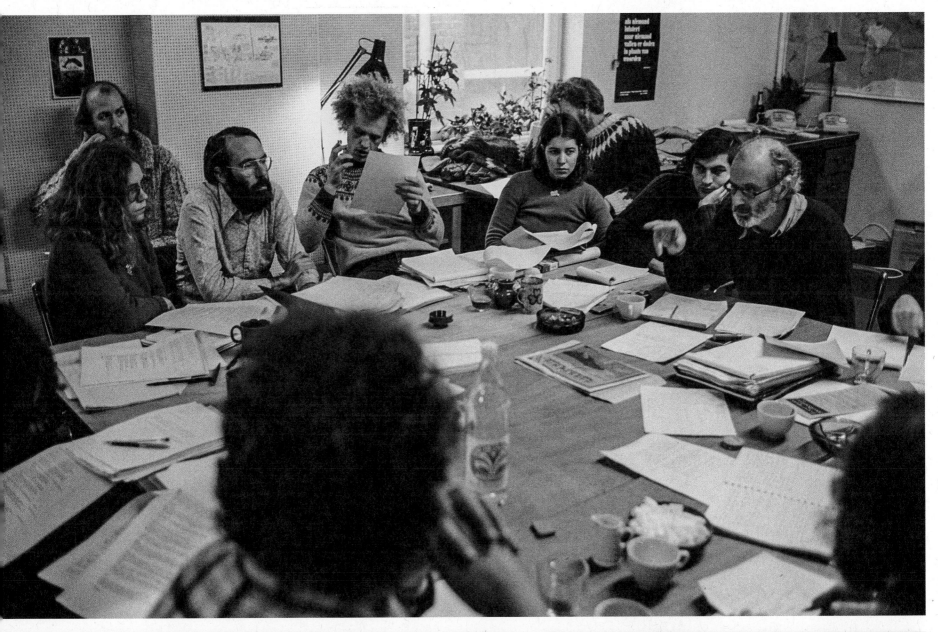

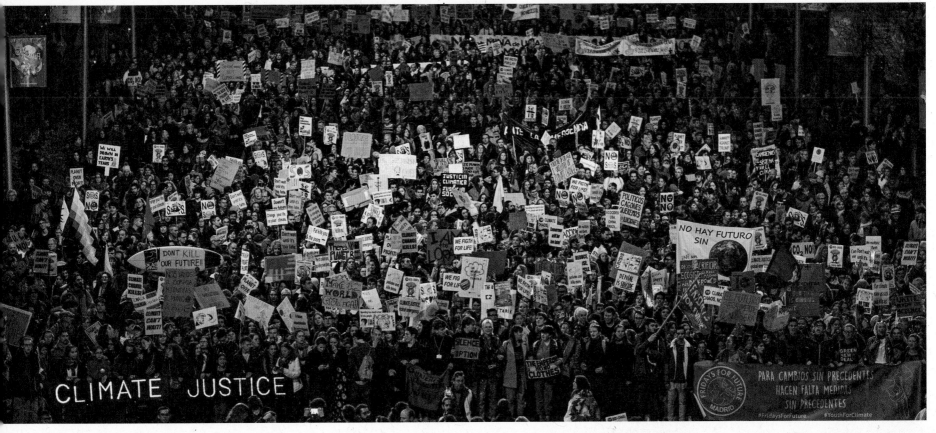

CLIMATE JUSTICE

Greenpeace Research Laboratories – Science Unit
founded 1986
Bearing witness through the use of science

Over the course of the 1980s, Greenpeace's work expanded to encompass issues such as climate change, deforestation and the environmental impacts of agricultural and industrial chemical use. The Greenpeace International Science Unit was established to provide scientific advice and analytical support to inform these campaigns and the increasing focus on shaping effective policies at national and international level.

Based at the University of Exeter in the U.K., the Science Unit has, over the last 25 years, supported the work being done by Greenpeace's national and regional organisations on a diversity of issues, with a particular focus on helping identify and address international priorities. The efforts being made to counteract the problems associated with plastics, as just one of these many issues, illustrates both the importance of continuity and technical capability in conducting such work, and the way in which the requirements evolve over time, sometimes turning full circle.

The work concentrating on plastics was inspired by Greenpeace's wider focus on toxic chemicals in the 1990s. Lifecycle emissions from PVC, a chlorinated plastic, emerged as a particular concern and the sophisticated analytical systems at the Science Unit were used to drill down on the many and varied chemicals associated with this material. This included forensic analyses of the harmful additives in PVC toys sampled around the globe, thereby contributing to recognition of the threat they pose to children and the imposition of legal restrictions on some of these chemicals.

Since then, plastics have emerged as a problem of global significance. Disposable »single-use« packaging and a host of other plastic items can break down into a myriad of microplastics which, in turn, have been found in water, soil, sediments and wildlife. The Science Unit has helped many offices with this work, sourcing equipment for taking samples at sea and in rivers and lakes, analysing samples to identify plastics, and helping build awareness of the huge scale of the problem. Samples collected from remote waters of the Arctic and Antarctic using the Greenpeace ships, for example, have been analysed using high-performance microscopes to identify plastic particles and fibres, which we found wherever we looked for them. State-of-the-art spectrometric techniques have been use to identify the chemical additives and contaminants associated with plastics – methods that were recently extended to the analysis of the »bioplastics« increasingly being proposed as substitutes. The collaborative scientific relationships that have developed through this work, including ones with academic institutes, have enabled Greenpeace to contribute directly to influential papers discussing plastics in turtles, marine mammals and waterbirds, and on shores from the Galapagos Islands to the Bay of Bengal.

Besides supplying the feedstocks to manufacture plastics and their chemical additives, the petrochemical industry is also a significant driver of the climate change problem. Plastics contribute to greenhouse gas emissions and to other forms of air pollution at every stage of their lifecycle, including their entry into the waste stream and in particular when they are burned, either in the open or in incinerators. It is becoming clear that the breadth of issues that have been caused by the wasteful use of plastics – both now and in the past – will only be resolved through an effective global treaty that can restrict their manufacture and use.

The Science Unit will continue to work with Greenpeace organisations around the world, providing access to the scientific evidence and expertise needed to address the full range of global priorities.

Sampling
is part of the scientific work done by the Exeter lab to identify exact origins – such as the effluent stream from Chemplast factory in Mettur in India shown here (top)
1 January 1996

Analysis
is another important activity at our research laboratory – such as the hazardous chemicals in textiles being analysed here. A total of 82 children's clothing products made by 12 brands (Adidas, American Apparel, Burberry, C&A, Disney, GAP, H&M, Li Ning, Nike, Primark, Puma and Uniqlo) were purchased in May and June 2013. Hazardous chemicals were found in all items analysed, except for six, and in at least one product made by every brand tested. The results were included in the Detox campaign report, »A Little Story About the Monsters in Your Closet« (right)
20 June 2013

THE POWER AND HEART OF GREENPEACE

WOMEN HAVE PLAYED A DECISIVE, TREND-SETTING ROLE IN THE HISTORY OF GREENPEACE FROM ITS BEGINNINGS TO THE PRESENT DAY – SOMETHING THAT HAS BEEN OVERLOOKED, ESPECIALLY IN THE EARLY YEARS, AND IS ALSO RARELY PORTRAYED IN TODAY'S REPORTS. WE WOULD LIKE TO REDRESS THIS NOW BY INTRODUCING SOME OF THE WOMEN WHO FOUNDED GREENPEACE, AND THE PIONEERS AND TRAILBLAZERS WHO FOLLOWED IN THEIR WAKE.

THE HEART OF THE WORLDWIDE GREENPEACE NETWORK, AS IT HAS ALWAYS BEEN SAID, BEATS IN ITS MANY THOUSANDS OF VOLUNTEERS. AND IT CERTAINLY BEATS VERY INTENSIVELY. A NUMBER OF THESE VOLUNTEERS SPEAK HERE – FOR THEMSELVES, BUT ALSO AS REPRESENTATIVES OF MANY PEOPLE ON EVERY CONTINENT AND FROM DOZENS OF COUNTRIES.

WE CAN'T DO WITHOUT THEM, THE MANY MILLIONS OF SUPPORTERS WHO GUARANTEE OUR FINANCIAL INDEPENDENCE AND HAVE STOOD ALONGSIDE US SO FAITHFULLY FOR DECADES. WE INTERVIEWED FOUR OF THEM BETWEEN THE AGES OF 13 AND 77, FROM FOUR DIFFERENT CONTINENTS, AND ASKED THEM WHAT THEY WANT US TO DO IN THE FUTURE.

THIS SPECIAL GREENPEACE SPIRIT HAS ALWAYS BEEN ON BOARD THE GREENPEACE SHIPS FROM THE VERY FIRST ACTION ONWARDS, AND CAN ALSO BE FELT AS A PRESENCE IN THE HARBOURS THEMSELVES. THE THREE RAINBOW WARRIORS, OUR FLAGSHIPS, ARE PRESENTED HERE – THEY WERE, ARE AND WILL CONTINUE TO BE THE POWERHOUSE THAT CARRIES OUR CAMPAIGN WORK.

Greenpeace women pioneers and founders
»Women's history is the primary tool for women's emancipation« (Gerda Lerner)

Women have always played a key role in the Greenpeace organisation, however their contribution has not always been fully celebrated and recognised.

Greenpeace protagonists came from the environmental, feminist, antiracist and pacifist movement of the so-called counterculture, which emerged in the 1960s and lasted until the mid-1970s. Ecofeminist thought is directly connected to the origins of Greenpeace and to the life history of our founders: feminist utopias of the seventies, anti-militarist activism and resistance of the time, and the anti-nuclear struggle.

It is only fair to recover our historical memory and recognise to all our founders. There were many women who made Greenpeace, but none of them embarked on voyages by ship, nor enjoyed the recognition given to the men. The men who comprised the first crew remained in the public eye and their image was known around the world. These women made it possible for the voyage (which failed to stop the nuclear tests in Amchitka) to end up being a resounding success in helping Greenpeace's mission reach every corner of the planet.

We cannot change the past, but we can tell the whole story, acknowledge the crucial role that women played, and highlight the value of the private sphere: it was, and will be, an essential element of Greenpeace's mission and any change of paradigm.

We want to tell you the story of Dorothy Stowe, Marie Bohlen, Dorothy Metcalfe, Zoe Hunter – and many other women pioneers who made their mark on Greenpeace.

We have not told the whole story, that is impossible, as legend has it that there are as many Greenpeaces as there are people, and as many visions as there are hearts that have joined our campaigns. But women were, are and will be half the planet. Diverse and protagonists of all the stories that put life and hope at the centre.

BUT WHERE WERE THE WOMEN? WELL, THEY WERE WORKING WITHOUT CAMERAS

»… we were all men, in spite of all our talk about of liberation and equality à la New Age. This was a delicate matter, because several women had spent months raising funds and preparing for the trip; in fact, the idea for the expedition had come from Marie Bohlen. The first Greenpeace trip was destined to be as macho as the military system we were fighting«
Bob Hunter. The Greenpeace To Amchitka:
An Environmental Odyssey

DOROTHY STOWE (1920–2010) – *the caregiver*
was the first president of the Rhode Island Civilian Employees Local Union, where she faced repressive attacks during the McCarthy era. She spent her wedding night at a civil rights dinner, participated in anti-nuclear weapons campaigns and emigrated to Canada with her husband Irving in protest of the Vietnam War. The couple changed their surname to Stowe, in honour of Heeriet Beecher Stowe, a feminist pioneer who helped bring about the end of slavery in the U.S.A. and wrote Uncle Tom's Cabin. Dorothy Stowe worked as family therapist in Vancouver, performed wedding ceremonies for same-sex couples and co-founded the first independent abortion clinic in the city. Dorothy Stowe was one of the people who launched the first Greenpeace campaign, organising the first Greenpeace meetings in her home, where she set aside a space for care. Dorothy was inspirational, infusing radical politics with a reassuring family and community

MARIE BOHLEN (NONNAST) (1925–2014) – *the ideologist*
was a nature illustrator, a member of the Sierra Club and a pacifist. When her son Paul was born, she vowed never to go to war. In 1958 she met Jim Bohlen at a Quaker peace rally in Philadelphia, Pennsylvania. They married and she introduced him to the Quaker Society of Friends and the Sierra Club. When in 1967 their son Paul Nonnast was old enough to enter the US Army, they immigrated to Vancouver, Canada, where they met the Stowes and co-founded the Don't Make A Wave Committee, which would later become Greenpeace. In February 1970, while discussing how to stop US nuclear testing in Alaska,

Dorothy Stowe
(top left)
Marilyn Kaga
(top right)
Bobbi Hunter
(bottom)

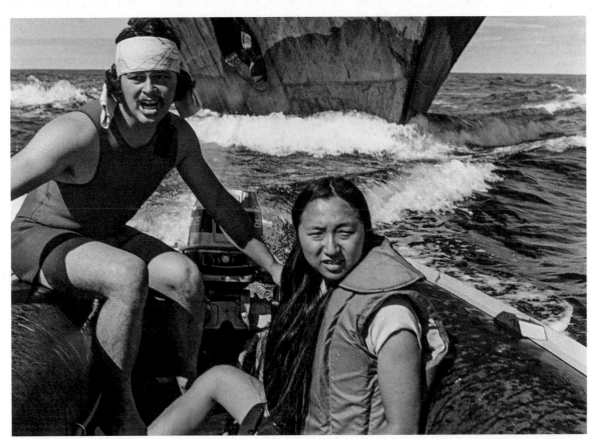

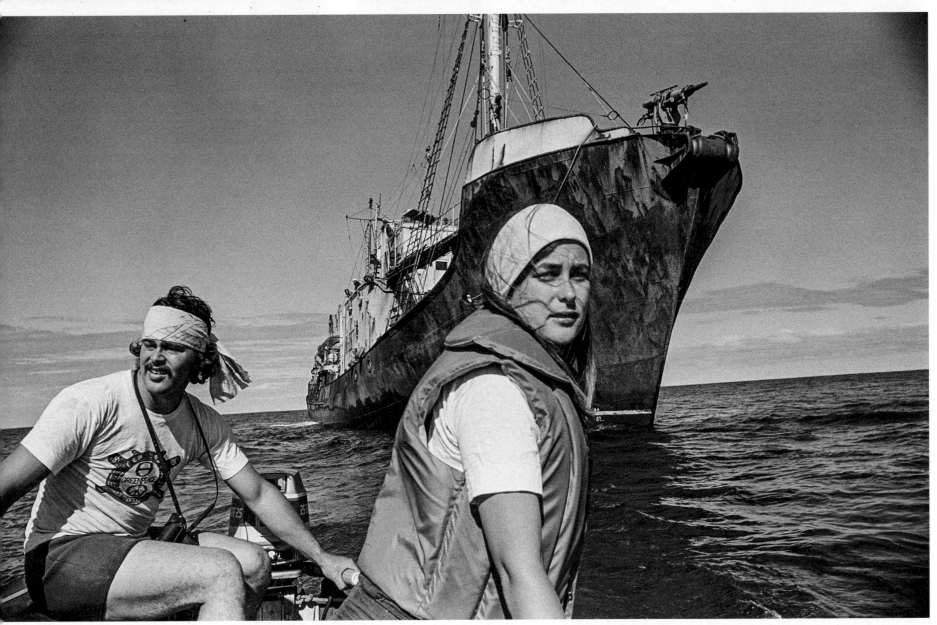

Marie came up with the idea of sailing a boat to the test site and confronting the bomb. Since the trip was her idea, Marie intended to represent the Quakers on the ship.

DOROTHY METCALFE (HARRIS)
(1931–2019) – *the press officer*

had been a reporter for the Winnipeg Tribune and wrote articles for the North America Newspaper Alliance. During the first Greenpeace campaign, Dorothy converted her home into a radio room, broadcasting to media around the world the reports Ben transmitted from the PHYLLIS CORMACK. When the U.S.A. delayed the test and the crew contemplated heading for safe harbour in Kodiak, Alaska, Dorothy encouraged them to keep sailing for the Aleutian Islands. Dorothy's lobbying of Canadian members of parliament resulted in three motions urging the U.S.A. to cancel the test. She contacted Canadian Prime Minister Pierre Trudeau's office and urged him to travel to Washington to confront the Americans. When she accused Trudeau of being a coward, some supporters thought she had gone too far. »This is a democracy. People have a responsibility to speak their minds,« said Dorothy Metcalfe. Dorothy and Ben Metcalfe founded a PR firm and coordinated the campaigns of the »Don't Make a Wave«, committee, soon to be renamed Greenpeace, against nuclear testing in the Aleutian Islands.

ZOE HUNTER (RAHIM) – *the pacifist mentor*

was part of the UK Campaign for Nuclear Disarmament. She met Bob Hunter in London in 1962 and introduced him to the peace movement. She exposed him to the pacifist work of Bertrand Russell and in 1963 took him to a peace march at the Aldermaston nuclear facility, which was Hunter's first political protest. They married and had two children, Conan and Justine. Zoe collaborated with Dorothy Stowe and Dorothy Metcalfe to provision the first two Greenpeace ships.

LILLE D'EASUM (1899–1980) – *the reporting expert*

Director of the Voice of Women, at the age of 71 wrote Greenpeace's first technical report, a study on the effects of radiation. In 1970, the »Don't Make A Wave« Committee published the first Greenpeace pamphlet. The Vancouver Sun published a story about the upcoming voyage, the article mentioned that the ship would be named Greenpeace, the first time the word appeared in print as a single word. The author of the text was Lille d'Easum, a British writer and activist with the Columbia Voice of Women.

DEENO BIRMINGHAM – *the fundraiser*

was head of the BC Voice of Women organisation and played a key role in the first campaign, raising funds and petitioning the Canadian government to support the protest. Deeno recruited her husband, Dave Birmingham, to fill the position of engineer at the Phyllis Cormack.

BOBBI HUNTER (Innes) and MARILYN KAGA

The firsts women to blockade a whaling ship, a Russian harpooner: Bobbi Hunter also helped launch the first whale campaign, ran Greenpeace's first public office in Vancouver and raised much of the money for the first whale and seal campaigns. She applied her knowledge and experience from working in cable television to Greenpeace and was a key figure in organising Greenpeace's disjointed groups.

LINDA SPONG – *leader in whale advocacy*

Linda Spong, a leading whale advocate, travelled to Japan with her son Yasha and interpreters Maya Koizumi and Michiko Sakata in 1974 to create a pro-whale movement among the Japanese scientific community, and to find supporters in Japan. In 1977, she served on the Greenpeace ship MEANDER when she blocked a vessel with representatives of 15 oil companies promoting an oil port in northern British Columbia. Today, Linda is still actively involved in the campaign to ban oil tankers off the Canadian coast.

CARLIE TRUEMAN – *the zodiac expert*

was the first person in Greenpeace to specialise in zodiac inflatable vessels. She embarked on the first whale campaign. She trained the crew in the handling and maintenance of zodiacs, one of Greenpeace's icons.

TAEKO MIWA – *director of campaigns against air pollution*
in Japan and a Japanese translator for Greenpeace.

A Japanese student and environmentalist who witnessed the devastating mercury poisoning in Minamata Bay.

In the 1970s **EILEEN CHIVERS, HENRIETTA NIELSON, BONNIE MACLEOD, BREE DRUMMOND, MARY-LEE BRASSARD** and **SUSI LEGER** were at the forefront of Greenpeace's whale and seal campaign actions.

Bree Drummond
in the engine room of the JAMES BAY
near Bamfield, British Columbia, during
the 1976 anti-whaling campaign (top)
1 July 1976

Eileen Chivers and Bobbi Hunter
on the day Greenpeace arrived in
Honolulu on the JAMES BAY (centre left)
1 July 1976

**Ann-Marie Horne, Mary Lornie
(front), David McTaggart
and Nigel Ingram**
are the crew on the voyage to Moruroa
Atoll to protest against French nuclear
testing. On board the VEGA (centre right)
1 January 1973

Susie Newborn
on the deck of the RAINBOW WARRIOR
DURING the campaign against Icelandic
whaling (bottom left)
1 June 1978

Denise Bell
on the RAINBOW WARRIOR (bottom right)
1 June 1979

ettie Geenen
aptain of the RAINBOW WARRIOR
she sails on a small vessel
Manila (top)
3 February 2018

alita Ramdas
ves a speech at the keel laying
remony for the RAINBOW WARRIOR III
Maritim Shipyard in Gdansk
ottom left)
July 2010

**nnifer Morgan and
unny McDiarmid**
ottom right)
May 2017

ANN-MARIE HORNE and **MARY LORNIE**

The first women to sail on a Greenpeace campaign.

In 1973, when the VEGA sailed to the French nuclear test site at Moruroa Atoll, French sailors boarded the VEGA and attacked David McTaggart and Nigel Ingram. Ann-Marie took photographs and Mary Lornie took videos. Ann-Marie's photographs, showing the beatings that both McTaggart and Ingram had received, went around the world.

SUSI NEWBORN and **DENISE BELL**

purchased and equipped the first ship operated by Greenpeace, the RAINBOW WARRIOR (1978 –1985) in London. Newborn and Bell wanted to take on Icelandic whalers in the North Pacific. They found the SIR WILLIAM HARDY, a 134-foot trawler that was in very poor condition in the London docks. They raised the money to buy it and Newborn recruited her childhood friend Athel von Koettlitz to help them restore the ship. Her normal fate should have been scrap metal, but they made it out of the Thames. In the spring of 1978, the ship sailed from the Thames with an international crew that included representatives from the Netherlands, France, the United Kingdom, South Africa, Switzerland, New Zealand, Australia, the United States and Canada. And the RAINBOW WARRIOR arrived off the coast of Galicia, Spain, in 1978, during the campaign to defend the whales in the late 1970s and early 1980s.

LALITA RAMDAS

was the founder of Greenpeace India and chair of the board of directors of Greenpeace International. An anti-nuclear and human rights activist, she has given voice to alternative education, gender sensitivity, secularism, peace and nuclear disarmament.

HETTIE GEENEN

first woman captain of Greenpeace ships.

JENNIFER MORGAN and **BUNNY MCDIARMID**

were the first women to be responsible for Greenpeace International, as executive directors.

ANA TONI

was the chair of the board of Greenpeace International, the board of the new Baobá Fund for Racial Equity, and was the first executive director of Action Aid Brazil.

AWA TRAORÉ

Activist, ocean and anti-plastic campaigner, global racial justice lead and representative in the People's Committee, racial justice project leader at in Greenpeace Africa.

AYESHA IMAM

The chair of the board of Greenpeace International from 2017 has worked for women's rights and democracy organisations, and UN agencies, conducted gender-sensitive research and programming, and given sustainable development and organisational support and training.

Ana Toni and
Melina Laboucan-Massimo
in front of the new RAINBOW WARRIOR
shortly after its official launch (top)
14 October 2011

Awa Traoré
explains why substituting single-use plastic with paper is a »false solution« to the plastic pollution crisis (bottom left)
17 August 2020

Ayesha Imam
speaks at the press conference held to mark the launch of Greenpeace Africa (bottom right)
13 November 2008

»IT IS AMAZING WHAT A FEW PEOPLE
SITTING AROUND THEIR
KITCHEN TABLE CAN ACHIEVE«
Dorothy Stowe

Volunteering for hope

63,000 volunteers in 55 countries – this is more than a number; it is thousands of hearts, hands, feet and minds for the planet

By Joan Meris and Dietmar Kress

Greenpeace has been a volunteer organisation since the very beginning. Fifty years ago, when the first activists set sail in Amchitka, volunteers on land spread news of the nuclear tests, rousing the support that eventually led to future tests being suspended. This model of volunteerism has not changed: bear witness where injustices happen, share it far and wide, and fight until change is achieved to pave way for more environmental justice.

»Many moons ago, or 48 years ago to be precise, a small seed of peace was planted within me. It urged me to stand up and volunteer to sail the seas to stop the nuclear nightmare that was taking place in the Pacific Ocean. Since then, this little seed within me has grown into a mighty tree, and embraced many other causes as well. Working and growing together with so many other people both young and old, trying to rectify the wrongs inflicted on our unique and beautiful planet. Thriving by continuing to nourish, protect and heal. Remaining receptive to learning and sharing and – yes – sowing new seeds of peace.«

RIEN ACHTERBERG
Veteran volunteer activist for Greenpeace

Victories that benefit the planet are unthinkable without activists and volunteers. They are at the forefront of every campaign and project we work on. Volunteers make our strategies real by organising and mobilising thousands of people worldwide, influencing decision-makers and creating long-lasting changes. Volunteering for Greenpeace is an act of protest, challenging those in power by demonstrating the power of the people. This, in turn, encourages others to discover how their personal power can make a difference.

»Greenpeace has always advocated for a green and peaceful world. Volunteering for Greenpeace means giving our planet a voice, fighting for a healthy ecosystem and protecting our Mother Earth for new generations to come. Our planet needs us to speak up, to take action each and every day to strive for a safer future for humanity, and a greener world where we can all come together to live peacefully, in harmony with our environment, society and other living beings.«

LINA OBEID
Volunteer leader, Greenpeace MENA

Greenpeace volunteers and activists' presence in 55 countries all over the world adds diversity and inclusivity to the environmental problems we are fighting against. The environment isn't just an abstract concept, but rather represents the experiences that different people from all corners of the world.

»My best moment with Greenpeace was when I was deployed as a forest firefighter to help put out burning peatland. It was an emotional moment because it was my first time. I know the reason why I breathe smoke every year: it's because of this, because the forests are burning, and I want to fix that. I never want to see a forest burning again in future because I don't want to have to fight forest fires again. I'm a strong woman. I'm taking part for the Earth, and because some of the paths we're taking really will have an impact.«

LARASATI WIDO
Volunteer firefighter,
Greenpeace Southeast Asia – Indonesia

Whenever we induct new volunteers into the network, one of the questions we ask is, »Why do you want to volunteer for Greenpeace?« Most respond by saying that they would like to share their skills and use their time for a worthwhile cause. Others are encouraged to join by their peers or friends. But once you start to dig deeper, you realise that their personal motivation is rooted in the common values they share. Our volunteers believe in the core values that Greenpeace advocates – peace, non-violence, and independence.

»I want to share my very best Greenpeace moment with you: it was at a national reunion. We were asked to stand up if we had participated in an activity to support the 30 activists who had been in jail that year. The campaign was called ›Free the Arctic 30‹. Just about everyone in the room stood up. It was amazing to be part of such a strong support network – I was really grateful for it. This is what I want for the future: to stick together as humanity and find common solutions so that everyone can live together as equals.«

JEANNE FREITAG
Youth volunteer, Greenpeace Germany

Volunteer fire fighters
The spring burning of dry grass in Russia is a big problem against which forestry and fire departments have been struggling unsuccessfully for years. The fire-extinguishing crew on an expedition organised by Greenpeace Russia came to the Astrakhan Biosphere Reserve to protect valuable natural areas from fire, to hold workshops with children, and to help volunteers in Astrakhan
11 June 2017

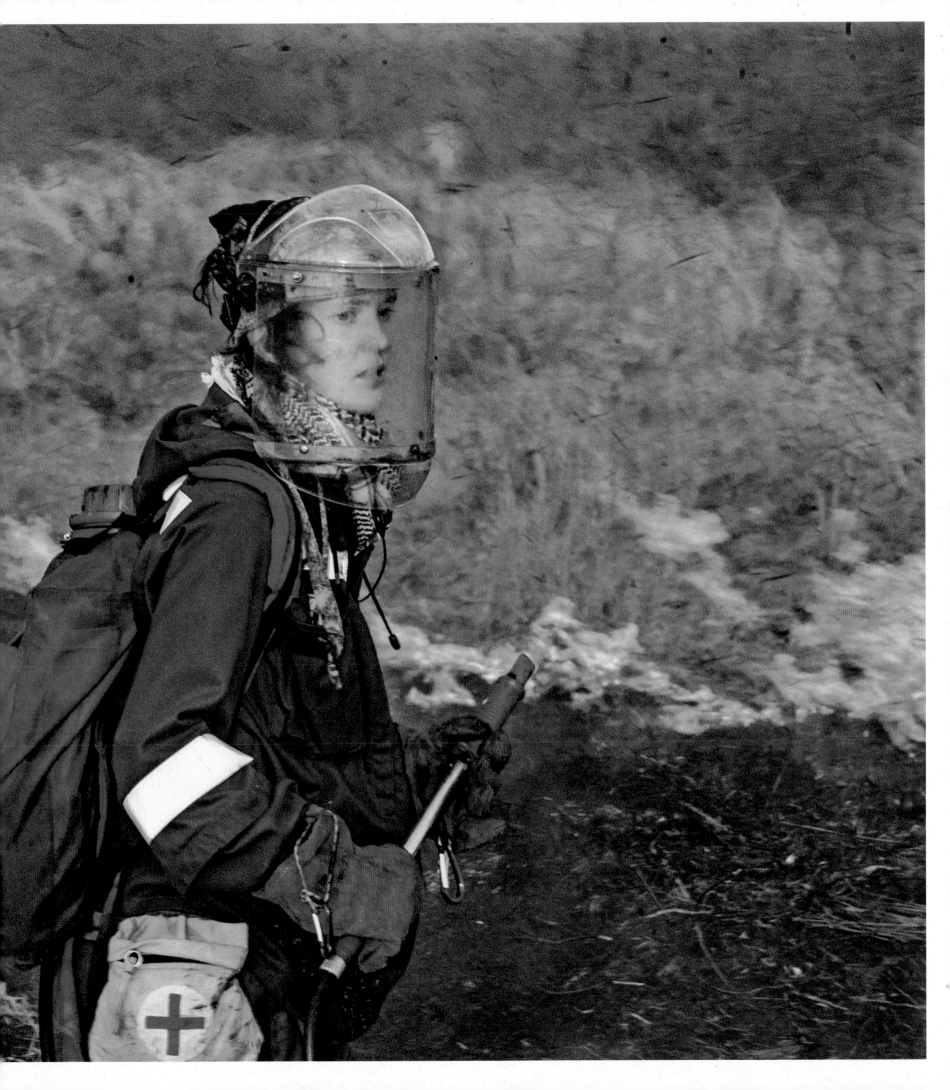

In 2020, the global COVID-19 pandemic presented a challenge for our volunteer and activist communities, forcing them to navigate unfamiliar and much smaller spaces for activism. There were moments of fear and doubts about how to protect the planet when everyone is confined to their homes. And yet pockets of hope started emerging everywhere. Our volunteers and activists have shown that their imagination has no limits – from using video conferencing technologies to organise and mobilise local groups, to live streaming activities to reach new audiences, as well as the use of holograms projected onto streets as protests. With strength, resilience and resourcefulness, they are continuing to work and fight for a cleaner, greener and safer future.

»The pandemic has given me new experiences, ones that have challenged me to change and learn about the tools that the digital world offers me, and allow me to continue reaching out to people with our message. In fact, I have learnt new skills and experienced new situations that, in the past, I would have never had the opportunity to discover.«
PAOLA GALLARDO
Volunteer, Greenpeace Mexico

As we move into the future, we need to keep asking what volunteering means for Greenpeace. We asked some of our volunteers to share their thoughts with us.

»Volunteering will, in future, require a combination of online and offline activities that will allow us to make great progress in reaching more people and connecting volunteers from different corners of the world. It should also include a support-centric approach to helping volunteers cope with issues resulting from the climate crisis and the pandemic.«
CINDY WANJIKU MWANGI
Volunteer, Greenpeace Africa – Kenya

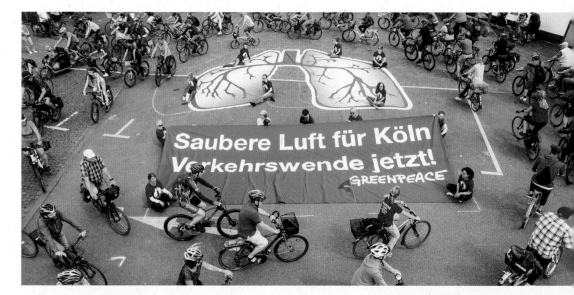

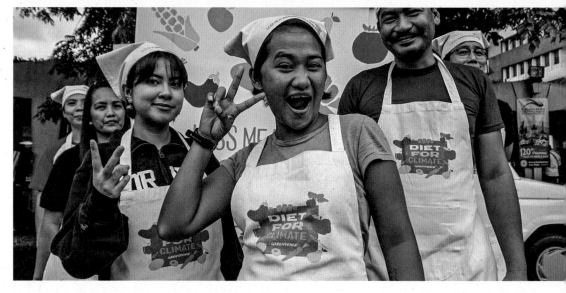

»World Meat-Free Week«
Greenpeace Philippines celebrated the launch of »World Meat-Free Week« – a global movement to encourage the public to adopt a healthier plant-based diet. The group sought the support of public officials to offer plant-based meal options in schools in an effort to instil a healthier and more environmentally conscious mindset among children. Greenpeace is calling on the Filipino public to eat at least two meat-free meals this week
11 June 2018

ke rally
r clean air. With an 8 × 8-metre
nner in the shape of a lung, activists
om Greenpeace Cologne, Germany,
gether with a large number of residents,
e calling for clean air and more
ace for cyclists
June 2018

Volunteers often report that they are not only active for the environment – and that their activities help them grow as a person and benefit from a positive group experience. A community allows you to counter the power of money and corporations.

»I really like the direction Greenpeace is taking right now. I appreciate that Greenpeace is recognising what is at the forefront right now. It's really what Greenpeace should do, shift their focus to other movements that need support. Perhaps with BLM (Black Lives Matter) getting more attention right now, food deserts, landfill pollution, things that affect black and brown (or low-income) communities could take center stage in Greenpeace's work. We have to show that Black Lives Matter in more ways than one.«
AMANDA JUST
Volunteer, Greenpeace USA

Half a century of campaigning really requires us to dig deep to learn who we have been Greenpeace in the past, and who we want to be in the future. As for volunteering, the fact that we are evolving from a highly specialised group of individuals to more decentralised, open and inclusive communities bringing systemic changes has been recognised. This not only makes volunteering an individual act, but also an act of communal courage, helping to elevate marginalised and underrepresented voices and communities. This comes with a keen understanding of the fact that we cannot simply fight for environmental justice – and should fight for justice in all areas of life.

»To me, the climate crisis is the biggest challenge we are facing. It threatens my future, the environment, and all other living beings with which we co-exist. As a volunteer at Greenpeace Korea, I have been given opportunities to have my say as a young person concerned about the climate crisis. Last year, I spoke passionately in favour of legislation for a fair Green New Deal, addressing the National Assembly by means of a hologram action. Since last year, I have been monitoring the National Assembly's response to climate change together with other Korean citizens. I expect more passion and solidarity among the volunteers, because the level of awareness among young people has grown. I think volunteering for Greenpeace will provide us with a stepping stone towards a better future. The activism and campaigning that the volunteers are involved in also help contribute to personal change, to changes in the others involved, and changes to institutions within our society.«
JIHYEON (CHERRY) SUNG
Volunteer, Greenpeace East Asia Seoul

We would like to take this opportunity to thank all volunteers, past and present, who have given their hearts, hands, feet and minds for the planet. Greenpeace will not be what it is today without your dedication to bringing about positive change. Our hearts are full.

Greenpeace supporters

4 people from 4 different regions of the world – Africa, Europe, Oceania and Asia – tell us here what moves them, why they support us, and what they expect of Greenpeace in future

LILLI

Lilli is 13 and one of our youngest supporters. She has been a member of Greenpeace since 2018, after asking for a sponsoring membership for Christmas three years ago. She has two older sisters and a younger brother, and lives with her family in Hamburg. Incidentally, her mother has also supported Greenpeace since she was 15 years old.

»What I like about Greenpeace is that they always keep me so well informed and explain everything to me so simply and clearly... and also that they remind me what I can do for the environment. I also think it's great that they use photos to illustrate environmental issues, even the worst catastrophes, along with their actions and successes. I like other organisations too, especially those that protect animals, but also Friday for Future because so many young people are involved, including a few friends of mine.

I would like Greenpeace to continue keeping us up to date by providing us with a wide range of information about the organisation, its actions, successes, special events, and of course environmental issues, and the many threats to our diverse and fascinating natural world; to continue to campaign on behalf of the oceans, forests and animals, and to keep on giving us tips about what we can do ourselves, in particular on an everyday basis. When I think about the future, I have my doubts that companies and politicians are taking things seriously, and I worry that they'll just keep procrastinating with our environmental problems. It sometimes unsettles me that they set targets that are supposed to be met in just a few years – even though the targets themselves give me a feeling of hope.

I myself want to be a lawyer someday, maybe even a judge. But above all, I want to do something for the environment, such as taking fewer flights even though I love travelling. And I want to keep getting better with regard to other environmental issues.«

BEATRICE

46 years old, married with two sons, lives in Nanyuki at the foot of Mount Kenya in Kenya. She works in horticulture and is also a student at the Kenya Institute of Management.

»I have been a supporter since January 2021, because I am very concerned about the environment and want to have a future in which there is a clean environment, consistent rainfall, an intact ozone layer, many trees instead of polluted air, and clean lakes and oceans in which marine life can thrive. What should Greenpeace do? I hope that Greenpeace will protect forests, educate people about the impact of deforestation, and will also help with planting more trees. This will help to increase rainfall in the area where I live. I see my own future in becoming a farmer's consultant and a horticulturalist, and also mobilising people to plant trees.«

MAXINE

Maxine is 77 years old, and is a volunteer first responder rural firefighter. She lives on the coast of Queensland, Australia. Maxine has supported Greenpeace for many years, ever since a US nuclear ship entered Sydney Harbour and she a saw guy surfing the bow wave with a Greenpeace banner. »That's for me,« she thought.

»Yes, I have met a few Greenpeace folks over the years – especially on board the RAINBOW WARRIOR for a visit, and I've also spoken on the phone to a few. I also support lots of other organisations. Greenpeace is courageous, unafraid to speak out, holds brave, non-violent actions, doesn't take government money, is big on protecting the environment, forests, waterways (the RAINBOW WARRIOR was amazing) – getting rid of fossil fuels, supporting renewables, working worldwide... just put on your Superman cape and GO! Our (the Australian – ed. note) government couldn't give a flying fit! Personal nest-feathering I suspect, doesn't understand climate change, didn't take action during the Black Summer fires, letting people – among them firefighters – die needlessly. They still have money locked away while some of these survivors are still living in tents. Whether it's reefs, animals, vegetation that are unable to survive, they pretend not to understand – or worse, pretend they are doing everything the right way, as required... but there's no plan in sight. There is also plastic and other waste – especially in the oceans, choking, killing, and causing huge problems such as ice melt in the Arctic and in Antarctica. Watching the climate drivers makes it clear that the cyclones, floods and fires will be more devastating than before. Insurance will be (and is) impossible for

many to afford — which will leave people homeless – even in this rich country. What stops me sleeping at times is the detention of asylum seekers on Manus Island and Nauru, leaving absolutely no future for them. What should Greenpeace do? I suspect Greenpeace does it all already. I follow events when I can – I read your emails and watch the news. At this short notice — just always do what you do best. Save us from our silly selves. My future? I will continue to fight fires and hope to goodness I can work with Indigenous burning techniques. I have, and will always, help others when I can... and hope I can always help myself too.«

HIDEO
is 64 years old, is a managing director and lives in Japan.

»I wholeheartedly agree with Greenpeace's mission, and I have always had full confidence in its activities. Greenpeace feels like a close friend with whom I share the same aspirations. What I find most remarkable is that for the past 50 years, Greenpeace has continued to act as a nexus for citizens with a sense of global citizenship. As an apiarist born to beekeeping parents, and as the heir to the family business, I consider conservation and sustainability to be the theme and mission of my life. Individual actions are important, but it is corporate activity that has a huge impact on society and the environment in our economic system. I would like to build and establish an environmentally friendly corporate culture that other companies will want to follow, and which citizens feel reassured by. Personally, I would like Greenpeace to develop a global campaign to eliminate hormone-disrupting chemicals, including pesticides and synthetic substances that endanger species' survival. I would like Greenpeace to remain close to the citizens and continue to act as the voice of the people on environmental issues that are not being addressed by governments. I want us to leave behind a beautiful planet for our children's generation.«

Ship views

Ocean-going coastal, river, polar, research or rescue vessels

Ships have been at the heart of Greenpeace campaign from our very first days. The first campaign we ever organised 50 years ago, »The trip for life and peace«, saw a determined crew set sail for Alaska from Vancouver in an old 24-metre-long fishing boat – the PHYLLIS CORMACK – in order to protest the largest nuclear bomb tests planned by the US government in Alaska. A few years later, in 1975 and 1976, the PHYLLIS CORMACK took part in Greenpeace's first anti-whaling campaigns, bearing witness and taking non-violent direct action (NVDA) when confronting Icelandic and Russian whalers.

As Greenpeace continued on its path of environmental campaigning, marine protection and campaigns at sea have continued to hold a special place in our work, and our ships have allowed us to reach some of the most remote places on earth, ones where pollution and environmental crimes were being committed – to bear witness, to protest against them, and to stop them. Greenpeace ships are used in many functions: as a mean of transport of course, but also a logistics centre, a media hub, an exhibition area, a »floating embassy« for political work or public outreach activities, and a platform for non-violent direct action or humanitarian support. They also provide temporary accommodation for our crew members, who are a highly diverse group of dedicated professional sailors and volunteers from all corners of the world. On the one hand, the crew that staff Greenpeace's ships are sailors – cooks and captains, engineers, and deck hands, while on the other hand, they are activists who bring their dedication and passion to their work, so that our ships fulfil their unique and important role:

SUPPORT CAMPAIGNS – START CAMPAIGNS – RUN CAMPAIGNS – WIN CAMPAIGNS

To represent the many ships and the hundreds of projects, campaigns and actions that have been held on the seas, rivers, coasts and ports over the last 50 years, we would like to introduce our flagships here: the three RAINBOW WARRIORS. The RAINBOW WARRIOR is an undisputed icon. Synonymous with breaking boundaries and fearless campaigning, Greenpeace has sailed under the name RAINBOW WARRIOR since 1978.

THE FIRST RAINBOW WARRIOR – THE LEGEND

Greenpeace set up its first European office in London in 1977. It was in this borrowed office with its leaking roof in central London that the plan was forged to buy a boat with the specific purpose of taking action against the whaling industry in order to prevent the impending extinction of these fascinating but endangered giants of the seas. Finally, when searching through British ports, an old and rusty, former North Sea trawler in Aberdeen appeared which seemed to meet the requirements. The SIR WILLIAM HARDY had been used by the Department of Agriculture, Fisheries and Food as a fisheries research trawler.

The SIR WILLIAM HARDY, built in 1955, was the first diesel-electric ship to be built in Great Britain. It quickly became clear that the ship needed a complete overhaul, because it was in a terrible condition. Within eight months, enough money was raised to pay the 10 percent deposit. The remaining amount was due within 60 days, and any hope of being able to pay for the old ship was lost. But then the Dutch branch of the World Wildlife Fund agreed to fund the campaign to save the whales. And so the ship could be brought to the London docks for a general overhaul. Fortunately, a number of experienced volunteers had offered their help with the work and repairs that were needed.

With only three months left before the RAINBOW WARRIOR was supposed to leave for her first mission in the North Atlantic, the rusty hull was repaired, 25 tonnes of fishing gear removed, engines overhauled, accommodation expanded, and navigation and radio equipment renewed. A rainbow was painted on the bow, together with a dove to represent peace and with an olive branch to make the mission visible from afar.

On 29 April 1978, as the RAINBOW WARRIOR steamed proudly from the London docks, the flags of Greenpeace and the United Nations fluttered together, not only reflecting the international makeup of the crew but also the global concern for the plight of the whales and the threat to the planet. The entire operation was plagued by almost insurmountable problems: a lack of money to buy fuel for the RAINBOW· WARRIOR, legal

RAINBOW WARRIOR
THE LEGEND
1978 to 1985
Length
44 m
Speed
12 knots
Crew
15

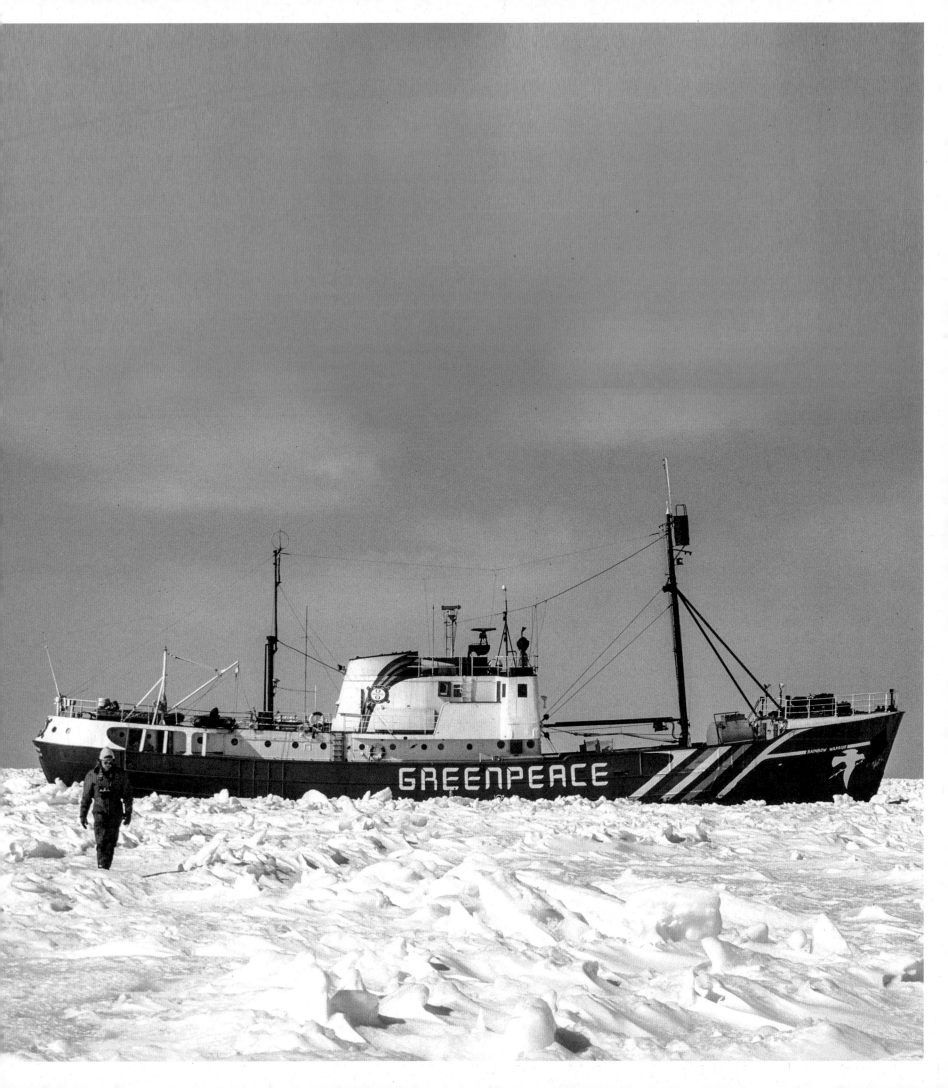

battles, unavailability of equipment, and sheer exhaustion. Yet despite all the adversities, the RAINBOW WARRIOR turned out to be a seaworthy ship that proved suitable for its upcoming missions.

As of spring 1978, the RAINBOW WARRIOR started its life actively campaigning for Greenpeace, staging a number of first non-violent direct actions to prevent more than 5,000 barrels of nuclear waste from being dumped in the sea. And the campaign against Icelandic whalers was also launched, as hundreds of whales continue to be killed in the North Atlantic every year. The Icelandic authorities arrested the crew and confiscated the ship's equipment. An injunction was issued against the captain and Greenpeace's board in London.

This was the prelude of the RAINBOW WARRIOR'S long history with Greenpeace. Since that spring, our flagship has been at centre stage in many confrontations with looters, polluters and governments across the globe.

In the late 1970s and early 1980s, the RAINBOW WARRIOR joined campaigns against the Norwegian and Canadian seal slaughter off the Scottish Orkney Islands, the Gulf of St. Lawrence, and Newfoundland. Members of the crew were arrested after painting the white fur of the baby seals with non-toxic green paint, thereby saving the animals from being clubbed to death.

Next to campaigns aimed against nuclear and toxic waste and the extended commercial seal slaughter, the protection of threatened whales has been the focus for many years, with endeavours to stop the Icelandic and Spanish whaling ships in the Atlantic or thwart the Peruvian and Russian whaling ships in the Pacific, including one in Siberia, where every year hundreds of the rare grey whales were killed.

The flagship and the crew were repeatedly attacked and arrested over this period, but their courageous actions not only triggered an upswell in global support, but ultimately also a global ban on commercial whaling of the large, endangered whale species. But as other small whales – porpoises and dolphins – as well as other marine life are also mass victims of destructive fishing practices and policies, the crew of the Rainbow Warrior protested against destructive driftnet fishing, which was causing millions of sea birds, turtles, sharks, seals and dolphins to perish.

After being converted to combined saildrive propulsion, the ship set sail for the Pacific in the mid-1980s. From Hawaii, it set course for the Marshall Islands with medical supplies on board for the population of the archipelago, because with the US military having been carrying out nuclear tests in the South Pacific since the 1950s, cancer cases, a consequence of radioactivity, were now increasing among the islands' residents. In May 1985, the crew reached the heavily radiation-contaminated Pacific Island of Rongelap. Its residents had asked Greenpeace for help. Our RAINBOW WARRIOR took around 300 people on board and relocated them to another island.

The ship then travelled to New Zealand to lead a flotilla of yachts protesting against French nuclear testing at the Moruroa Atoll in French Polynesia. On 10 July 1985, as the Greenpeace flagship dropped anchor in the port of Auckland, two bombs detonated and tore a huge hole in the side of the ship. The RAINBOW WARRIOR sank instantly. Greenpeace photographer Fernando Perreira was killed in this violent, and criminal, attack. The investigation quickly led to the French secret service, and the French government admitted that it knew about the planned bombing of our ship, thereby resulting in a political crisis in France. The destroyed RAINBOW WARRIOR was towed to Matauri Bay in northern New Zealand and sunk not far from the beach, accompanied by a solemn ceremony.

THE SECOND RAINBOW WARRIOR – THE SUCCESSOR

In 1989, four years after the sinking of its namesake, Greenpeace launched a new RAINBOW WARRIOR built from an old steamship and converted into a motor sailing vessel. With new masts and extended sails, the objective was to have a ship that should be able to cross the Pacific without fuel and be equipped with modern technology.

During the campaign against nuclear tests in the Pacific in March 1992, new video technology allowed our crew to film and broadcast the violent intervention of the French navy live to audiences all over the world for the first time in history. A few years later in 1995, during a protest against the resumption of nuclear bomb tests by the French in the South Pacific, the RAINBOW WARRIOR was rammed and damaged while the French Navy boarded the vessel with force, also deploying tear gas.

A year later, the campaign ship sailed to Chile to support the activities to stop destructive fishing practices in the region. The government of Chile banned our ship and crew from its territorial waters. This did not, however, deter Greenpeace, which instead sent its ship to the coast of Australia to collect data about the impact of oil and gas drilling on marine life, from plankton to coral reefs and whales. The ship also supported

RAINBOW WARRIOR
THE SUCCESSOR
1989 to 2011
Length
55 m
Speed
13 knots
Crew
15 (max. 30)

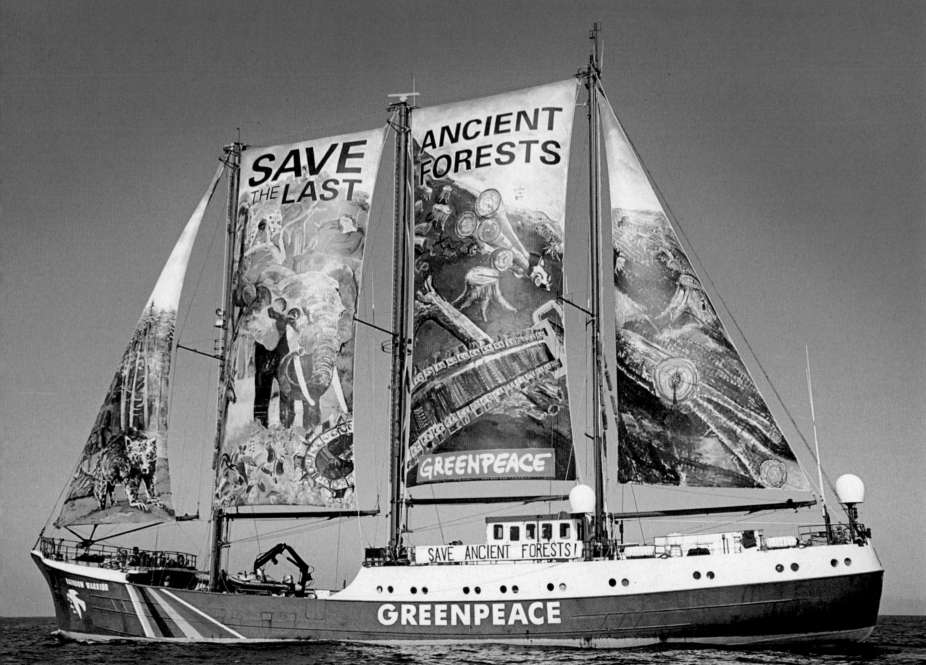

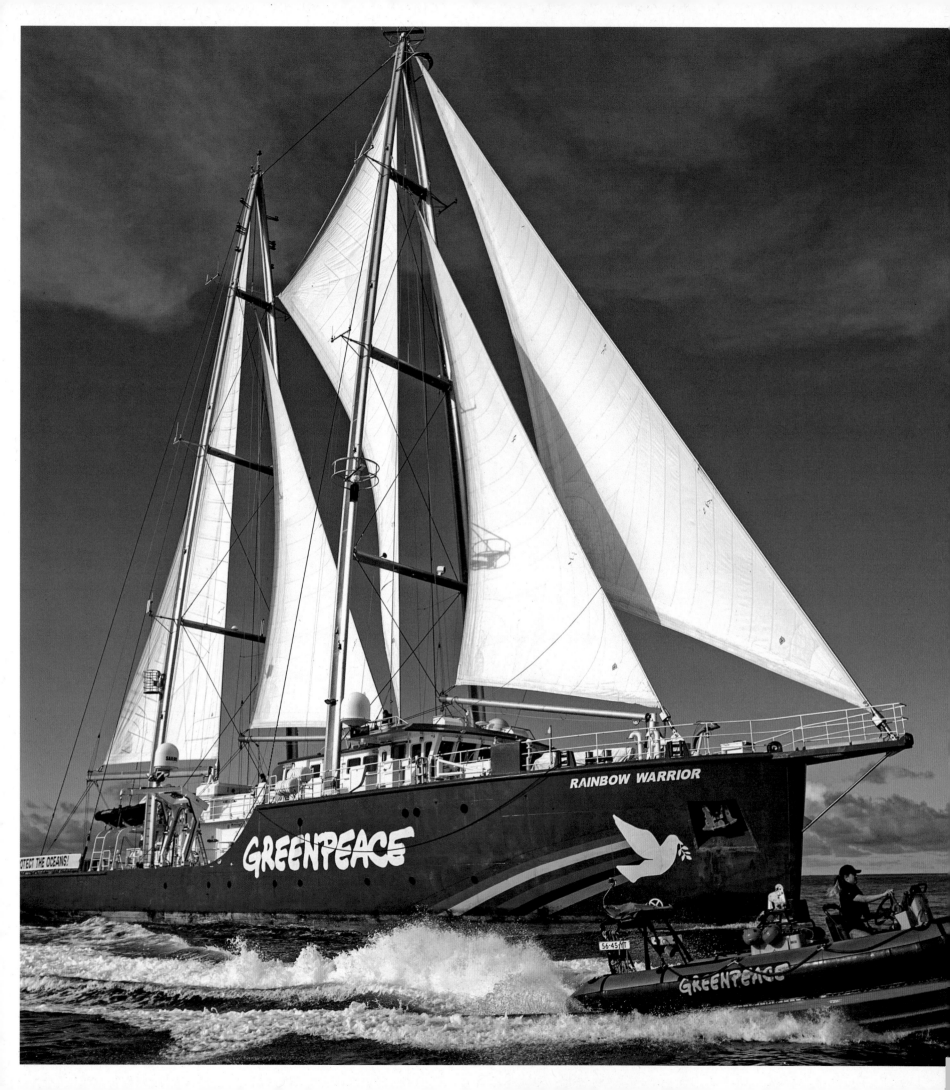

RAINBOW WARRIOR
THE »GREEN SHIP«
From 2011 on
Length
61 m
Speed
15 knots
Crew
16 (max. 32)

the climate campaign in Mexico and, after Hurricane Mitch devastated entire regions of Central America in 1998, supplied aid to Nicaragua. At the end of November 1998, the RAINBOW WARRIOR was the first ship in our Greenpeace fleet to reach the coast of India for the launch of the »Toxic Free Asia« campaign. From India it continued on to Thailand and the Philippines, and reached Japan in April 1999.

At the end of March 2001, the ship reached the Marshall Islands (U.S.A.) to protest the planned American rocket programme known as Star Wars. As part of the Star Wars campaign, the RAINBOW toured the US east coast over the summer. In March 2003, the RAINBOW WARRIOR took action in front of the Spanish military naval base of Rotato and blocked the US navy ship CAPE HORN. Greenpeace highlighted how the U.S.A. was undermining the UN charter with the Iraq War. After the deadly tsunami in Southeast Asia in December 2004, the RAINBOW WARRIOR transported around 450 tonnes of food and relief supplies to Aceh, north Sumatra, to support the local population and humanitarian organisations. In August 2006, while Lebanon was being bombed, the Rainbow Warrior transported tonnes of aid supplies from Cyprus to Beirut for Doctors Without Borders.

After dozens of campaigns and expeditions, the second RAINBOW WARRIOR set sail for the last time in 2011, with its final voyage heading for Japan. After the nuclear accident at Fukushima, the team documented the levels of radiation exposure in the vicinity of the destroyed nuclear facility. From Japan, the ship sailed to Korea for the opening of the new Greenpeace office there, announcing that the nuclear campaign would also have a key importance in Korea. In Singapore in August 2011, Greenpeace handed over the ship to the Bangladeshi nongovernmental organisation Friendship, which converted it into a hospital.

THE THIRD RAINBOW WARRIOR – GOING GREEN
Since its launch in 2011, the original spirit now lives on in the latest RAINBOW WARRIOR. The latest RAINBOW WARRIOR is Greenpeace's first purpose-built ship, financed by over 100,000 donations. Equipped with the most environmentally friendly technology available at the time of its construction, and having been constantly upgraded with green technology since then, the Rainbow Warrior is primarily geared towards sailing. The 1,300-square-metre sails, suspended from innovative triangular frame masts, propel the ship forwards. In contrast to its predecessors, the ship has an almost unlimited range. And if the weather conditions are too adverse for sailing, an electric motor can power the rainbow ship at lower speeds.

If even more engine power is required, two diesel engines with an exhaust gas cleaning system and light diesel as fuel instead of the usual heavy fuel oil can be used for the drive.

The ship also sets other environmentally friendly standards: garbage is sorted directly on board, drinking water is obtained from the sea, and the wastewater is also recycled on board. The entire lighting is based on energy-saving and low-maintenance LED technology.

In addition to these environmental benefits, the new RAINBOW WARRIOR also features equipment that transforms the ship into a perfect campaign ship. The inflatable boats on board can be easily lowered into the water even in bad weather and rough seas. State-of-the-art (communication) technology is also fitted on board. In addition, there is a helicopter landing pad, a conference room for 50 people, an infirmary and cabins for 32 crew members, campaigners and activists.

The shipyard in Gdańsk, Poland, started work on the hull in the summer of 2010. 340 tonnes of steel were then transported to a shipyard near Bremen, in Germany, where the ship was fitted out. It entered water for the first time in July 2011 and was officially launched in Hamburg, Germany, in October the same year before immediately joining its first campaign against the construction of the largest coal-fired power plant in the Netherlands at the mouth of the Ems River.

Since then, the RAINBOW WARRIOR has actively supported, and continues to support, Greenpeace campaigns around the world, from Asia to Brazil and Africa, from Europe to Oceania. With our allies in the social and environmental justice movement, and together with our supporters, the RAINBOW WARRIOR joins campaigns to highlight the biodiversity crisis, as well as the climate emergency and its consequences, to take action against the looters and polluters and to make governments and corporations accountable for their role in environmental destruction. Like its predecessor, it is the flagship of nonviolent protest. The old legend lives on: you can't sink a rainbow.

Future views
What's next?

by Anabella Rosemberg and Thomas Henningsen

The fate of life on this planet depends on people getting organised in large numbers to imagine and come up with way to live equitably and in harmony with other living beings. It also depends on continuing to fight the powers that have made our ecological crisis so extreme with their greed for material wealth and power. What is Greenpeace's role in making this web of action an effective one?

There is no moment in history that wasn't a decisive one, and this moment in history is no exception. The forces of extractivism and fossil fuel dependence and use, global and industrialised food chains, and consumerism, are holding us back, causing climate chaos and loss of life, and perpetuating inequality, the abuse of basic rights, violence, and conflict.

The past 50 years – as all the different parts of this book illustrate – Greenpeace has dedicated all its energy to accompanying, supporting, and sometimes inspiring the movement to protect life and well-being on our planet. Sometimes we got it right, and sometimes we even won the battle – but sometimes we didn't. And yet no day goes by on which we don't try to do even better.

Greenpeace, as a network, as an idea, needs to keep imagining new ways to confront those powers and support everyone who is willing to build a better future. Our battles, our demands, and our ideas for the future that we need will look rather different to the ones we had when we first started out, as we keep trying to understand the root causes of the problems we are facing.

THIS IS WHAT A DIVERSE AND EVER-GROWING COLLECTIVE IS CALLING FOR:
- *People and all life on the planet must be put above profits and power for a few, and economic growth. The investments and regulations that could make our lives better and our societies capable nurturing life on Earth are often ignored, delayed or openly opposed, as they are not considered a priority for our decision-makers.*
- *Wealth and power need to be more equitably distributed – a few individuals and corporations are responsible for a majority of the emissions and destruction of ecosystems.*
- *Environmental destruction, pollution, and climate change will, above all, impact the least privileged. Our societies must address, and repair, centuries of oppression that different groups experienced – this is the key to building a peaceful future for us all. There is no peace without equity and no green without peace. Justice is the journey as much as it is the destination.*
- *Our societies must strive to attain well-being for all their members, and to make their communities more resilient. In these times of destruction and crisis, we need to give people a space to gather, reconnect, and protect each other.*

WITH THESE GOALS ON OUR HORIZON, GREENPEACE IS NOW MOBILISING IN SUPPORT OF SOME SPECIFIC SOLUTIONS:
- *Implement the energy revolution worldwide. Leave fossil fuels – coal, oil and gas – behind, and eliminate their impact on our lives and influence on our governments. Give workers and communities new opportunities, and complete the shift to a society that embraces the enormous potential of regenerative energies – wind, solar and geothermals – and ensures everyone has access to them. Ensure there is no senseless waste, and make homes, public buildings and other facilities energy-efficient and safe (especially in vulnerable communities and areas).*
- *Protect and restore nature, and make good on the commitment to protect at least 30 percent of our lands and oceans by 2030 in partnership with, and not against the will of, local and Indigenous communities.*

The rainbow
symbolises how fascinating, beautiful and diverse nature is – and also provides Greenpeace with a symbol of courage, hope and commitment

- *Stop the use of disposable and single-use plastic products, and consumer and trade packaging. Set targets for recycling and composting, and ensure adequate conditions for all workers in the value-creation chain. Support initiatives that promote the concept of circular economy, and strive to not just »slow the loop«, but also close the loop.*
- *Increase access to healthy food for everyone, and give farmers a livelihood, while simultaneously promoting changes in diet and patterns of consumption, which also involves setting targets to reduce the amount of meat and dairy products that are consumed.*
- *Guarantee new generations access to information about the real causes of the ecological crisis and the systemic solutions to solve it, and access to opportunities to reconnect with nature.*
- *Transform our taxation systems to ensure justice and a more equitable distribution of wealth and resources, and put more fiscal pressure on the companies and wealthy individuals whose environmental footprint is the worst. Create schemes to protect the most vulnerable households during the transition.*
- *No-one's basic needs should remain unmet. A healthy and biodiverse environment, and access to food, mobility,*

healthcare, housing, education and culture are rights that must be safeguarded against profiteering. Introduce regulations and even bans to protect the environment and the climate with the intention of safeguarding the rights of both current and future generations.

These ambitious goals require that we continue to mobilise, that we remain committed to the cause, and most importantly, that we never lose our imagination or relentless optimism.

We don't consider our past successes a reason to keep repeating ourselves and our way of doing things. Instead, our victories inspire us to continue to try and be innovative and surprising, and to keep touching people's hearts and minds with new tales of hope and action.

Many things at and about Greenpeace have changed since it was first created – things that make us proud, such as our growing presence and diverse approaches to geographies of development in the Global South, the role given to women and the support for gender diversity across the network, the continued endeavours to challenge the damaging colonial narratives that we were inadvertently perpetuating, and our transition from lone warriors to proud teammates and allies in a diverse global movement.

But there's one thing that hasn't changed, any that's the firm belief held by everyone who makes Greenpeace what it is – volunteers, friends, supporters and staff – that it is in action that we find hope. And it is this hope keeps us striving for more, with our minds open, and our hearts full of love.

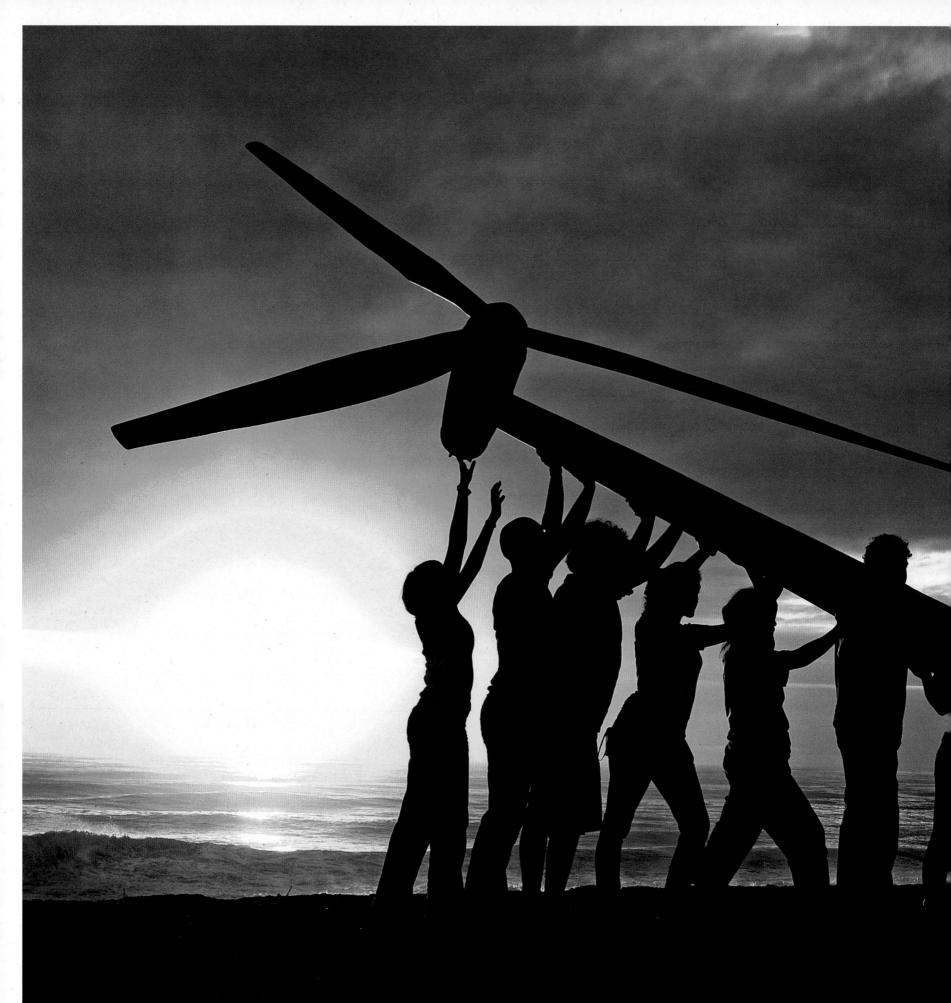

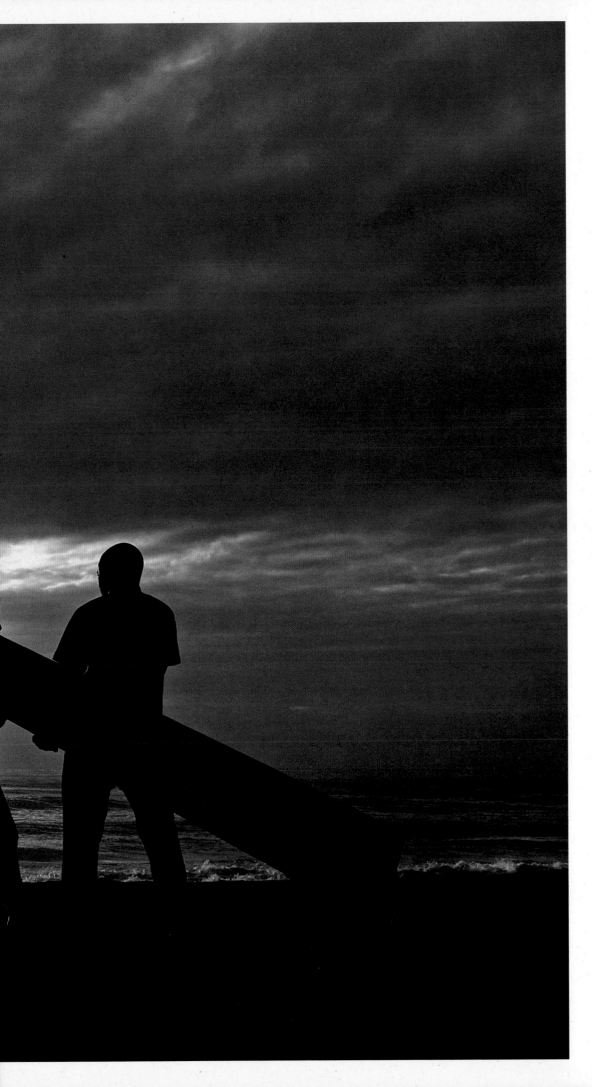

HOPE
IN
ACTION

Authors

ANA ARIAS

Works at Greenpeace Spain, has a degree in history with university training in education, gender, human rights, document management and writing.

JOAN MERIS

Her journey with Greenpeace started in 2006 as a volunteer on the MV ESPERANZA's first tour of Southeast Asia. At present, she works for Greenpeace International together with different Greenpeace colleagues across the organisation on ambitious and productive engagement strategies.

ANABELLA ROSEMBERG

International programme director at GPI since 2018, born in Argentina, former advisor on environment in the international labour movement.

FABIEN RONDAL

Actions coordinator, trainer and manager for 15 years at Greenpeace International and its current operations director, is responsible for coordination and strategic support for Greenpeace across the world in the fields of actions, investigations and security; and for the science unit and the ships.

DR DIETMAR KRESS

Project leader of the education programme at Greenpeace Germany, formerly a long-term volunteer coordinator.

JENNIFER MORGAN

Executive Director of Greenpeace International since 2016. Former Global Director of the Climate Program of the World Resources Institute in Washington, as well as involvement in leading climate campaigns for the WWF, Climate Action Network and E3G.

DR THOMAS HENNINGSEN

Editor and coordinator of this book. Marine biologist and expert for global environmental developments. Over 33 years of work worldwide as a long-time activist for Greenpeace Germany, project and campaign manager, and global team leader in Russia, Europe, the U.S.A., and Canada. Participation in the Arctic, the Amazon, forest conservation and anti-whaling campaigns.

Thanks

SPECIAL THANKS FOR THEIR CONTRIBUTIONS, SUPPORT AND HELP

Simon Black, Tica Minami, Mike Townsley, Alexis Escavy, Elena Keil, Kirstie Kinley, Regine Rhode, Ryoko Yoshino, Yuntak Cha, Daniel Simons, Mario Damato, Stephanie Weigel, Rolf Holzmann, Hellen Dena, Cristina Castro, Matt Mannion, Nick Young, Oksana Ilyushina, Valerie Land, Dania Cherry, Caroline Wagner, Lukas Hrabek, Julia Kerschbaumsteiner, Rex Weyler, Rodrigo Gerhardt, Graham Thompson, Felix Kempf, Martina Duckenthaner, Martina Holbach, Birgit Radebold, Jan Haase, Mari Vaara, Oda Grønbekk, Poul Bonke Justesen, Ludvig Tillman, Markus Mattisson, Jack Sharp, Nadja Kneissler, Axel Gerber, Thomas Cashman Avila-Beck, Nikos Charalambides, Nikita Kekana, Noor Spanjer, Reka Tercza, Denitza Petrova, Dunja Ribaric, Reka Hunyadi, Dominik Zgoda, Katarzyna Gusek, Robert Cyglicki, Katarna Jurikova, Katja Hus, Carla Donciu, Marija Tomac, Balazs Horvath, Cristin Kasper, Hagen Rogg, Mélody Bridoux, Delphine de La Encina, Joel Widmer, Steve Cairns, Daniel Müller, Luisa Toribio

DEDICATION

This book is dedicated to the youth of today and future generations in particular for their courageous efforts and their commitment to the cause.

Imprint

Bibliographic information published by the Deutsche Nationalbibliothek
The Deutsche Nationalbibliothek lists this publication inthe Deutsche Nationalbibliografie; detailed bibliographic data are available in the Internet at http://dnb.dnb.de.

1st edition, ISBN 978-3-667-12381-7
© Delius Klasing & Co. KG, Bielefeld

Published by Greenpeace International, Amsterdam

Editor Director and Coordination: Dr Thomas Henningsen / **2nd Editor:** Simon Black / **Art Director and Layout:** Felix Kempf, fx68.de / **Translation:** RWS Group Germany / **Photos:** Cover: Bence Jardany, Marty Melville, Philip Reynaers, Kate Davison, Mitja Kobal, Asnaya, Christian Aslund, Yang Di, Igor Podgorny, Midia Ninja, Nick Cobbing, Alan Katowitz, Jeremy Sutton-Hibbert, Deden Iman, Paul Hilton, Jonas Gratzer, Christian Aslund, Zamyslov Slava, Andreas Schölzel, Dhemas Reviyanto, Chris Grodotzki, Virginia Lee Hunter, Clement Tardif, Keith K Annis,, Vinai Dithajohn, Dhemas Reviyanto, Ardiles Rante; p. 8, 12/13 Daniel Beltra; p. 14/15 Ulet Ifansasti; p. 16/17 Roger Grace; p. 18/19 Nick Cobbing; p. 20/21, 22/23 Daniel Beltra; p.24/25, 26/27 Lu Guang; p.28/29 Daniel Beltra; p.30/31 Lu Guang; p.32/33 Alex Hofford; p.34/35 Jeremy Sutton-Hibbert; p. 36/37 Julia Petrenka; p. 45 Kurt Abrahamson; p. 46 Rex Wyler; p. 47 Lesli Stone; p. 48/49 Kate Davison; p. 50 Miguel Angel Gremo; p. 51 James Perez; p.52 Joshua Marx, Stratospheric Productions, Greenpeace (2); p. 53 Greenpeace, Mitja Kobal; p. 54 David Sims; p. 55 Pedro Armestre; p. 56 Marten van Dijl; p. 57 Nigel Marple; p. 58 Greenpeace; p. 59 Fernanda Ligabue; p. 60 Thomas Reinicke, Daniel Müller; p. 61 Mitja Kobal; p. 62 Paul Langrock; p. 63 Clement Tardif, Israel Ronin, Sebastian Araya; p. 64 Maria Vasilieva, FB Anggoro; p. 65 Maria Vasilieva,; p. 66 Liza Udilova, Evgeny Usov; p. 67 Greenpeace; p. 68 Saris, Greenpeace; p. 69 Will Rose; p. 70 Pedro Armestre; p. 71 Paul Hilton; p.72 Lu Guang; p. 73 Jacob Balzani Lööv; p. 74 Nick Cobbing, Jeremy Sutton-Hibbert; p. 75 Dean Sewell, Vadim Kantor; p.76 Christian Aslund; p. 77 Christian Aslund (3); p. 78 Marten van Dijl (2); p. 79 Bara Sommersova, Max Zielinski; p. 80 Ruben Neugebauer; p. 81 Micka Bayu Kristiavan; p. 82 Denis Sinyakov (2); p. 83 Tom Jefferson, Nicolas Chauveau, David Kawai; p. 84/85 Pedro Armestre; p. 86 Melvias Priananda; p. 87 Matti Snellman; p. 88 Nick Cobbing; p. 89 Athit Perawongmetha; p. 90 Clement Tardif, Greenpeace; p. 91 Robert Visser, Chris Stowers; p. 92 Daniel Beltra; p. 93 Ricardo Beliel; p. 94 Daniel Beltra (2); p. 95 Rogério Assis; p. 96 Fred Dott; p. 97 Greenpeace; p. 98 Dhemas Reviyanto, Nugroho Adi Putera (2); p. 99 John Novis; p. 100 Fred Dott (3); p. 101 Jo Traver,; p. 102 John Novis; p. 103 Sebastian Pani; p. 104 Roger Grace; p. 105 Christian Aslund; p. 106 Greenpeace; p.107 Steve Morgan; p. 108 Prometeo Luzero, Steve Morgan, Greenpeace; p. 109 Fred Dott; p. 110 Pierre Gleizes; p. 111 Pierre Gleizes; p. 112 Rivan Hanggarai; p. 113 Pierre Gleizes; p. 114 Justin Hofman; p. 115 Mario Dib; p. 116 Pierre Gleizes (3); p. 117 Steve Morgan; p. 118 Jiri Rezac; p. 119 Greenpeace; p. 120 Steve Morgan; p. 121 Francesco Alesi; p. 122 Ex-Press / Michael Würtenberg; p. 123 Daniel Grunder; p. 124 Alex Hofford; p. 125 Mario Gomez, Vinai Dithajohn; p. 126 Jim Hodson; p. 127 Will Rose; p. 128 Adhi Wicaksong, Clement Tardif; p. 129 Greenpeace; p. 130 Greenpeace; p. 131 Alan Greig; p. 132 Shane Robinson; p. 133 Maity; p. 134 Keith K. Annis; p. 135 Thomas Henningsen, Ibra Ibrahimovic; p. 136 Manuel Citak; p. 137 Maria Feck; p. 138 Daniel Müller, Marty Melville, Lu Guang; p. 139 Marty Melville; p. 140/141 N. Scott Trimble; p. 145 Robert Keziere, Greenpeace; p. 147 N. Scott Trimble; p. 149 Ivan Castaneira, Prometeo Lucero; p. 151 Fabio Nascimento, Greenpeace (2); p.153 Jukio Pantoja, Martin Katz, Fernando Garcia; p. 155 Patricio Mirianda, Martin Katz, Sabine Greppo; p.157 Juan Diego Cano, Camilo Rozo (2); p. 159 Rasmus Törnqvist, Jana, Ericsson, Bas Beentjes, Dimitry Sharomov; p. 160 Uffe, Weng, Peter Thompson, Christian Aslund; p. 161 Jani Sipilä, Emil Holba, Andrew Mc Connell; p. 163 Will Rose (2); p. 165 Philp Reynaers (2), Paul Museol; p. 166 Wolfgang Hain; p. 167 Gordon Welters, Gregor Fischer, Fred Dott; p. 169 Marten van Dijl, Bente Stachowske; p. 170 Greenpeace; p. 171 Tim Dirven; p. 172 Pierre Gleizes; p. 173 David McTaggert; p. 175 Pierre Gleizes, Bas Beentjes; p. 177 Yokon, Benner; p. 178 Lorenzo Moscia; p. 179 Franzesco Alesi; p. 181 Pablo Blasquez (2); p. 183 Ibra Ibrahimovic, Lenka Kucerova; p. 185 Pawel Starnawski; p. 187 Max Zielinski, Greenpeace; p. 189 Mitja Kobal; p. 191 Catalin Georgescu, Ivan Donchev; p. 193 Nevio Smajic, Marcus Goritschnig; p. 195 Will Rose, Mihalis Karavannis; p. 197 Andy Booth, Greenpeace (2); p. 199 Medina Street, Roland Salem; p. 201 Pierre Gleizes (2); p. 203 Pierre Gleizes; p. 204/205 Pierre Baelen; p. 207 John Novis (2), Miche Patault; p. 208/209 Junior D. Kannah; p. 211 Nadine Hutton, Shane Robinson, Justin Sholk; p. 213 Z-eyezs, Greenpeace; p. 215 Gavin Parsons, Greenpeace, Caner Ozkan; p. 217 Vinai Dithajohn, Yvan Cohen; p. 219 Nandakumar; p. 221 Ardiles Rante Nugroho, Adi Putera; p. 223 Geric Cruz, Vincent Go; p. 225 Lu Guang; p. 227 Masaya Noda; p.229 Vincent Chan; p. 231 Sungwoo Lee; p. 233 Chad Liu; p. 235 Sarah Pannell, Dean Miller, Greenpeace; p. 237 Jason Blair, Greenpeace, John Miller; p. 239 Sajan Ponappa, Greenpeace; p. 241 Rex Weyler, Greenpeace; p.242 Bob Edwards; p. 243 Alex Stoneman; p. 247 Greenpeace; p. 248 Rex Wyler (2), Greenpeace; p. 250 Greenpeace; p. 251 Angel Pago, Oliver Tjaden, Bas Beentjes; p. 253 Oliver Tjaden, James Oatway, Greenpeace; p. 255 Maria Valilieva; p. 256 Bernd Arnold, Greenpeace; p. 261 Pierre Gleizes; p. 263 Daniel Beltra; p. 264 Marten van Dijl; p. 267 Market Redondo; p. 286/289 Shane Robinson / **Lithography:** Mohn Media, Gütersloh / **Print:** Druckerei Lokay e.K., Reinheim / Printed in Germany 2021

Delius Klasing Verlag
Siekerwall 21 / D - 33602 Bielefeld / Tel.: 0521/559-0, Fax: 0521/559-115 / E-Mail: info@delius-klasing.de / www.delius-klasing.de

The book is printed on 100% recycled paper.

WK9
Dieses Druckerzeugnis wurde mit dem Blauen Engel ausgezeichnet

www.blauer-engel.de/uz195

print production
www.natureoffice.com/DE-344-KQ9JN5D
carbon neutral
through CO2 offsetting